Widescreen Cinema

WIDESCREEN CINEMA

John Belton

HARVARD UNIVERSITY PRESS
Cambridge, Massachusetts
London, England
1992

Copyright © 1992 by the President and Fellows of Harvard College
All rights reserved
Printed in the United States of America
10 9 8 7 6 5 4 3 2 1

This book is printed on acid-free paper, and its binding materials have been chosen for strength and durability.

Library of Congress Cataloging-in-Publication Data

Belton, John.
 Widescreen cinema / John Belton.
 p. cm.
 Includes bibliographical references and index.
 ISBN 0-674-95260-X (cloth).—ISBN 0-674-95261-8 (paper)
 1. Wide-screen processes (Cinematography)—History. I. Title. TR855.B46 1992
 778.5'34—dc20 92-5985
 CIP

To my mother

PREFACE

This book began in 1968 with a rediscovery of American cinema of the 1950s that was facilitated by film societies at Harvard and MIT and by revival houses in Cambridge, Massachusetts, and New York City. It evolved through a series of courses dealing with film aesthetics, film technology, and film history which I taught at Columbia University, Yale University, New York University, and Rutgers University. The project crystallized when the papers of the Research Department of Twentieth Century–Fox, the studio which innovated Grandeur and CinemaScope, were deposited, through the auspices of Alex Alden, Stephen C. Chamberlain, and the Archival Papers and Historical Committee of the Society of Motion Picture and Television Engineers, in the Columbia University Libraries, providing scholars with access to previously unavailable technical information.

In 1987 the National Endowment for the Humanities awarded me a year-long Independent Fellowship and Research Grant which enabled me to begin research for this book. Primary and secondary research made use of the Sponable Collection at the Columbia University Libraries, the Warner Brothers Archives at the University of Southern California, the Twentieth Century–Fox Collection at UCLA, the Film Archives at UCLA, the Film Study Center at the Museum of Modern Art, and the Lincoln Center Library for the Performing Arts.

Individuals who were instrumental in assisting my research include Leith Adams, Rudy Behlmer, Matthew Bernstein, Willem Bouwmeester, Stephen Chamberlain, Ned Comstock, Robert de Pietro, Raffaele Donato, Bruce Goldstein, John Harvey, Lea Jacobs, Richard Koszarski, Al Lewis, John Mosely, David Rodowick, Philip Rosen, Ralph Sargent, Charles Silver, Martin Scorsese, and Tony Slide. Robert Gitt, Paul Rayton, and Mike Schleiger were especially helpful in supplying me with valuable information and in providing me with access to crucial widescreen films. I remain indebted to Alex Alden and Herbert Bragg, who worked in the Research Department at Twentieth Century–Fox in the 1950s and who graciously

answered scores of questions about the development of CinemaScope and CinemaScope 55 at Fox and the introduction of other wide-film and widescreen formats elsewhere during this period.

Portions of this manuscript were read by Rick Altman; William C. Dowling; Tom Gunning; Dana Polan; William Paul; my editor, Lindsay Waters; and my wife, Ellen. I also wish to thank Ann Hawthorne, who carefully edited the manuscript for publication; and Lisa Clark, who designed the book. Their comments and suggestions proved invaluable in the final stages of the preparation of this book.

CONTENTS

Widescreen Cinema

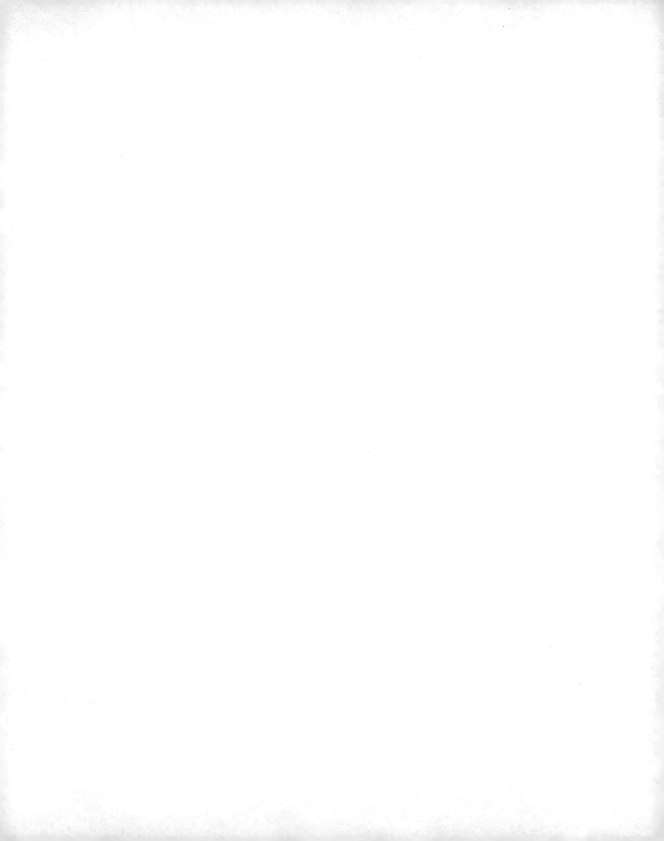

INTRODUCTION:
WRITING HISTORY BACKWARD

The lights went out, and for a few minutes the well-known newsreel commentator Lowell Thomas, filmed in black and white on standard, narrow-screen 35mm film, delivered a thirteen-minute lecture about the history of art. He traced its evolution from cave paintings and frescoes to canvas portraits and landscapes, from magic lanterns to moving pictures, from the era of nickelodeons to that of silent picture movie palaces. "Artists, photographers and motion picture cameramen," he announced, "have worked since the dawn of history to give the illusion of depth, dimension and space" to their work, "to convey the sense of living motion."[1] Then Thomas lamented the limitation of artists to formats necessarily constricted by frames of one sort or another—by cave walls, picture frames, theater screens, and other internally or externally imposed boundaries. "From the beginning," he said, "pictures have been restricted in space. A painting is hemmed in by its frame . . . Conventional motion pictures are confined to a narrow screen . . . Movies are like looking through a keyhole. Cinerama breaks out the sides of the ordinary screen, and presents very nearly the scope of normal vision and hearing."[2] Then, with the introductory words "Ladies and Gentlemen—THIS IS CINERAMA," the burgundy red theater curtains in New York's Broadway Theatre began to open—and open—and open, and a panoramic, engulfing Technicolor image of the Rockaways Playland Atom-Smasher Roller Coaster ride filled the screen, which had expanded to triple its initial width.

As the roller coaster moved forward, so did the camera. Spectators in the theater were suddenly plunged into one of the most visceral motion picture experiences ever created. The frame of the theater proscenium seemed to disappear, and the audience had the uncanny sensation of entering into the events depicted on the deeply curved screen in front and to the sides of them. Cinerama put the audience in the front car of the roller coaster and surrounded them with eye-filling peripheral images which created an unprecedented illusion of depth. At the same time, the monaural sound

featured in Thomas' prologue suddenly gave way to stereo: the music and sound effects spread from the center to speakers to the left and right behind the screen and to surround speakers in the rear of the auditorium. With Cinerama, Lowell Thomas' evolutionary history of realism in the arts had reached its apogee—or so it seemed. Cinerama had realized what the film historian-cum-theorist André Bazin had once referred to as the "myth of total cinema," that ideal goal toward which the cinema autonomously progressed in its attempt to satisfy our unconscious desire for "a total and complete representation of reality . . . a perfect illusion of the outside world in sound, color, and relief."[3]

Virtually overnight, the traditional conditions of spectatorship in the cinema were radically redefined. On September 30, 1952, Cinerama launched a widescreen revolution in which passive observation gave way to a dramatic new engagement with the image. Cinerama-inspired processes such as CinemaScope (1953) and Todd-AO (1955) engulfed spectators in a startlingly new world of oversized images and multidirectional sounds and transformed their experience of motion pictures. But this transformation did not in fact take place overnight, nor was it evolutionary in the Darwinian sense of the word. It took decades for the cinema to change its shape, and the path leading to this change was not linear, whatever Thomas' thumbnail sketch of the history of Western representation suggested. Rather it was full of twists and turns.

Neither Lowell Thomas' history nor, for that matter, that of Bazin or of Charles Barr (who wrote specifically about the coming of widescreen as the fulfillment of the cinema's integral realism) manages to capture the complex interplay of ideological, technological, economic, and sociocultural forces that informed the development of widescreen cinema.[4] None of these accounts adequately deals with the relation of widescreen to the enhanced illusion of cinematic realism with which it is so often associated. The appeal of widescreen in the 1950s rests as much upon its production of greater spectacle as upon that of greater realism.

For "idealist" historiographers such as Bazin and Barr, the widescreen revolution represents the final stage in a cause-and-effect chain of events leading toward greater realism in the cinema. Cinerama and other widescreen systems emerged in the 1950s, completing the illusion of cinematic realism begun in the late 1920s and early 1930s by the addition of sound and color to the silent, black-and-white moving image. But in fact

widescreen and wide-film processes had been in existence since the 1890s, and a wide-film revolution had been attempted in the late 1920s, during the transition-to-sound period. Only by considering the "evolution" of widescreen cinema in the context of other technological and cultural activities is it possible to explain why "narrow-gauge" 35mm film rather than wide film was adopted as a standard in the first decade of the cinema's development, why wide film failed in the late 1920s, and why widescreen and wide film succeeded in the 1950s.[5]

History, as Louis Althusser has suggested, "is a process without a *telos* or a subject."[6] In other words, history does not possess a goal (a *telos*), nor does it have an "I," a sense of self. But historians and the discipline of historiography routinely provide the object "history" with both a *telos* and a subject, describing it in terms of its pattern of development, direction, or goal and characterizing its movement(s) in terms of its essential nature, as linear, cyclical, or dialectical, or as progressive or regressive, or as utopian or dystopian, or the like. The task of the historian is to explain the process of history in terms of a narrative logic which coheres it.[7] And, once it is given coherence, historical process takes on the identity constructed for it in the mirror held up to it by the writing of history. In other words, when we write history, we render it as a story—with a beginning, middle, and an end.

But when we write history, we do not write it in the way that it occurs. In narrativizing events, we reverse the temporality of history, which is chronological, to produce "history," which *recounts* that chronology. That is, we write history backward, explaining an event or moment as the effect of an earlier cause, scanning the past for likely determinants of this effect. This practice informs all historiography—even theoretically informed works, though it is perhaps most evident in film historiography in the writings of Bazin. In effect, Bazin's quasi-teleological methodology determines his (re)shaping of history. He begins quite often with an enigma and constructs out of it a retrohistory, working back from the "end" to a "middle" and finally to a "beginning," which explains that enigma.

"An Aesthetic of Reality," his essay on neorealism, for example, begins with the fact of Italian postwar cinema's apparent rejection of traditional film styles but then locates sources for neorealist aesthetics in Soviet cinema of the 1920s, Italian cinema of the 1930s, and American popular fiction of the 1920s and 1930s.[8] His study of deep focus identifies its origins in

classical editing of the middle to late 1930s; and his evolution of the language of sound cinema is linked to the silent films of F. W. Murnau, Erich von Stroheim, and Robert Flaherty.[9] In each case, Bazin reconstructs an evolutionary, linear development to the present moment. In other words, Bazin's historiography, which projects into the past far more often than it does into the future, is not so much teleological, as his critics would suggest, as it is archeological, intent on uncovering the origins of phenomena.

Bazin is not alone in retrofitting history to explain the present. Film theorist and filmmaker Sergei Eisenstein employs a similar strategy. In his films, he reconstructs a dialectical chain of events leading to moments of revolutionary brotherhood, suggesting the inexorability of that process. In his theoretical work, he traces his own development as an artist (and that of the Meyerholdian splinter of the Futuro-constructivist movement to which he belonged) "Through Theater to Cinema" and demonstrates how the shot and montage derived from practices found in the theater.[10] In "Dickens, Griffith, and the Film Today," he provides a history of the dialectical development of montage from the simple, naive parallelisms of Charles Dickens and D. W. Griffith to the dynamic juxtapositions of Soviet film in the present day.[11] Unlike Dziga Vertov, who "presumptuously" dehistoricizes formal techniques such as montage, claiming for it a "virgin-birth" in the new art form of the cinema, Eisenstein insists that "our cinema is not altogether without parents and without pedigree, without a past, without the traditions and rich cultural heritage of the past epochs."[12] Again and again, Eisenstein moves from a present moment to its origins in the past. Yet his attempt at the reconstruction of history, unlike Bazin's, was designed to reveal its essentially dialectical nature. For Eisenstein, a priori notions of the subject and *telos* of history, notions which had been derived from the dialectical materialism set forth in Engels' *Dialectics of Nature*, ultimately determine his narrativization of events.

My own history of widescreen cinema is written forward and sideways as well as backward, spreading out in all directions from an original target of study. It began as a straightforward history of Twentieth Century–Fox's innovation of CinemaScope in 1953. But it soon became clear that this innovation could not be adequately discussed independently of Cinerama, which was introduced several months earlier, in September 1952, and which prompted the research leading to the development of CinemaScope and to the premiere of the first CinemaScope film, *The Robe*, in September 1953.

Nor could either process be fully understood without an examination of Todd-AO and other wide-film processes which displaced Cinerama and CinemaScope in the motion picture marketplace in the mid-to-late 1950s. What emerged was not a history of events but a history of the *relationship among* an ever-expanding field of interrelated events.

I had to enlarge the parameters of my study. I began to construct not only an industrial setting within which to situate the widescreen revolution but a sociocultural terrain as well, tracing changes in the conditions of spectatorship which accompanied the shift to a new, more highly participatory form of screen entertainment. The scope of the work broadened once again as I began to historicize the seemingly sudden shift to widescreen formats in the 1950s. Cinerama, CinemaScope, and other widescreen systems did not emerge magically from the head of Hollywood; their success in the mid-1950s did not occur in a historical vacuum but against a background of earlier failure. A close examination of the factors which led to the abortion of the wide-film revolution of 1926–1930, when Fox and other studios attempted to innovate various wide-film systems, revealed that these "negative" determinants were reversed in the postwar era, prompting the adoption of technologies remarkably similar to those which had earlier been rejected. I also look forward from the 1950s to the transformations that have taken place in motion picture exhibition during the past thirty years. If the "rise" of widescreen could be located in the period 1926–1930, then its "demise" would seem to be integrally bound up with multiplexing, the marketing of widescreen films to television, the advent of the videocassette recorder, and, with it, the growth of a major subsidiary form of distribution for widescreen films through videotape sales and rentals.

Writing backward, forward, and, at times, sideways sent me back even further than the transition-to-sound period—back to the 1890s, when the cinema was "invented" and when the 35mm film standard was first established. Widescreen cinema was not born in the 1950s nor even in the 1920s but was the product of the first "large-screen" projections of motion pictures in 1896. Factors surrounding the transition of the cinema from peepshows to projection then led this project forward again into the 1990s, when, with the immanent introduction of a widescreen high-definition television (HDTV) format, the nature of the at-home widescreen motion picture experience promises to be redefined in a way that is somewhat reminiscent of that which took place during the first large-screen revolution of 1896.

And finally, like the crab, I must repeatedly move sideways to situate specific historical events within a larger field of industrial and sociocultural development. This enables me to ground events in a system of relationships which extends beyond the specific subject of widescreen cinema and to consider changes that took place in mass-produced leisure-time entertainment during the twentieth century. By considering the appeal of widescreen cinema to postwar spectators, I want to trace connections between technological change (or the lack of it) and periods of stability or change in the patterns of popular consumption of mass entertainment and attempts to highlight the role that widescreen played in redefining the nature of the spectator's experience of motion pictures in the mid-1950s.

NONLINEAR DETERMINATION

The logic which holds this history together is that of a stratified, uneven—that is, nonlinear—determination in which events are viewed as the product of a complex array of socioeconomic, cultural, technological, ideological, and other determinants and in which each determinant is itself multiply determined. In other words, I view technological, economical, and ideological demands not so much as monolithic forces, working in conjunction to drive the development of widescreen, but as mechanisms that are "multilithic." That is, they function as often in conflict as in harmony; they emerge as fragmented phenomena—both externally in their relationship with one another (for example, the relationship of economics to technology) and internally in the relationship of each part to each other part within a larger whole (for example, the relationship of one economic demand to another).

I aim to rewrite the simple, linear technological histories, such as those of Kenneth Macgowan and Barry Salt, and provide a fuller scenario which is sensitive to the dead ends and detours which inform the cinema's development.[13] But I also attempt to extend certain models of nonlinear historiography beyond the reductionist implementation that has characterized their use in the work of Jean-Louis Comolli and others.[14] Comolli, for example, regards technology, economics, and ideology as *isolable* determinants that are monolithic rather than multiple in nature. Ideology, for instance, is always singular in Comolli's work rather than plural, as it is in Althusser. And Comolli reduces its operations to the simple satisfaction of a single demand—that for greater realism.[15]

If, as John Hess suggests, "ideology is a relatively systematic body of ideas, attitudes, values and perceptions, as well as actual modes of thinking (usually unconscious) typical of a given class or group of people in a specific time and place,"[16] then there are as many different ideologies as there are different classes or groups and different times or places. But Comolli reduces the complex interaction of various (often conflicting) ideologies to the uniform operation of a single, unchanging Ideology.

By the same token, differing economic demands are flattened into a single Economic Demand—the demand to make a profit.[17] For Comolli, the film industry operates as a single economic entity, united in its quest for profit. However, Comolli's Economic Demand ought properly to be broken down into smaller, potentially conflicting economic demands. Comolli refuses to consider that the economic demands of the industry as a whole are, more often than not, at variance with one another. Production does not share the same short- or long-term economic goals as exhibition, especially after the 1948 Consent Decree, which divorced production and distribution from exhibition; and even exhibition, which consists of various tiers, is frequently at odds with itself.

IDEALIST VERSUS MATERIALIST HISTORIOGRAPHY

As a retro-writing, this history tries to profit from the mistakes of the past. My work takes its cue from the theoretically informed historiography of Bazin and Eisenstein but attempts to avoid certain idealist assumptions which underlie their writings and which have been singled out for attack in the work of Bazin in particular. At the same time, it also benefits from a critical reading of those attacks and the reductionism implicit in their conclusions. Bazin's notion of historical development has been subjected to critique, by Comolli and others, as idealist.[18] That is, Bazin is said to trace a course of events in such a way that the events unfold or reveal a preexistent idea which informs their development. Against this idealism, Comolli has called for a form of "materialism," somewhat akin to Engels' notion of historical materialism, in which the writing of history is rooted in the contradictory nature of events themselves.[19]

Materialist historiography can be characterized, in part, by a series of rejections—the rejection of the concept of linear causality, the rejection of a teleological view of history, the rejection of the notion that the cinema

evolves autonomously, independently of technological, economic, and ideological factors, the rejection of cinematic darwinism—the notion that there is a gradual *perfection* of cinematic forms and technique, and the rejection of historical essentialism—that is, that its evolution gradually unfolds its essence.[20]

But materialism is itself flawed by its own teleological project. Rather than looking for a linear chain of events to explain the present (as Bazin does), materialist historiography looks for uneven development, constructing a history that confirms its notion of historical process. In other words, it generates a scenario of events which is essentially idealistic in nature, which confirms an a priori notion of how history works.

There is no simple solution to this dilemma. "History" must necessarily shape, cohere, and transform its object—history. "History" frequently tells us more about the historical period in which a "history" is written than it does about history. Thus, much as Bazin's initial writing of film history remains informed by a certain postwar need to cohere the fragmentation of experience with an illusory continuum which suggested history's transcendent sense of destiny and order, Comolli's rewriting of Bazin belongs to a specific revisionist phase of film studies in which that fragmentation of experience is conveyed—in which the incoherence, discontinuity, and contradiction which inform contemporary constructions of historical process determine historical form. Both narrativizations of history seek to impose certain temporal and logical patterns upon events that observe their own temporality and logic and that thus elude representation. My own work necessarily engages in the same sort of temporal mediation, projecting patterns upon the past from the privileged perspective of the present.

HISTORY'S TWO TEMPORALITIES

Film history is written from a perspective in the present which seeks to cohere a past temporality. Because of the different natures of their temporalities, the historical narrative and historical reality pose, as texts, radically different problems for those of us who try to read them. Each text is written according to a different form of determination; in the historical narrative, determination takes place a posteriori in the fictional space of the historian's reconstruction of events; in historical reality, determination takes place within the time and at the very moment of the events' occurrence. No matter

how much narrative and history resemble one another, they can never be collapsed—the historian's writing of history takes place in a different space and at a different time from the events that history produces as writings of its own.

The historian, of course, has no choice but to attempt to write history, and must repeatedly confront the temptation to equate a record of events with history itself, to collapse history's dual identity as fact and fiction into a coherent, fully integrated personality. Historiography is forever condemned to the status of a representation whose object of study lies elsewhere—inaccessible to the historian.

Since it is essentially unrepresentable, historical reality can be adequately represented only as an absence. But, as Paul Ricoeur has suggested, historical reality is not entirely inaccessible; it does provide us with a text. This text consists of events—what we call the evidence of history itself, the sign of its existence. Ricoeur refers to this evidence as the trace of history; this trace is a presence marking an absence. As a presence which signifies an absence, that trace can be "read" in such a way as to reconstruct, through a complex process of decipherment, a partial representation—albeit Imaginary—of its absent cause, of history itself.[21] In other words, in order to write history we must assume that historical traces can be read, that there is a connection between historical traces and the invisible forces which they represent, and that the relationship of trace or evidence as representation to the object "history" is necessarily motivated. But we can also assume that the nature of that motivation is not direct but indirect, not immediate but mediated.

REWRITING HISTORY

Historical evidence, then, is a text that, in many ways, resembles other texts, especially in its need to be read, to be deciphered.[22] When we look at history in an attempt to write it, what we look at is, in a sense, already written. We take as primary source material history as it exists through and in secondary representations of it (in original documents, eyewitness accounts, newspaper stories, and traces left behind which testify, directly or indirectly, to the existence or occurrence of some prior event). We then reshape this evidence, writing over an earlier inscription of history. The writing of film history, then, remains entirely a discursive practice, situated

within language and thus necessarily distanced from historical reality by the various discourses and texts that stand between it and the historian's attempt to rewrite it. If the film historian is to do anything more than duplicate those texts and discourses as if they were history, then he or she must learn to look at historical evidence as a field of different discourses and to read and analyze them as such. The sources of these discourses need to be identified; it is necessary to consider not only who (or what) is speaking and why, but also how these discourses have been circulated, by whom, and for what reason. In short, the messages in these texts must be decoded before they can be read. In this way, historical "evidence" would be forced to reveal to us the *telos* and the subject given to it in its initial inscription.

As Fredric Jameson might observe, an account of history which relied chiefly on mechanistic causality has been replaced with one that is shaped by structural causality. Events are seen not as products of a simple cause–effect determination but as the products of a system of relationships—that is, a structure—among several semiautonomous elements which exist on a variety of different levels and whose relationship with one another is nontransparent, complex, and mediated.[23]

If events exist for us as already written, then the best that a historian can do is to rewrite them. That rewriting which coheres the greatest number of other, earlier writings will achieve a special status as master-narrative or superstory, achieving greater credibility than all other narratives because it not only acknowledges its own status as a narrative but treats the events it seeks to understand as already narrativized, reading them in such a way as to pressure to the surface the absent forces which their presence conceals. Historiography remains incapable of telling us what "really" happened, but it can tell us how what happened has been transformed into a fiction. The historian can never create a representation that is adequate to the complex reality of history, but can, by acknowledging his or her own activity in the rewriting of history, lay bare the device, revealing how the "story" in "history" has been written.[24]

The narrative which follows attempts to achieve the status of such a master-narrative while remaining cognizant of its own operations as a narrative. *Widescreen Cinema* is, first and foremost, a *history;* though it deals, at times, with aesthetic issues, it is concerned primarily with the writing of a history of widescreen cinema rather than with analysis of the visual and aural style of individual widescreen films. As a history, it endeavors to

construct a quasi-materialist, uneven account of the development of motion pictures from narrow-screen entertainments to widescreen "events" and then, with the advent of small-screen theaters and home video screens, their "devolution" back into a narrow-screen phenomenon. It strives to be discursive while remaining aware of its necessary status as a discourse itself within other discursive practices.

This book traces the (repeated) rise and demise of widescreen cinema since the development of the 35mm motion picture film format in the early 1890s. It analyzes the symptomatic appearance and reappearance of wide-film and widescreen formats during three distinct phases of film history: its initial emergence during the first decade of the cinema's invention, innovation, and diffusion; its reemergence twenty years later, during the transition-to-sound period; and, finally, its successful institutionalization in the mid-1950s. This overview is designed to reveal the contribution of widescreen cinema to the evolution of the cinema as a whole, situating its initial invention in the context of the establishment of the cinema itself as a form of mass entertainment. Its aborted innovation during the years 1926–1930 confirms the stability of the cinema as a medium geared to the desires of a habitualized mass audience. Its reemergence during the 1950s testifies to the need for a redefinition of the motion picture experience for the traditional spectator, and its demise in the era of multiplexes and videotape illustrates the ways in which contemporary spectatorship has itself been transformed by television and the video revolution.

The history of widescreen cinema, like that of the cinema itself, is hereby given a *telos* and a subject. The discontinuity of its development reflects the complex play of technological, socioeconomic, and ideological forces at work in the motion picture marketplace, which determined the unique form which that development took. The history which follows has the unenviable task of attempting to motivate connections with a past which is constantly changing. The writing of this history necessarily forces those connections, functioning somewhat like a lawyer with a reluctant witness and imposing meaning upon events that defy representation—that have no meaning outside of that with which this (attempt at a) master-narrative invests them. With history, as with the past, the only thing of which we can be certain is its uncertainty, a characteristic which informs the "hesitant" account of widescreen cinema which follows.

THE SHAPE OF THINGS TO COME

When Cinerama, CinemaScope, VistaVision, Todd-AO, and other wide-screen formats were introduced in the early 1950s, they were initially regarded, like 3-D, as novelties, as developments of only passing interest and little importance. During a brief but cataclysmic eighteen-month period from late 1952 to early 1954, dozens of new widescreen and 3-D processes were announced or unveiled to the motion picture industry, the press, and the general public. Industry publicists enthusiastically promoted these new entertainment technologies as remedies that would restore the health of the ailing motion picture industry and lure audiences back into motion picture theaters. The popular press eyed these developments with a certain skepticism, questioning whether Hollywood had developed a radical new technology that would, as the coming of sound had done almost twenty-five years earlier, "revolutionize the screen or whether it [was] wildly romancing a novelty that [would] soon turn out to be a dud."[1]

By the end of the decade, widescreen had evolved from a transitory fad into a permanent fixture of motion picture production and exhibition, supplanting the old production and exhibition standard. Although other technological innovations, such as 3-D, never progressed beyond the status of novelty items, widescreen, like sound and color, transformed the face of the cinema, establishing a new set of technological and aesthetic norms. This evolution of widescreen cinema resembles that of the cinema itself, which also evolved from novelty to norm. And, like the larger phenomenon of the cinema, widescreen advanced unevenly, plagued with false starts, snares, and detours. Though wide film and the potential for widescreen appeared in the first phases of the cinema, economic, technological, and ideological factors produced another norm—35mm cinema—which came to dominate the industry. This domination faltered momentarily during the transition-to-sound era with the introduction of Grandeur and other wide-film systems. But the 35mm norm remained in place even in this period of turmoil, and continued to provide the standard for production and exhibition until the

early 1950s. This history thus begins by exploring the failure of a novelty to become a norm, by examining the necessary elimination of initial experimentation with wide film in order to establish this first norm and the subsequent unwillingness of later, silent-era, widescreen systems, such as Abel Gance's Polyvision or Paramount's Magnascope, to shed their status as novelties and to establish a new norm.

CINEMA AS NOVELTY

The history of American widescreen cinema, like the history of American cinema itself, begins with notions of novelty. Indeed, the popular reception of the widescreen revolution looks back to attitudes surrounding the invention of the cinema; both were considered to be short-lived phenomena of minor cultural or aesthetic significance. A new technology designed primarily for short-term amusement, the cinema remained a novelty item until its technology no longer supplied the greater part of its amusement value. The cinema began as a scientific curiosity; audiences were more intrigued by its hardware than by its software. Exhibited as a wonder of science, as the latest piece of mechanical magic devised by the Wizard of Menlo Park, its significance as a revolutionary form of entertainment was initially minimized. The Kinetoscope was dubbed "Edison's latest toy."[2] Even Edison himself, as a technology-centered industrialist, saw no future in the device beyond its limited exploitation in peepshow parlors.[3] Similarly, Louis and Auguste Lumière initially viewed their Cinématographe "only as a plaything of which the public would soon tire."[4] Though the toy "grew up" into a rather serious billion-dollar industry, its initial identity as "plaything" remained. Now, however, its novelty value was displaced from its basic technology to the actualities, trick films, and primitive narratives that it presented to its growing audiences.

Although the first chroniclers of the cinema (such as Terry Ramsaye) tend to write its early history as a saga of heroic technological invention driven by the demands of a marketplace hungry for novelty, contemporary historians, ranging from Noël Burch to David Bordwell, Janet Staiger, and Kristin Thompson, construct the first few decades of the American cinema's development more in terms of the emergence of narrative codes than in terms of technological invention.[5] Burch, for example, traces the establishment of an "Institutional Mode" of representation, which he links to a shift

in the address of film as an institution from lower-class to middle-class audiences. Though Bordwell, Staiger, and Thompson integrate technological factors into their account of the emergence of "Classical Hollywood Style," technology enters in primarily as the mechanical basis upon which an economically determined, industrial mode of production rests.

Clearly, the relationship between the cinema as a technological phenomenon and as a narrative apparatus is complex, especially within the massive field of mainstream narrative cinema, which sustains a dual (if not triple, quadruple, or more) identity as both technological spectacle and seamlessly invisible mode of narrative representation. In many ways, a materialist writing of the cinema's technological history is remarkably well suited to acknowledge this interplay of identities and to capture those aspects of the cinema as novelty item which certain idealist histories ignore. Each new technological development—the advent of sound, color, widescreen, and so on—can be seen, through a materialist scenario, to restore briefly the cinema's initial identity as novelty, foregrounding the new technology in ways which disrupt the medium's carefully constructed, seamless surface of invisibility.

The term *widescreen cinema* refers to a form of motion picture production and exhibition in which the width of the projected image is greater than its height, generally by a factor of at least 1.66:1.[6] During the past century, scores of different widescreen systems have been developed, and, though some have been wider than others, they have all ultimately been referred to simply as "widescreen." This term has thus come to denote not merely one but all wide motion picture formats. Though each widescreen format varies to some degree from the others, they all distinguish themselves, as a group, from one basic format—the early industry standard of 1.33:1. Thus widescreen is "wide" only in relation to another form of cinema that is "narrow."[7]

Widescreen cinema exists, then, both as a linguistic and as a historical phenomenon, as a term of difference—intitially as a deviation from the norm of "narrow-screen" cinema and ultimately as a new norm, having become virtually the standard for all contemporary motion picture practice and differing today only from the alternate form of "narrow-screen" television. Given the relative nature of its status, the significance of widescreen cinema lies, to a great extent, in its difference from an earlier standard. It is only against this background that the history of widescreen cinema's

passage from novelty to alternative format and, finally, to new norm can be mapped.

If widescreen cinema emerges as a deviation from the norm, from a background set of conventions and codes, then its meaning and significance depend on the meaning and significance of those earlier conventions and codes, which must themselves be identified and investigated and whose origins must similarly be isolated and explored. The history of widescreen cinema necessarily begins as an archeological project with the exhumation of its origins in "narrow-screen" cinema (the norm which it violates)—that is, with answers to the question of where the standards of 35mm film and its initial aspect ratio (of width to height) of 4:3 came from.[8]

ESTABLISHING THE NORM

"At the end of the year 1889," wrote W. K. L. Dickson, Thomas Edison's assistant, in the fall of 1933, "I increased the width of the picture from ½ inch to ¾ inch, then, to 1 inch by ¾ inch high. The actual width of the film was 1⅜ inches to allow for the perforations now punched on both edges, 4 holes to the phase or picture, which perforations were a shade smaller than those now in use. This standarized film size of 1889 has remained, with only minor variations, unaltered to date."[9]

In the course of developing the first motion picture camera that used strips of flexible celluloid film, the Kinetograph, and the Kinetoscope, the peephole device which displayed films made with the Kinetograph to the public, Dickson established two of the most durable standards of the motion picture industry: that of 35mm film as a production and exhibiton format and an image aspect ratio of 4 units wide to 3 units high.[10] "With only minor variations," 35mm film has remained the standard medium for the production and exhibition of commercial motion pictures since 1889.[11] In settling on a negative image that was 1 inch wide by ¾ inch high, or 1.33:1, Dickson introduced a shape that is still with us today in the form of the television screen, 16mm productions, and 8mm home movies. In terms of commerical production and exhibition, it lasted as a standard for over sixty years, from 1889 until 1953.[12]

Unlike the basic technological *machinery* developed by Dickson (consisting of camera and viewing mechanism/projector), without which there would be no cinema, 35mm film and the 4:3 aspect ratio are *formats*, each

THE MAIN
FEATURES OF THE
KINETOGRAPH
CAMERA (CA. 1889),
INCLUDING FOUR
FRAMES OF 35MM
MOTION PICTURE
FILM (COURTESY OF
SOCIETY OF MOTION
PICTURE AND
TELEVISION
ENGINEERS).

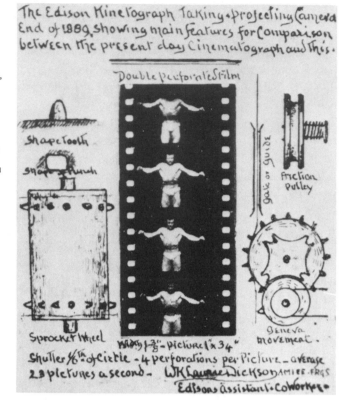

being one among several possible options available to the inventor.[13] In other words, Dickson could have chosen a wider or narrower film gauge and a different aspect ratio but could not have done without a camera and viewing mechanism or projector and still have "invented" the cinema.[14] Indeed, film history itself confirms this difference between "basic" and "optional" technology. Although the film industry has witnessed relatively little change in its basic technological machinery, it has, over the years, experimented with a variety of different formats.

Yet, for more than sixty years, the American film industry regarded 35mm film and the 4:3 aspect ratio as basic rather than optional technology, marginalizing all deviations from these norms. Given their "optional" nature, what accounts for their special status as "basic": why were they adopted by the film industry as a whole, and why did they last for as long

as they did? At the same time, if these formats represent an option, what were the other options available, and what led Dickson to select these particular formats rather than others?

Why 4:3?

Dickson himself wrote several accounts of the development of the Kineto-graph and Kinetoscope, but he never explained why 35mm film and the 4:3 aspect ratio were chosen as formats.[15] In constructing histories of the beginnings of the cinema, scholars, like Dickson himself, have tended to take these formats for granted, presuming that Dickson merely adopted formats previously established by George Eastman for the flexible-base roll film used in the Kodak camera.[16] This, however, was not the case. Eastman, like other manufacturers of flexible film, produced film in large sheets, which were then cut in strips to order.[17] "Mass-produced" film strips for the Kodak came in 70mm and 90mm, not 35mm gauges.[18]

The 4:3 aspect ratio has been traced back to a previous projection standard—that of lantern slides.[19] Nineteenth-century hand-painted lantern slides, however, came in a variety of shapes and sizes, including circular, square, and rectangular.[20] Though certain lantern slide standards were eventually established in Europe, they tended to be square (3¼ × 3¼ inches) rather than rectangular.[21] Photographic slides were similarly diverse in size and shape and did not become standardized at 4:3 until the latter part of the first decade of the twentieth century, several years *after* the standardization of the motion picture format.[22] Indeed, motion picture dimensions may have actually played a major role in determining the aspect ratio for slides.

Another possible origin for the 4:3 ratio might be located in the ratio of width to height in nineteenth-century photographs. But photographic plates and prints also came in a variety of formats, depending upon the content of the image (portraits tended to be taller than wider, landscapes wider than taller).[23] Eadweard Muybridge's and Etienne-Jules Marey's sequence photographs, with which Dickson and Edison were familiar and which played a crucial role in their development of the Kinetograph, also varied in aspect ratio depending upon the subject matter. It is possible, however, that Ottomar Anschütz's Electrical Tachyscope (1887), which projected 9 × 12 cm transparencies sequentially onto a screen, influenced Dickson, who

experimented with with Anschütz's projection device in 1889, shortly before turning from the microphotography associated with the cylinder apparatus to larger image dimensions made possible by the introduction of Eastman roll film.[24]

The immediate adoption of 35mm film in 1896 by the Lumière Brothers, the largest producer of motion picture films (and, a few years later, the largest supplier of raw stock) in Europe, and the reliance of British producers on 35mm film (supplied by the Blair Company) solidified the position of 35mm film in the international marketplace.[25] The emergence of 35mm film and the 4:3 aspect ratio as standards during the first decade of the century served only to confirm their assumed status as the end products of a Darwinian course of events which evolved through the process of natural selection.

Yet there is nothing "natural" about these formats. They do not seem to have grown "organically" out of some prior medium of representation. Nor do they initially appear to be automatic consequences of the invention process. At the same time, they were not quite arrived at arbitrarily, as Cecil Hepworth and others suggest.[26] On the contrary, they were determined by constraints that were as much extrinsic as intrinsic. These dimensions came into being in response to specific economic, technological, social, and ideological demands which shaped Dickson's work in certain ways.[27]

Why 35mm Film?

The 35mm film gauge derives, in part, from an already-existing *technological* standard—Eastman flexible-base film, which Dickson merely adapted for his own purposes. The Kodak No. 1 still camera was introduced by George Eastman in 1888. By August 1889 it had evolved from reliance upon a paper-base film to the use of a transparent, celluloid-base film (popularly known as "Eastman Transparent Film"). This was a 70mm film which Eastman produced in his plant. For use in his motion picture experiments, Dickson simply slit this film in half, producing a gauge of 35mm.[28]

Though a 70mm format would have undoubtedly provided a superior image, a 35mm film gauge, even after perforation of the film along both edges, still left enough space for an image large enough to ensure satisfactory reproduction by means of a peephole viewing mechanism.[29] Even when magnified in projection, the silver haloids in the slit Eastman emulsion

THE KODAK NO. 1
STILL CAMERA
(1888), LOADED
WITH 70MM FILM
(AUTHOR'S
COLLECTION).

remained invisible (unlike those in earlier, experimental emulsions and in smaller-gauge films).[30] Thus 35mm film satisfied a minimal *ideological* demand—the demand for verisimilitude, for a credible illusion of reality. Jean-Louis Comolli refers to this desire, which drove the invention of both photography and the cinema, as the desire "to see life as it is."[31] Dickson's dimensions provided sufficient sharpness and clarity to guarantee the necessary illusion of reality required for the successful exploitation of the peep-show Kinetoscope (and for eventual small-screen projection, with which Dickson had also experimented).

By slitting the 70mm film in half, Dickson came up with a format that was *economically* efficient. He maximized his use of Eastman's raw stock, doubling the amount of footage he could obtain from each roll and, at the same time, avoiding any waste.[32]

Circles, Squares, and Rectangles

The reason for Dickson's choice of the 1.33:1 format remains somewhat less clear, though economics and ideology do appear to have played a part.[33] Unlike the 35mm film width, the 4:3 aspect ratio cannot be traced back,

either directly or indirectly, to Eastman's 70mm or 90mm flexible-base camera film. The Kodak No. 1 camera produced neither a square nor a rectangular but rather a *circular* image, 2½ inches in diameter.[34] The Kodak No. 2, introduced in October 1889, took pictures 3½ inches in diameter.[35] According to Phil Condax of the George Eastman House, the images were circular for two reasons. The spherical lenses used in the camera (like all spherical lenses) automatically produced circular images (because no aperture was used in the camera to alter the shape of the image before it reached the film). And, since the early Kodak still camera had no viewfinder, it was difficult for inexperienced, amateur photographers to frame their photographs properly; indeed, if a rectangular aperture had been used in the camera, there would have been no way of ensuring that the vertical and horizonal lines in the amateur photographer's images would be parallel or perpendicular to the borders of the rectangular frame of the print. In printing circular images, Kodak technicians could simply rotate the negatives to correct for skewed horizontal or vertical lines.[36]

Dickson's experiments in early 1888 with Carbutt film exposed horizontally (like still camera film) in a strip-film motion picture camera similarly resulted in small circular images, ½ inch in diameter.[37] Circular images, however, were both unnecessary and inefficient, wasting a considerable percentage of the total image area (the black beyond the circumference of the image).[38] Unlike the still photograph Kodak camera, Dickson's motion picture camera was too heavy and too large to be hand held; mounted on a stable camera support, the camera could be relied upon to produce a series of images in which horizontal and vertical lines remained fixed from frame to frame; for both of these reasons, a circular image was less desirable than either a square or a rectangular image; at the same time, the latter would be more economical in their use of image area on the negative.

Dickson also conducted experiments with Carbutt film which resulted in images that were, at first, ¼ inch, and then ½ inch *squares*.[39] Ultimately he considered these images to be too small for purposes of enlargement and opted for images 1 inch square.[40] Two of Dickson's foreign rivals, Etienne-Jules Marey and William Friese-Greene, also experimented around 1888 with roll film to produce somewhat larger images that were 3½ and 3¼ inches square, respectively.[41] In switching to Eastman, 35mm rollfilm exposed vertically in the camera, Dickson could easily have retained a square image by establishing a frame height that equalled the width of the image. But he did not, opting instead for a rectangular image.

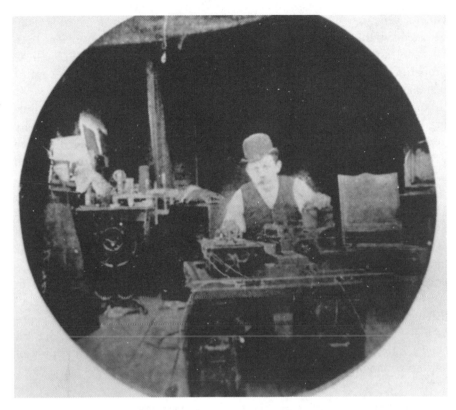

A CIRCULAR KODAK
IMAGE OF EDISON
EMPLOYEE
CHARLES KAYSER
WITH A STRIP
KINETOGRAPH (CA.
1890; COURTESY
OF EDISON
NATIONAL
HISTORIC SITE).

Perforation of the 35mm Eastman filmstrip on both sides reduced the area left for the image to a width of 1 inch, thereby determining that dimension of the format. Since Dickson had been working with image sizes in increments of ¼ inch, it might be reasoned that he would establish an image height of 1, ¾, or ½ inch. An image height of 1 inch would have provided a square frame area that was compositionally static as well as economically inefficient, using more negative area than necessary for adequate reproduction on the small Kinetoscope viewer.[42] An image height of ½ inch, on the other hand, would provide too little image information; in fact Dickson had rejected that size (as a square) earlier in his experiments.

The use of a ¾ inch height would appear to maximize the number of frames/images Dickson could create in the short fifty-foot strips of film that he initially used, while providing an aspect ratio that still remained close to the Golden Section of 1.618:1 (also known as the Divine Proportion, the

Golden Cut, and the Golden Rectangle) of Greek art, which was greatly admired for the mathematical purity of its proportions by engineers (like Dickson) and by mathematicians (but not necessarily by artists).[43] These proportions also could be seen to reflect a compromise between aspect ratios deemed suitable for portraits (from 0.88:1 to 1.48:1) and for landscapes (from 1.55:1 to 1.60:1), genres which dominated nineteenth-century painting.[44] Indeed, Dickson's earliest experiments in motion picture photography consisted of portraits (head and shoulder shots) and action scenes (from two and three shots of Edison employees engaged in various enterprises, such as blacksmithing or boxing matches) but not of landscapes.[45]

Dickson's own efforts as an amateur still photographer were exhibited in 1892 at the Orange Camera Club in New Jersey. These photographs included both portraits and landscapes and may have played a part in his selection of proportions that permitted both of these subjects.[46] Since neither landscapes nor the Edison Kinetograph "moved," however, landscapes were not initially featured in the Kinetoscope as motion picture subjects; yet subsequent actuality films, which endowed landscapes with "movement" through the use of tracking and panning shots, restored the landscape genre as a staple of the early motion picture experience. In other words, the 4:3 aspect ratio appears to have been determined by a complex interplay of various economic and ideological factors.

FROM ENGINEERING TO ENTREPRENEURING

Though Dickson, as engineer, may be credited with "proposing" 35mm film and the 4:3 aspect ratio as standards, the initial establishment and ultimate longevity of these standards has less to do with engineering than with entrepreneuring. The success of the 35mm/4:3 aspect ratio format is undoubtedly the direct result of the monopolistic practices and business acumen of Thomas Edison and George Eastman, who oversaw the innovation and diffusion of this invention.[47]

The history of early motion picture technology and the development of much subsequent motion picture technology must be understood, in part, as an attempt to establish or circumvent basic patents, the regulation of which would enable companies to secure control over the highly competitive motion picture marketplace. Edison labored to establish the priority and dominance of his motion picture patents, while his rivals either openly

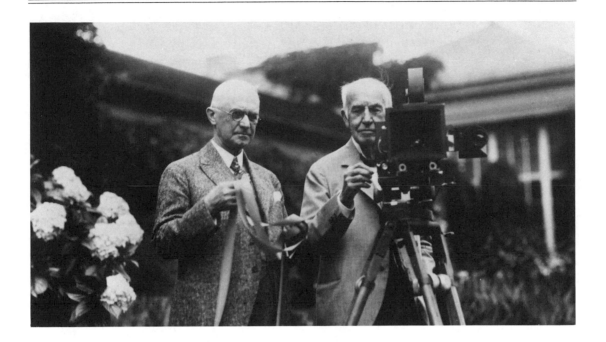

infringed them or tried to develop noninfringing technology that would provide them with patents of their own.

 Through the management of his patents, Edison controlled the use of motion picture cameras and, in collaboration with Eastman, the use of 35mm motion picture film.[48] Beginning in 1897, Edison spent several years in patent litigation with rival inventors and companies.[49] Finally, pooling his patents with those of others, Edison established in 1908 a cartel of production companies (the Motion Picture Patents Company) which adhered to the standards set forth in his patents and licensed exhibitors to use projection equipment developed to handle films made in accordance with these standards.[50] Through their combined efforts as patent-holders, Edison and others used their license agreements with producers, distributors (the MPPC's General Film Company, created in 1911), and exhibitors to establish these standards in the film industry during the crucial period of its initial growth (1896–1909).[51] Long before certain Edison patents were set aside as invalid and before the practices of Edison and the Motion Picture Patents Company were ruled unlawful and in restraint of trade by the courts

GEORGE EASTMAN (LEFT) AND THOMAS EDISON IN THE LATE 1920S (AUTHOR'S COLLECTION).

in October 1914, these standards had come to dominate the industry and had been adopted by non-MPPC members for purposes of production and exhibition. Indeed, in February 1909, the unquestioned dominance of 35mm film (with Edison's rectangular perforations rather than the Lumières' circular sprocket holes) and the 4:3 aspect ratio was publicly acknowledged when these formats were adopted as professional standards by filmmakers attending an international conference in Paris.[52]

The introduction of different film formats in peepshow parlors around the country during the period immediately following Edison's innovation of the Kinetoscope in 1894 stemmed both from attempts by rivals to avoid infringement of Edison's patents and from a shift in the industry's mode of exhibition from peepshow to projection in a theater.

CIRCUMVENTING PATENTS

Given Edison's initial success in the defense of his patents, potential rivals could challenge him without patent infringement only by developing cameras, film gauges, and projectors that differed from Edison's. A flood of different gauges followed Edison's filing of a patent in 1896, which seemingly gave him control over 35mm negative film; but, by 1900, when Edison's claims were no longer regarded seriously by the industry, this flood slowed to a trickle and Edison's rivals, unable to sustain the enormous expenses involved in the innovation and diffusion of wider gauges, returned to the cheaper and more widely available 35mm film stock.

The first wide-film and widescreen processes arose from these attempts to circumvent Edison's patents.[53] The Latham Eidoloscope (1895) was developed with the help of Edison's former assistant, W. K. L. Dickson. Dickson, who was obviously familiar with what was and was not protected by Edison's patents, avoided infringing them in several ways, including (in addition to a different camera design) the use of 51mm rather than 35mm film.[54] This format produced an image that was 1 ¾ inches wide by ¾ high and had an aspect ratio of 2.33:1 (or 7:3).[55] Biograph's 68mm camera and film (1897), used to produce photographic cards for that company's Mutoscope, was also developed by Dickson. With its 2⅝ × 1¹⁵⁄₁₆ inch negative area, it retained an aspect ratio of 1.35:1, which was quite similar to that used by Edison, and thus provided a certain conformity for the peepshow industry.[56] Less successful wide-film formats included the Demeny-Gaumont

(and Prestwich) 60mm, 1¾ × 1¼ inch (1.4:1) format (1896); Blair's 48mm, 1½ × 1 inch (1.5:1) Viventoscope (1897); Enoch Rector's 63mm, 1⅞ × 1⅛ inch (1.66:1) Veriscope (1897); and Lumière's 75mm, 2⁵⁄₁₆ × 1⅞ inch (1.6:1) wide film (1900).[57]

PROJECTION

As Terry Ramsaye observes, Woodville Latham and his sons Otway and Gray innovated the projection of motion picture film in an attempt to maximize their profits. The total income of peepshow parlor exhibition was restricted by Kinetoscope technology, which was modeled on Edison's earlier success in marketing his invention of the phonograph through the creation of phonograph parlors in which patrons listened to records privately using ear tubes. Drawing on the model of the magic-lantern show, the Lathams developed a technology for the projection of films upon a screen, enabling them to accommodate several hundred customers at a time (rather than one per Kinetoscope).[58] In fact the Eidoloscope was referred to in the press as a "Magic Lantern Kinetoscope," a designation which acknowledged its relation to earlier projection technology.[59] In an effort to obtain an image suitable for projection upon a screen, the Lathams looked to wide-gauge film, which provided a larger negative area than film used in the peepshow device and therefore provided a superior image when projected.

The Eidoloscope employed wide film for legal and aesthetic reasons, but also for a significant technical reason: 35mm film was designed for use in the Kinetoscope viewing machine and was not orginally intended for projection in large theaters.[60] Cecil Hepworth noted that Edison's Kinetoscope pictures were "unsuitable for projection" because "they were exceedingly dense."[61] By "dense," Hepworth meant simply that the Kinetoscope film was semi-opaque—more translucent than transparent. The density of the film reduced the amount of light that could be transmitted through the film onto the screen. To get sufficient illumination for projection, Hepworth, like the Lathams, sought a film of larger dimensions (and greater transparency). In fact he suggested a format closer to that of the lantern slide, which had already proved that it could produce an adequate image when projected on a large screen, since its larger original image area decreased the amount of magnification necessary.[62] To improve the sharpness of the projected image and to get more light on the screen, the Lathams increased the gauge

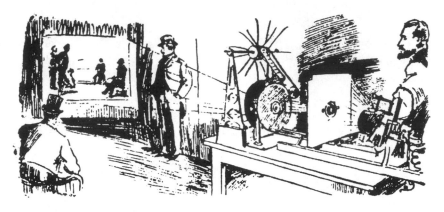

of their film stock (and, with it, the aperture in their camera and projector), enlarging it to dimensions approaching those of contemporary lantern slides, which were approximately 3¼ inches square.[63] In April 1895 the Lathams unveiled their Eidoloscope, referring to it as a "Magic Lantern Kineto-scope." But the device disappeared from the market by 1897. The failure of the wide-film Eidoloscope projection system was partly a result of technical imperfections—it lacked the intermittent motion necessary for the projection of unblurred images—and partly a result of the Lathams' lack of capital, marketing expertise, and showmanship.[64] Around the same time, in November 1895, Carl and Max Skladanowsky exhibited a wide-film projection system in the Berlin Wintergarten.[65] Their Bioscope used 45mm film, obtained by slitting Eastman No. 2 Kodak camera film in half.[66]

The Eidoloscope's brief success was soon eclipsed by that of the 35mm Vitascope projection system, developed by C. Francis Jenkins and Thomas Armat in 1895. This device provided a projection standard compatible with Edison's patents.[67] Edison's decision to enter the theatrical exhibition market in 1896 with a projection system led to his purchase of the Jenkins-Armat machine, which possessed an intermittent motion and was thus technically superior to the Eidoloscope. The success of the Vitascope, which was publicly introduced at Koster and Bial's Music Hall in New York on April 23, 1896, coupled with that of the Lumières' 35mm Cinématographe, which opened in Paris on December 28, 1895, led to the successful innovation of 35mm as an exhibition standard.[68]

WIDE FILM AND MODES OF EXHIBITION

The proliferation of different film gauges around the turn of the century was made possible, in part, by the dominant mode of film exhibition at the time. Imitating vaudeville booking practices, producers of motion pictures supplied theaters with a motion picture "act," providing both films and projectors (along with a projectionist).[69] This practice permitted greater flexibility in exhibition, enabling theaters to show films in different gauges from engagement to engagement. In discussing the first ten years of motion picture projection in Rochester, New York, George Pratt provides a portrait of early exhibition practice. He recounts the premiere of the Eidoloscope at the Wonderland Theater (a vaudeville house) in January 1896, which was followed by the first showing of the Vitascope at the nearby Ontario Beach Park that summer. In early November the Lumière Cinématographe was booked into the Wonderland and ran there continuously until February 1897, to be replaced by the wide-film Biograph projection system in March 1897.[70] Thus in a little more than a year the Wonderland booked three different film acts, featuring three distinct projection systems.

As the popularity of films increased, vaudeville theater chains such as the Keith Theatre Circuit began to purchase their own projection equipment. Keith selected the 35mm Lumière projector, favoring it over Edison's Vitascope because it was portable and did not depend upon electricity for its operation. And by 1902 theaters designed solely for the exhibition of motion pictures began to appear, launching the era of the nickelodeon.[71] The growth of these theaters along with that of film exchanges (which dealt only in 35mm films) resulted in further standardization of film gauges and projection equipment at 35mm.[72] By 1909, when the Motion Picture Patents Company had agreed on the 35mm standard, the Bell & Howell Company, an equipment manufacturer, had perfected a 35mm projector, camera, and perforator, which the film industry gradually adopted because of their precision and exceptionally high quality, further consolidating 35mm as the dominant film format.[73]

Independent producers and exhibitors who were not members of the MPPC trust might have turned to wide film in order to circumvent trust patents (as Biograph had before joining the trust). Most independents, however, lacked the capital required to innovate a new format. They chose instead to compete with the trust on its own (format) ground, hoping in that way to secure a foothold in an already well-established, clearly lucrative

35mm marketplace. Though Eastman initially refused to supply them with 35mm film, they could easily (as well as cheaply and legally) obtain 35mm film from the Lumière company, which by 1911 was exporting more than 35 million feet of raw stock a year to the United States.[74] In 1917 the recently formed Society of Motion Picture Engineers acknowledged the de facto status of 35mm as the industry's dominant film gauge, officially adopting it as an engineering standard.[75]

Although 35mm film and the sixty-year reign of the 4:3 aspect ratio tend to be taken for granted, the history of their emergence as a standard is anything but obvious. The constraints of designing a film format that provided an image of sufficient quality at minimal cost for the Kinetoscope led Dickson to 35mm film. In an attempt to compromise between the traditional dimensions of portraiture and landscapes employed in painting and photography, while also observing (as closely as possible) aesthetic principles which favored proportions of the classic Golden Section, Dickson settled on an aspect ratio of 4:3. Edison's entrepreneurial skills and the power of the MPPC in the motion picture marketplace ensured the success of these standards, which survived long after the demise of the companies which invented, innovated, and diffused them. Even though Dickson's "invention" of 35mm film and the 4:3 aspect ratio appear to have been determined by prevailing economic and technological factors, they have remarkably outlasted those constraints, easily making the transition from small-screen peepshow to large-screen projection. Dickson's original design thus emerges as a model for future technological innovation in the industry, setting a standard of excellence in quality and flexibility that enabled it to last longer than any other standard the motion picture industry has ever known.

SPECTATORSHIP: FROM PEEPSHOW TO PROJECTION

Though only one standard—35mm film—emerged from this period of technological innovation, the origins of widescreen cinema can be traced back to the medium's first few years and to the competition among various entrepreneurs in the motion picture marketplace to achieve dominance. The triumph of a single standard over a variety of standards, including wide-film formats, was clearly a necessary stage in the evolution of a viable, technologically based industry which relies on mass production, mass distribution,

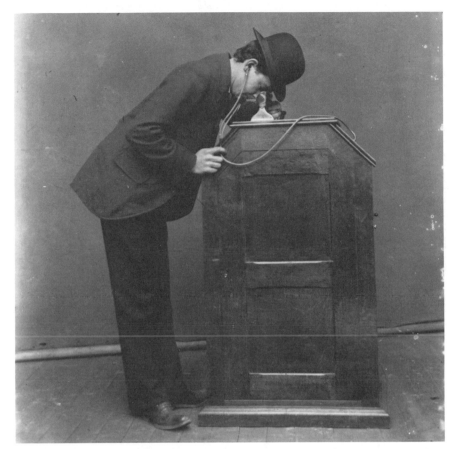

THE KINETOSCOPE
PEEPSHOW
(COURTESY OF
EDISON NATIONAL
HISTORIC SITE).

and mass consumption for its success. Yet the format which achieved hegemony—production in and projection of 35mm film—established itself through its impact as a *large-screen* medium. The lesson taught by this history is that whoever controls the large screen provides audiences with the consummate motion picture experience and thereby controls the industry.

The phenomenon of widescreen cinema clearly owes its impact to the advent of projection, which prompted its invention and revealed the potential of large-screen projection as a novelty in itself, radically different from the novelty of the small-screen peepshow. The shift in motion picture

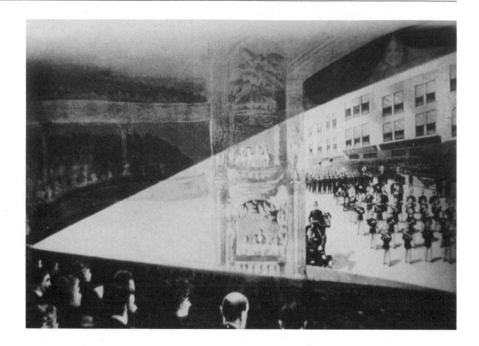

exhibition from peepshow parlor to projection hall may have been motivated by simple economics, but its impact extended considerably beyond the realm of economics. This shift transformed the very nature of the motion picture experience from a privatized encounter with a miniaturized image to a shared mass spectacle in which an audience of several hundred viewers engaged with "life-size" images on a large screen.[76] Their status as "life-size" testified to their reception as an enhanced, illusionistic spectacle which surpassed in both size and credibility the small-scale representations provided by the Kinetoscope.

Described as "Edison's latest toy," the Kinetoscope had been received as a "development of that marvel of our youth, the Thaumatrope."[77] Like a child's toy, the Kinetoscope was a device over which the spectator exerted a certain degree of mastery and control, symbolized by the viewer's physical position in relation to the image and by the relative sizes of spectator and image. With the Kinetoscope, the viewer not only looked down through a peephole at minuscule images but also moved from machine to machine, setting the images in motion by inserting a coin into a slot. The images then

ran independently of the control of the spectator, who in all other respects, however, dominated the apparatus. With the Mutoscope, morever, the spectator could start and stop the image at will, as well as run it in reverse, controlling its motion through the manipulation of a hand crank. However, with projection, the spectator no longer looked down at small images but up at larger ones. The viewer did not set the film in motion but was, as Stephen Heath suggests, set "in motion" by it.[78] The audience sat motionless before a fixed screen, watching life-size images projected onto that screen by a concealed apparatus situated somewhere in the back of the theater and operated by another. Projected images dramatically reversed the relationship spectators had with the peepshow, instantly achieving the ability to overwhelm them. In watching waves strike the shore, audiences ducked their heads for fear of getting wet.[79] When images were projected onto a screen, audiences marveled at their "life-like" illusion of reality; the size of people and objects in these images enhanced their credibility, matching or surpassing their size in real life. Projection produced an increased sense of the presence of the thing represented, whose size now conformed more closely to its size in the real world.

To paraphrase Stephen Heath, with the advent of projection, the cinema begins.[80] The presence of the screen completes the transformation of the cinema from a purely mechanical to an ideological apparatus by creating a fixed position for both the image and the spectator to occupy and a new, more "realistic" scale to use in defining their relationship. Suddenly, it is the spectator who is set in motion by the "machinery of cinema," engaging the spectator-as-subject, through the operations of suture, in a process of perpetual movement while holding the spectator-as-body in place, centered in front of the screen.[81]

FROM PRIVATE TO PUBLIC SPHERE

At the same time, projection enabled the spectator to become a social subject, to share his or her experience of the images with others, identifying, as one member of the audience, with the audience as a whole and participating in an experience that was, like that of the traditional theater, spatially and temporally coextensive.[82]

With projection, the spectator's relationship with the image is no longer private and direct but public and mediated (by the presence of other

spectators). In this shared space, the spectator's gaze becomes a collective look. For that reason, it is impossible to describe the spectator-screen relationship as a simple, voyeuristic trajectory consisting of an unseen, solitary spectator-subject looking (as it were) through a keyhole at an unseeing, exhibitionistic image-object. Instead, the spectator possesses a dual identity, constantly shifting back and forth between an individual and a communal subjectivity and occupying a succession of disparate subject positions. A spectator is not only the "transcendent" subject constructed by the narrative and the signifying practices of the film but also the physical, gendered, "proprioceptive" subject sitting in the theater, the "collective" subject identifying with the surrounding audiences, and the "historical" subject who remains distinct from other members of the audience through the uniqueness of his or her personal history, age, level of education, ethnic background, nationality, regionality, race, and class.

In other words, the spectator-as-subject is simultaneously both an individual and a complexly determined social-economic-historical subject; the identification which the spectator enjoys with the image is shared with the surrounding audience, with whom the spectator also identifies, though in varying degrees. Unlike the Lacanian subject who constitutes himself or herself primarily through a one-on-one identification with his or her image in a mirror,[83] the cinema spectator constructs himself or herself through a private identification with the camera (which Christian Metz refers to as "primary" identification) and with the characters in the film (Metz's secondary identification) which is *shared* with hundreds (or thousands) of other spectators (a tertiary identification).[84] In short, the transition from peepshow to projection reconstitutes the spectator in ways for which contemporary applications of Lacanian psychoanalytic theory (which posits an individual, nonsocial subject) have not always attempted to account.

The culmination of this transformation of the viewing experience lies in the growth of the audience from the individual spectator to the mass audience, a phenomenon associated, in particular, with the advent of the movie palaces. As Siegfried Kracauer suggests, the spectator in the age of the movie palace is addicted to "distraction," a tendency fostered by the design of the theater, which rivets "the audience's attention to the peripheral."[85] The film, as object, exists within a larger field of experiences, which include not only architecture but stage shows, musical accompaniment, and other effects which the movie palace, as a unified architectural structure,

attempts to cohere into an organic whole. But the movie palace, by its very nature, also threatens to expose the essential incoherence of contemporary mass culture, which bombards us with a variety of stimuli, each of which demands our attention.[86] But, most importantly, it is the movie palace which ultimately calls into question the traditional size of the projected image, which changes in an attempt to become more commensurate with this new space for entertainment.

A complex array of determinants influenced the development of the technological apparatus of the Kinetograph/Kinetoscope, which satisfied, in as economical and efficient a way as possible, a minimal ideological demand for reproducing "life as it is" in moving images and which oversaw the establishment of 35mm film and the 1.33:1 aspect ratio as a standard. Another layer of determinants prompted initial experimentation with wide film. These same factors subsequently encouraged the shift from peepshows to large-screen projection, which satisfied an ideological demand for even greater realism than the peepshow could provide—answering a desire for life-size images—while retaining the 35mm standard and thus adhering to the technological and economic constraints of the contemporary motion picture marketplace. The demise of the small-screen nickelodeon and the advent of the large-screen movie palace introduced a new set of circumstances which, in turn, transformed the conditions of motion picture spectatorship. As we shall see in the following chapters, the creation of the movie palace—a new space for motion picture exhibition—played a considerable part in the advent of a new era of widescreen innovation. And it was the distraction of the movie palace that experimental, proscenium-filling widescreen processes sought to counteract. The unsuccessful wide-screen/wide-film revolution of the late 1920s attempted to create viewing conditions which did not so much permit distraction as demand participation, drawing viewers into the illusionary world depicted on a greatly expanded screen.

Though the shift from peepshow to projection introduced a variety of wide-film processes, establishing it as a site for the origins of widescreen cinema, the ultimate source of widescreen cinema lies not so much in the introduction of wide-gauge film as in the development of "large-screen" cinema. In other words, subsequent widescreen cinema can be said to look back to the medium's shift from a small-screen to a large-screen format rather than to any one wide-film process, and the *shape* of the screen in this period can be said to be less significant in terms of the subsequent development of widescreen cinema than the *size* of the screen.[1]

Widescreen cinema derives from this new experience the spectator had with the image, from the recognition of the tremendous affective power released by this simple shift from small- to large-screen exhibition. In fact, experiments with widescreen in the 1920s (as well as in the 1950s) can be seen as attempts to recapture the experience of this "original" transformation, rehearsing it through calculated shifts from standard to large-screen exhibition during the unfolding of the film's narrative, as in the dramatic shift from single- to triple-screen projection in Abel Gance's *Napoleon* or the abrupt magnification used in the Magnascope process for the presentation of spectacle. The experiments with widescreen in the years 1926–1930 constituted a first step in the film industry's attempted redefinition of the spectator's relationship with the image (which was prompted, in part, by the transformation of traditional conditions of spectatorship introduced by the advent of sound). Though this initial process of redefinition failed, the fascination revealed in these special presentational systems for spectacular shifts from narrow to widescreen formats looks both backward to the audience's initial experience with the projected image and forward to its rediscovery of that experience through the sensation of engulfment created by large-screen, widescreen, stereophonic exhibition which flourished in the mid-1950s.

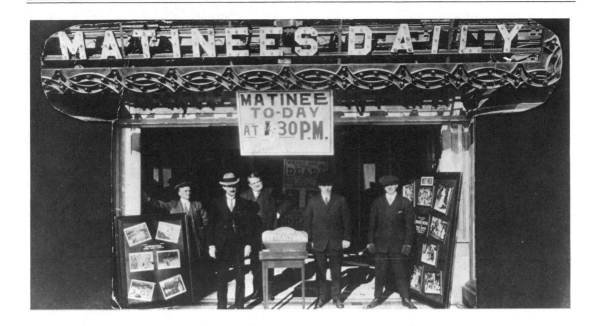

THEATERS AND IMAGE SIZE

The only serious pre-widescreen-era challenge to the 35mm standard came during the 1920s, spearheaded by the growth of movie palaces in the preceding decade and by the advent of sound. During the nickelodeon era, theaters and theater screens remained small. Seating in New York City theaters was initially limited to 200 so that owners could avoid the $500 fee required by the city for a theatrical license (though the 200-seat limit may not have been observed outside New York).[2] The typical nickelodeon tended to be about 25 feet wide and 70–100 feet long.[3] Though the image size obtainable in a nickelodeon depended in part on the projection lens used and the length of the throw, the standard image width appears to have been somewhere between 10 and 15 feet.[4] However, in large nickelodeons with 500 seats (and space for a ten-piece orchestra), screens as large as 24 × 18 feet were installed.[5] (Earlier, turn-of-the-century widescreen cinema was not much larger than this: the projected image size of Veriscope prize fights was only 28 × 15 feet.)[6] Magnifying the 35mm film image to fit

THE EXTERIOR OF A TYPICAL NICKELODEON (CA. 1903; AUTHOR'S COLLECTION).

these relatively small screens posed little threat to the quality of the projected image. As the quality of film stock, screen brightness, and projector illumination improved during the 1910s and 1920s, theater projectionists found that they could increase the size of the projected image to 16 × 12 or even 20 × 15 feet without sacrificing image quality.[7] When movie palaces were built to accommodate from 3,000 to more than 6,200 customers, screens tended to be no larger than 24 by 18 feet, which engineers considered to be the maximum size for good-quality 35mm projection.[8] The result was a new spectator "psychology" in relation to the projected image: as theaters grew larger, the image appeared (especially to those who were now seated farther away from the screen) to grow smaller and appeared incommensurate with the increased space of the auditorium.

WIDESCREEN AS NOVELTY

Movie Palaces and Magnascope

Most of the new movie palaces were built with fairly wide, 35-to-45-foot prosceniums complete with theater stages, which facilitated the presentation of live-action prologues, dramatic sketches, variety acts, and other theatrical spectacles such as S. L. Rothafel's lavish stage productions at the Roxy in the 1920s and at Radio City Music Hall in the 1930s and thereafter; Radio City's proscenium was more than 70 feet wide and 40 feet high, permitting the full line of the Rockettes to stretch across the stage.[9] The movie screen occupied only a small portion of the total space of the stage. Indeed, the routine shift during the standard theater program, from the live stage show which preceded the film presentation and which filled the proscenium to the dramatically smaller projected image on the screen, accentuated the disparity between the two events and drew attention to the diminished nature of the motion picture program. Given the enormous size of the theater, the relatively small size of the screen, and the potential space available for increasing its width and the height, it was not long before individual entrepreneurs began experimenting with larger projected images. In December 1926 Paramount installed an oversized screen in one movie palace, the Rivoli Theatre, which took up the full 40-foot width of the theater's proscenium area.[10] During two sequences in the silent naval spectacle *Old Ironsides*, the Rivoli's curtains and screen maskings opened,

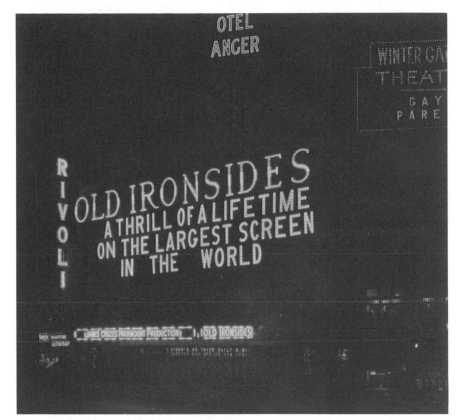

THE MARQUEE OF
THE RIVOLI
THEATRE,
FEBRUARY 15,
1927 (COURTESY
OF MUSEUM OF
MODERN ART).

on signal, beyond their usual position for 1.33:1 projection. Scenes of the launching of the U.S.S. *Constitution*, moving under full sail directly toward the camera, and the climactic sea battle were projected on this expanded screen with the wide-angle Magnascope lens, which Lorenzo del Riccio had developed in 1924.[11] The movement of the *Constitution* toward the camera, magnified by the gradually increasing image size, looks back to the viewer-aggressive tactics of early "large"-screen projection (and forward to viewer participation techniques of Cinerama and 3-D in the 1950s). In particular, the pseudo-sense of "emergence" created by this particular shot recalls the famous Vitascope presentation of the "breaking of waves on the seashore," which appeared to those spectators seated in the first rows to threaten to wash over them.[12] (The effect of gradual enlargement was accomplished by

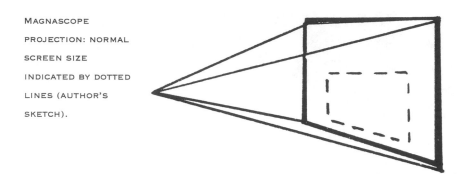

MAGNASCOPE
PROJECTION: NORMAL
SCREEN SIZE
INDICATED BY DOTTED
LINES (AUTHOR'S
SKETCH).

the projectionist's movement of the black maskings framing the projected image on the top and the right and left sides, not by a manipulation of the Magnascope lens.)[13] The cumulative effect was that of an illusion of the image's movement into the space of the theater auditorium, breaking down the spectator's sense of the barriers of the proscenium.

The following year Merian C. Cooper (who became involved with the Cinerama process twenty-five years later) projected a sequence of stampeding elephants in *Chang* in Magnascope, and several other Paramount features used the lens for projection of 40 × 30 foot images as well. However, the lens could not be used in traditional theaters with small prosceniums, and its use on large screens in movie palaces necessarily resulted in increased grain in the projected image and decreased screen illumination, which projectionists attempted to lessen by employing thinner shutter blades and projection lamps with greater amperage.[14] Magnascope projection quickly disappeared from use, though it is said to have inspired William Fox (who subsequently attempted to innovate the wide-film Grandeur process) "to build all [his] theatres with big screens and 5,000 seats."[15]

Polyvision

Polyvision, a three-camera system used by Abel Gance in his production of a silent film, *Napoleon* (1927), emerged as a related development in specialized theatrical presentation. Like Magnascope, Polyvision was designed for limited use within a film shot and projected in the conventional

1.33:1 format, achieving much of its effect by means of the sudden expansion of screen size, though in this instance the quality of Gance's large-screen projection was assured by his use of three interlocked 35mm cameras in production instead of the simple magnification of the single 35mm film used in Magnascope.[16] In both cases, expanded screen size functioned largely as a novelty—as a special effect that was underscored by its isolation within the film as a whole. In this respect, Magnascope and Polyvision resembled the first few sound films, which contained talking sequences encased within a traditionally silent motion picture experience. The abrupt shift to and departure from sound foregrounded the technology as a novelty, much as the presence of color sequences within black-and-white films during the same period drew attention to the new technology as a novelty item.

Gance viewed the three-screen process as a means of representation that would permit him to capture the breadth of his subject matter as well as to get on screen the thousands of extras he had hired for certain spectacular sequences.[17] At the same time, Gance used the format to spectacularize his famous accelerated montage techniques, juxtaposing three different images side by side like the three rings of the circus (though often the right and left images were identical, albeit reversed).

Napoleon was screened in Polyvision in its initial release in Europe in only a handful of theaters and then only for limited runs, ranging from several days to several weeks;[18] for its American release, Metro-Goldwyn-Mayer (M-G-M) eliminated the triptychs; after several years of attempting to distribute the original version, both Gance and his producers went bankrupt.[19]

POLYVISION'S
PANORAMIC
TRIPTYCH
(COURTESY OF
ROBERT HARRIS).

Chrétien's Hypergonar

From a superficial perspective, Magnascope and Polyvision appear to have played a crucial role in Henri Chrétien's development of an "anamorphoser," a taking and projection lens which compressed a wide horizontal angle of view onto 35mm film. However, the relation of Chrétien's invention to Polyvision is less a direct than an indirect development.

Chrétien's patent for the lens as the basis of a widescreen technology describes it as suitable for filming and projecting scenes involving extreme width or height.[20] Chrétien envisioned an enormous theater screen (built in the shape of a cross) that would accommodate not only a conventional 1.33:1 image (in its center) but also a 2.66:1 panoramic image and a 1:2.66 tall image.[21] More of a scientist than a showman, Chrétien tried to market his anamorphoser as a dual-purpose lens, imagining that the industry would find as much use for its vertical as for its horizontal compression capabilities.

Chrétien's lens, which he called the Hypergonar, was used to film sequences in Claude Autant-Lara's *Construire un feu* (begun in December 1927 but not released until 1930).[22] Autant-Lara's film exploited a variety of the lens's possibilities, using it to present a traditional 1.33:1 image (at screen center, left, or right), a diptych or triptych image, a 2.66:1 panoramic image, and a 1:2.66 vertical image.[23] (Transitions from horizontal to vertical images were accomplished by using two projectors outfitted with anamorphic lenses mounted at right angles to each other.)[24] Acquired by Pathé-Nathan in 1929, the Hypergonar was also used to film entire sequences in André Hugon's *La femme et le rossignol* and the battle sequences for Marco de Gastyne's *La merveilleuse vie de Jeanne d'Arc* (1929).[25] In all these instances, its function was, like the Magnascope lens, to provide an image

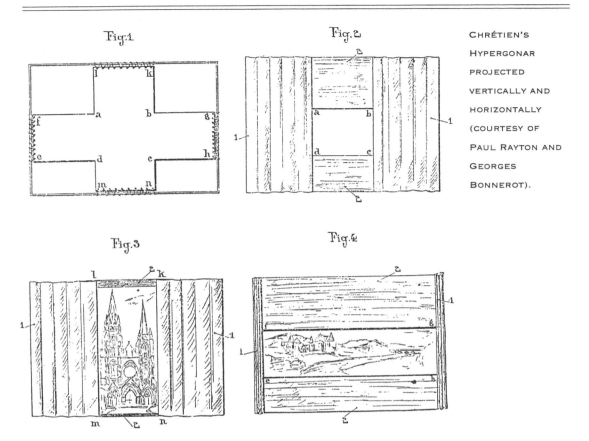

CHRÉTIEN'S
HYPERGONAR
PROJECTED
VERTICALLY AND
HORIZONTALLY
(COURTESY OF
PAUL RAYTON AND
GEORGES
BONNEROT).

radically different in size and shape from the standard 1.33:1 image used elsewhere in the films. In other words, it served primarily as a novelty rather than as a new standard.[26]

According to popular accounts, Chrétien's invention of the Hypergonar was inspired by Abel Gance's experiments with Polyvision in the filming of *Napoleon*. However, the causal chain of events leading to Chrétien's development of the Hypergonar is not as linear as this suggests. Kevin Brownlow writes of *Napoleon* that "the triptychs had an immediate effect on one member of the Opéra audience, although it would be years before the full significance of their impact became apparent. Professor Henri Chrétien wanted to bring panoramic pictures to the screen without the use

of two additional projectors. To do this, he designed the Hypergonar lens. Years later, he wrote Gance a letter saying that he had been influenced in his design by seeing *Napoleon,* and he later dedicated his first Hypergonar to Gance."[27] However, two aspects of Chrétien's initial patent would seem to call this traditional scenario into question. In the first place, the date of Chrétien's patent application *precedes* that of the premiere of *Napoleon* in April 1927 by roughly five months. Second, Chrétien's initial patent concerns the use of anamorphic optics for the creation of color and 3-D processes, not a widescreen system. Brownlow's reading of events, however, is not entirely in error, for just after the premiere of *Napoleon,* at the end of April 1927, Chrétien filed another patent—his third related to anamorphics—adapting his original invention for the production of widescreen motion pictures. Apparently the opening of *Napoleon* prompted him to rethink the potential uses for his original invention. The existence of three different Chrétien patents attests to the uneven development of Chrétien's invention, whose specific history demonstrates the sort of nonlinear evolution which characterizes the development of widescreen in general.

In other words, though the *innovation* of the Hypergonar may be linked to the "profound impression" Polyvision made on him, Chrétien's initial *invention* of an anamorphic motion picture lens had little to do with Gance.[28] Chrétien's experimentation with anamorphic optics and, more importantly, his involvement with the cinema can be traced back to 1925, a year before Gance's development of Polyvision and two years before the release of *Napoleon.*[29] At that time Chrétien was involved with the Keller-Dorian Color Film Company and had developed a multiple-lens anamorphoser which could be used to squeeze three different color records (red, blue, and green) of an image, juxtaposing them on a single strip of film. This anamorphic system attempted to make possible an additive color process without the related problems of color fringing (inherent in the Kinemacolor technology), faulty registration, or parallax introduced by the use of three different lenses filming scenes from slightly different positions.[30] Chrétien's patent application for the device also noted that it could be used to squeeze left-eye and right-eye images onto a single strip of film for stereo cinematography.[31] Though both of these applications of anamorphic optics involved squeezing and unsqueezing images generated by spherical lenses, neither of them resulted in widescreen projection. Chrétien's invention seems to have been developed in answer to the needs within the existing marketplace for a color

film technology (though the viability of the process remains in question, since it was never used for motion picture production in color).

Having left Keller-Dorian in mid-1926, Chrétien realized, after seeing Gance's triptychs in *Napoleon*, that anamorphic optics could be used to provide the basic technology for a potentially new market in widescreen filmmaking. A simple reworking of his original patent for color and 3-D optics provided Chrétien with yet another practical application for his earlier invention.[32] Speaking at the Academy of Sciences on May 30, 1927, Chrétien acknowledged the Hypergonar as an outgrowth of his earlier work in optics, noting that "the interest that the public has recently shown in panoramic films had encouraged [him] to provide a solution [to the technical problems of widescreen filmmaking and projection] that was *immediately available* and practical" (emphasis added).[33]

In 1928 Paramount (which was experimenting with the Magnascope lens) entered into negotiations with Chrétien, securing a six-month option on the lens (which expired and was not renewed), and in 1929 Chrétien journeyed to the United States in an unsuccessful attempt to interest other American studios in the lens.[34] Chrétien's lens, like Gance's Polyvision, found little acceptance in the film industry. It was subsequently used to film a documentary, *L'Exposition coloniale* (1931), which also used horizontal and vertical images, and Jean Tedesco's *Panorama au fil de l'eau* (1937), which was projected on the facade of the Palace of Light during the International Exposition.[35] In both instances, however, the device seems to have been relegated to the status of a "fairground" attraction, retaining its identity as a novelty item.

VIOLATING THE 1.33:1 NORM

Serious consideration of widescreen and wide-film systems as a potential new standard rather than as a novelty did not occur until late in the transition-to-sound period. The advent of sound in 1926–1927 threatened the quality of the projected image on large screens. Single-system sound-on-film processes involved the addition of an optical sound track alongside the image, with a resultant loss of a significant portion of the 35mm film image area. (Warner Brothers' sound-on-disc Vitaphone system, which continued to use the full, silent aperture for both filming and projection, obviously encountered none of these problems. Sound-on-disc played a

valuable role during this period in ensuring satisfactory image quality: several of the new wide-film systems, such as Warners' Vitascope and M-G-M's Realife, employed sound-on-disc in an attempt to gain greater image width.) The silent screen aspect ratio changed from 1.33:1 to roughly 1:15:1, with a loss in image width of about 25 percent.[36] Motion picture engineers described the new, square image as static, nondynamic, and inappropriate for typical motion picture dramatic content, which was seen to involve horizontal rather than vertical actions and elements.[37] Suggestions that the squarish format was aesthetically unpleasing were reinforced by arguments based on the psychology of human vision, which takes in a field of view that is roughly 8 units by 5 (or 1.6:1); the 1.15:1 aspect ratio did not match this field of "natural vision."[38] Visiting Hollywood in 1930 at the time of these debates, Sergei Eisenstein spoke out on behalf of the new square-shaped image, praising it for its dynamic potential, but his arguments apparently had little impact on either the scientific community or members of the film industry.[39]

REESTABLISHING THE 1.33:1 NORM

The square aspect ratio posed problems for sound recordists, who found it difficult to record actors from above because of the effective "increase" in image height. A number of studio cameramen also objected to the square shape of the image and called for a return to what they felt was a more aesthetically pleasing ratio of 1.33:1 or for the adoption of a widescreen, wide-film format.[40] At the same time, projectionists for several large theater chains began to take matters into their own hands, masking the top and bottom of the image and blowing it up slightly through the use of lenses with shorter focal lengths in an attempt to restore the 1.33:1 aspect ratio and to make the image fill the old 1.33:1-proportioned screens.[41] This practice alarmed Hollywood producers, who found that the heads and feet of actors and other important elements of the picture were being cut off in projection.[42] In 1932 the Academy of Motion Picture Arts and Sciences voted to restore the old aspect ratio, altering it slighting to achieve a 1.37:1 image (though it continues to be referred to within the industry as 1.33:1).[43] This was achieved by masking the top and bottom of the frame during shooting and projection with specially-cut aperture plates in both cameras and projectors.[44] This format became known as the Academy aperture or

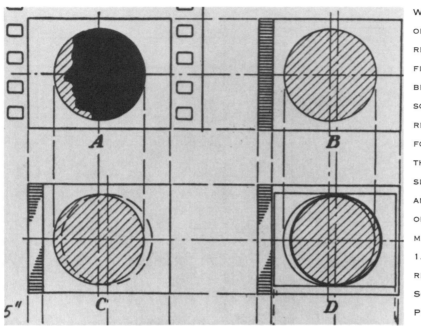

WITH THE ADDITION OF AN OPTICAL SOUNDTRACK, THE RECTANGULAR SILENT FILM FRAME (TOP LEFT) BECAME MORE OR LESS SQUARE (TOP RIGHT); TO RECOVER THE OLD FORMAT, THE CENTER OF THE FRAME WAS SHIFTED SLIGHTLY (BOTTOM LEFT), AND THE TOP AND BOTTOM OF THE IMAGE WERE MASKED TO PRODUCE A 1.33/7:1 IMAGE (BOTTOM RIGHT) (COURTESY OF SOCIETY OF MOTION PICTURE AND TELEVISION ENGINEERS).

ratio, a standard which remained in effect until 1953. (Henri Chrétien, working together with Tobis Films, proposed a somewhat different solution, suggesting that anamorphic optics be used in both filming and projection, giving the image an extremely slight squeeze/unsqueeze in order to restore the 4:3 aspect ratio; but their solution was not adopted by any other European or American companies, nor is there evidence that any films were ever photographed using this process.)[45]

WIDE FILM AS POTENTIAL NORM

The new Academy film design, however, was inefficient in its use of the potential space available within the 35mm film frame. Indeed, the silent 1.33 frame possessed 31 percent more negative area than does the sound 1.33/7 frame. In effect, less film area was being used but it was asked to fill, in projection, the same size screens that the larger-framed silent film filled. A report by the Society of Motion Picture Engineers (SMPE) Com-

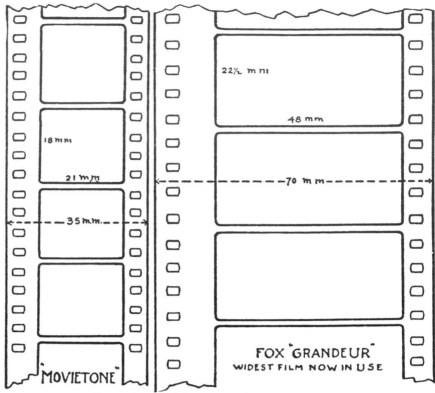

Comparative size of Grandeur and Standard Movietone film

mittee on Wide Film Standardization in 1930 reviewed various wide-film systems, including Fox's 70mm Grandeur, Paramount's 56mm Magnafilm, and George K. Spoor and P. John Berggren's 63.5mm Natural Vision, arguing for a need for a film standard wider than 35mm.[46] As the SMPE's Standards and Nomenclature Committee observed, "the magnification [of 35mm sound film] has already been pushed close to the limit set by the graininess of the film and its unsteadiness in the projector," making "the projection of pictures of even moderate screen dimensions not altogether satisfactory."[47] A proposed shift to wide film would not only improve image resolution but also permit the expansion of the area used for optical sound tracks, dramatically increasing sound quality as well. Fox's Grandeur process, for example, provided space for a sound track 7mm wide, as opposed to the

standard 2mm sound track used on 35mm film, the increased sound track area permitting a greater volume range in recording.[48]

Industry engineers argued that large theaters with screens wider than 24 feet required wide-gauge film for projection (though small theaters could continue to achieve acceptable screen images using 35mm film), and a variety of wide-film formats, ranging from 50mm to 70mm, were proposed.[49] Fifty-millimeter film was suggested as the widest gauge that could be introduced without the installation of entirely new projection machinery, necessitating only slight modification of existing theater equipment.[50] Magnafilm's 56mm format was proposed as the gauge that retained the height of 35mm film while doubling its width; increases in image height were considered problematic in that existing theater architecture, in particular the balcony overhang, threatened to cut off the top of any image higher than four perforations.[51]

Paramount's Magnafilm process, like Fox's 70mm Grandeur, produced a 2:1 image, which directors and engineers alike considered to be the widest desirable aspect ratio.[52] Another way to secure a 2:1 image was to increase image height one perforation and expand the width of the film stock to 65mm.[53] To avoid balcony cutoff, slightly longer focal length projection lenses had to be used with 65mm prints. With the exception of Radio-Keith-Orpheum's (RKO's) 63.5mm Natural Vision, which had an aspect ratio of 1.85:1, all the wide-film systems developed by the industry at this time had 2:1 dimensions.[54]

Every major studio experimented to some extent with wide film. For Grandeur, Fox had the Mitchell Camera Company build 70mm cameras and projectors, which were installed in several major Fox theaters in New York and Los Angeles.[55] M-G-M also adopted 70mm as its wide-film format, using Grandeur cameras built by Mitchell; it released films shot "in Grandeur," however, in optically reduced 35mm prints.[56] Warner Brothers, First National, and United Artists used 65mm cameras, UA making use of a 70mm Grandeur camera adapted by Mitchell to handle 65mm film stock.[57] RKO toyed with Natural Vision's 63.5mm system, while Paramount, after negotiating with André Debrie to build a 65mm camera, decided to back Lorenzo del Riccio's development of 56mm cameras and projectors.[58] But by the spring of 1930, both RKO and Paramount had shifted to experimentation with 65mm equipment (though RKO's *Danger Lights* was released in 63.5mm in Chicago).[59]

Though the studios did not know which wide-film process would become the industry standard, they all believed that they would soon "have a standard film wider than the present standard of 35 millimeters."[60] *The 1930 Film Daily Yearbook* featured the advent of wide film on its first page, predicting that "double width films on screens that fill the proscenium arches are forecast for the larger theaters long before this year comes to a close."[61] Indeed, so widespread were the expectations that the industry would convert to wide film that virtually no new 35mm cameras were purchased by the studios during 1930 and 1931 while Hollywood waited for the SMPE to create a wide-film standard.[62] Near the end of 1931 the SMPE proposed a wide-film standard of 50mm, but no studio had as yet made a film in 50mm, and by this time the wide-film processes that had been tested commercially had performed dismally at the box office.[63]

65/70MM FORMATS

In September 1929 Fox had installed 70mm projection equipment at the Gaiety Theatre in New York for a run of Grandeur Movietone News on a 28 × 14 foot screen; and in early 1930 Fox had set up 70mm equipment for the release of *Happy Days* (February) and *The Big Trail* (October), which played on a 42 × 20 foot screen.[64] The Grandeur system was both the brainchild and the personal property of William Fox, who began financing its development at the studio's Research Department in the summer of 1927 and who subsequently leased it to Fox Film Corporation for the making of individual films.[65] Unfortunately, Fox was unable to equip more than a handful of his theaters for 70mm projection, and *The Big Trail* was released nationally in 35mm.[66] Injured in an automobile accident in July 1929 and financially hamstrung by the conversion to sound and the dramatic expansion of his theater empire, Fox was unable to provide the personal and financial backing necessary for the successful innovation of Grandeur. Moreover, in late 1929 and early 1930 the Fox Film Corporation stood on the verge of receivership, and Fox himself was forced out of the company in April 1930, just around the time that shooting began on the studio's make-or-break Grandeur production of *The Big Trail*.[67] In an attempt to cut costs and restore the company's financial health, the new Fox administration abandoned the Grandeur process as an unnecessary extravagance (for both the studio and its theaters) in a time of forced retrenchment.

Drawn, like Fox, to the Western for widescreen subject matter, M-G-M

shot *Billy the Kid* in 70mm (using Grandeur cameras borrowed from Fox), dubbing the process "Realife."[68] Since first-run theaters in only three cities (New York, Chicago, and Los Angeles) could show films in 70mm, M-G-M planned to release *Billy the Kid* in 35mm, using an optical reduction printer to reduce the 70mm original to 35mm for standard exhibition.[69] The 35mm printdowns, however, retained the 2:1 aspect ratio by reducing the height of the projected frame to three (rather than four) perforations (masking off the unexposed top and bottom of the frame); by using sound-on-disc, which left space for increased image width; and by projecting the prints with a wide angle-lens, which blew the film up to fill the enlarged screen.[70] (Apparently the film was also released on 35mm in 1.33/7:1; Robert E. Carr and R. M. Hayes report that it was shot simultaneously in Realife and on normal 35mm film.)[71] In 1931 M-G-M released its second (and last) Realife production, *The Great Meadow.*

Warners' 65mm process, named Vitascope, was used to film a Harry Langdon vehicle, *Soldier's Plaything* (1930), a Richard Barthelmess Western called *The Lash* (1930), and the Broadway costumer *Kismet* (1930), as well as one or two shorts, including *Larry Ceballos Review.* UA shot another stage play, *The Bat Whispers* (1930), in 65mm; and RKO released *Danger Lights* (1930), a railroad picture, in Natural Vision, which had ealier been used to film a series of shorts, including *Rollercoaster Ride* (1926), *Niagara Falls* (1926), and *Campus Sweethearts* (1928).[72]

Unlike the earlier experiments with Magnascope, these wide-gauge/wide-screen films attempted to naturalize the format, avoiding the earlier gimmick of varying screen size and shape during the films themselves. Fox also used the public's familiarity with Magnascope to differentiate its own product, which it promoted as "new and momentous." Thus, in the program for the first public Grandeur exhibition of the *Fox Movietone Follies of 1929*, Fox carefully distinguished Grandeur from Magnascope, stressing that it achieved its large, widescreen images through the "new" technique of wide film rather than the "old" process of magnification.[73] At the same time, properties for Grandeur (and other widescreen systems) were selected on the basis of their "suitability" for widescreen presentation in toto rather than in part, resulting in the proliferation of panoramic Westerns, musical reviews, and adaptations of Broadway stage shows. In the case of theatrical adaptations, wide film clearly attempted to duplicate on film the breadth and scope of the theater stage, focusing on dramatic material that filled "the whole width of the proscenium."[74] In this way, the screen became a

substitute for the theatrical proscenium and, in movie palaces, filled in a space regularly left vacant when the bill shifted from live action to motion pictures. In film musicals, it was suggested, only four to five chorus girls could be crowded into the frame while still permitting their movement in dance and still achieving the recording of important detail, while Grandeur "gives a field that permits of natural action" (and, presumably, more chorus girls).[75] *Happy Days* featured a minstrel show with eighty-six performers arranged in four tiers, thirty-two chorus girls involved in "intricate maneuvers," "spectacular stage ensembles that are eye openers in screen pageantry, [and] numbers involving masses of people and bigness of background."[76]

In filming exterior action, such as Westerns or newsreels, Grandeur provided a "panoramic expanse" that was more appropriate to the material.[77] In newsreels of football games, for example, "not only is the man carrying the ball shown in relation to the other players with a field of view that permits the play to be followed, but also there need be no jerky shifting of the camera field in attempting to keep the player in frame."[78] Tennis and baseball were featured prominently in the *Movietone Follies of 1929*, permitting a display of panoramic action without reframing or editing.[79]

A number of other widescreen projects took advantage of the full width of the theater proscenium provided by the expanded screen area to present theatrical material which ranged from stage shows on film *(Fox Movietone Follies of 1929)* and full-length musical revues *(Happy Days)* to theatrical adaptations *(The Bat Whispers, Kismet)*. *The Bat Whispers* even ends with a self-reflexive acknowledgment of its theatrical origins when the camera tracks back to reveal the stage proscenium, the curtains close, and the film's star, Chester Morris, steps forward to address the audience in an extended theatrical aside.

THE FAILURE OF WIDE FILM

The status of wide film as a potential new norm, however, remained uncertain even within the industry, which repeatedly spoke of it in terms of its novelty value. Studio publicists misleadingly attempted to market several wide-film systems as three-dimensional, suggesting that the expanded field of view, when projected on a large screen, produced a 3-D effect. The printed program for *Fox Movietone Follies of 1929* noted that "Grandeur pictures reveal not only greater scope but produce stereoscopic effect—oth-

erwise known as third dimension." Somewhat more emphatically, ads for RKO's *Danger Lights* in Natural Vision stressed its supposed 3-D effect: "By this process the performers seem as if to step from the screen to greet the audience . . . the figures take on depth and become life-like . . . the picture starts with the screen and extends into the background . . . retaining the natural perspective of all objects photographed."[80] This marketing strategy backfired, however, when independent engineers who had seen demonstrations of these processes acknowledged that they produced little, if any, sensation of three dimensions and suggested that any wholesale conversion to wide-film production be delayed until a sufficiently convincing sensation of depth could be produced.[81]

The lack of theaters equipped to show these films and their failure at the box office (even in 35mm versions), coupled with the economic constraints imposed upon theaters by the conversion to sound, precluded the widespread adoption of wide film, and the 35mm standard remained.[82] Though wide film enjoyed little or no commercial success during this period, it appeared to answer the needs of the movie palaces for large-screen entertainment, encouraging these exhibitors virtually to double the size of their screens and thus provide a film image more commensurate with the size of the theater than they had previously been able to offer.

Nonetheless, the experimentation in the mid-1920s with Magnascope in America and with Polyvision in Europe and in the late 1920s with various wide-film systems established a pattern for the specialized presentation of large-screen motion pictures in the industry's premiere exhibition sites, the movie palaces, while smaller theaters ran a more conventional product. This pattern of two-tiered exhibition practice continued to inform industry thinking about the place widescreen would occupy in the postwar era, when it took another step in its evolution from peripheral novelty to mainstream standard.

Thus widescreen remained more of a novelty than a norm, even though Grandeur and other wide-film processes avoided the gimmicky, image-expansion techniques of Polyvision and Magnascope and attempted to work within a fixed, "theatricalized" playing space. Although it did transform the established spectator-screen relationship, filling the spectator's field of vision and refiguring passive distractions as engrossing attractions, the heterogeneous tradition of multi-event presentations in the theater continued to entertain audiences in pre-wide-film ways, and "distraction" remained the dominant form of spectatorial engagement.

3 WIDE FILM AND THE GENERAL AUDIENCE

As we have seen, the uneven development of widescreen cinema remained subject to shifting forces not only in the motion picture marketplace but also in the larger society. Prompted by efforts to circumvent Edison's patents and by the need for an improved image quality to facilitate the transition from peepshow to projection, the wide-film movement began with the advent of "large"-screen cinema in 1896.[1] Then large-format film suddenly disappeared around 1910 with the standardization of 35mm film as a format— only to resurface in the large-screen and wide-film experiments of the late 1920s, which sought to satisfy demands for a form of screen entertainment commensurate with the stage spectacles mounted in movie palaces. But again the wide-film movement faltered, and it was not until 1952–1955 that widescreen was successfully innovated and diffused. Why, given these earlier failures, did the reintroduction of widescreen cinema in the 1950s succeed?

The answer is necessarily bound up with the prewar failures, and particularly with the complex interplay of forces during the transition-to-sound period.[2] Factors which prevented Fox and others in the industry from successfully innovating and diffusing widescreen in the late 1920s can be traced to the specific social and economic context in which the industry then functioned. This web of constraints worked against the adoption of a wide-film/widescreen format. Changes after World War Two in American social, cultural, and economic patterns, especially those in the socioeconomics of the entertainment industry, created a new climate for technological innovation. In this new field of economic and cultural demands, these earlier, failed technologies were "reinvented," adapted to meet the requirements of a market whose demands they now satisfied.[3] In short, wide-film/widescreen cinema succeeded in the 1950s because it answered needs that had not existed earlier—needs that had been created by dramatic shifts in the postwar economy and in the nature of leisure-time activities.

The failed widescreen revolution of the late 1920s can be attributed to

a variety of interrelated economic, industrial, social, and cultural factors. (Technological factors do not seem to have played a major role; theaters which converted their projection booths to show the major wide-film processes, such as Grandeur, Realife, Magnifilm, and Natural Vision, experienced few technical problems, and critics generally commented favorably on the large-screen experience.)[4]

WIDE FILM AND THE CRASH

In 1929–30, economic problems beset both the nation as a whole and the film industry in particular, though the national economy's impact upon that of the film industry was complexly mediated. Historians generally cite the stock market crash of October 1929 as the chief cause underlying the demise of the Grandeur, Realife, and other widescreen systems, yet the direct linkage between the collapse on Wall Street and that in wide-film exhibition is never discussed in any detail.[5] Although the onset of the Great Depression did play a minor role in the economics of wide-film innovation, the "crash thesis" implies a direct, immediate, and linear determination. However, this thesis ignores two crucial facts: the studios continued their attempts to innovate a number of wide-film formats *after* October 1929, launching several productions in the spring of 1930 which culminated in the release, seven months later, of *The Big Trail, Billy the Kid,* and *Kismet* in October 1930, *The Bat Whispers* a month after that in November 1930, and *The Lash* in December 1930.[6] And the Depression did not hit the film industry until 1931, several months after M-G-M and Warners had attempted to market the last of that era's widescreen films.[7] In other words, the attempted innovation of wide film had failed *before* the impact of the Depression reached Hollywood.

Though industry revenues in 1930 did fall below the level they had reached in 1929, suggesting that the Depression had begun to take its toll on Hollywood, the figures for 1929 had in fact marked an all-time high for the industry. Profits rose, no doubt, because more people than ever were going to the movies; weekly attendance increased from 65 million in 1928 to 95 million in 1929, falling slightly to 90 million in 1930.[8] Even though there was a depression, industry income for 1930 remained higher than it had been in 1928 because of this increase in attendance. Indeed, M-G-M, Columbia, Paramount, and RKO actually earned *more* money in 1930 than

they did in 1929.[9] Significant losses did not occur until 1931, by which time the industry had already abandoned wide film as a format because wide-film releases had not drawn large crowds to the handful of movie palaces in which they had played.[10] In other words, it was not so much the collapse on Wall Street as the poor showing of wide films at the box office that accounts for the demise of widescreen exhibition.

An additional explanation given by historians for the failure of wide film was the inability of the various studios involved in its innovation to agree upon a single standard.[11] However, the opposite was actually the case; it was the industry's decision to adopt a single standard that led to the demise of wide film. At one point in the late 1920s virtually every major studio was developing a different standard, ranging from Paramount's 56mm and RKO's 63.5mm systems to Warner's 65mm and Fox's 70mm processes. Though two incompatible sound processes (Warner's sound-on-disc and Fox's and RKO/RCA's sound-on-film) coexisted during this period, the double standard was generally considered a liability, increasing costs both for film exchanges, which had to redesign their operations to handle both formats, and for film exhibitors, many of whom were forced to install both systems. In the case of the advent of sound, the major studios had attempted to avoid costly format wars by adopting a wait-and-see attitude. In 1927 Loew's, Universal, First National, Paramount, and Producers Distributing Corporation signed the "Big Five Agreement," pledging to remain neutral in the battle between Warners, Fox, and RKO and to "employ no system unless it was made available to all producers, distributors, and exhibitors on 'reasonable' terms."[12]

In late 1929 the major studios arrived at a similar agreement with regard to wide film. The Motion Picture Producers and Distributors of America, fearing an expensive format war involving different wide-film systems, declared that no new wide-film standard would be approved unless it had been accepted by all the studios.[13] In May 1930 the major studios involved with wide-film experimentation met at the Hays Office and agreed to limit their testing of new formats until an independent expert could evaluate all the systems and make recommendations about a potential standard. In December 1930, after the first batch of wide-film releases had failed at the box office, the MPPDA, again acting through the agency of the Hays Office, placed a two-year ban on the introduction of any new formats in an attempt to prevent further costly experimentation before a standard had been agreed

upon.[14] The contents of this Hays Office agreement and the context in which it was reached provide the major "industrial" reasons behind the failure of wide film at this time.

FOX AND GRANDEUR

Trade papers identified the Fox Film Corporation as the force behind the innovation of wide film, citing the studio's "aggressiveness and pioneering in the extra width field."[15] William Fox initiated development of a wide-film system in the summer of 1927, shortly after Gance's experiments with Polyvision and Paramount's with Magnascope. Earlier, in 1925, Fox had begun an aggressive campaign of expansion, increasing the budgets for feature films, enlarging the scope of his newsreels program, and augmenting his chain of theaters.[16] Part of this program involved the acquisition of patents crucial to motion picture production and exhibition—those held by Theodore W. Case and the Tri-Ergon group for sound technology and that held by J. D. Elms for Widescope, a wide-screen technology which was shortly thereafter abandoned for the 70mm wide-film process which Fox called "Grandeur." Through his sound patents, Fox hoped to secure a hold over sound film production, reducing other studios to the status of his licensees. The successful innovation of Grandeur could have resulted in the displacement of 35mm technology as the dominant mode of production, distribution, and exhibition and would have given him a similar control over image technology. Cameras would have been provided by the Mitchell Camera Company, which Fox had recently purchased, while projectors would have been marketed to theaters through the Fox-owned General Theatres Equipment Corporation. The scope of Fox's intentions can be seen in his most ambitious project—his attempt, in 1929, to obtain a controlling interest in Loew's/M-G-M, ownership of which would have automatically made the Fox-Loew's combine the dominant force in the industry.

In the summer of 1929 Fox's plans began to fall apart. His automobile accident on the Long Island Expressway in July, which killed his driver and incapacitated him for more than two months, prevented him "from completing his financial structure" before the stock market crash in October.[17] His battle for control of Fox Film Corporation with his investors—the Telephone Company and Halsey, Stuart, and Company—diverted his attention from Grandeur to more pressing matters and interfered with his sched-

ule for the installation of wide-film projection equipment in theaters.[18] In April Fox was forced to resign control of the studio, signing over his voting shares to his opponents. His successor, Harley Clarke, as president of General Theatres Equipment, Inc., had been Fox's partner in the development of Grandeur. But Clarke, who had joined forces with the Telephone Company and Halsey Stuart to oust Fox, played only a negative role in the innovation of Grandeur. In May Clarke, along with executives from Loew's, Paramount, Warners, RKO, Universal, and other companies, signed the Hays Office agreement, which limited the development of wide film. At that time Clarke himself declared that the studio would be willing to scrap its $2 million investment in Grandeur and take the loss if a standard incompatible with it were ultimately chosen.[19]

William Fox's strategy was to force Grandeur on an industry which did not really want or need it and which was desperately trying to maintain the status quo, much as he and Warners, in an earlier effort to improve their positions in the hierarchy of Hollywood, had forced sound on a similarly unwilling industry, successfully upsetting the status quo. If he had been successful, Fox would have made his studio the most powerful in the industry. But Fox's wide-film plans involved considerable risk, requiring tremendous capital investment with no guarantee of return if Grandeur failed. As SMPE engineer Joseph Coffman pointed out, "the company which attempts to force wide film [on the industry] will have to spend millions, taking the chance of losing at the same time. Wide film will never succeed in the picture business as long as it is handled as a by-product."[20] Clarke was more conservative than Fox, nor did he share Fox's ambitions to dominate the industry. All he wanted was to control the Fox empire, which would provide him with a market for his theater supply company to exploit.[21] Thus Clarke was willing to join forces with other members of the industry to minimize potential losses and to treat wide film as something of secondary rather than primary importance.

THE HAYS OFFICE

The Hays Office agreement reasoned that a conversion to wide-film production would be too costly for the industry at that time. It would triple production and distribution costs as well as require the alteration or rebuilding of 75 percent of first-run theaters and all the lesser houses in the

world.[22] Clearly, even if there had been a demand for wide film, economic constraints would have limited it to thirty or forty large urban theaters—though the advocates of wide film within the industry clearly expected more theaters to install wide-film systems in the late 1920s than actually did; Fox's W. R. Sheehan, for example, initially projected that *The Big Trail* would play in Grandeur at "100 key theaters in America."[23] But wide-film projection, which required a broad theater proscenium outfitted with an enormous screen, was possible only in theaters seating 1,500 or more; the new format would have been unfeasible in over 90 percent of the world's theaters.[24]

At the same time, the existing motion picture marketplace was keyed to a single-format production, distribution, and exhibition system. Changes in this market from a single- to a double-format system would have required not only a rethinking of traditional distribution practices and standards such as blind bidding, block booking, and customary runs and clearances or "zoning" (all of which would then be subject to the particular projection technology possessed by individual theaters) but a tremendous influx of new capital as well. In an era in which the industry was attempting to ward off government antitrust legislation, any additional movement in the direction of the establishment of an exhibition system that was hierarchically organized, providing specialized products (such as wide-film releases) to certain large, urban, studio-owned theaters before 35mm prints were made available to others (such as the smaller, independently owned theaters) would have disturbed the already-delicate balance which the industry was trying to maintain vis-à-vis its antitrust critics.[25]

Investment capital traditionally available to the major studios was currently tied up in theater expansion and in the conversion of these new and old theaters to sound. The industry had already spent an estimated $500 million for sound equipment.[26] Few studios could afford the additional costs related to wide film—costs which included new production equipment (cameras, lenses, film magazines, cases, rewinds, moviolas, and splicers), wide-film projection equipment (projectors, lenses, sound heads, rewinders, and splicers), and new, larger screens in theaters. Grandeur cameras cost $12,600 each, Natural Vision projectors cost $12,000 each, and the conversion of existing theater projectors from 35mm to 65mm or 70mm cost over $2,700 each.[27] Contemporary estimates predicted industry-wide, one-time conversion costs for wide film at $250 million, and annual expenses

(for negative and intermediate film stock and positive prints) as high as $10 million.[28]

The idea behind the Hays pact was to create a controlled, artificial environment in which experimentation could take place. The powers within the industry had been undermined by the chaotic and expensive transition to sound and thus sought to protect themselves through this industry-wide agreement which "compelled producers to let the industry give normal birth to the big screen without any of the panic and financial distress which ushered in sound."[29] But the conditions set forth in the compact virtually guaranteed that the wide-film baby would be stillborn. And no one really wanted the baby now that its father, William Fox, was out of the picture.

None of the major studios except Fox had invested heavily in wide film; thus there was little pressure on them to pursue widescreen in an attempt to secure a return on their investment. In the case of Fox, the Grandeur system belonged not to the studio but to William Fox himself. He certainly had a vested interest in protecting his investment. However, by the end of March 1930 Fox Film Corporation had been taken over by a new management which did not share his personal commitment to the Grandeur process. Since wide-film activity at other studios was directly related to Fox's own efforts in this area, his removal from Fox studio operations clearly played a major role in undermining wide film's innovation and diffusion throughout the industry.[30]

There was no large-scale corporate commitment within (or outside) the industry to technological change as there had been in the case of sound. The advent of sound, for example, had been spearheaded by American Telephone & Telegraph, Radio Corporation of America, Western Electric, Bell Telephone, Westinghouse, and other large corporations which held major patents related to sound technology and which had a vested interest in expanding their market for sound equipment to the motion picture industry. No similar financial interests underwrote the development of wide-film technology during this period. Rather, it was the product of a few individual entrepreneurs, such as William Fox, who attempted to innovate Grandeur through a separate corporation that was related to the Fox Film Corporation only through his joint ownership of stock in both.[31] Other processes were developed by relatively small camera manufacturing outfits or by independent tinkerers such as Spoor and Berggren, who pioneered Natural Vision; del Riccio, who designed Magnafilm; and Ralph Fear, who developed the Fearless Wide Picture.[32]

Wide-film processes had been in existence since 1895, and although individual camera systems and other elements of the processes could be protected by patents, there was, unlike in the case of sound, no patentable basic technology that would give any company monopolistic (or oligopolistic) control over the wide-film marketplace necessary to ensure profits. Potential competitors could and did merely vary the gauge of the film that they used and modify existing cameras slightly to establish a "unique" system.

Under the terms of the original Hays Office agreement, none of the companies experimenting with wide film was permitted to exhibit these films "outside of the prescribed 10 key cities." The effect was to limit the playoff of wide films to fewer theaters than were necessary for the companies to recoup their cost in this format and thus to force them to distribute the films in 35mm as well.[33] This restriction explains why there were only about ten or twelve theaters which were equipped during this period for the projection of wide-film formats.[34]

The theater limitation also drastically limited the number of wide films produced. "The arithmetic of the pact provides that with one picture any 10 houses in the U.S. may be selected for projection test purposes. Two films and the circulation is cut in half, each picture being allowed only five theaters."[35] In this context, producers put all their eggs into one basket, betting everything on the performance of one wide-film release; if that one film failed at the box office, as happened in the case of the Grandeur version of *The Big Trail*, which was limited to playing in only one or two theaters, there would be no second chance for the system. Hamstrung as it was by these restrictions, it is no wonder that the wide-film revolution failed; it had been the victim of an in-house coup, destroyed by the industry itself before it could take hold.

POPULAR DEMAND

The economics of the motion picture marketplace and the industry's anxiety-driven attempts to control the development of wide film clearly determined much of the fate of this new technology, but the "economic" failure of wide film was itself, in turn, determined by social and cultural factors. In particular, it failed because of a lack of public demand for widescreen. People continued to attend the movies in great numbers, but their demands for novelty had been satisfied by sound. If the first wide-film releases had

secured audiences and had made money, the industry would undoubtedly have persevered in the innovation of this new format. The success of wide film might have led to the establishment of either a new, wide-film standard replacing 35mm or a two-format standard for production and exhibition, creating an exclusive circuit of theaters equipped to project wide film while continuing to supply the majority of theaters with 35mm versions. However, wide films did not even make money in an era when standard-gauge sound films continued to earn a profit. The public did not need a specialized product to attract them to the larger movie palaces or to the smaller neighborhood theaters.

Why didn't widescreen films do at least as well as standard 35mm films at the box office? One answer is that the industry was shortsighted in its selection of properties to be filmed in the new formats, especially given the location of theaters in which the films could play. Though the genre experienced a revitalization during the transition to sound period, Westerns (such as *The Big Trail, Billy the Kid,* and *The Lash*) did not traditionally play well in large urban movie palaces. And New York audiences were unlikely to flock to film adaptations of theatrical productions (such as *Kismet,* starring Otis Skinner, or *The Bat Whispers*) which had recently played "live" on Broadway. The audiences for these kinds of films tended to be outside the major metropolitan areas, where the theatrical productions had not yet played and where (as it turned out) there were no theaters equipped to show wide-film productions (which is why these films were released in 35mm versions as well). Nor did these initial wide-film releases feature established screen stars.[36]

Another answer is that the quality of these films was less than spectacular. Although major directors such as Raoul Walsh and King Vidor were involved, they were assigned to what turned out to be essentially nothing but overproduced "B" pictures, that is, to routine genre vehicles. *Variety* characterized Vidor's *Billy the Kid* as "just another western," and the *New York Times* reported that although the use of widescreen was effective, "the story is merely a moderately entertaining and often unconvincing Western melodrama."[37] *Danger Lights* was described as "a pretty good railroad melodrama."[38] *The Lash* was "not an especially perturbing tale, but its scenes in the open [were] always interesting."[39] And Walsh's *The Big Trail,* though praised for "its magnitude," was given a short life expectancy by *Variety,* which described it, in terms which were as kindly as possible, as "not a holdover picture."[40]

More importantly, in the context of another, more radical technological innovation—sound—wide film failed to differentiate itself sufficiently as a unique product; wide film was just not spectacular enough, either in story content or in visual thrills. In its review of *The Big Trail*, *Variety* concluded that "the wide screen is not big enough in itself to become an additional stimulant at present to the picture house trade."[41] Sound had proved itself through its novelty value, drawing audiences to average or even mediocre films; as *Variety* concluded, widescreen had no such power: it has not "proved strong enough as a novelty to hold up bad pictures as sound did when it first came in."[42]

Wide film did not introduce, as sound did, dramatically different conditions of perception for its audiences; it merely expanded existing parameters of reception. Sound was perceived as "adding to" the spectator's experience of motion picture entertainment. Studio publicists capitalized upon sound's special status as a carrier of dramatic new information, which could satisfy the average moviegoer's curiosity about what people, places, and events sounded like. Thus ads for *Weary River* said of silent star Richard Barthelmess: "You don't know the HALF of him . . . Wait to you get ALL of him."[43] In contrast, wide films merely expanded existing features of the silent-era motion picture experience.

The failure of producers to shoot wide-film productions in color was another missed opportunity to distinguish them from traditional motion picture fare. Though developments in color technology lagged behind those in sound and widescreen, the innovation and diffusion of three-color Technicolor, which remained unavailable until 1933, could have been accelerated and used in conjunction with Grandeur and other widescreen processes. It could even be argued, from the vantage point of historical hindsight, that wide film's 2:1 aspect ratio did not provide a significant enough difference for most audiences from the standard 1.33:1 aspect ratio. It took the more exaggerated aspect ratios of Cinerama, at 2.77:1, and CinemaScope, at 2.55:1, combined with curved screens and stereo sound to catch the public's attention.

The fact that standard 35mm versions of all the major wide-film releases opened only a few weeks after the wide film had been premiered also tended to confuse audiences, who had difficulty in distinguishing between the different versions. The double-release pattern also necessitated dual advertising campaigns. Trade press ads, for example, made no distinction between the wide-film and the 35mm versions, while local newspaper ads for

individual theaters included the names of wide-film processes if the films were shown in those formats. Thus, the advertising of the films as wide-screen works was limited to local markets, and a national campaign to sell exhibitors and the public on wide film was never mounted.

THE CRISIS ECONOMY

Even if there had been forces within the industry committed to engineering a widescreen revolution, economic conditions would have tied their hands for both the present and the foreseeable future. It was not possible for the industry merely to wait out the immediate economic difficulties of the period; a "crisis economy" continued to predominate for almost twenty years, from 1929 until the postwar era. In the automobile industry, for example, sales of new cars peaked in 1929 and did not return to that level for twenty years.[44] By the same token, studio profits did not hit their 1929–30 highs again until 1946. As economic historian Harold Vatter reports, the national economy fell victim, from late 1929 through 1949, to a series of economic emergencies brought about by the abnormal conditions of the Depression and the war years.[45] During the 1930s technological innovation in general was severely limited by a drastic reduction in the availability of venture capital for new products; and even though some investment capital remained obtainable during the Depression, its primary function was to restabilize the faltering industry rather than to create new products.[46]

Since cash receipts from the box office could be quickly pumped back into new projects, cash flow proved less of a problem in the film industry than in other industries. But even in Hollywood funds were generally difficult to find for new investments. Theater acquisition and conversion had been financed during the transition-to-sound period through loans rather than through the issuance of new stock, and a number of studios (such as Warners, Fox, RKO, and Paramount) spent most of their income after the crash in paying back the interest on these loans rather than on continued expansion or investments in new technologies.[47] Fresh capital was used primarily to take over or to rescue from receivership major studios that had been crippled by costs related to expansion, to theater acquisition, and to the conversion of theaters for sound. Thus, as we have seen, William Fox was unseated by his creditors. Various banks and investment houses inter-

ceded to keep a bankrupt Paramount in business, while RKO and Universal went into receivership.[48]

The industry could ill afford to fund further research and development. Most research and development on 65mm and 70mm wide-film systems had been accomplished by the early 1930s, but additional engineering would have been necessary for studios to develop a 50mm system to meet the wide-film standard proposed by the SMPE in late 1930. And technological research was one of the first casualties of studio retrenchment once the Depression hit Hollywood. Indeed, during the early 1930s, shortly after the ouster of Fox, the new Fox management briefly closed down its research and development unit in an attempt to cut costs, halting its tests on a 50mm system (which did not resume until 1944–1946).[49] Though Fox soon reinstated its Research Department (and kept it in operation until 1962), staffing it with trained engineers, other studios, which had created research and development units to design equipment and handle sound installation in theaters during the transition-to-sound period, permanently closed their R&D departments during the 1930s, dispensing with most of their engineers and keeping only one or two technicians on staff to handle all technical problems. Often, R&D technicians were assigned to serve as members of the sound department, as was the case with Douglas Shearer at M-G-M, William A. Mueller at Warners, John Livadary at Columbia, and Loren L. Ryder at Paramount. Others became members of the camera department. As a result of these cutbacks and staffing assignments, the studios were neither thinking about the innovation of any new technology nor equipped to do so during the 1930s and 1940s.

Whatever technological development there was came not from the studios themselves but from "service" companies which supplied the industry with film stock or equipment. Companies involved in the motion picture service industry ranged from corporate giants such as Eastman Kodak and Bausch & Lomb to small firms such as Bell & Howell, the Mitchell Camera Company, and Mole-Richardson.[50] Even Fox's R&D department, which experimented with a lenticular color process, a wide-film system, and theater television during the 1940s, faced a management and an economic climate that discouraged industry-wide innovation.[51] In other words, research and development remained a low priority within the industry throughout this period of crisis economy.

The industry discovered that one technological innovation at a time was

sufficient to satisfy the public's desire for novelty; there was no apparent need for both sound and widescreen—at the same time. Indeed, twenty years later, when widescreen and stereophonic sound were introduced to audiences as an integrated package, the novelty of widescreen overshadowed that of stereo sound, which failed to establish itself as a norm. From the beginnings of the cinema to the present, major technological innovation—especially that which involved considerable cost to exhibitors—took place at the conservative rate of one technology at a time. The attempt to innovate wide film during the transition-to-sound period proved no exception to this rule.

THE MOVIEGOING HABIT

Novelty, however, was not the sole criterion determining attendance figures during the 1920s and 1930s. Motion pictures had become an integral part of the nation's social and cultural life. The moviegoing habit that took hold in the late 1920s—during the silent era—kept its grip on audiences through the early sound era, providing a steady supply of customers who sought entertainment rather than technological innovation. Motion picture attendance grew steadily throughout the silent era, climbing from 40 million per week in 1922 to 57 million per week in 1927, peaking at 95 million in 1929.[52] After a drop in attendance in 1931 and 1932 to 75 and 60 million spectators per week, the weekly average rose steadily until 1948; during this time there were no major technological innovations except for the advent of color—a change in format which involved only a small percentage of films (and no installation or renovation costs on the part of the exhibitor).[53]

From the 1910s through the 1930s the movies became the beneficiary of radical changes in America in leisure-time entertainment, answering a demand for a new form of mass entertainment for urban working-class and middle-class audiences, whose work week had dropped from approximately 55 hours per week in 1910 to roughly 45 hours per week in 1930 and whose leisure time had gradually increased from 30 to 40 hours per week.[54] As population shifted from rural to urban areas in response to the rapid industrialization that took place at the turn of the century, traditional recreational activities changed to meet new needs. As George Lundberg, Mirra Komarovsky, and Mary Alice McInery noted, "spontaneous and informal neighborhood life, . . . a chief [form] of leisure, . . . disappeared

TYPICAL MOVIE
THEATER (UPTOWN
THEATRE,
WASHINGTON,
D.C., CA. 1936;
COURTESY OF
MUSEUM OF
MODERN ART).

as a result of the tremendous mobility of modern urban society . . . and occupation tend[ed] to supplant geographic location as a basis of fellowfeeling and association. Congested living quarters and the disappearance of the yard and other outdoor facilities . . . further shifted recreation to the school, the club, and the commercial recreation place."[55] Leisure-time activities, which had been centered on family and community, were brought into the public sphere, becoming mass recreation, which took place in more commercialized, consumer-oriented spaces. Instead of relaxing at home or in a local social club or neighborhood dance hall, people in the 1910s went en masse to amusement parks, to popular theaters and variety shows, and to the movies.[56] By the 1920s the motion picture had emerged as the cheapest, the most widely available, and the most broadly appealing form of mass entertainment—except radio—in the country. And by the 1930s the movies, along with radio, had developed a tremendously large and loyal following. For many middle- and working-class individuals and families, the movies

become the leisure-time activity par excellence.[57] During the first four decades of the century, as succeeding generations of Americans left rural areas for the city, the audience for commercialized entertainment—for the movies—was continually replenished, providing Hollywood with a virtually guaranteed pool of consumers for its product.

In terms of audience demand, then, there was no need for a new technology in order to hold spectator interest in the late 1920s and early 1930s; the popularity of standard 35mm black-and-white films remained high throughout this period even without the introduction of a new technology. In fact rising attendance figures during the mid-to-late 1920s suggest that even the addition of sound was unnecessary to the economic well-being of the industry as a whole, its innovation and diffusion being prompted by competition within the industry rather than by a decline in attendance.[58]

The steadiness of the habitual moviegoing audience can be measured in terms of yet another technological innovation which was, to all extents and purposes, "frozen" during the 1930s and 1940s until attendance began to decline. A viable motion picture color technology, in the form of two-color imbibition-printed Technicolor, was introduced around the same time (ca. 1928) that wide-film systems were first demonstrated. Yet color film production took almost as long as widescreen to become established as an industry norm. Though three-strip Technicolor was introduced for filming features in 1934, color films accounted, by 1938, for only 2.6 percent of all films made. This figure rose slowly to 3.9 percent in 1941 and 8.2 percent in 1945, then climbed to 12 percent in 1947 and to 18 percent in 1949.[59] By the mid-1950s, when motion pictures began to exploit new technologies such as color and widescreen to differentiate themselves from traditional black-and-white narrow-screen films as well as from television, the percentage of color films had skyrocketed to over 50. By 1979 (after the successful diffusion of color television), 96 percent of all films were made in color.[60] In other words, color filmmaking did not become a standard until *after* the steady moviegoing audiences of the 1930s and 1940s had begun to disappear in the 1950s, when its innovation and diffusion were accelerated in an attempt to lure this dwindling audience back into the movie theater.[61]

The slow but steady increase in color production differs from the uneven advancement of widescreen production in several ways. Unlike wide films, color films involved no new expensive projection technology; no financial outlay was required on the part of exhibitors. Color films could be projected

with existing theater technology, a factor which clearly facilitated the rapid adoption of color once producers committed themselves to its diffusion. The diffusion of wide-film and widescreen processes, on the other hand, demanded the cooperation and shared expense of both producers and exhibitors.[62] Technicolor, which controlled patents for crucial aspects of various color processes, had a vested interest in promoting productions in color; yet even though Technicolor became involved in financing initial productions in its various processes to demonstrate its work to the industry, it was unable to stimulate widespread diffusion.[63] From the onset of the Depression through the end of World War II, American motion pictures enjoyed a remarkably privileged economic status, consistently patronized by a loyal audience of regular moviegoers. From 1928 to 1948, Americans went to the movies on the average of once a week.[64] Though audiences continued to differentiate among the various motion picture productions which Hollywood offered, preferring certain stories, genres, and stars to others, they remained entranced by the same sort of entertainment *experience*—predominantly black-and-white sound cinema—for twenty years.[65] There was no popular demand for a different kind of screen presentation.

The film industry's chief competition for mass audiences during this period came from radio, which began to lure spectators away from the silent cinema in the mid-1920s.[66] After the advent of sound, however, the motion picture became radio's chief rival as the most popular form of low-cost mass entertainment. In many communities, movies emerged as the major form of commercial leisure-time activity.[67] The amount of the recreation dollar spent on going to the movies actually increased during the years 1929–1945, accounting for 20–25 percent of all entertainment expenditures.[68]

Even though radio, unlike the movies, was free, statistical studies indicate that radio, rather than luring movie audiences away from movie theaters, actually helped contribute to the moviegoing habit, not only as an advertising medium for new releases but also as a subsidiary form of distribution—through its broadcast, on programs such as the "Lux Radio Theater," of radio versions of popular movies.[69] At the same time, both media shared certain stars, such as Will Rogers, Jack Benny, Bing Crosby, Rudi Vallee, Edgar Bergen and Charlie McCarthy, and George Burns and Gracie Allen, a factor that symbolized the collaborative nature of the two industries' relationship.[70] Radio networks even began to broadcast from Hollywood studios during the 1930s, and several film studios, such as

Paramount (which bought half-ownership of the Columbia Broadcasting System in 1929), RKO (which was affiliated, through RCA, with the National Broadcasting Company), and Warner Brothers (which owned a radio station and had its own broadcasting corporation), expanded into the field of radio broadcasting.[71]

From the 1920s through the 1940s, the movies satisfied a need for a cheap form of commercialized mass entertainment. The length of a motion picture show and the cost of a ticket conformed more or less to the amount of time and money Americans had, within their budgets of leisure time and of disposable personal income, to spend on amusement. During this period the moviegoing audience remained steadfastly loyal; they were enthralled week after week and year after year by an entertainment experience which had not changed substantially since the advent of sound. The stability of this audience precluded any need for technological innovation to hold their interest: there was simply no demand for wide-film or for widescreen cinema. But beneath the surface of this apparently constant consumption of the cinema lay a repressed desire for a more active form of recreational endeavor. Audiences went to the movies, listened to radio, and read books and magazines; but, according to a 1934 survey conducted by the National Recreation Association, people actually wanted to play golf or tennis, go swimming or boating, camp, or work in the garden.[72] They went to the movies instead because they lacked the time and money for those more time-consuming and more costly activities. The illusion of stability in the field of commercialized entertainment was shattered during the postwar years, when consumers suddenly discovered that they could afford to spend more time and money than they ever had in the past on amusing themselves. The motion picture industry had to adjust itself to the new postwar penchant for recreation and to a declining interest in prewar forms of mass entertainment.

During the 1940s social, cultural, and economic changes transformed the demands of American consumers for certain kinds of amusement activities. Traditional moviegoing gave way to a desire for more participatory engagement with mass-produced entertainment, creating a climate for the introduction during the early 1950s of new, widescreen motion picture technologies capable of providing radically different spectatorial experiences.[1] Some of the changes which took place in American leisure-time activity during the war and postwar period throw light on subsequent developments in the motion picture industry leading up to the advent of Cinerama in 1952.

The industry's self-imposed technological stasis from the aborted wide-film movement of 1929–30 through the war years was made possible by a corresponding stability in the moviegoing public. The interests and activities of this group remained fairly constant, as did (more or less) their leisure time. And, even though work patterns changed dramatically during the war years, affecting both the quantity and quality of leisure time, these changes did not interfere, for the most part, with moviegoing.

Attempts to reach production goals set by government and industry during World War II resulted in a sharp increase in the length of the average work week from roughly 40 hours in 1940 to 48 hours in the mid-1940s.[2] Though this longer work week provided less time for recreational activities, it did not result in decreased motion picture attendance; rather, audiences, more desperate than ever for diversion, sought film entertainment in ever-increasing numbers.[3] Even though the work day was longer, there was still enough time left after work to see a movie; and it was still easier to squeeze a 90-to-120-minute feature-length film into busy work schedules than it was other, more time-consuming endeavors, such as hunting, fishing, sports, and other outdoor recreational activities. In fact the latter pastimes declined in popularity during this period.[4] The average weekly attendance at motion pictures grew from 80 million in 1940 to 85 million in the years 1941–1944,

even though hundreds of thousands of regular moviegoers were now participants in different "theaters" of action—namely the Atlantic and the Pacific.[5] Attendance continued to increase right after the war, rising to 90 million in 1945 and remaining at that level through 1948.[6] This growth, which restored weekly attendance figures to a level they had reached just before the Depression, marked a postwar readjustment in leisure-time activities as many of the returning veterans resumed their prewar moviegoing habits and as those who had remained at home continued to go to the cinema.

POSTWAR DECLINE

However, postwar changes in the average work week, leisure time, disposable income, and consumer interest disrupted the loyal partnership that had existed for more than twenty years between the motion picture industry and its audience. Attendance dropped sharply to 60 million per week in 1950 and continued to fall steadily throughout the decade, reaching 40 million in 1960.[7] The advent of television, which began to expand its market in earnest in 1948, is commonly cited as the reason for this decline in attendance.[8] More recently, however, historians have begun to read these decreasing attendance figures against a background of other, complexly interconnected determinants, situating the decline of the movies within a larger field of cultural transformation.[9] The metamorphosis of the habitual moviegoer into a sometime spectator took place within a changing leisure-time market, and these changes both help explain the rapid decline in film attendance and informed the attempts of the film industry to recapture its dwindling audience.

The first stage in the dismantling and demise of the Hollywood studio system is commonly understood to have begun with the Paramount Case, an antitrust suit lodged against the major studios in the 1930s by the federal government on behalf of independent producers and exhibitors, which resulted in a court decree (in late 1946) prohibiting the industry from fixing admission prices, engaging in block booking and blind bidding, and establishing a system of runs and clearances. In 1948, after an appeal, the defendants agreed to sign consent decrees divorcing their production and distribution organizations from their theater circuits.[10] However, these

changes played only a minor role in the motion picture industry's postwar problems at the box office. In fact many of the majors successfully delayed divestment proceedings for years; Loew's, Warners, and Twentieth Century–Fox held off divestiture until July 1953 and continued to sell off their theaters as late as 1957 by pleading, quite convincingly, that the current market price for theaters was too low for them to recoup their investment.[11] Throughout the 1950s, the majors continued many of their pre–consent decree distribution practices without strictly violating the terms of those decrees, which forbade them from *conspiring* with one another to control the market.[12] At the same time, segments of the industry could—and did—appeal to the courts for special waivers. Thus the Stanley Warner theater circuit obtained permission to produce and distribute features made in Cinerama for exhibition in their theaters equipped to show this special process.[13] It was not so much changes within the film industry that deprived it of its former audiences as it was changes within society as a whole.

After the war, the average work week returned to its prewar norm of 40 hours. While the work week grew shorter, wages and salaries continued to increase; average weekly wages rose from $44.99 in 1946 to $60.53 in 1950.[14] Disposable personal income grew from $26.6 billion in 1909 to $83.1 billion in 1929 and then fell abruptly to $45.7 billion in 1933; it climbed to $76.1 billion in 1940 and then took off, skyrocketing to $207.1 billion in 1950, and to $350 billion in 1960.[15] While income rose during the war because of an increase in hourly wages (from $.67 in 1940 to $1.03 in 1945) as well as in the length of the work week, wartime shortages in consumer items, especially in cars, housing, clothing, and other "luxury" goods, resulted in a decrease in consumer spending.[16] As a result, Americans saved rather than spent their incomes, amassing savings accounts in excess of $150 billion.[17]

THE SUBURBS

The combination of wartime shortages, accumulated savings, and increased earnings prompted a postwar spending boom. And the things that Americans bought tended to take them away from the movies, both literally and figuratively. Through their most important purchases—cars and houses—Americans bought their way into the suburbs, where new interests began

to fill their leisure time. New car sales jumped from 69,500 in 1945 to 5.1 million in 1949 and to 6.7 million in 1950.[18] Automobile registrations doubled, growing from 25.8 million in 1945 to 54.3 million in 1956.[19] The postwar popularity of the automobile peaked in 1955, when over 7.9 million new cars were sold.[20] As automobile sales increased, so did the mobility of the population;[21] by the summer of 1957, over half of the total population— over 90 million people—went away for vacation, giving rise to a multibill-ion-dollar tourism industry, which drew more and more Americans away from their neighborhood movie theaters during seasonal vacation times.[22] By 1953, 83 percent of all domestic vacations were taken by automobile (rather than boat or airplane).[23] And by 1960, over 80 percent of American families owned at least one car.[24]

Automobiles, quite clearly, played a significant role in changing demographic patterns, permitting wage earners to travel greater distances to get to work. Almost-universal automobile ownership made it possible for more and more postwar Americans to live in the suburbs and work in the city. During the 1950s, for example, over 1.5 million New Yorkers moved to communities outside the city proper but still within its greater metropolitan area. And while the population shifted from the East, the South, and the Midwest to the West and from rural to urban areas, the greatest growth of population during the decade—over 83 percent—took place in the suburbs.[25]

Housing shortages during the war, which forced many young couples to share cramped houses or apartment space with their parents, gave way to a postwar surge in home building and buying.[26] By 1945 more Americans were home owners than renters.[27] GI loans, low-interest rates provided through VA/FHA mortgages, and affordable, standardized housing introduced by construction entrepreneurs such as William J. Levitt led to the sale of 1.4 million homes in 1950.[28] Building on sites near large metropolitan areas in New York, New Jersey, and Pennsylvania, Levitt constructed look-alike houses with similar exteriors and uniform floor plans, installing standard appliances in fully-equipped kitchens and selling his homes for as little as $8,000.[29] Other builders took note, especially after Levitt made the cover of *Time* in July 1950, and began buying up tracts of land, which they would then bulldoze and build upon. During the mid-1950s, suburban land tracts were being bulldozed for housing developments, shopping centers, and other new construction projects at the rate of over 3,000 acres a

day.[30] By the end of the decade, there were over 10 million more homeowners than there had been at its start,[31] and of the 13 million new homes built between 1948 and 1958, 11 million were located in the suburbs.[32]

Many of these new suburban homes were equipped with labor-saving appliances that had previously been unavailable to the majority of Americans; these products transformed the home into a technological, domestic paradise, encouraging consumers to stay at home rather than to "escape" to the movies (as they had done previously when living in small, claustrophobic apartments in the city).[33] These appliances also tended to increase leisure time still further, freeing people to engage in other, more pleasurable home-related activities. By 1950, 86 percent of all homes wired for electricity possessed refrigerators, while 70 percent had modern stoves and washing machines; many also had electric vacuum cleaners.[34] By 1959, these figures had increased even more: 98 percent of American homes had refrigerators and 93 percent washing machines; over 90 percent had television sets and 37 percent vacuums.[35] Television emerged, of course, as the domestic appliance par excellence, soaking up leisure time made available by these other appliances. The number of television sets increased from 8,000 in 1946 to 14,000 in 1947, then escalated more rapidly to 172,000 in 1948, 940,000 in 1949, 3.875 million in 1950, 10.32 million in 1951, and 34.9 million in 1956.[36] By the end of the decade, 90 percent of American homes boasted television sets.[37]

Americans began to spend more and more time and money in home-related activities, ranging from gardening and outdoor barbecuing to do-it-yourself home improvement and repair. Suburban home owners passed more and more time in home-related "work" and relaxation. According to a 1953 *Saturday Evening Post* survey, over 30 million Americans took up gardening in the postwar era.[38] According to the Department of Commerce, the sale of flowers, seeds, and plants had risen from $475 million in 1947 to over $684 million in 1953.[39] During the same 1947–1953 period, the sale of power tools for use in home workshops increased by almost 700 percent, rising from a $31 billion to a $209 billion industry.[40] After a day digging around the garden or puttering around the house, Americans stayed (or went) out of doors and took it easy. They sat, socialized, and ate. The sale of lawn and porch furniture soared from a total expenditure of $53.6 million in 1950 to $145.2 million in 1960, while grill items, such as hot dogs, were sold in ever-increasing quantities, jumping from 750 million pounds sold

in 1950 to 1,050 million pounds in 1960, while potato chip sales increased from 320 million (1950) to 532 million (1960) pounds.[41]

The suburbs also served as the site for the postwar baby boom, which kept millions of young couples at home with the kids, depriving the movies of a significant portion of their most loyal patrons, men and women under the age of thirty.[42] The birth rate, which had declined to 19 children per 1,000 women in the 1930s, soared in the postwar era, reaching 27 per 1,000 in the mid-1950s. In 1940 there were 2.6 million births per year. In the years 1946–1950 the average was 3.6 million per year; and the average steadily increased, rising to 4 million in 1950–1954 and peaking at 4.3 million in 1957. So many of these births took place in the suburbs that new housing developments were often jokingly referred to as "Fertile Acres" and pregnancy as the "Levittown Look."[43] The baby boom prompted new patterns of entertainment in the home, such as an increased use of television (which rose to five hours a day by 1955), and recreation outside the home, consisting of family outings to playgrounds, swimming pools, beaches, and public recreation areas and trips to national parks, such as Yellowstone, Bryce Canyon, and Great Smoky, where the number of visitors nearly doubled (from 25 million in 1947 to 46 million in 1953).[44]

INDUSTRY RESPONSE

As people moved to the suburbs, they left behind traditional forms of entertainment, such as the theater and the motion picture, and sought out new recreational enterprises, especially outdoor leisure-time activities. Since its inception the motion picture industry had relied heavily upon urban audiences for its profits. Though industry revenues ultimately depended upon how films played in rural and foreign as well as in urban markets, first-run theaters in major urban areas traditionally accounted for the bulk of the industry's income.[45] In the late 1940s and early 1950s, Hollywood suddenly discovered that its audience was gradually moving away; many former patrons were now living on the outskirts of the cities, where there were few, if any, theaters. Two solutions to this demographic change presented themselves; exhibitors could follow these audiences to the suburbs, building new theaters in these areas; or exhibitors could attempt to lure audiences back to existing theaters in the cities.

The first option proved to be no option at all. It took time and money to

WOODBRIDGE
DRIVE-IN THEATRE
(CA. 1960;
COURTESY OF
MUSEUM OF
MODERN ART).

build new theaters, and the most highly capitalized theater chains—those which had recently been divorced from the major production and distribution organizations—were prevented from acquiring new theaters by the terms of the Paramount Case consent decrees.[46] (They could secure permission to acquire new theaters only by pleading their case for each new acquisition in costly court proceedings.) Formerly "independent" theater chains were not bound by these restrictions and could take advantage of the constraints placed upon their competition, but only a handful of chains could afford to invest in new theaters, especially given declining attendance figures, reduced cash flow, minimal cash reserves, increased theater closings, and the unstable state of motion picture exhibition in general. Nonetheless, some new theaters were built in response to the population shift, and the majority of these were situated in the suburbs, though it took a number of years for this new "suburban circuit" to be created. Of all the movie theaters in existence in 1972, 37.7 percent of all indoor theaters and 44.5 percent of all drive-ins were built after 1954, and virtually all of these

theaters were located in the suburbs.[47] But the construction of new theaters in the suburbs failed to address the source of the problem—the need of audiences for a different kind of entertainment; and by 1972, when these statistics were compiled, the habitual moviegoing that had sustained the industry in the past had disappeared; in fact average weekly attendance had dropped to 18 million.[48]

The quickest and cheapest solution to the problem of theater construction in the suburbs was the drive-in, the building of which involved "a minimum of land improvement and very little investment risk."[49] The tremendous increase in the number of drive-ins in the postwar era, from 554 in 1947 to 4,700 in 1958, reflects an attempt by one group of exhibitors in the industry to catch up with this new, highly mobile, suburban audience.[50] And, in part, drive-ins succeeded where other exhibition situations failed. As *Variety* reported in 1953, competition from other leisure-time activities (such as television) "had reduced first-run grosses by 20 percent, neighborhoods by as much as 50 percent, [but] drive-ins only 10 percent."[51] However, mainstream Hollywood tended to view drive-ins as inherently inferior to hard-top theaters and, even after the consent decree which forbade it, attempted to continue its prewar policy of withholding first-run products from drive-ins, forcing them to accept sub-run distribution agreements and to book B and exploitation pictures.[52] Throughout the first half of the 1950s, drive-ins retained their marginal status; they were owned primarily by small, independent exhibition chains and, for the most part, were limited in terms of the selection of films which the major studios permitted them to show.

ENTERTAINMENT VERSUS RECREATION

The majority of motion picture exhibitors were unable to follow audiences to the suburbs. As a result, they were forced to try to lure them back to theaters in the city. In order to compete with other leisure-time activities, the movies had to redefine themselves, transforming passive entertainment into active recreation. In doing so, they attempted to deal not so much with superficial demographic changes as with the psychological factors underlying declining attendance figures—the need of postwar audiences for a new, more participatory kind of motion picture experience.

Thus the suburbanization of postwar America did not singlehandedly

wrest the movies from their audiences. The standard motion picture, whether shown in drive-ins, suburban shopping centers, neighborhood theaters, or downtown movie palaces, no longer held spectators in thrall. Postwar consumers demanded more engagement from their diversions. Passive entertainment no longer satisfied those millions of Americans who now had more time and money to spend on their leisure-time activities.[53]

In its 1955 analysis of the recreational market, *Fortune* categorized leisure activities as either passive or active and traced a twenty-year trend toward more active leisure-time pursuits, noting that "the sharpest fact about the postwar leisure market is the growing preference for active fun rather than mere onlooking."[54] *Fortune* read the figures on the wall and saw that leisure expenditures were down for movies and spectator amusements and up for everything else, including durable and nondurable toys and sports supplies, foreign travel, domestic recreational travel, dining out, boats, golf, bowling, and other activities.[55]

Several years earlier, Twentieth Century–Fox executive Darryl Zanuck had recognized this same shift in the "ever-changing cycles" of the entertainment business, noting that "now the public is more participation-minded than ever."[56] Zanuck distinguished between recreation and traditional forms of entertainment: "Entertainment," he explained, "is something others provide for you, while recreation is something you provide in some measure for yourself—something in which you participate."[57] The new demand for recreation resulted in increased involvement in outdoor sports—there were 3.5 million golfers and $175 million being spent for green fees, $21 million was spent each year on fishing and hunting licenses, $800 million for sporting goods, and $200 million for musical instruments—and there was record-breaking attendance at amusement parks, fairs, and carnivals.[58] Unlike *Fortune*, Zanuck, for obvious reasons, still saw a future for motion pictures, and, using the recreational language of the day, he recast them—at least some of them, such as Cinerama, CinemaScope, 3-D, and other films made in the new technologies—as "participatory events."

Audience demand for engaging entertainment mirrored people's growing fascination with new modes of recreation. During the postwar era, as leisure time in general increased, so did certain forms of time-demanding leisure-time activities, which grew more rapidly than did others. Statistics for outdoor recreational activities, for example, provide a useful index for measuring the changing profile of the leisure time market. The number of

hours-per-person spent in travel for pleasure, hunting, fishing, boating, sports, and other recreational activities rose steadily over the first half of the decade, climbing from 2,100 in 1920 to 12,200 in 1950, doubling during every decade except the 1930s (because of the Depression). These statistics continued to increase throughout the 1950s, reaching 21,012 hours per person by 1960.[59]

DRIVE-INS

Though Zanuck's argument for the participatory nature of moviegoing was largely figurative, certain segments of the motion picture industry sought to literalize participation. Drive-ins successfully competed with indoor movie theaters by expanding the range of services they offered and the variety of activities in which their patrons could indulge. Unlike traditional hard-top theaters, whose design had been fixed at the time of their initial construction and whose architecture restricted them to certain kinds of entertainment experiences, drive-ins, which were situated on relatively undeveloped pieces of land, possessed a greater spatial flexibility which could easily be adapted to suit the needs of their audiences. Many drive-ins, for example, provided playgrounds for the amusement of children before the show;[60] others contained laundry facilities, enabling families to spend an evening at the movies while completing unfinished household chores.[61] One Florida theater, opened in 1951 near Lake Hartridge, promoted itself as "The Only Drive-In Theatre in the World That Offers Lake Fishing," and boasted that its patrons could fish and watch the movies at the same time.[62] Certain entrepreneurs created entertainment complexes around their drive-ins: George Haar combined his drive-in operation near Dillsburg, Pennsylvania, with an auction, a roller-skating rink, and a furniture store.[63] Gilmore Island in Los Angeles brought an outdoor theater together with "a baseball park, an amusement park, the Pan-Pacific Auditorium, and the Farmer's Market."[64] Houston's Sharpstown Drive-In, built in 1958, featured a playground, a miniature railroad which featured a trip through a sixty-foot tunnel where mechanical elves working in a diamond mine swung picks and shovels, a zoo, a "Disney fairyland," a pet adoption center, and a fulltime clown.[65] Sharpstown obviously sought to copy the successful formula for participatory amusement pioneered several years earlier by another member of the film industry—Walt Disney.

DISNEYLAND

Disney's expansion from motion picture production into full-scale leisure-time amusement took the the form of Disneyland, which was conceived in 1948, planned during the early 1950s, and which opened in July 1955.[66] In this theme-park-to-end-all-theme-parks, two-dimensional motion picture stories and spaces were reconstructed in three-dimensional space and transformed into amusement park rides. Animated films, such as *Snow White, Peter Pan,* and *The Wind and the Willows,* provided characters and narrative material for several of the park's first attractions.[67]

The park itself was merely part of a larger scheme of postwar entertainment design that included television programming and product merchandising as well. The creation of Disneyland was coordinated with that of a Disney television series, which was used to publicize the park and the studio's theatrical features, and the park itself was financed in part by the American Broadcasting Company, which owned 35 percent of the Disneyland stock.[68] Plans for the park and the television show were announced simultaneously on April 2, 1954, and different segments of the television show were organized around the different lands to be built in the park, such as Frontierland, Fantasyland, and Adventureland. During its first season the series ran a documentary about the filming of *20,000 Leagues under the Sea,* Disney's first CinemaScope feature, as well as progress reports on the development of the park. The program not only advertised other Disney products but, with the success of the *Davy Crockett* series during the 1954–55 season, became a source of merchandising in itself. The show's title song, "The Ballad of Davy Crockett," topped the *Hit Parade* for thirteen weeks and sold over 10 million copies, while Disney realized additional profits through his licensing of Davy Crockett toy guns and coonskin caps.[69]

Unlike other Hollywood producers, who initially boycotted the medium, Disney used television to build an audience for his motion pictures; at the same time, he diversified, attacking the leisure-time market on a variety of fronts (motion pictures, television, theme parks, toys, product tie-ins, and records). After the success of *Walt Disney Presents,* Hollywood followed Disney's example the following year when Warner Brothers, Twentieth Century–Fox, and M-G-M began producing various series for television.[70] But Disney's enterprise and inventiveness in attempting to recapture control of the changing entertainment marketplace was an exception, and it would

be several decades before other studios would diversify, become entertainment conglomerates, and set up amusement parks of their own.

One crucial factor leading to the increase in outdoor recreational activity had to do with significant changes during the postwar era in the status of salaried employees. Before the war, wage earners received paid vacations ranging from three to five days a year. After the war, workers tended to get two weeks off (with pay) per year.[71] During the 1950s, annual paid vacations of from two to three weeks became the norm for the majority of American workers. Between 1929 and 1959, total vacation time rose from 17.5 million to 78 million weeks. The institutionalization of paid vacations permitted workers to engage more readily than they had been able to in the past in outdoor activities, which tended to demand more time than did traditional, commercialized entertainments.[72] Fees paid for hunting and fishing licenses rose dramatically during the postwar era from $13.5 and $10.5 million respectively in 1944 to $37.6 million and $34 million respectively in 1950.[73] Entrance fees at national and state parks jumped from $525,000 in 1944 to $3.8 million in 1950 while expenditures for sports equipment grew from $297,000 (1944) to $863,000 (1950).[74] By the end of the decade, most of these figures had doubled. The implications of these statistics for the motion picture industry were clear: the more time and money spent in outdoor recreation, the less there was left for going to the movies.

Though the percentage of daily leisure time has remained fairly constant since the turn of the century, weekend leisure time rose dramatically from 28 percent of a weekend in 1900 to 39 percent of a weekend in 1950, chiefly owing to the demise of Saturday as a full work day. This increase in weekend leisure time enabled consumers to go away for the weekend or to spend more time (and money) on outdoor recreational activities that required larger blocks of free time. This new rise in weekend activities necessarily cut into motion picture attendance, which was traditionally highest on weekends.[75] Indeed, overall motion picture attendance fell drastically during the postwar period from an average weekly attendance of 90 million in 1948 to 46 million in 1953.[76]

THE NEW MIDDLE CLASS

Increased leisure time, however, does not in itself lead to a decline in motion picture attendance. In fact, in certain situations it could permit more

frequent moviegoing. What the dramatic increase in leisure time did was to reveal ways in which audiences themselves had changed. Before the war (and before Hollywood had begun to conduct audience research in the early 1940s), the industry made films for a mythical general audience, a heterogeneous assortment of different age and economic groups possessing a varied educational background.[77] As Lundberg, Komarovsky, and McInery observed, "on the whole, the movie theater trie[d] to cater to all tastes in all performances."[78] During the 1940s, when the industry began to keep statistics on its audiences, it discovered that this heterogeneous general audience was growing more and more homogeneous—that the average viewer was growing younger, more affluent, and better educated.[79] In other words, audiences were gradually becoming more middle and upper-middle class. These tendencies continued throughout the decade so that by 1957, three-fourths of all moviegoers were under thirty years of age and over 50 percent were under twenty.[80] Fifty-eight percent had completed high school or college.[81]

The shift in motion picture audiences from a general mixture of different classes to a predominantly middle-class phenomenon served as a barometer of changes in society as a whole. By 1956 white-collar workers outnumbered blue-collar workers for the first time in U.S. history; 75 percent of adult Americans—including lower-class workers—tended to *think* of themselves as middle class, giving rise to the (mis)conception that America was becoming a single-class, thus classless, society.[82] This potential audience, however, did not continue to be regular moviegoers as a group, and those who did were far from homogeneous in their demands for certain kinds of entertainment. They represented what C. Wright Mills termed "the new middle class," as distinct from the "old middle class," which consisted of land-owning farmers and small businessmen. Unlike the old middle class, whose identity was based on its ownership of property, this new, propertyless middle class of salaried employees established class identity on the basis of professional occupation rather than property ownership.[83]

Given the diversity of occupations within this new middle class, class identity emerged as a highly stratified, heterogeneous phenomenon. Each strata demanded a slightly different kind of entertainment, and, as a class, this new, emerging group of consumers sought for ways in which to distinguish themselves socially and culturally from previous generations of audiences and from other classes—from the lower classes from which they

had emerged and from the upper classes which they had traditionally disdained as elitist. Participation in leisure-time activities became a way of setting themselves apart from the Depression-enforced passivity of the lower classes, while the enthusiasm and populist egalitarianism with which they approached these activities marked an attempt to distinguish themselves from the supposedly willful idleness of the upper classes. In one crucial area of upper-class lifestyle, the middle class appropriated the once-exclusive domain of the wealthy—an estate in the country—and transformed it to suit their own needs—a house in the suburbs, located within easy access of supermarkets and shopping centers.

MIDDLE-CLASS CULTURE

In their leisure-time activities the leisured masses began to lay the foundations for a new middle-class culture, combining traditionally upper-class activities with characteristically middle-class energy. In terms of athletic activities, for example, the new middle class chose golf, a sport that had been associated with expensive and elitist social organizations such as private country clubs. In their hands golf became a middle-class obsession, which the increasing size of disposable personal incomes and the growth of public golf courses in the postwar period made accessible to greater and greater numbers of people.[84] Golf became emblematic of this new class and of its entry into a new era of leisure-time activities. The sport achieved this, in part, through the familiar media image of America's chief executive, former general Dwight David Eisenhower—who was seen less sitting at his desk in the Oval Office than teeing-off at the golf course. A leisure-time president par excellence, Ike represented the former, hard-working, wartime laborer enjoying the postwar fruits of his earlier efforts. Though the press may have joked about the amount of time Eisenhower seemed to spend on the golf course, no one begrudged him his game of golf. Former presidents had installed screening rooms in the White House; Eisenhower's contribution consisted of a driving range and a putting green.[85]

This new middle-class culture made itself apparent in the rampant commercialization of leisure that took place in the 1950s. Leisure "sold," becoming an item for mass consumption. Indeed, one-sixth of all personal income was spent on "leisure pursuits."[86] Traditional suits and formal attire gave way to a new industry in "leisure" wear; adults began to dress in

informal, casual clothing, such as sport coats, slacks, trench coats with zip-in linings, nylon shirts, skirts, sweaters, and lounging pajamas while teenagers wore dungarees, sneakers, sweaters, and loafers.[87]

In a related area, personal consumption climbed to the $218 billion mark in 1952—with Americans spending $255 million on chewing gum, "$235 million on greeting cards, $130 million on laxatives, $38 million on stomach sweeteners, and $23 million on mouthwash."[88] Teenagers now constituted a growing consumer market, spending $10 billion annually on personal entertainment, cars, clothing, sporting goods, cosmetics, and other consumer items.[89] Teens bought rock-and-roll and pop records at the rate of $75 million worth a year.[90] Together, personal expenditures for recreation by these various strata of the new middle class more than tripled in the postwar era, leaping from $6.1 billion in 1945 to $19.5 billion in 1960. Most of this money was being spent on outdoor recreation.[91]

As moviegoers, this new middle class required something different from the previous generation of moviegoers, which was now being serviced by television. They sought a more specialized commodity—something designed for their particular interests. Their demand gave rise to a variety of individualized genres. For the high school crowd, there were teen exploitation films. These ranged from rock 'n roll films *(Rock around the Clock, Jailhouse Rock)* and teen problem pictures *(City across the River, Blackboard Jungle)* to horror and science fiction films *(I Was a Teenage Werewolf, The Blob, Invasion of the Body Snatchers)* as well as car and motorcycle films *(Thunder Road, The Wild One)*.

Older audiences demanded a somewhat different product. A large sector of the new middle class sought out lavishly made spectacles, ranging from musicals *(Showboat, An American in Paris, Singin' in the Rain)* to historical costume pictures *(Samson and Delilah, David and Bathsheba, Quo Vadis, Ivanhoe)*. Another tier of this new group, which included college students and college-educated white-collar workers, preferred "adult" films. For them, Hollywood produced more sophisticated versions of traditional, general audience genres which raised issues or problems that had previously been kept well beneath the surface. These pictures ranged from Westerns *(Broken Arrow, High Noon, Shane)* and melodramas *(All about Eve, Marty, Not as a Stranger, Giant)* to "war" films *(Battleground, From Here to Eternity, The Caine Mutiny)* and social problem films *(Gentleman's Agreement, Pinky, On the Waterfront, The Man with the Golden Arm)*.

Thus the kinds of films being made changed in certain respects during the postwar era as the composition of the moviegoing audience shifted from an ill-defined and somewhat amorphous general audience to a more highly stratified, younger, better-educated, and more affluent middle-class audience. These changes, however, represented no revolutionary redefinition of the nature of the cinematic experience but merely constituted a shift within traditional models of spectatorship and motion picture product. Like the movement of theaters to the suburbs, this shift in storytelling style and content served only as a superficial solution to the deeper problem of audience disaffection. To compete with other leisure-time amusements, the motion picture experience was in need of redefinition. Movies had to become more participatory; the movie theater had to become the equivalent of an amusement park. The advent of Cinerama launched this revolution.

CINERAMA:
A NEW ERA IN THE CINEMA

Cinerama, like the cinema itself, traces its origins back to its dubious antecedents in the fairground, where con men, pickpockets, sword-swallowers, Barnumesque showmen, Rube Goldberg–like inventors, and genuine scientists pitched their wares. The fanciest of fairgrounds is the "Exposition" or world's fair, and it is here, in the meeting ground for scientists and showmen, that the cinema was truly born, not in the privacy of some inventor's laboratory, toolshed, carriage house, or barn.

Edison publicly introduced (or at least attempted to introduce) his Kinetoscope at the World's Columbian Exposition at Chicago in 1893;[1] C. Francis Jenkins and Thomas Armat unveiled the prototype of the Vitascope projector at the Cotton States Exposition in Atlanta in 1895 (acquired a year later by Edison, the Jenkins-Armat device became the basis of the standard motion picture projector in use today); and the Paris Exposition of 1900 featured not only Cinéorama (in which ten interlocked 70mm projectors filled a 360-degree 300 × 30 foot screen) but a large-screen (70 × 53 foot) projection system devised by Louis Lumière.[2]

The Paris Exposition provides an early example of the variety of cinematic devices on display and the range of experiences they made available. Raoul Grimoin-Sanson's Cinéorama (also known as the Cinépanorama) featured a balloon ascension, filmed from a real balloon which rose from the Tuileries and descended in La Grande Place de Bruxelles. The illusion of reality was enhanced by the presence of an airship captain who announced the various sights.[3] However, this "ride" was quickly closed by the prefect of police after the projectionist, collapsing from the 115-degree heat in the booth, had an accident with the projection machinery, losing two fingers in the process.[4] Installed in the Galerie des Machines, the Lumières' giant-screen cinema consisted of fifteen "vues cinématographiques" projected to an audience which numbered from 3,000 to 5,000 per show. The spectators watched these "vues" from either side of an enormous, 400-square-meter screen which was made translucent by soaking

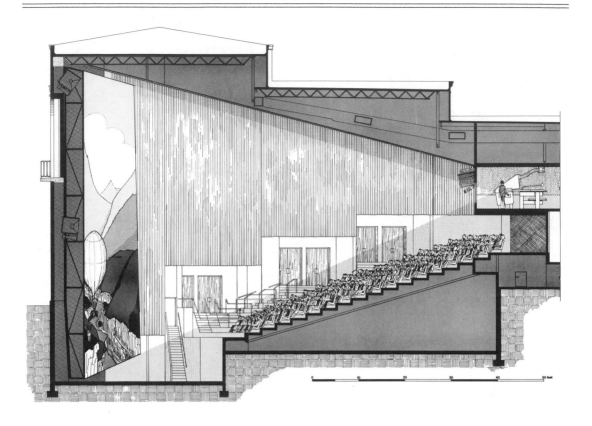

in water between shows and periodically spraying with water jets during the show.[5]

Years later, in 1939, Fred Waller developed a prototype of Cinerama, which he called Vitarama, in conjunction with his development of a mechanism designed to project a mosaic of still pictures for the Eastman Kodak exhibit at the New York World's Fair, where he also served as a consultant for the motion picture installation in the Perisphere.[6] By a strange coincidence, producer Mike Todd, who was later to become involved in the production of the first Cinerama film, was working at the same fair, presenting a shortened version of his Broadway production, *The Hot Mikado,* in the Hall of Music.[7] Though Waller the do-it-yourself inventor and Todd the showman did not meet until years later, the crossing of their paths at the fair retains symbolic significance.

The history of multiscreen or large-screen motion picture formats could be written on the backs of a succession of world's fair ticket stubs, from the Chicago Exposition of 1893 and Paris Exposition of 1900 to the Brussels World's Fair of 1958, where Disney's Circarama was introduced, and the Seattle World's Fair of 1962, which featured "Spacearium," a 70mm Cinerama-like process in which images shot with a fisheye lens were projected onto a huge curved dome, filling an angle of view of 360 × 160 degrees. This history would extend from Expo '67 in Montreal, which boasted a 360-degree projection system, a 70mm multiple-image device, and a 35mm mosiac of vertical and horizontal images, to Expo '70 in Osaka, which featured the Imax process; and from the recent world's fairs in

TYPICAL OMNIMAX THEATER (COURTESY OF IMAX CORPORATION).

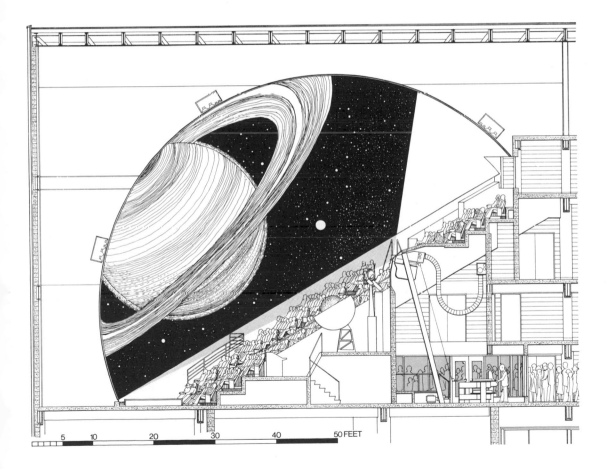

Vancouver and Tokyo, where Showscan was premiered, to Expo '85 in Tsukuba, Japan, where a black-and-white Omnimax 3-D system premiered, Expo '86 in Vancouver, Canada, where Imax 3-D was demonstrated, and Expo '90 in Osaka again, where both Imax Solido (a full-color, wrap-around, 70mm 3-D system) and Imax Magic Carpet (a two-projector, two-screen, 70mm process) were unveiled.[8] The last system consists of two Imax projectors and two Imax screens—"one in front of the audience and the other, visible through a transparent floor, underneath," which gives audiences the illusion that they are floating in space, "like the magic flying carpet of Arabian Nights."[9]

Fairs, amusement parks such as Disneyland and Walt Disney World (which contain Circlevision and 70mm 3-D systems), national parks, museums, planetariums, and other tourist sites continue to serve as venues for special presentations of motion pictures. Indeed, today there are over ninety Imax and Omnimax theaters alone, located in museums, city center developments, tourist destinations (such as the Grand Canyon), and leisure parks.[10]

World's fair exhibits typically present displays of a country's latest technological developments in science or industry through the use of entertainment programs designed to showcase its artistic achievements as well. These fairs serve as both trade shows and forums for individual nations to use in propagandizing their overall cultural progress. Motion pictures in general have long been regarded as a means of either direct or indirect propaganda, ranging from Sergei Eisenstein's didactic lessons in Russian history and Leni Riefenstahl's epic paeans to Nazi power to the (supposedly) more subtle American agitprop of Frank Capra and others. But large-screen motion pictures in particular have become associated over the years with the promotion of national identity either through their origins as exhibits in national pavilions at world's fairs or through their inherent ability to convey certain kinds of subject matter.

Though not developed for a world's fair, Abel Gance's multiscreen process suggests one way in which widescreen has lent itself to ideological purposes. In 1926–27 Gance developed the three-screen system known as Polyvision in an attempt to create a canvas large enough to convey the epic nature of his subject matter—Napoleon. His hero, in turn, is integrally linked to the identity of the nation as a whole. Gance's triptych screen not only draws upon (Catholic) religious numerology to deify his hero but recalls the French

flag—the tricolor—as well. This allusion is driven home by the use of red, blue, and "white" tinting in adjacent panels of the triptych at certain moments in the film.[11] The shape of the film echoes its content, and the dramatic changes in shape from one to three screens, which Gance orchestrates at crucial moments in his narrative, mirror the explosive energies of both Napoleon and France. (Unfortunately, the video version of the film, though retaining the triptych, reduces it in size, optically zooming out to the letterbox format to accommodate the three panels within the same space initially occupied by one. This reduction in image size reverses the impact of the sudden shift to three screens in the original version.)

CINERAMA AND IDEOLOGY

Initially a medium for documentary travelogues, Cinerama is similarly an overt agent of ideology, functioning as a means of displaying the scenic wonders of America to both domestic and foreign audiences. For example, the initial half of the first Cinerama film, *This Is Cinerama*, takes its audience on a whirlwind tour of Europe, which is interspersed with an aerial view of Niagara Falls in which "you experience the unique thrill of hanging in space over [this] great natural wonder" and a performance of Handel's *Messiah* by the Long Island Choral Society.[12] In Europe, the audience is treated to ballet at La Scala, a gondola ride in Venice, the gathering of the clans (complete with bagpipers) in Scotland, a bullfight and flamenco dancing in Spain, and the Vienna Boys' Choir, returning to La Scala for the finale from act 2 of *Aïda*.

After the intermission the film shifts its attention to the United States, including in its itinerary a tour of Florida's Cypress Gardens. *This Is Cinerama* concludes with a sequence patriotically titled "America the Beautiful," which consists of aerial views of the United States from New York City to California. "Never," wrote Hedda Hopper, "has any other medium so caught America in all its beauty, true greatness, and glory."[13] "I thought I had seen everything there was to see across America," said Lowell Thomas, "but Cinerama changed my mind. Here is America as *no one* has seen it . . . Here is an America that only Cinerama can picture and bring to you."[14] Hedgehopping across "fruited plains" and "fields of grain," the Cinerama camera, mounted in the nose of stunt pilot Paul Mantz's B-25, fetishizes the American landscape, climaxing its erotic fas-

cination with it by barnstorming through Bryce Canyon, Yosemite, the Grand Canyon, and Zion Canyon in Zion National Park. The patriotic strategy paid off—for one viewer at least. The *New York Times* reported that President Eisenhower "sang aloud the words of 'America the Beautiful' and 'The Battle Hymn of the Republic' as the music was played during the motion picture."[15]

Cinerama Holiday (1955) followed a somewhat similar format, interspersing a European couple's tour of America with an American couple's trip to Europe. From aerial footage of the Alps and bobsled racing in St. Moritz, the film cuts to gambling in the Desert Inn in Los Vegas, modern-day Apaches in Arizona, and a train trip, seen from the Vista-Dome of the California Zephyr, east to Chicago.[16] The film concludes with a dazzling Fourth-of-July-style fireworks display at Alton Bay, New Hampshire, which is intercut with the "fires of a giant Bessemer furnace of the Bethlehem Steel Company."[17]

A few months after the opening of *This Is Cinerama* its producer, Lowell Thomas, predicted its value as an instrument of American propaganda.[18] In 1955 newspaper columnist Hazel Flynn reported that "Cinerama has been entered in the *Congressional Record* as being an important instrument through which the American way of life is illustrated to other nations. It has been presented by the State Department to refute the communists' appeal in other lands. Among these showings was one in Damascus, Syria, and Bangkok, Thailand."[19]

The Cinerama installation at the world trade fair in Bangkok in early 1955 proved enormously popular among visitors to the U.S. exhibit and was credited with securing first place for the United States in exhibit competition there. Cinerama enabled the United States to defeat the rival exhibit of the Soviet Union, which *Life* charged had been "using the world's trade fairs to peddle its politics with exhibits that are shrewd mixtures of commerce and propaganda."[20] Thus large-screen cinema, as an index of technological prowess, became an unlikely participant in the Cold War. Like other inventions, it became a site for polemical confrontation. Not only did the Russians claim priority in inventing Cinerama, CinemaScope, and other widescreen systems, but they also fought back in the marketplace, developing a three-strip process called Kinopanorama which was used to film the glories of the Russian landscape in a film titled *Great Is My Country* (1957), which won the Grand Prize at the Brussels World's Fair in 1958, three years after the defeat in Bangkok.[21]

CINERAMA AS TRAVELOGUE

Walt Disney's eleven-camera Circarama system, which initially featured views of American landscape, has evolved, over the years, into the nine-camera Circle-Vision system, which was used to photograph similarly nationalistic odes to the United States—*America the Beautiful* and *American Journeys* (which recently shared the bill at Disneyland with *Wonders of China*, a film celebrating an American ally against the Soviet Union in the 1980s, when Russia was still "the evil empire"). Designed for use in Marriott's Great America theme parks (and elsewhere), Imax has followed suit, producing, among other titles, *An American Adventure* (1981), which takes its audiences surfing in Hawaii, bronco riding in Florida, and boating through the Okefenokee Swamp; and *The Dream Is Alive* (1985), which documents the voyage of an American space shuttle, filmed by NASA astronauts during three 1984 shuttle missions.[22]

In looking at the rest of the world (or universe, in the case of the NASA film), whether from the apex of a Cinerama arc or from the center of Circarama/Circle-Vision circle, whatever the spectator sees is *seen through an American perspective*, which reduces everything to stereotypes. *This Is Cinerama* renders Italy through opera at La Scala in Milan and Scotland through a parade of bagpipes. In *Cinerama Holiday* the world takes shape through the eyes of a typical American couple, John and Betty Marsh of Kansas City, whose sightseeing takes them to familiar tourist traps, and through the eyes of a European couple, Fred and Beatrice Toller, whose holiday in America consists of "many of the things that make up a European's dream of America."[23] For its stars, the film's producers sought representative American types; they stipulated that the central couple must be from the Midwest, must never have been to New York (much less Europe), and must never have seen Cinerama—a lack of experience which ensures both their naïveté and their essential Americanism. Their holiday ends in New York, where both couples "see Cinerama for the first time."[24] In this way, they live out the fantasies of a typical would-be Cinerama spectator.

The Seven Wonders of the World (1956) visits such clichéd sites as the Taj Mahal, the Leaning Tower of Pisa, St. Peter's in Rome, the Parthenon, the Sphinx, the Pyramids, Mt. Sinai, the Hoover Dam, the Grand Canyon, and Niagara Falls, providing a compendium of exotic locales whose "interest" consists chiefly in their programmatic nature as requisite items on a

travel agent's agenda for what humorist Mark Twain might refer to as "innocent" Americans abroad. By the same token, Circle-Vision's *Magic Carpet around the World* and *Wonders of China* are about as perceptive of exotic foreign cultures as a James Bond movie.[25]

It is no accident that the first five Cinerama features were American-oriented travelogues.[26] The Cinerama medium is ideally suited to the "nature" documentary and the sightseeing excursion. Cinerama's celebrated "participation effect," whereby the audience has the sensation of entering into the world depicted on the screen, would even seem to realize the basic fantasy which underlies tourism and which is succinctly articulated in the famous motto of Cook's Tours—"The World Is Yours." And even though subsequent Cinerama films, such as *How the West Was Won* (1962), *It's a Mad, Mad, Mad, Mad World* (1963), and *2001: A Space Odyssey* (1968), turn from episodic travelogue to the more traditional narrative format of Hollywood films, they never quite rid themselves of Cinerama's Original Sin—its essential affinity for the episodic and the picaresque and its fascination with journeys and various means of locomotion. These fiction films still rely heavily on the travelogue format, as the "Odyssey" subtitle of *2001* attests.

Beneath a thin veneer of storytelling lie the thrills and chills of Cinerama of old. *How the West Was Won* features frontier-era "roller coaster" rides as pioneers raft through treacherous rapids and struggle amid buffalo stampedes. The subjective Cinerama camera looks out from within covered wagons that turn over and from atop careening trains. In *The Wonderful World of the Brothers Grimm* (1962), the camera, mounted in a large steel drum framework resembling an enormous squirrel's cage, rolls down a steep hill, simulating actor Russ Tamblyn's point of view as he falls, tumbling head over heels downhill. The "star-gate" sequence in *2001*, a theme-park-like "wild celestial ride through a series of galaxies that create a psychedelic effect on [the central character] and the audience," marks the culmination of the medium's exploration of its participatory aspects.[27] Cinerama's penchant for wraparound stimuli which plunge spectators into the midst of a viscerally provocative experience continues to be an integral element of its appeal, surviving from its earlier fairground identity as an "attraction" into its later phase as narrative spectacle.

The Cinerama effect looks back to the participatory quality of the first actuality films projected on a large screen. In their reviews of *This Is Cinerama*, both *New York Times* critic Bosley Crowther and *American*

Mercury essayist Milton Klonsky compared Cinerama with the first large-screen projection of motion pictures at Koster and Bial's Music Hall in 1896, when shots of sea waves rolling in on a beach supposedly sent naive viewers running for cover.[28] Other reviewers spoke of Cinerama as if they were seeing motion pictures for the first time.[29] Cinerama recaptured the *experience* of those early films and restored affective power to the motion picture. During Cinerama's aerial sequences, audiences are said to have "leaned sharply in their seats to compensate for the steep banks of the airplane. Others became nauseated by their vicarious ride in a roller-coaster. Still others ducked to avoid the spray when a motor boat cut across the path of the canoe in which they were apparently riding."[30] Even veteran airmen reacted to Cinerama's illusion of reality. Lowell Thomas reports that war ace Gen. James Doolittle clutched his chair when stunt pilot Paul Mantz flew through the Grand Canyon. Drugstores near the Cinerama theater in New York did a landoffice business during intermission, selling dramamine to spectators who either became airsick in the first half or wanted to prepare themselves for the film's finale.[31]

The concept of Cinerama looks back even further than 1896, when filmed images were first projected on a screen. As the names which Waller chose to call his system at various stages suggest, "Vitarama" and "Cinerama" recall much earlier inventions—the panoramas and dioramas of the late eighteenth and early nineteenth centuries. With the Panorama, which was patented by Robert Barker in 1787, circular or semicircular views painted on a 16-foot-high canvas revolved slowly around spectators seated at the center of an enclosed rotunda approximately 45 feet in diameter.[32] In the Diorama, developed by J. M. Daguerre and C. M. Bouton in 1822, the audience, seated in a cylindrical auditorium, moved around a large station-ary transparent picture measuring as much as 71 × 45 feet; various visual effects were produced through a manipulation of the light behind the painting.[33] The success of these spectacles gave rise to a host of other "sights" or "ramas," including the Betaniorama, the Cyclorama, the Europerama, the Cosmorama, the Giorama, the Pleorama, the Kalorama, the Kineorama, the Poecilorama, the Neorama, the Nausorama, the Octorama, the Physiorama, the Typorama, the Udorama, and the Uranorama.[34]

Cinerama's connection to these earlier spectacles is more than etymolog-ical.[35] The content of Cinerama travelogues resembled that of the views provided by various Panoramas and Dioramas. Barker's first Panorama

displayed the English fleet at anchor between Portsmouth and the Isle of Wight.[36] Subsequent panoramas exploited the potential for spectacle implicit in tableaux of battles and landscapes, ranging from a *View of London, Lord Howe's Naval Victory over the French, The Battle of Aboukir, The Environs of Windsor* to "Views" of Vienna, Paris, Amsterdam, and other cities.[37] Appropriating the device to celebrate the Third Republic's imperialist endeavors overseas, French panoramas sought to familiarize that nation's citizens with new, distant and exotic French colonies, such as the Congo and Madagascar.[38] Other French panoramas took the form of travelogues, featuring a forty-five-minute journey by train across Siberia, a Mediterranean voyage from Marseilles to Constantinople, and tours of Rome, Indochina, Monaco, and other sights.[39]

LIMITATIONS

Like the early panoramas and dioramas and like the "actualities" which dominated early film production, Cinerama presented documentary-style spectacles rather than narratives. In fact Cinerama initially had difficulty telling stories. Crowther suggested that "the very size and sweep of the Cinerama screen would seem to render it impractical for story-telling techniques now employed in film."[40] Traditional close-ups were impossible, given its lens technology. Cinerama relied on three 27mm lenses, mounted at angles to one another. The use of extreme wide-angle lenses resulted in noticeable distortion which was magnified in close-up cinematography. Unlike the single focal length required by Cinerama, traditional motion pictures employed a variety of lenses. The optical restriction in the focal length of Cinerama lenses further reduced the medium's options, denying it what Bosley Crowther referred to as the basis of narrative cinema— "flexibility of the images and the facility of varying the shots."[41]

Scenes staged before the Cinerama camera also proved hard to light, given the extreme angle of view covered by the three 27mm lenses. Standard backlighting techniques were impossible to implement across the expanse of three images, and unless cinematographers lit scenes neutrally for all three lenses, the resultant three-panel image was likely to possess three different light directionalities: in one panel there might be a strong backlight; in another, direct crosslight; and in the third, flat, directionless light.[42] Since traditional Hollywood narrative technique relied heavily upon the control of light to shape the mise-en-scène and to convey certain narrative

information, the flat lighting setups necessitated by Cinerama severely restricted any narrative role which lighting might play. Early, three-strip Cinerama also avoided panning shots, which tended to reveal the system's "blend lines," that is, the points where the three images met.[43]

Without the close-up, which had become the linchpin of classic Hollywood narrative, and without highly expressive lighting or panning capability, the Cinerama medium was virtually forced to choose the travelogue as its presentational format. Yet Cinerama publicists made a virtue of these limitations. In the program booklet to *This Is Cinerama* producer Lowell Thomas informed readers that, in making the film, he decided not to let subject matter get in the way. He announced that there would be no central story or star; instead, he wanted "to make Cinerama the hero."[44] Years later, in promoting *The Search for Paradise* (1957), the film's publicists proclaimed that the Cinerama medium was too big to concern itself with mere plot and character. "Plot," they suggested, "is replaced by audience envelopment—there is something that makes the excitement of going places and participating in adventure more than enough . . . the medium forces you to concentrate on something bigger than people, for it has a range of vision and sound that no other medium offers."[45]

THE CINERAMA PHENOMENON

Cinerama resembled early cinema not only in its stylistic simplicity but in other ways as well. Like early cinema, Cinerama was a social phenomenon. Much as the advent of projection transformed the cinema from an individual, privatized experience into a public experience, Cinerama transformed the traditional movie theater into a revitalized site for shared experience in which viewers gained a heightened sense of their own participation in a mass phenomenon, aware of the screams, gasps of astonishment, and oohs and ahs of their fellow spectators. Unlike conventional narrative cinema, Cinerama was not so much passively "consumed" as it was actively experienced; or, as inventor Fred Waller put it, Cinerama was "not a child of motion pictures but a brand new form of entertainment."[46] In other words, it became not so much something people saw as something they *did*.

As a social phenomenon, it both reflected and generated popular culture as a whole; in fact, it served as a remarkable index of postwar leisure-time activities. Cinerama's travelogue format, for example, not only took advantage of Americans' increased interest in domestic sightseeing and travel

abroad but functioned itself to stimulate tourism. The *New York Herald-Tribune* reported that

> almost immediately after the New York premiere, transcontinental airlines began to report requests for flights that "go over those canyons" seen in Cinerama. The British Travel Bureau was flooded with inquiries about the date of the Rally of Pipers, which is featured in the film. So many people asked the State Tourist Office of Italy about the festival of Venice that a painting depicting the scene in the film was installed in the office window . . .
>
> Closer to home, the roller coaster at Rockaways' Playland, which provides the first sensation in the film, did a record-breaking business all last winter, when amusement parks are generally deserted and a huge billboard proclaiming it as the star of Cinerama helped make it the most popular attraction on the midway. Cypress Gardens in Florida . . . reported that the number of visitors jumped 40 per cent after Cinerama was released.[47]

Sam Goody, a New York phonograph record retailer, noted a sharp increase in demands for music featured in the film, ranging from Verdi's *Aïda* and Handel's *Messiah* to the Vienna Boys' Choir recording of *Tales from the Vienna Woods*.[48] The Cinerama craze even influenced other entertainment forms: soon after the opening of *This Is Cinerama* a burlesque stripper began to bill herself as the "Sinerama Girl."[49]

Like the sights seen in its films, Cinerama itself became a tourist attraction. Cinerama advertising capitalized on its own status as one of the seven wonders of the modern world, suggesting to the midwestern populace that "when you visit Detroit, Cinerama is a must stop." One Texas columnist even confessed that "whoever said it was practically worth a trip to New York to see Cinerama . . . wasn't exaggerating too much."[50] Going to see Cinerama became a special event in itself, like a trip to a world's fair.

THE EXPERIENCE OF CINERAMA

Unlike other consumer wares, motion pictures (and other forms of popular entertainment) provide those who pay for them with an intangible product— with admission to an experience. Spectators come away from the movie theater with only memories of what they heard and saw. Until recently,

CINERAMA
PUBLICITY:
WATERSKIING IN
CYPRESS GARDENS
(AUTHOR'S
COLLECTION).

before films could be purchased on video disc and tape, the average spectator could own neither motion pictures nor the means of their reproduction.[51] Even though the sale of films in today's video market somewhat alters the psychology of this aspect of the motion picture experience, the motion picture remains an experiential phenomenon whose existence continues to be abstract rather than concrete and whose essence cannot be located in any material source. On the cinematic spectrum, Cinerama and other multiple-screen systems constitute the most extreme instances of cinema as pure spectacle, pure sensation, pure experience.

The initial advertising campaign for *This Is Cinerama*, devised by the

CINERAMA
PUBLICITY: AN
INNOCENT ABROAD
IN LA SCALA,
MILAN (AUTHOR'S
COLLECTION).

McCann-Erickson agency, promoted the film as an incomparable motion picture experience. Unlike 3-D and CinemaScope, which stressed the dramatic content of their story material and the radical new means of technology employed in production, Cinerama used a saturation advertising campaign in the newspapers and on radio to promote the "excitement aspects" of the new medium.[52] Cinerama sold itself through appeals neither to content nor to form but to audience involvement. Ad copy promised that with Cinerama "you won't be gazing at a movie screen—you'll find yourself swept right *into* the picture, surrounded with sight and sound."[53] Publicity photos literalized this promise, superimposing images of delighted spectators in their theater seats onto scenes from the film. And while 3-D slowly alienated its audience by throwing things at them, Cinerama drew them into

the screen—and the movie theater—in droves. Despite the absence of story or characters, Cinerama enthralled its customers. *This Is Cinerama*, which cost $1 million to produce, grossed over $32 million, and the first five Cinerama features (all travelogues) grossed $82 million, though they could be seen in only twenty-two theaters.[54]

According to Fred Waller, the inventor of Cinerama, the medium owes its sense of audience participation to the phenomenon of peripheral vision. Waller's own empirical experiments with depth perception led him to conclude that the successful illusion of three-dimensionality derived as much from peripheral as from binocular vision.[55] The three lenses of the Cinerama camera, set at angles of 48 degrees to one another, encompass a composite angle of view of 146 degrees by 55 degrees, nearly approximating the angle of view of human vision, which is 165 degrees by 60 degrees. When projected on a deeply curved screen, this view tends to envelop the spectator sitting in the center of the theater. Stereo sound, broadcast from five speakers behind the screen and from one to three surround horns, reinforces the illusion of three-dimensionality.

FRED WALLER

Though most famous for his development of Cinerama, Waller is also well known as a do-it-yourself tinkerer and inventor. When he was eighteen he developed a photographic timer.[56] Later he assembled a machine that printed, developed, and dried over 1,800 photographic prints in an hour and used this piece of equipment as the basis for a business that supplied motion picture studios with display photos for use in theater lobbies.[57] In the 1920s Waller went to work for Paramount's Special Effects Department, where he developed an optical printer and supervised special effects work.[58] His experimentation with photographic devices extended to the perfection of a still camera that could take a 360-degree picture and of a Photo-Metric camera that could measure a man for a suit of clothes in a fiftieth of a second.[59] Waller also specialized in leisure-time/maritime inventions. He invented water skis (which figure prominently in the Coral Gables sequence of *This Is Cinerama*), a remote recording anemometer for reading wind-velocity statistics from within a ship's cabin, a means of steering and altering ship speed from a crow's-nest, and an adjustable sail battan.[60]

The fifteen-year history of Waller's invention of Cinerama follows a classic

pattern of uneven development, charting a course across several different media (still photography and motion pictures) and through a variety of industrial domains (the armed services, the motion picture industry). Waller's work in special effects photography at Paramount brought him in contact with wide-angle lenses. His investigation of the effects which they produced led to an examination of how illusions of depth are created and how the eye perceives depth. His empirical discovery of the role of peripheral vision in depth perception, confirmed by laboratory experiments in perspective and optical illusion conducted by Adelbert Ames, Jr., of the Dartmouth Eye Institute, led Waller to conclude that he could create a credible illusion of depth through the use of several cameras outfitted with wide-angle lenses; this camera system would be used, in turn, to produce multiple images that could be projected on an extra-wide screen.[61] Waller soon realized, however, that in order to fill the field of human peripheral vision using this arrangement, he would need a screen that was the width of an entire city block.[62] Teamed with architect Ralph Walker, who sought Waller's assistance in designing a motion picture exhibit for the Petroleum Industry's 1939 world's fair display, Waller discovered that, since normal human vision is arc-shaped, he could achieve the desired effect by projecting his muliple images upon a *curved* screen, thus filling the field of peripheral vision within a more theatrically practical space.[63]

Waller and Walker filed patents for a multicamera, multiprojector system and formed the Vitarama Corporation to exploit these patents, but they could not convince their initial sponsors to install the system at the fair, though they continued to work on it under funding provided by Laurence Rockefeller and *Time*.[64] A few years earlier, in late 1937, during preproduction on *Gone with the Wind*, David O. Selznick had learned of Waller's work on the multicamera system for the fair and contemplated using it to film the burning and evacuation of Atlanta.[65] Selznick's production designer, William Cameron Menzies, eventually bypassed Waller and developed a two-camera system of his own, which was used to film the Atlanta fire sequence but which was not used in the final film because of potential problems in outfitting theaters to show it. Selznick feared that "the further delay [of at least two years] that this would mean in the national release of the picture, plus the cost of equipping theatres, was not warranted for the one sequence."[66]

CINERAMA GOES TO WAR

In May 1940 Waller, encouraged by an old friend and graduate of the Naval Academy, began to transform his Vitarama system into an aerial gunnery trainer, which the Army Air Corps, the Navy, and the Marines used during the war to instruct its machine gunners. A direct predecessor of Cinerama, the Waller Flexible Gunnery Trainer consisted of five synchronized projectors which threw a continuous mosaic image of attacking enemy fighters onto a large spherical screen. Using this granddaddy of contemporary arcade and computer games, trainees fired electronic machine guns at diving enemy planes. Elaborate calculations involving air speed and ballistics enabled Waller to predict which electronic bullets would hit their target; these hits were noted by beeps broadcast through individual earphones to the gunners and their instructor, who were thus able to tell immediately whether or not they had scored a hit and which machine-gun bursts had been on target. Previously, gunnery trainees and instructors had had to wait several hours for the towed-sleeve target to land and be examined, and they had had no way of knowing which of their bullets had hit the target. Moreover, Waller's simulated trainer proved to be cheaper—in terms of both money and lives—than traditional flight training. It eliminated the approximately one death during every 6,000 hours of flying time. All in all, Waller's device, which dramatically improved the accuracy of gunners trained on it, was credited with saving an estimated 250,000–300,000 casualties during the war.[67]

After the war Waller turned his gunnery sword back into a cinematic ploughshare. He streamlined the Trainer's five cameras and projectors down to three. He devised a special screen made up of 1,100 vertical strips which were mounted on louvers and angled toward the audience so as to prevent reflected light from one part of the highly curved screen from washing out the image on another part of the screen.[68] Finally, he enlisted the aid of sound engineer Hazard Reeves, a pioneer in magnetic sound recording and striping, who designed the Cinerama's seven-track stereo magnetic recording and playback system. But even with the backing of Rockefeller and Time, Inc., Waller was unable to market his system to the motion picture industry. Repeated demonstrations failed to outweigh major producers' and studios' concerns about the problems that Cinerama's specialized format

posed in terms of traditional motion picture production, distribution, and exhibition practices, which continued to rely on principles of mass rather than specialized marketing.

Though impressed by the Cinerama demo, Nicholas Schenck, President of Loew's, was reluctant to invest in the project, explaining, "Who am I to offer a Rockefeller money? I'll wait and then buy my way in later when I'll probably have to pay double."[69] According to *Fortune*, Hollywood's resis-

tance stemmed from a fear that the adoption of Cinerama would be self-destructive: the system's success "would dilute the value of millions of dollars' worth of 'flat' films in circulation and in Hollywood vaults." Nor, the magazine suggested, could the studios afford the approximately $1 billion it would cost to convert the nation's theaters to show films in Cinerama. Reeves even feared that Hollywood might buy up the rights to the system in order to prevent its successful exploitation by others.[70] Unable to innovate the Cinerama process through normal industry channels, Waller and Reeves decided that the only way to convince Hollywood of the viability of the system was to produce, distribute, and exhibit a Cinerama film independently.

THIS IS CINERAMA

After Rockefeller and Time, Inc., pulled out of the Cinerama venture in 1950, Reeves, who bought up their shares, succeeded in interesting the celebrated radio commentator, lecturer, and globe-trotting journalist Lowell Thomas in the process. Thomas joined the operation and, along with Mike Todd, spearheaded production activities. They formed the Thomas-Todd production company, secured the rights to make the first Cinerama film, and began to raise money to finance production costs.[71] Thomas had initially contracted with Robert Flaherty to direct the picture, but when Flaherty died just before production began, Todd took his place and began filming material, including a helicopter ride over Niagara Falls, the famous rollercoaster sequence, and various sights in Europe.[72] To edit the footage shot by Todd and his son, Thomas brought in producer Merian C. Cooper, who, together with television executive Robert Bendick, shot the Cypress Gardens sequence and produced the "America the Beautiful" section, replacing Todd, who had by this time alienated Thomas and Cinerama's board of directors.[73] (Todd did not officially sever his association with Cinerama until August 1952.)[74]

When *This Is Cinerama* opened at the Broadway Theatre in New York on September 30, 1952, the response of the public and the press was unprecedented. Both audiences and critics raved about the new process. For the first time in its history, the *New York Times* ran a story about film on the front page, celebrating the opening of Cinerama as the start of a new era in motion picture exhibition. The Associated Press pulled its regular

Sunday feature for a story about Cinerama; Macy's Department Store placed an ad in the newspapers praising the process; both the *Journal-American* and *Commonweal* touted it as "the most important step in motion picture history since sound."[75] The film proved to be an instant success, prompting critics to invoke it as a standard against which to measure all other productions and would-be spectators to wait in lines for hours to buy tickets.[76]

The success of *This Is Cinerama* did not, however, result in an industry-wide conversion. The new process was not adopted by a major studio until ten years later, when M-G-M negotiated with the system's current owners

to shoot two feature-length narrative films—*How the West Was Won* and *The Wonderful World of the Brothers Grimm*—in Cinerama. Former M-G-M studio head Louis B. Mayer became chairman of the board of Cinerama Productions a few weeks after the New York premiere of *This Is Cinerama*, bringing with him the rights to the Broadway musical *Paint Your Wagon* (which was not made until 1969, when it was filmed in Panavision not Cinerama) and several other properties.[77] Mayer left the Cinerama organization in November 1954 without having produced a feature.[78] In October 1952 Merian C. Cooper announced that his former Argosy Productions business partner, John Ford, would direct the second Cinerama feature, which was reported to be a Civil War epic (and which Ford finally did make a decade later—in the form of the Civil War sequence in *How the West Was Won*).[79] Indeed, Cinerama, plagued with what *Variety* called "intra-company wrangling and other complications," failed to take advantage of its initial success and was unable to release a second feature until 1955, when Louis de Rochemont's *Cinerama Holiday* opened.[80]

THE ECONOMICS OF CINERAMA

Dissension in the upper echelons of the Cinerama organization proved to be one obstacle that slowed its innovation and diffusion within the industry; a shortage of capital proved to be another, preventing its backers from financing future productions and additional theater conversions—problems which were not solved until the more heavily capitalized Stanley Warner Theater Circuit bought into the operation in the summer of 1953, enabling the company to begin planning production for the second Cinerama feature.[81] Even after this, Cinerama remained stalled because of problems relating to cash flow, which was limited to revenues generated by only four theaters (located in New York, Los Angeles, Detroit, and Chicago).[82] Almost a year later, when there were ten theaters in operation, *Variety* reported that theater operating expenses consumed about 50 percent of the total box-office gross of $200,000–250,000 per week.[83] Many of Cinerama's financial problems had their origins in the system's complex exhibition technology. As a special-event, showcase process, it was limited to a handful of large theaters in urban areas. Even its own designers put a limit on its potential diffusion, predicting that Cinerama films would eventually play in a maximum of only 200 theaters.[84] As late as 1959 there were only 22 theaters

equipped to show Cinerama; after an aggressive expansion campaign in the early 1960s, this figure rose to 95 worldwide by the mid-1960s.[85] During the mid-1960s Cinerama launched a theater-building program, using Buckminster Fuller's geodesic dome design; coordinated with the system's entry into narrative film production, construction of over 600 of these new, inexpensive ($250,000) dome theaters was planned; fewer than 30 were ever built.[86] (In contrast, by the end of 1956 there were over 41,000 CinemaScope installations around the world.)

Diffusion of the process was also hampered by the fact that Cinerama films could be shown only in Cinerama theaters and could not be subsequently played off in any of the roughly 20,000 other theaters in the country. Films made in Cinerama were shot and projected at twenty-six frames a second rather than at the standard twenty-four; even if its tryptich image could be squeezed onto 35mm, this variation in projection speed would make it impossible for distributors to adapt Cinerama features for conventional commercial exhibition. In fact when M-G-M became involved with Cinerama in the early 1960s, it did so only after the Cinerama organization agreed to change the film speed to twenty-four frames per second so that *How the West Was Won* and *The Wonderful World of the Brothers Grimm* could be reduced after playing in Cinerama theaters to a 35mm anamorphic format and played in standard exhibition sites.

Three-strip Cinerama remained rather expensive as a production format, requiring slightly more than three and a half times as much negative film as a standard 35mm production (whereas standard-format 35mm film was four sprocket holes high, each Cinerama frame was six; a fourth strip of 35mm film, carrying the stereo soundtrack, was required at the distribution and exhibition stages).[87] Cinerama also proved expensive as a means of exhibition. The installation of Cinerama in a theater cost, according to various estimates in the trade press, from $75,000 to $140,000.[88] At the same time, the construction of a separate booth for each of its three projectors (as well as an additional sound control booth) intruded on the space of the auditorium and forced a reduction in the overall number of seats. (Cinerama required head-on, orchestra-level projection to minimize distortion; only the black-and-white narrow-screen 35mm prologue which accompanied all the travelogue features could be projected from existing balcony booths.)[89] New York's Broadway Theatre lost 300 of its 1,600 seats during the conversion process.[90] In one Los Angeles theater, the installation

of Cinerama resulted in the loss of almost 1,300 seats (seating fell from 2,756 to 1,468), which were more seats than most theaters at the time possessed (the average number was 750).

However, the chief limiting factor in the economics of Cinerama was not the one-time expense of theater conversion or the loss of seats but the constant increase in labor costs that it introduced. As noted above, Cinerama's operating expenses ate up around 50 percent of the gross.[91] Cinerama required the full staffing of three projection booths, of a booth containing a picture-control engineer, and of an additional sound control booth where an engineer oversaw the playback of the seven-track stereo magnetic sound.[92] At the Broadway Theatre, seventeen projectionists were required to put on a Cinerama show. It is no wonder that Roy Brewer of the International Alliance of Theatrical Stage Employees (the union which represented projectionists) praised Cinerama as the film industry's solution to the threat of television. At a time when theaters were closing at the rate of three a day,[93] it provided new jobs for his recently unemployed membership.[94] These additional costs stood in the way of any expansion of the process. The opening of the Cinerama theater in Chicago was delayed for several months as a result of union demands for a full staff of seventeen projectionists at an increased pay rate of $7.15 per hour; the union later settled for twelve operators.[95] Overseas expansion was similarly delayed. *This Is Cinerama* did not open in England until October 1, 1954, two years after its New York premiere.[96]

TROUBLED TECHNOLOGY

Cinerama was not only expensive but technically flawed.[97] The seams where the three images joined were distractingly visible, and variation in projector illumination frequently accentuated this effect. Even those involved with promoting Cinerama were aware of certain defects in the system. Mike Todd, for example, complained to Waller and others about the optical distortion of horizontal lines in the side panels.[98] After filming a scene on the steps of the Schonbrunn Monument in Vienna, Todd's son noted that when he saw the sequence projected, "the wings of the monument in the side panels were distorted downwards at the seams," making it resemble the then-new TWA terminal at New York's Idlewild (JFK) airport.[99]

Studios which had passed over Cinerama years earlier when Waller and

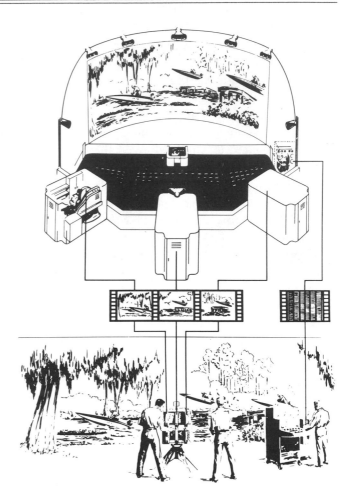

Reeves were trying to market it justified their original decision and pointed to inherent problems which had still not been solved. In a long report to his superiors Fox engineer Lorin Grignon complained of "inherent picture distortion," noted that there was only "a very limited area of seats where the visual effects are best," and advised that "the technical difficulties of identical projection from three separate machines and three separate prints all in exact register are extremely hard to surmount."[100] Projectionists

encountered difficulty in keeping horizontal lines straight; operators in the right and left booths had to ride the frame knob in order to keep the right and left images in perfect lateral synchronization.[101] Though Waller had developed a vibrating comblike device called a "gigolo" to blur the blend lines in projection, the lines between each of the three panels remained quite visible, and Cinerama cameramen struggled to compose shots in such a way as to help conceal them. At the same time, screen brightness varied from panel to panel, depending on the exact color temperature of the arc lamp in each of the three projectors.[102] The multitrack stereo sound also tended to vary from show to show because its seven tracks were "mixed" differently during each projection of the film by an engineer in the sound control booth.[103]

The various problems involved in three-strip Cinerama took over ten years for the Cinerama organization to solve, though other companies arrived at solutions considerably earlier--most notably with Fox's innovation of CinemaScope in 1953 and Michael Todd's introduction of Todd-AO in 1955, which initiated subsequent developments in the 70mm format. (In the interim Cinerama solved certain problems through its acquisition of the Cinemiracle system in 1960, which permitted Cinerama to reduce the visibility of the blend lines and to project three-strip Cinerama from a single booth, thus decreasing theater installation costs and improving the coordination of projection activities.)[104] By June 1963 Cinerama had shifted from multistrip mosaic photography to Ultra Panavision, which put all visual and aural information onto a single strip of film. Ultra Panavision was a wide-film system utilizing a 65mm negative film and a slight anamorphic compression of 1.25:1, which enabled it to duplicate Cinerama's original aspect ratio and angle of view without three separate film strips and thus without the presence of annoying vertical lines dividing the image into thirds. At the same time, it permitted the use of a greater variety of lenses and reduced the distortion produced by the original battery of 27mm lenses. Introduced with the release of United Artists' *It's a Mad, Mad, Mad, Mad World* in November 1963, Ultra Panavision enabled both showcase exhibition in 70mm in Cinerama theaters and standard exhibition by printing down to 35mm CinemaScope.[105] However, single-strip projection resulted in a diminished aspect ratio and failed to achieve the participatory effect of three-strip Cinerama.[106]

THE DEMISE OF CINERAMA

Cinerama's entry into narrative film production and its shift to a single-strip wide-film format succeeded only in depriving the process of its unique identity in a highly competitive field of specialized roadshow exhibition. Though it survived the turmoil of the widescreen revolution of the 1950s, Cinerama in the mid-1960s was no longer Cinerama. It lost its exclusive association with the travelogue spectacle and now relied on technology that had been developed by others and that was being exploited by a number of other production companies. Though the Cinerama name continued to exert considerable influence as a drawing card at the box office, Cinerama's productions after *How the West Was Won* and *The Brothers Grimm* were essentially no different from the standard roadshow fare of the period (though they were shown on huge curved screens in Cinerama theaters). They consisted of works such as *Circus World* (Super Technirama 70, Paramount, 1964), *Battle of the Bulge* (Ultra Panavision, Warner Brothers, 1965), *The Greatest Story Ever Told* and *The Hallelujah Trail* (Ultra Panavision 70, United Artists, 1965), *Grand Prix* (Super Panavision 70, M-G-M, 1966), *Khartoum* (Ultra Panavision, UA, 1966), *Custer of the West* (Super Technirama, Cinerama Releasing Corporation, 1968), *2001: A Space Odyssey* and *Ice Station Zebra* (Super Panavision 70, M-G-M, 1968), *Krakatoa, East of Java* (Super Panavision 70, Cinerama Releasing, 1969), and *Song of Norway* (Super Panavision 70, Cinerama Releasing, 1970). Even the most notable of these productions, *2001*, did little to revive interest in Cinerama; indeed, while reviewers praised the film's Super Panavision photography in 70mm, they found fault with its projection in Cinerama on a deeply curved screen.[107]

The demise of Cinerama began in 1960, when Hazard Reeves sold his shares of Cinerama, Inc. to financier Nicholas Reisini. Though Reisini successfully negotiated Cinerama's transition to Hollywood narratives, his failure to consolidate his gains led to the sale of Cinerama, Inc. in 1963 to William R. Foreman, the owner of a West Coast theater chain.[108] In 1967, several months before the release of *2001*, the Cinerama organization began to diversify, setting up the Cinerama Releasing Corporation (CRC), which produced and distributed standard widescreen and anamorphic 35mm films (including such titles as *For Love of Ivy* and *Hell in the Pacific*) as well as a handful of Super Technirama and Super Panavision 70mm titles.[109]

Cinerama, Inc. survived until the mid-1970s, when accumulated debt forced Foreman to call a halt to Cinerama's operations. Cinerama, Inc. was liquidated in May 1978, and its theaters were taken over by the Pacific Theaters circuit (also owned by Forman), which currently uses the Cinerama, Inc. name.[110]

Cinerama-like systems survive today chiefly in theme parks like Disneyland, which themselves share the medium's goal of plunging spectators into an illusory reality. Cinerama itself entered this field through its development of a new lens, possessing an angle of view of 360 by 160 degrees, which was used in the Spacearium, the U.S. Science Exhibition at the Century 21 Seattle World's Fair in 1961–62, in a film which simulated a space flight from Earth to Saturn and back.[111]

Though Cinerama as such no longer exists, contemporary commercial cinema remains in its debt, not only in terms of its continued reliance on widescreen formats but also in terms of its transformation of the mainstream motion picture into an "event," into an attraction which would draw spectators out of their houses, away from their TV sets, and back into the theater. In this respect, the cycle with which Cinerama--and the cinema--began has come full circle. Born at the fair, the cinema returned to it for its own regeneration in the 1950s, transforming standard, "flat" motion pictures into illusionistic, three-dimensional roller-coaster rides. During the 1970s, at the end of an era of blockbuster roadshows, Hollywood turned again to the notion of the cinema as an event, leading to what critics of the Lucas-Spielberg fantasy-adventure format called a "rollercoaster ride" cinema.[112] Raised in 1950s California on Disneyland fantasies, George Lucas produced films that curiously resembled Disneyland rides, designed to generate thrills almost programmatically.[113] Though a latecomer to southern California, Steven Spielberg seemed to have been bitten by the same bug. Taken together, *Jaws*, the *Star Wars* films, *Raiders of the Lost Ark*, and *E. T.* heralded a new era in mass-market consumer-oriented entertainment, complete with Disney-like marketing tie-ins. Indeed, it comes as no surprise that Lucas and Spielberg have collaborated on the design of a Disneyland ride called "Star Tours," nor that their 70mm 3-D Michael Jackson film, *Captain EO*, has become one of the most popular attractions at Disneyland and Disney World. The final turn of the wheel, begun by Disney himself in the mid-1950s when he based rides on his earlier films, appears in Universal Studios' exploitation of recent films such as *Jaws*, *Earthquake*, and

King Kong in rides at its theme parks in California and Florida and in the entry of other Hollywood studios into the theme park business.[114] Fairs give rise to films, and films, in turn, help to produce a new generation of theme parks. What keeps the wheel turning is the shared identity of the cinema and the fairground as highly participatory entertainment experiences--an identity which the advent of Cinerama enabled the cinema to recapture.

Though Cinerama remained true to its fairground origins, it also inspired other widescreen systems, such as CinemaScope and Todd-AO, which attempted to transform the novelty of Cinerama into a norm, suitable for both mass production and mass consumption within the existing practices of the film industry. It is to these systems that we owe the survival of the widescreen revolution in the contemporary motion picture marketplace.

CinemaScope:
A Poor Man's Cinerama

Unlike Cinerama, which was invented and innovated outside the motion picture industry itself—and which, for this and a variety of other reasons, was never successfully diffused into that industry—CinemaScope was a product of the industry, forged within its highly competitive and often chaotic marketplace. Cinerama virtually leaped from the laboratory to the Broadway Theatre, and it underwent little adaptation to meet the requirements of current motion picture production, distribution, and exhibition practices. Indeed, as far as the needs of the industry were concerned, Cinerama did not really begin its innovation stage until ten years after its initial introduction, when it began to adapt itself for narrative film production in 1962–1964 and reemerged in the form of Ultra Panavision. Although various aspects of the CinemaScope process were invented earlier and elsewhere, the system as a whole was the product of a major motion picture studio—Twentieth Century–Fox—caught up in the turmoil of an industry-wide financial crisis and self-redefinition. Forces within the industry shaped its reinvention (by Fox engineers), innovation, and diffusion. But these forces were as often in conflict as in concert, resulting in a final product that was clearly marked with the scars of its own development process. Whereas Cinerama was conceived and developed in something of a vacuum, CinemaScope came into being on the battleground of intra- and interstudio politics. The final form of the process, which evolved dramatically over the first eighteen months of its innovation in response to these shifting needs and conflicting pressures, was a product of struggles within Fox itself (between its management and stockholders and between its executives and engineers) and within the industry as a whole (between Fox and other studios and between Fox and small, independent exhibitors).

Responses to Cinerama

CinemaScope owes its existence, in large part, to the phenomenal success of *This Is Cinerama*, which ran for more than 122 weeks and grossed over

$4.7 million in its initial New York run alone, and which demonstrated to an economically troubled film industry that considerable popular demand existed for a new kind of motion picture entertainment.[1] Industry responses to Cinerama varied, depending upon the status (major or minor) of the individual studio and its willingness or ability to finance potentially costly technological innovation. A handful of independent producers, among them Sam Goldwyn, and one or two smaller studios, including United Artists (which had distributed *Bwana Devil* in 3-D) and Republic, reaffirmed their commitment to the production of "quality" films in the traditional format, insisting that all the industry needed was good films not gimmicks.[2] But the rest of the industry, led by four of the five majors (M-G-M, Warner Brothers, Twentieth Century–Fox, and Paramount; RKO, under Howard Hughes, was on the verge of going out of business and played only a minor role, though it did produce a number of films in 3-D) immediately joined the widescreen revolution launched by the introduction of Cinerama. These studios began to produce and release films that, if they did not exactly duplicate the Cinerama experience, at least visibly differed from previous motion picture fare.

3-D AND NOT 3-D

Although the nomenclature created considerable confusion among industry outsiders, new production and exhibition processes, including Cinerama and CinemaScope, were generically referred to within the industry as "3-D." This marked an attempt to distinguish them from the earlier 1.33/7:1 standard, which the industry and the trade press now referred to as "2-D" or "flat." However, many of these new "3-D" systems, such as Cinerama and CinemaScope, were merely widescreen processes and did not rely upon "true" (binocular) stereo photography. Fox initially represented Cinema-Scope in its press releases as a 3-D process in an attempt to distinguish its new product from traditional flat films as well as to exploit the current interest in "genuine" 3-D.[3] Fox's 3-D campaign reflected, on one level, a rift within the studio between CinemaScope's marketing strategy, which was aimed at the clear and present rival of 3-D (which was playing in theaters around the country), and the basic concept underlying its engineering, which sought to duplicate Cinerama (which could be seen only in New York).

Though both Cinerama and (to a lesser extent) CinemaScope did produce

an enhanced illusion of depth, reviewers subsequently corrected Fox's misleading claims of CinemaScope as being a 3-D system, as did Fox itself in an effort to distinguish its big-budget CinemaScope productions from low-budget 3-D exploitation films.[4] Fox nonetheless retained certain elements of this initial association of CinemaScope with 3-D in its marketing of *The Robe* (and its first batch of other CinemaScope features) as "the modern miracle you see without the use of glasses," capitalizing on popular recognition of 3-D as a novelty while also—through the phrase "without the use of glasses"—clearly differentiating CinemaScope from the industry's earlier, inferior, 3-D product.[5] Thus CinemaScope, as a latecomer to the "3-D" field, attempted to define itself, against the background of both Cinerama and 3-D, as both a known and an unknown quantity, threading a difficult path between its would-be marketing status as something both familiar to the public yet different from its predecessors.

3-D

Less than two months after the opening of *This Is Cinerama,* on November 26, 1952, *Bwana Devil,* an independent production filmed in 3-D, premiered in Los Angeles. As in the case of Cinerama, the major studios had initially refused to invest in 3-D when it was put on the market early in 1951 in the form of Milton and Julian Gunzburg's Natural Vision; and, again, as in the case of Cinerama's choice of Lowell Thomas as a producer, the first film in this "new" process was produced not by a Hollywood filmmaker but by a radio personality—suspense storyteller Arch Oboler.[6] In both instances, Hollywood was caught napping and it took independent outsiders to wake the studios up. As one filmmaker noted, commenting on Hollywood's blindness as well as on the quality of Oboler's cheaply made jungle adventure: "The truth is that the movie industry didn't have the sense to follow its own nose into 3-D. They had to be led by a dog."[7]

The industry quickly absorbed this competiton from outside, but in different forms—3-D and pseudo-Cinerama. Within weeks Warners and Columbia had signed contracts with Natural Vision, while Paramount, M-G-M, and Universal announced that they would make 3-D films using their own processes. The first wave of studio-produced 3-D films hit the theaters in April 1953 with the release of *House of Wax* (Warners) and *Man in the Dark* (Columbia).

ERSATZ WIDESCREEN

Although 3-D enjoyed only a short commercial life, lasting for about a year, Cinerama had a more profound impact on the industry.[8] Cinerama changed the level of expectations for film audiences; after Cinerama, motion pictures had to be at least projected in, if not made in, widescreen. Its success made obsolete the traditional 1.33/7:1 aspect ratio, which was now identified with television. More to the point, the advent of Cinerama threatened, as the editors of *Fortune* pointed out, to "dilute the value of millions of dollars' worth of 'flat' films in circulation and in Hollywood vaults."[9] M-G-M had $80 million, Twentieth Century–Fox $55 million, and the industry as a whole over $300 million invested in unreleased films.[10] Spyros Skouras informed Fox stockholders that the studio's library of over 900 flat films would soon be sold to television because the success of Cinerama, Cinema-Scope, and other widescreen systems would render the flat format obsolete and thus destroy the theatrical marketability of these pictures.[11] Although Fox did not actually sell off its backlog of old features until November 1956, after RKO, Warners, Columbia, and M-G-M had released their older features to TV, the economic viability of films made in the old Academy format was clearly put in jeopardy by the widescreen revolution.[12]

The more immediate issue facing the studios was what to do with as-yet-unreleased films that had been shot in 1.33/7:1. The solution presented by a number of studios was to produce an ersatz widescreen image by cropping films already shot in the standard 1.33/7:1 format to an aspect ratio of from 1.66:1 to 1.85:1 and enlarging the image on the screen by using a wide-angle projection lens. (In selecting widescreen aspect ratios, Paramount, Republic, and RKO opted for 1.66:1; M-G-M for 1.75:1; Warners, Universal, and Columbia for 1.85:1; and Fox for 2.55:1.)[13] In April 1953 Paramount released *Shane*, suggesting that it be projected at 1.66:1.[14] At the end of May Universal promoted *Thunder Bay* as a widescreen film, encouraging exhibitors to project it on a slightly curved screen, in an obvious imitation of the Cinerama screen.[15] Fox, which was promoting what it considered to be a more authentic widescreen process, CinemaScope, labeled these widescreen blowups "frauds."[16] *Time* magazine, noting that cropping provided only a bargain-basement solution to the challenge posed by Cinerama, drily observed that "the widescreen revolution was looking more and more like an inventory sale."[17]

Almost every studio wanted a system that would duplicate the experience of Cinerama, but none of them wanted Cinerama itself because of its expense and technical imperfections. Even if they had wanted Cinerama, it was no longer for sale; the exclusive rights to produce films in that format through the year 1956 had been sold to Cinerama Productions, Inc.[18] Fox resolved to create its own, better form of Cinerama. On October 20, three weeks after the opening of Cinerama, Al Lichtman, director of sales at Fox, called an "informal" meeting of the Fox Research Department to discuss "the impact of Cinerama and to consider what the Company might technically do to bolster mass motion picture entertainment."[19]

RESEARCH AT FOX

The Fox Research Department had dissuaded Skouras from buying into Cinerama years earlier, reporting that it was "of no interest to Twentieth Century–Fox in its present form."[20] Given Cinerama's present success, Lichtman "bemoaned the fact that [Fox] did not take over Cinerama," and the Research Department "took the brunt of the argument" for not having supported Skouras in his initial enthusiasm for Waller's device. The engineers were charged with "sav[ing] the situation."[21] Lichtman commissioned them to devise "a new system of motion picture presentation to offset public apathy to 2-D pictures," and the engineers agreed to do this, proposing to begin with a review of their earlier work on wide film.[22] The Fox research staff pointedly reminded management that they had experimented with a 50mm system, possessing an aspect ratio of 1.8:1 and stereophonic sound, five years earlier and that "no one, even in our own Company, cared to proceed with these innovations and therefore, the investigations were terminated."[23]

The advent of Cinerama thus served as a catalyst of sorts, revealing a deep-seated friction within the Fox organization in the form of the conflicting goals of its scientists and its showmen. Ever since the demise of Grandeur, Sponable and Bragg had used the idealist rhetoric of scientific progress in their attempt to elicit support for the 50mm/stereo sound project. However, West Coast management—Darryl Zanuck and Joe Schenck in particular—had repeatedly failed to support them.[24] Increased investment in research and development was unnecessary, as far as Zanuck and other Hollywood-based executives were concerned; all the studio needed was

good pictures. These policies changed with the postwar falloff in attendance and the advent of Cinerama, 3-D, and other new technologies. Now Fox (and other studios) needed its engineers more than ever and endorsed their goals, underwriting the costliest period of technological experimentation since the coming of sound; Fox alone spent over $10 million in the first nine months of its development of CinemaScope.[25] Under Skouras' leadership, the East Coast engineers and the West Coast producers resolved their differences and presented a united front to the rest of the industry, although minor disagreements continued to arise over the differing aims of each party (especially when management "betrayed" the engineers by abandoning the requirement that theaters play CinemaScope films in stereo sound).[26]

SKOURAS VERSUS GREEN

While the Research Department was reviewing its earlier experiments in widescreen, conflict opened on another front—this time between between Fox management and a small but powerful group of stockholders, led by New York appliance wholesaler Charles Green. Green's threat to take over Fox also served as something of a catalyst in the history of Fox's development of CinemaScope. On December 17, 1952, at almost exactly the moment that Skouras was in France taking out an option on Chrétien's lens, *Daily Variety* reported "heavy purchases of 20th-Fox stock by Charles Green."[27] Green had a history of corporate takeovers, which he was reported to have engineered through mudslinging proxy battles. *Time* reported that Green, using "the help of such people as Nightclub Proprietor Isadore Blumenfeld (alias Kidd Cann), a wealthy Minneapolis hoodlum with a record of 30 arrests," had gained control of Minneapolis and St. Paul's Twin City Rapid Transit Company and had later ousted the management of United Cigar–Whelan Stores.[28] (A *Collier's* exposé of Green's takeover of Twin City Rapid Transit had earlier been read into the *Congressional Record* by Congressman Franklin Delano Roosevelt, Jr. The effect of its publication there was automatically to protect all references to it, such as *Time*'s account, and all reprints of the original article, such as those subsequently circulated by Skouras to Fox stockholders, from libel suits.)[29]

Green's aggressive takeover bid appeared to have been prompted by a snub the previous summer, when Fox studio chief Harry Brand refused Green and his wife permission to tour the Fox lot while they were on

vacation in California.[30] Later in the year, in preparation for his planned proxy fight with Skouras, Green attempted to strike a deal with Zanuck, "promising him the presidency if he would help oust Skouras," but Zanuck turned the offer down.[31] In the spring of 1953 Green filed a stockholder's suit, charging Skouras and Zanuck with "excessive and exhorbitant employment deals" (that is, they earned too much money), with the "payment of huge sums in false and fictitious expenses," and with "gross mismanagement."[32]

Skouras' desperate need to convince Fox stockholders of the competence of current Fox management compelled him to put Fox finances back into the black as soon as possible. His "mistake" in passing up Cinerama had to be corrected with decisive action. He took one of the greatest gambles ever made by a studio executive, wagering all or nothing on CinemaScope. On February 2, 1953, shortly after the proxy fight had begun but before it was extensively reported in the trades, Skouras announced that all future Fox products would be made in CinemaScope.[33] For Green, Skouras' wholesale commitment of the Fox organization to CinemaScope became yet another indication of poor management. Green complained that no other film company was "putting all its eggs into one basket" and insisted that if CinemaScope was not successful the company could stand to lose millions of dollars.[34]

In effect, CinemaScope became a test of Fox management—a test which Skouras and Zanuck desperately needed to pass. Skouras' all-or-nothing announcement had its desired effect on the market, driving Fox stock up 1.25 points overnight; over 37,000 shares were sold in one day alone, making it the most active film stock during that trading session (the nearest contender was Loew's, which also announced it would make films in CinemaScope and which sold 14,000 shares).[35] But then Fox had to follow up on its wager, producing a viable widescreen system and marketing it successfully to the rest of the industry. Skouras' accelerated development of the process, condensing a potentially lengthy innovation stage into a mere three months, permitted public demonstrations of CinemaScope to producers, exhibitors, stockholders, and the press in mid-March, shortly before Green and the current Fox management began to campaign heavily for proxy votes in April.[36] Fox held additional demos of CinemaScope for exhibitors, stockholders, and the press in various cities around the country in mid-to-late April, less than two weeks before the final showdown with Green at a

stockholders' meeting on May 5. The enthusiastic response of those who attended these screenings and the laudatory reviews of CinemaScope in the trade press undoubtedly played a major role in Green's defeat.

FOX AND CHRÉTIEN

It was with a special sense of urgency that Fox engineers assembled the stereophonic-sound widescreen process ultimately known as CinemaScope, for they were in a race not only with Green and his attempted coup but with other studios as well. As for Green, Skouras warned Fox personnel that if he won the proxy fight, Green would probably liquidate the company, close the Westwood studio, and sell off the Fox library of features to television for a quick profit (and, at the very least, close down the Research Department).[37] Green, of course, was not Fox's only problem. Cinerama's front-page coverage in the *New York Times* also sent M-G-M, Warners, and Paramount in search of a widescreen substitute.[38] While other studios pondered their own response to Cinerama, Earl Sponable, director of research at Fox, and Herbert E. Bragg, his assistant, began reviewing the studio's earlier experiments in widescreen immediately after their October 20 meeting with Lichtman. They looked at tests they had earlier performed using 50mm film and considered the use of a system that Paramount would eventually adopt and call VistaVision—35mm film exposed horizontally to produce a wide picture (instead of a wider film exposed vertically). Bragg recalled the work of Henri Chrétien and others on anamorphic optical systems,[39] and at his suggestion the research staff began to explore the possible use of cylindrical lenses to produce a panoramic widescreen image,[40] while a Fox representative in France, Jack Muth, attempted to locate Chrétien.[41] Meanwhile Warners began its own search for Chrétien.[42]

In early November Bragg commissioned Bausch & Lomb to manufacture several cylindrical lenses for use in optical tests. By November 13, Fox had located Chrétien, discovered that several of his original lenses were still in existence, and begun to make arrangements to film some tests with them. In the process Fox also discovered that the Arthur Rank Organization currently held an option on the lens which was due to expire on December 16. Sponable negotiated with Chrétien on December 1, 12, and 13 for permission to use his lens, taking out an option on it on December 18.[43] Outfitting a Movietone newsreel camera with Chrétien's Hypergonar attach-

HENRI CHRÉTIEN
WITH HIS
HYPERGONAR LENS
(AUTHOR'S
COLLECTION).

ment, Fox cameramen completed their initial tests on December 13 and screened them for Skouras at the Rex Theatre in Paris on December 19. After additional demonstrations of the Hypergonar test footage, which was shown to Zanuck and others (including representatives from M-G-M and Warners)[44] in Hollywood on January 26, 1953, Sponable and Skouras returned to Nice, where Chrétien lived, and finalized their deal with him

on February 10.[45] According to Zanuck, Fox reached an agreement with Chrétien only one day before Jack Warner's representative, Joe Hummel, contacted him.[46]

The initial rivalry between the two studios to obtain Chrétien's lens continued in the form of a format cold war marked by cloak-and-dagger dealings. This intense competition influenced subsequent phases of Fox's innovation and diffusion of CinemaScope until shortly after the release of *The Robe,* in early November 1953, when Warners finally abandoned its own anamorphic experimentation and contracted with Fox to produce films in CinemaScope.[47]

Ironically, the drama of expiring options and of Fox's race with Warners to sign a contract with Chrétien did not involve an attempt to obtain Chrétien's patents; they had expired several years earlier, in 1951, and his work was, as Chrétien himself repeatedly acknowleged, now in the public domain.[48] Fox contracted with Chrétien in order to obtain his lenses and thus gain a temporal advantage over potential rivals, who would have to begin the lengthy process of designing and constructing cylindrical lenses from scratch. The use of existing Hypergonar lenses enabled Fox to commence the actual filming of CinemaScope productions by mid-February 1953.

Meanwhile Skouras was busy negotiating contracts with the industry's major service firms and by early March had, according to *Business Week,* "sewed up all production sources of the essential lenses and screens [for CinemaScope-like processes] for a long time to come." Warners, which was then forced to develop its own anamorphic lenses, had difficulty finding a supplier. Having finally made arrangements with a foreign company which Skouras appeared to have missed, Zeiss, to manufacture lenses, Warners soon discovered that Fox had shortly thereafter contacted the firm and asked Zeiss to make lenses for it too. Because of these delays Warners did not obtain sample lenses from Zeiss until early September 1953, and these proved to be unacceptable.[49]

CONVERTING THE INDUSTRY

Fox's February 2 announcement that it would film all future productions in CinemaScope "dropped a bombshell" on the film industry.[50] The *Motion Picture Herald* reported that Fox's decision "struck the industry with dra-

matic and electrifying force" and represented "the first definite commitment by a major company to a single method."[51] A former exhibitor himself, Skouras reasoned (as *Fortune* put it) that "theatre owners would not invest heavily in CinemaScope equipment unless they knew the company was in for keeps."[52] Indeed, the more films made in CinemaScope (or in a comparable anamorphic process), the more incentive there would be for theaters to convert; as a result, in addition to announcing the titles of the eleven Fox films slated for production in CinemaScope, Fox simultaneously launched an aggressive campaign to convince other studios to make films in CinemaScope.

Shortly after Fox's announcement, Nicholas Schenck, president of Loew's, who had seen a special preview of CinemaScope in late January,[53] reported that "M-G-M technicians had been working on a system similar to Cinema-Scope and that in the interests of uniformity Loew's would join with 20th-Fox in making available one system to production and exhibition"[54] and announced that M-G-M would make two films in CinemaScope.[55] On March 18, after additional demonstrations of footage from *The Robe* and other films shot in CinemaScope, M-G-M officially committed itself to the production of additional films in CinemaScope, securing a license to make an unspecified number over the next ten years.[56] During the next few months M-G-M became Fox's staunchest ally in support of the new process (former M-G-M head Louis B. Mayer's association with Cinerama "was rumored to have helped earn Fox M-G-M's cooperation with CinemaScope"), consenting to film a number of its most prestigious productions, such as *Knights of the Round Table,* in CinemaScope (as well as in flat versions).[57]

HOLDOUTS

Executives from Warner Brothers, however, whom Fox had invited to the same preview that Schenck attended, remained silent. They knew that Fox's lens was in the public domain and were wary of signing a long-term contract with Fox which would give the latter script approval over its own productions. Moreover, they remained reluctant to associate Warners with a trademark that was so closely identified with a rival studio.[58] Warners also undoubtedly recalled that, after signing a contract with Natural Vision to make films in 3-D, it had stood by and watched other studios build their own 3-D systems and thus avoid expensive licensing fees. Paramount, one

of those studios which had assembled its own 3-D cameras, quite likely followed a similar line of reasoning and also refused to commit itself to CinemaScope.

Though Paramount had expressed an interest in Chrétien's Hypergonar lens back in the mid-1930s, had taken out an option on it which the studio had subsequently permitted to let lapse,[59] and even possessed an old, sample Chrétien lens, the studio never did convert to CinemaScope, toying first with 3-D, then with an ersatz widescreen process, and finally with VistaVision, a large-negative-area camera process which, when reduced onto 35mm film, produced an image with a 1.66:1 aspect ratio. Throughout Fox's marketing campaign to convert the industry to CinemaScope, Paramount attempted to undermine Fox's efforts and repeatedly voiced its reservations regarding what it considered overly extreme widescreen ratios (in particular, CinemaScope's 2.66:1, then 2.55:1 aspect ratio).

During Fox's mid-March demonstrations of CinemaScope, Paramount staged rival demonstrations of its own, "unveiling" a fairly conventional widescreen projection system which relied on the simple use of 1.66:1 aperture plates in the projector and wide-angle projection lenses.[60] In August, while Fox was ballyhooing the upcoming premiere of *The Robe*, Paramount reaffirmed its skepticism regarding CinemaScope, complaining that the Fox process was too wide and lacked height, and declared that it was looking for another widescreen system to use instead, a statement which *Daily Variety* interpreted as an implicit attack on Fox's conversion campaign.[61] A few days after the opening of *The Robe*, Paramount's chairman of the board, Adolph Zukor, sought to dampen the general enthusiasm for the Fox process, which had captured headlines in both the trade and popular press, by announcing that his studio would make films in every system but CinemaScope. Claiming that "I have no prejudice against CinemaScope," he nevertheless insisted that Fox's emphasis on technology had blinded it to its chief responsibility, which was to make good films.[62]

Zukor's statement only confirmed previous Paramount policy, which, like Warners', strove to establish the studio's autonomy within the industry, refusing to contract itself to systems developed by other studios.[63] But it also prompted an indirect response by Charles Skouras, brother of Spyros Skouras and president of National Theatres. Skouras wrote an open letter to Y. Frank Freeman, vice-president in charge of production and studio operations at Paramount, extolling the virtues and box-office performance

of CinemaScope and urging him to "strike while the iron is hot" by enlisting his studio's support of CinemaScope's efforts to bring audiences back into the nation's motion picture theaters.[64] Skouras, whose theater circuit had been an early supporter of CinemaScope, published this letter in the trade press.[65] Paramount responded with VistaVision, which it used to film *White Christmas*.

Paramount and VistaVision

The chief virtues of VistaVision, according to Paramount president Barney Balaban, were its "compatibility" with traditional modes of production and exhibition and its "flexibility," that is, its adaptability to different theater situations.[66] VistaVision's wide-area negative, achieved by using 35mm film exposed horizontally (as in a still camera), resulted in a wide, eight-sprocket-hole two-frame image. When rotated 90 degrees and reduced to standard 35mm, it produced an extremely sharp image and possessed excellent depth of field. VistaVision thus solved many of the problems inherent in ersatz widescreen, providing greater image resolution and a better angle of view for widescreen projection, without committing itself to the radical redefinition called for by Cinerama, CinemaScope, and other extreme widescreen processes. At the same time, VistaVision offered theaters which, for economic or architectural reasons, were unable to convert to CinemaScope, a viable widescreen alternative, permitting them to project VistaVision pictures in aspect ratios ranging from 1.33:1 to 2:1, which it considered the maximum width that most medium-sized and small theaters in the country could employ.[67]

Paramount escalated its undeclared war on Fox's CinemaScope through its advertising campaign for VistaVision, which involved a direct comparison of the two processes. In a demonstration of VistaVision staged at Radio City Music Hall in late April 1954, Paramount first projected CinemaScope footage on a screen of diminished width, then, using a different set of lenses, projected its VistaVision material on a screen of the same width, producing an image that equaled CinemaScope in width but dramatically surpassed it in height. Fox objected to this tactic, pointing out that CinemaScope films, when projected correctly at Radio City, covered the full width of the theater's screen and equaled VistaVision in height.[68] The promotion book which Paramount distributed to exhibitors and the press employed the same sales

BING CROSBY AND
DANNY KAYE IN
WHITE CHRISTMAS
(COURTESY OF
PARAMOUNT
PICTURES).

BING CROSBY AND DANNY KAYE IN WHITE CHRISTMAS (COURTESY OF PARAMOUNT PICTURES).

strategy, comparing the traditional 1.33/7:1 and CinemaScope's 2.55:1 projection aspect ratios with that of VistaVision, which, at 1.85:1, was shown to fill a screen that the other systems did not.[69]

Paramount, which publicly criticized Fox for the excessive width of the CinemaScope aspect ratio, marketed VistaVision less as a widescreen process than as a big-screen process. The VistaVision image could be blown up to fill an enormous 62 × 35 foot screen without the loss in clarity or sharpness that plagued ersatz widescreen (and without the blurring or fuzziness which occasionally appeared at the extreme edges of the first CinemaScope films). Knowing full well that VistaVision could not compare with CinemaScope in terms of width, Paramount insisted that "height was equally important as width."[70] The first few VistaVision films, *White Christmas* and *Strategic Air Command*, adhered to this aesthetic, stressing image height rather than width. While characters in CinemaScope films tended to recline on sofas or easy chairs *(How to Marry a Millionaire)* or sprawl on the ground *(Rebel without a Cause)*, those in VistaVision films tended to

sing and dance *(White Christmas)* or stand at attention *(Strategic Air Command)*.

Paramount's objections to CinemaScope technology also extended to the Miracle Mirror screen, which Fox initially required exhibitors to install but which Paramount claimed was inferior to standard theater screens because of the visibility of its seams. In June 1954, before it would permit one of its own pictures to be exhibited in one CinemaScope-equipped theater, Paramount insisted that Fox's Miracle Mirror screen be removed and replaced by a Walker seamless screen.[71]

Though Paramount remained opposed to CinemaScope, United Artists and Disney joined M-G-M, contracting with Fox in June 1953 to make additional films in CinemaScope.[72] Columbia followed suit in mid-July, declaring its intention to make films in CinemaScope;[73] however, it did not officially sign with Fox until October 29, 1953, shortly after the release of *The Robe.* Columbia, which had also bid for the Chrétien lens and lost, had adopted a fairly conservative attitude toward the 3-D/widescreen revolution.[74] It could afford to, having enjoyed record box-office returns from pre-widescreen flat releases such as *From Here to Eternity* and banking on the success of a slate of future releases in the old format, including films such as *The Caine Mutiny* and *On the Waterfront.*[75] Harry Cohn initiated a policy of releasing Columbia's 3-D films in both 3-D and 2-D versions and instructed his cinematographers, even when filming in CinemaScope, to compose widescreen shots so that theaters could project them in a variety of aspect ratios.[76] Though none of these studios followed Fox's example of filming all subsequent productions in CinemaScope (and none insisted, as did Fox, that theaters show them in stereo sound only), they nonetheless provided Fox with the promise of additional product to use as leverage in its marketing campaign to theaters.

Warners

Warner Brothers, which did not convert to CinemaScope until after the premiere of *The Robe,* waiting until November 4, 1953, to sign with Fox, emerged as the most cautious studio during this period of tumult, involving itself with a variety of new processes. Nor did it, as a would-be industry leader, make much of an attempt to conceal its hostility toward Fox, which had captured the limelight through its heroic attempts to "save the movies"

by means of its "Bible-stumping" promotion of CinemaScope.[77] Paramount, which took issue not only with Fox and CinemaScope but with extreme widescreen ratios in general, never converted to CinemaScope, and thus (until it adopted the Panavision process in 1961)[78] eliminated itself from the field of anamorphic competition. Warners, on the other hand, engaged directly with Fox in a race for anamorphic hegemony and, as a result, played a major role in Fox's attempts to innovate and diffuse CinemaScope. In retrospect its activities during the spring and summer of 1953 take on the appearance of a battle plan, which was aimed at outmaneuvering Fox and other rival studios but which resulted only in throwing obstacles in the way of Fox's campaign to convert the industry as a whole to CinemaScope.

Warners' initial strategy looked back to the days of the industry's transition to sound, when the other studios (Paramount, M-G-M, First National, United Artists, Universal, and Columbia) adopted a wait-and-see attitude while Warners' sound-on-disc system competed with Fox's sound-on-film process for control of the marketplace. Only this time Warners was on the sidelines with the others watching Fox go it alone. On March 5, 1953, Warners declared that it would close down its operations for ninety days, keeping its properties out of production until it could ascertain which format would win over the public.[79] It also cut back on its contract personnel, terminating longtime Warners staff such as director Michael Curtiz, who had been with the company for over twenty-six years.[80] A few months later, unsure as to which new process to film cartoons in, Warners also shut down its animation department, insisting it had a two-year backlog of unreleased cartoons with which to supply theaters anyway.[81]

On March 7, in the very same week that it shut down its production facilities, Warners, having failed to obtain anamorphic lenses from Chrétien, entered into secret negotiations with the Zeiss company in Germany to manufacture anamorphic lenses based on Chrétien's specifications, modifying them slightly to produce a 2:1 (instead of 2.66:1) aspect ratio.[82] Fox, in the interim, had obtained the exclusive services of H. Sidney Newcomer, a former student of Chrétien's who held several American patents for anamorphic lenses. Fox's move proved to be part of a larger strategy to lock up under contract the talents of cylindrical lens experts and thus "to retard the adoption of the 1:2 [*sic*] aspect ratio by other producers."[83]

Though its public domain status meant that anyone could manufacture Chrétien's lens, the complexity of cylindrical lens design effectively limited

the construction of this kind of lens to a handful of firms. Unlike 3-D cameras, which any competent studio camera department could construct by bolting together a pair of interlocked cameras, acceptable anamorphic lenses could not be so easily obtained, as Warners soon discovered in its dealings with Carl Dudley (who developed Vistarama) and Zeiss. Fox's contracts with Bausch & Lomb and with virtually every other company capable of manufacturing high-quality, precision anamorphic lenses tied up the time, equipment, and personnel of the best equipment-supply firms and thus prevented any rivals from securing lenses from the few companies that were skilled enough to make them.[84] Nonetheless, Warners persisted in its efforts to obtain usable anamorphic lenses from Zeiss, even after learning that the firm had reneged on its intial verbal agreement to produce lenses exclusively for Warners and had secretly entertained offers from Fox to purchase 2,000 projection lenses.[85]

During the first few months of 1953 Warners, unlike Fox, took few risks, attempting to keep all its options open. Just before Christmas in 1952, the studio contracted with Natural Vision to produce a number of films in 3-D.[86] In mid-March Warners held trade screenings of its first 3-D film, *House of Wax,* at the same time that Fox was demonstrating CinemaScope, using its best available weapon in an attempt to undermine Fox's CinemaScope campaign.[87] While it was committing itself publicly to 3-D, Warners was also privately exploring other new marketing possibilities. Later in the spring, on May 7, Warners reported that it would release some films in WarnerScope, a nonanamorphic process comparable to other ersatz wide-screen techniques, apparently attempting to cash in on Fox's heavy promo-tion of CinemaScope while also continuing its strategy of subverting the very process with which it sought to compete.

As a result of this latter move, the cold war between Fox and Warners escalated briefly. Zanuck, learning that Warners was going to market an ersatz widescreen system as its own "Scope" process, complained to the studio, citing Fox's prior use of the term "CinemaScope" and expressing concern that reference to a nonanamorphic process as "Scope" might cause a certain amount of public confusion.[88] Jack Warner fired back a letter informing Zanuck that Warners had registered the name WarnerScope on November 21, 1952, long before Fox had come up with the CinemaScope trademark, and that when he had learned of Fox's selection of the name CinemaScope, Warner had advised Al Lichtman of the WarnerScope title

registration. Warner concluded, "I am the one who should be complaining about the use of the word 'Scope' and not you. However, since you brought up the question, don't you believe that 'CinemaScope' is too close to 'Cinerama'? At least WarnerScope has nothing to do with a name that has been in print for several years."[89]

On May 29, 1953, after the successful release of *House of Wax* in 3-D, Warners dropped its plans for WarnerScope and announced that it would put a full slate of twenty-two 3-D pictures into production, converting all of its product to this format.[90] But on July 20, after the 3-D craze had begun to dwindle, Warners announced its own anamorphic process, WarnerSuper-Scope, adding that all of Warner's anamorphic films would "also be photographed by the Warner All-Media Camera in WarnerColor, 3-D and 2-D to meet any desired aspect ratio."[91] *Daily Variety* reported that before announcing its own 2.66:1 anamorphic process, WarnerSuperScope, the studio had attempted to buy 50 percent of CinemaScope from Fox for $5 million, but that Fox had refused to give up exclusive ownership of its process.[92] In mid-July, still unable to obtain adequate anamorphic lenses from Zeiss and eager to resume production, which had been halted since May, Warners contracted with Carl Dudley to use his Vistarama lens to film the studio's first anamorphic feature, *The Command* (which was also shot in 3-D).[93] (The studio also put into production *The Bounty Hunter,* which was shot flat, and *Dial M for Murder* in 3-D.) Though shot in Vistarama, *The Command* was, with Fox's consent, ultimately released as a CinemaScope production after Warners had converted to CinemaScope.[94]

From July to October Warners struggled unsuccessfully to obtain anamorphic camera and projection lenses from Zeiss. Warners had promised to rent (rather than to sell, as was Fox's practice) anamorphic lenses to theaters which had contracted with it to exhibit *The Command,* and Zeiss's failure to deliver lenses on schedule put Warners in an untenable position, preventing its release of *The Command.*

Zeiss's anamorphic lenses, like Chrétien's prototypes, suffered from varying compression ratios, swale (curved horizontal lines), and vignetting, in addition to poor definition of vertical lines.[95] In early September Warners performed comparison tests of Fox's new Bausch & Lomb lenses and Zeiss's lens, concluding that the latter was "definitely inferior."[96] These tests and a last-minute meeting with a Zeiss engineer in Hollywood in mid-October, coupled with the critical and box-office success of *The Robe* and concern

over its inability to fulfill its promise to supply potential exhibitors of *The Command* with anamorphic lenses, forced Warners, in the last week of October, to abandon its own anamorphic experimentation and sign with Fox. In return, Fox promised to supply Warners with 300 projection lenses in time for the release of *The Command* and agreed to take Warners' place in its contract with Zeiss. Its decision to sign with Fox also enabled Warners "to take advantage of the well publicized [CinemaScope] trademark."[97] Defeated in its attempts to outwit Fox, Warners now played the part of an industry mediator, explaining its latest action as a step toward greater cooperation among the leading producers in Hollywood. Invoking the "best interest of the business," Warners attributed its sudden adoption of Cinema-Scope to "an effort to clarify and standardize for exhibitors and the public a single process, thus eliminating any possibility of confusion."[98]

Warners' punch-and-jab policy shifts during this period are best illustrated by its tactics to promote its most attractive property, which went through a variety of formats in a succession of publicity announcements. Warners "dangled" *A Star is Born* in the press, testing possible responses to its filming in rival and incompatible systems: the film was first slated for production in 3-D, then in normal widescreen (that is, WarnerScope), and then in WarnerSuperScope.[99] Ultimately it was shot and released in Cinema-Scope.

UNCERTAINTY AT FOX

Fox was not entirely immune to the uncertainty which gripped the industry during this period; it merely concealed its doubts more carefully in order to demonstrate its public enthusiasm for CinemaScope. Just after its CinemaScope-only announcement in early February, Fox acknowledged that it would film *The Inferno, Vicki,* and possibly one or two other pictures in 3-D, claiming that it would do so only to fulfill "a prior verbal commitment" which Zanuck had made with Milton Gunzburg of Natural Vision.[100] (Only *The Inferno* ever made it to the screen in 3-D.) Fox dropped several projects deemed unsuitable for filming in CinemaScope and lost Elia Kazan's *On the Waterfront,* which was slated for production at Fox, to Columbia because of its CinemaScope-only policy and because Zanuck could not see this property as a full-color widescreen spectacle.[101]

But as late as June 15 Fox also announced a deal with an independent

producer, Leonard Goldstein, to finance the filming (off the lot) and release of several former Fox properties in flat versions, again citing an earlier obligation with the producer. The deal guaranteed Fox some product to distribute just in case the industry failed to adopt CinemaScope.[102] And though Fox disclosed that it was shooting *The Robe* in a flat version as well as in CinemaScope "so that it would be available for churches and schools in 16mm," industry insiders recognized this as a cover story designed to conceal the studio's quite genuine fears that CinemaScope might not take hold.[103] At the same time, it was unlikely that Fox would be able to get full financing to film a $4 million production like *The Robe* unless it protected this investment against the possible failure of CinemaScope at the box office by shooting a 2-D version as well.[104]

What only a few individuals in Hollywood knew was that Fox had also shot *The Robe* in 3-D, just in case that format, which was sweeping the industry when *The Robe* went into production, evolved over the summer from a novelty item into a new standard.[105] Though Fox took certain measures to ensure that it would survive the format war, its prestige rested upon acceptance of CinemaScope by the industry, the press, and the public.

THE CINEMASCOPE DEMONSTRATIONS

Fox's initial campaign to convert other producers to the CinemaScope format hinged on one main event which was also staged to secure the commitment of exhibitors and of Fox stockholders—the first public demonstrations of the process in Hollywood in a series of "previews" that began on March 18. The March demonstrations, which included footage from *The Robe, How to Marry a Millionaire,* and the "Diamonds Are a Girl's Best Friend" number from *Gentlemen Prefer Blondes,* were staged to coincide with the annual Academy of Motion Picture Arts and Science's Academy Awards, which were scheduled for March 19.[106] Hundreds of producers and exhibitors were in Los Angeles at this time, and Fox tapped into this built-in audience for an unveiling of CinemaScope, which received exceptionally enthusiastic reviews in the *Hollywood Reporter, Daily Variety,* and the *Motion Picture Herald* the day before the Oscar results. Page one headlines in the *Hollywood Reporter* declared "Industry Hails CinemaScope: Throw Away the Glasses."[107] *Daily Variety* reported that "CinemaScope Wins Hollywood Favor," citing positive responses from Dore Schary (M-G-M), Don Hartman

(Paramount), Milton Rackmil, Bill Goetz, and Al Daff (Universal-International), and Jerry Wald (Columbia).[108] The *Motion Picture Herald,* a trade magazine addressed to exhibitors, noted that "save for a time-out last Thursday night for the Academy Awards telecast, Hollywood has talked since then [the morning of March 18] of very little else than CinemaScope" and then quoted the responses of the executives of a number of major theater circuits.[109]

During four days of demos, over 4,600 people saw CinemaScope projected at Fox's Western Avenue lot.[110] These screenings proved so successful that Fox extended them for another week, scheduling a total of thirty-seven screenings. The 50-minute double-system test reel of CinemaScope footage was seen by over 12,000 people in nine days.[111] Later that week, following the example of Warners and Paramount, which had taken advantage of the CinemaScope demos to draw attention to their own rival systems, the Magna Theatre Corporation, Michael Todd, George Skouras, and Joe Schenck announced the formation of Todd-AO to produce films in a 65mm format which was clearly designed to compete with Cinerama and CinemaScope.[112] With all eyes on Hollywood, every rival system struggled for attention, but CinemaScope emerged with the greatest recognition, receiving, by noon on March 23, over 1,200 orders from exhibitors around the country for the installation of CinemaScope equipment in their theaters.[113]

Most of these orders came from large first-run theaters and the major national theater chains.[114] *Daily Variety* reported that the major studios received "80% of their revenue from 1,000–1,500 first-run houses"; Fox had clearly targeted these theaters in the initial stages of its marketing campaign, privileging them over the smaller neighborhood theaters and drive-ins.[115] Indeed, though the Fox Research Department began considering the problems of adapting CinemaScope for drive-ins in the summer of 1953, it did not get approval to establish recommendations for CinemaScope drive-in installations or to begin work on problems related to stereo sound and screens for these theaters until January 1954.[116]

RESISTANCE TO CINEMASCOPE

Although large first-run theaters viewed CinemaScope as "the ultimate answer" to exhibitors debating which new system to adopt,[117] smaller theaters refused to accept the full CinemaScope package, targeting magnetic

stereophonic sound as an expendable component which they felt Fox would ultimately have to drop as an exhibition requirement. Though Skouras campaigned heavily among exhibitors, selling them on the virtues of CinemaScope, including stereo magnetic sound and curved Miracle Mirror screens, small theaters objected to the expense. As one British theater owner complained, "I don't want the package . . . I'm voicing the opinion of hundreds of little fellows. They cannot afford stereophonic sound, but they are going to get a lens and a large screen and get as near as they can to a poor man's CinemaScope."[118] Allied States Association, an organization representing independent theater owners, encouraged its members to do the same, suggesting that they did not even need to buy lenses from Fox, since Chrétien's work was in the public domain and cheaper versions of it would undoubtedly soon become available.[119]

Opposition to Fox's insistence that all exhibitors who wished to show CinemaScope films install special Fox-approved screens and equipment for stereo magnetic sound began to mount after the release of *The Robe*, as more and more exhibitors sought to book the film. In December both the Allied States Association of Motion Picture Exhibitors (an organization of small, independent theaters) and the Theater Owners of America (TOA represented larger theaters and chains) publicly denounced Fox for its stereo-only policy.[120] In January 1954, TOA president Walter Reade attempted to cut costs by installing mixers, which blended the four magnetic tracks on the film into one and played it back over a conventional (monaural) speaker system, in his theaters.[121] Fox engineer L. D. Grignon objected that with mixers each projectionist was given the opportunity of doing the final mix and that dialogue intelligibility might suffer as a result.[122] Fox filed an injunction against Reade to prevent him from using the mixer and changed its standard exhibitor's contract to prohibit this specific practice.[123]

Under pressure from his own membership, which included the very first-run theaters expected to benefit most from CinemaScope, Reade apologized and agreed to use full stereo on all future CinemaScope pictures.[124] However, Allied States continued to campaign against Fox's screen and stereo-only policies.[125] Under pressure from small exhibitors, in early December 1953 Fox relaxed its screen requirements, permitting "the exhibitor in the case of the narrow and small theatre to choose whatever make or type of screen he desires to use."[126] Since neither M-G-M nor Warners,

which were about to release their first CinemaScope films, demanded special screens, Fox realized that it could not hold firm on the question of screens; however, since neither M-G-M nor Warners offered potential exhibitors of CinemaScope films anything but magnetic stereo prints at this time, Fox did hold firm on its stereo-only policy.[127]

PERSPECTA SOUND

Though Fox continued to insist on stereo magnetic sound in the theater, other studios, in an attempt to avoid the anger directed by exhibitors at Fox, soon approved other means of sound reproduction. In March 1954 former Fox ally M-G-M endorsed an optical stereo sound process, Perspecta Sound, in which it held a half interest, and adopted it as a standard for all foreign releases of CinemaScope productions (while retaining a magnetic-only policy domestically).[128] Perspecta was a pseudostereo system in which a single photographic sound track containing three subaudible control tones could be used to direct sound to the left, center, or right speakers (or, when special reproducing equipment was not in use, would play this track back as if it were monaural).

On April 15, 1954, the *Motion Picture Herald* announced that M-G-M, Warners, and Paramount planned to use Perspecta Sound in all future productions. Though Perspecta sound reproduction equipment did not save much money for those exhibitors who installed it (since the same amplifiers, wiring, and theater speakers were required as in magnetic stereo systems), Perspecta did offer a compatible sound system.[129] Exhibitors could now decide for themselves whether or not to install "stereo" equipment and, if they objected to the cost of Perspecta, could use conventional equipment to screen Perspecta prints monaurally.

Skouras responded to M-G-M's announcement by inviting about 500 exhibitors to attend a special forum at Fox's East Coast offices to discuss the issue of stereo magnetic sound.[130] In addition to the defection of its allies to Perspecta, Fox was concerned about the activities of Paramount with VistaVision, which had been trade-shown in late April and which, in early May, was being hailed as "the exhibitor's darling," because Paramount did not insist that theaters install stereo sound or special screens in order to show VistaVision films.[131]

FOX RELENTS

Business Week described VistaVision as "Paramount's direct challenge to Fox for the mass movie market," explaining that the studio was using it as a tool to make "a big pitch for neighborhood houses and drive-ins, as well as for the foreign market," which accounted for 35–40 percent of the industry's annual gross profits.[132] At the same time, Fox had, with *The Robe*, one of the biggest moneymaking films ever and was eager to continue to play the film off in second-run and sub-run houses, which had not yet converted to CinemaScope. For all these reasons, Skouras, after a five-and-a-half-hour session with over 550 angry exhibitors who attended his "exhibitors' forum," reversed the studio's former policy on stereo sound, permitting CinemaScope features to be booked by theaters which had not fully converted.[133] Fox subsequently agreed to release CinemaScope features in a variety of sound formats—four-track magnetic, one-track magnetic, and one-track optical sound. As a result, requests for CinemaScope theater installations soared to 200–250 per week, climbing from roughly 3,500 in April 1954 to 13,500 a year later.[134]

In the early 1950s many of the factors which had led to the failure of the wide-film revolution in 1930 had been reversed. Popular demand for a new kind of motion picture entertainment existed, as did an economic demand by the major studios for a product that would bring the dwindling audiences of the postwar era back into motion picture theaters. And this product had to be significantly different from traditional motion picture fare while remaining more or less compatible with existing technology. Fox's development of CinemaScope answered these demands, but it did so in an industry that had become increasingly competitive, fragmented, and stratified, as the diffusion stage of the CinemaScope process so clearly illustrates. Hollywood in the 1950s was at war with itself, and one of the most prominent casualties of this conflict was stereo magnetic sound.

Producers attempted to innovate rival, incompatible widescreen systems, publicly trusting, as their press releases in the trades proclaimed, in the forces of the marketplace to provide a form of "natural selection," while privately engaging in activities designed to undermine the efforts of the competition. Thus Fox outdesigned Warners in the area of anamorphic optics and convinced it, through the box-office success of *The Robe*, of the value of the CinemaScope trademark, only to find Warners—and Fox's former ally M-G-M—subverting its efforts to convert the industry to stereo

magnetic sound. At the same time Fox had to contend with Paramount's efforts to (quite literally) belittle CinemaScope and to outfox Fox in its campaign to win over the nation's exhibitors by requiring "no special equipment."[135]

While Fox fought a widescreen war with rival studios, its struggle to convert exhibitors to CinemaScope opened up hostilities on yet another front—between the formerly integrated but now divorced spheres of production/distribution and exhibition. Yet even here, as in the case of production, it is impossible to characterize the goals of exhibitors as a group. The aims of exhibition's various tiers and factions crisscrossed in a complex pattern of support and conflict, with former theater chains, such as Charles Skouras' National Theatres, and large first-run circuits backing Fox and with independents and small theaters opposing it. Thus the highly capitalized theater chains could—and did—convert to CinemaScope and, by doing so, realized enormous profits—with *Robe* theater grosses (domestic and foreign) totaling over $29.5 million by mid-April 1954.[136] But smaller theaters, which could not afford to convert, complained that Fox was putting them out of business. The battle between Fox and exhibitors and among exhibitors themselves ultimately forced Fox to abandon its Miracle Mirror screen and stereo-only policies.

Though CinemaScope was engineered and marketed as a multitechnological format, involving color, anamorphic lenses, special screens, and stereo magnetic sound, it was not bought that way by exhibitors, who unpacked the package, dispensing first with special screens and then with stereo sound. Fox's campaign to sell CinemaScope to the industry reveals that the industry was no monolithic empire. The industry may have shared a single economic goal—the desire to maximize profits—but its various factions—and factions within factions—disagreed on the best way to do this, realizing that one person's profit was another's loss. In designing the CinemaScope package, Fox attempted to satisfy as many of the conflicting demands of production, distribution, and exhibition as possible. Its success can be measured in CinemaScope's ultimate adoption as a new industry standard; its failure in the inability of those who engineered it to foresee just how much at war the industry was with itself.

Fox engineers next had to try to design CinemaScope in such a way that it could satisfy the needs of this conflicted motion picture marketplace for a dramatically new entertainment form while making it conform as much as possible with existing exhibition standards and practices.

THE DEVELOPMENT OF CINEMASCOPE

Although Twentieth Century–Fox did not invent CinemaScope, the Research Department of that studio effectively innovated it by linking disparate developments in lens, screen, and sound technologies. In one sense, CinemaScope marked the culmination of years of research in these fields, not only by Fox but by other, wide-ranging American and European interests. At the same time, it drew upon innovations in both film and television engineering, taking advantage of the recent computerization of lens design, the advent of acetate film stock, and Eastman Color (all film technologies), as well as magnetic recording equipment designed for use in radio and television broadcasting and screen material developed for theater television. In this respect it was a compendium of state-of-the-art technologies of the postwar period.

Fox, which had maintained a Research Department since 1926, had a long history of contributions to technological development in the cinema, especially in sound (seen in its introduction of the Movietone sound-on-film system in 1927, which brought Theodore Case's associate, Earl Sponable, to Fox) and wide film (seen in its introduction of the 70mm Grandeur process in 1929–30). Fox's innovation of a widescreen process with high-fidelity sound thus began long before its purchase of Henri Chrétien's Hypergonar lens in December 1952 or its adoption of a Cinerama-style multitrack magnetic stereo sound system in 1953.

Fox's Research Department not only pioneered certain improvements in existing technologies; it also oversaw their successful combination into a complete "package," which the studio then proceeded to sell through its own marketing agency, CinemaScope Products, Inc., to the rest of the film industry. What remains astounding about the development of CinemaScope at Fox is the rapidity with which it was perfected. As a contemporary progress report by the Society of Motion Picture and Television Engineers (SMPTE) pointed out, CinemaScope "was conceived, engineered, standards established, and the system co-ordinated and promoted . . . in less than ten

months from the first simple tests to public release of *The Robe* on September 16, 1953."[1] By contrast, the entry of Magna Theatre Corporation and Todd-AO into widescreen production (via their 65mm format) was announced at the end of March 1953. The first industry-wide demonstration of their process did not take place until June 1954, and the first film shot in this process, *Oklahoma,* was not released until April 1955.[2]

The activities of the Fox research team went beyond mere engineering to coordinating the efforts of various manufacturers of CinemaScope equipment and supervising the installation of that equipment in motion picture theaters. The ultimate design of CinemaScope incorporated many of the quite pragmatic concerns, on the part of film producers, equipment suppliers, and theaters, that the studio's engineers encountered during this accelerated period of innovation, and its final form reflected the different demands placed upon it by the various (and often opposed) needs of producers, distributors, and exhibitors.

SIMULATING CINERAMA

The innovation of CinemaScope was guided, in large part, by the prior development of Cinerama, which served as both a positive and a negative determinant in Fox's development of its own widescreen system, providing Fox engineers with a model on which to base the studio's own process and with a list of highly publicized flaws to avoid. Though Fox rarely mentioned Cinerama in its own promotion of CinemaScope, the resemblance of its own process to Cinerama did not escape the attention of the industry. Shortly after Fox's initial announcement that it had obtained "Anamorphoscope, a French large-screen process," *Daily Variety* described it as "a new 3-D [*sic*] process which more or less simulates Cinerama."[3] Immediately after Fox had publicly demonstrated CinemaScope to members of the film industry, Fox stockholders, and the press in Los Angeles in mid-March, *Variety* pointed to the system's real attraction in its headline—"Pix Execs Hail 20th's CinemaScope for Its Practicality and Low Cost," admitting that although CinemaScope "doesn't have anywhere near the depth illusion of Cinerama, it has much greater practicality in production and exhibition."[4]

Even the contents of the first demonstration reels for CinemaScope invited comparison with Cinerama. In addition to clips from upcoming Fox productions such as *The Robe*, the demo contained roller-coaster-like shots

of dirt-track auto racing, aerial sequences, and travelogue footage of winter sports at Sun Valley and shots of the New York City skyline, harbor, and streets, as well as scenes of Alfred Newman rehearsing the Twentieth Century–Fox orchestra.[5] Later, after a demonstration in New York, *New York Times* critic Bosley Crowther reiterated *Variety's* analysis in his review of the process, noting that it was "similar to Cinerama," whose complex technology it streamlined and simplified.[6] CinemaScope was, for another industry analyst, a "poor man's Cinerama," providing something of the experience of Cinerama at considerably less cost.[7]

Though based on a different photographic technique and a radical new film design, the final CinemaScope process, which reduced the three-strip technique of Cinerama to one and its seven-track magnetic stereo sound system to four, was clearly developed to adapt the basic ingredients of Cinerama for use by the film industry as a whole. If Fred Waller, Hazard Reeves, and Co. did not choose to fully innovate and diffuse Cinerama, Fox did—in the form of CinemaScope. With CinemaScope, Fox designed a psuedo-Cinerama system that incorporated all of Cinerama's spectacular features—its large curved screen, its aspect ratio, and its multitrack stereo sound. But CinemaScope, unlike Cinerama, was designed for use in all of the nation's first-run theaters and in thousands of its sub-run sites (though not in drive-ins or thousands of small theaters).[8] Though most theaters ultimately rejected certain aspects of CinemaScope, such as its four-track stereo magnetic sound system, it penetrated the exhibition market to the point of saturation. By September 1957 Fox boasted that there were 46,544 CinemaScope installations around the world, with 17,644 in the United States and Canada alone (out of a total of 20,971 domestic theaters).[9]

DESIGNING CINEMASCOPE

It was the design of CinemaScope that won the approval of producers and exhibitors. Fox innovated CinemaScope in such a way as to provide an entirely new entertainment experience for the audience yet to conform, as much as possible, to existing production and exhibition technology, which was based on the 35mm standard. With Chrétien's Hypergonar lens, which possessed a squeeze ratio of roughly 2:1, Fox was able virtually to duplicate the 2.77:1 aspect ratio achieved by Cinerama, producing, when unsqueezed in projection, an image that was 2.66 times as wide as it was high. At the

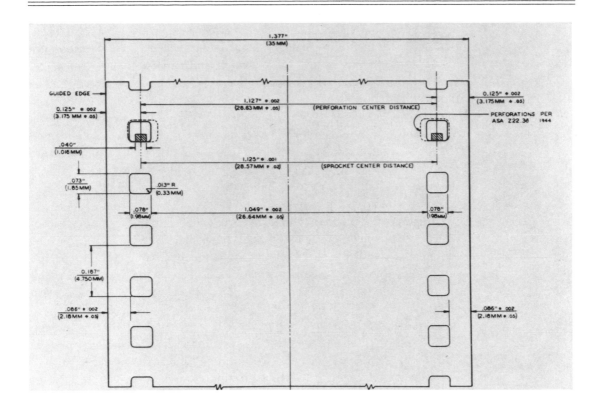

same time, Fox engineers investigated the use of stereo magnetic sound and curved projection screens.[10] Their task seemed simple: all they needed to do was to get Chrétien's anamorphic image and four tracks of stereo magnetic sound onto one strip of 35mm film. But in order to accomplish this and, at the same time, to achieve satisfactory image resolution in projection as well as high-quality sound reproduction, they had to create an entirely new 35mm film format which could accommodate four stereo magnetic soundtracks as well as a somewhat enlarged 35mm image. (The standard 35mm camera image was too small to contain all this information; it was only 0.631 inch high and 0.868 inch wide; the useful area was further reduced in projection to 0.600 × 0.825 inch.) Fox engineers achieved this by redesigning the 1.33/7:1 Academy format. As Sponable, Bragg, and Grignon pointed out in "Design Considerations of CinemaScope Film," the area of the 35mm frame could be maximized by reducing the size of the

REDESIGNING THE FRAME AND REDUCING THE SIZE OF PERFORATIONS (COURTESY OF SOCIETY OF MOTION PICTURE AND TELEVISION ENGINEERS).

perforations, thereby increasing the area left for conveying visual information while still permitting enough space for four magnetic sound tracks—two on each side "sandwiching" these smaller perforations.[11] Other widescreen formats, which employed masking in the projector for their effect, decreased the useful picture area: a 1.66:1 mask in projection wasted 29 percent of the image area, while 1.85:1 eliminated 36 percent. CinemaScope, on the other hand, was designed to take advantage of the entire area of the camera negative, which had not been done since the days of silent film. Using a camera aperture cut to 0.735 × 0.937 inch (and an aperture of 0.715 × 0.912 inch in the projector), CinemaScope actually increased the area within the frame by 32 percent.[12]

Large perforations had been necessary for the nitrate-base film stock on which motion pictures had previously been filmed and released because nitrate stock tended to shrink during and after processing. The new acetate film stock, which had been in use since 1948–49, underwent negligible shrinkage, and thus permitted a reduction in the size of perforations. These small perforations, which became known in the industry as "fox-holes," necessitated some retooling of film stock perforators and projector sprocket wheels, which were designed to transport films with conventional perforations as well. In April 1953, Eastman Kodak Company was put to work on the project and began converting printing equipment to handle the new perforations.

Kodak had introduced a new single-strip multilayered color negative film in 1950 which produced a sharper image on release prints than did Technicolor's dye-transfer process, which suffered from "the spread or wandering of dye during the transfer from the matrices to the release print blank."[13] Fox shifted from Technicolor to Eastman Color in order to take advantage of this improvement in image resolution and thus obtain sharper images on the screen, which had become a problem in the large-screen projection of Technicolor prints.[14] Fox chose Eastman Color over Technicolor for several other, equally practical reasons. Technicolor's three-strip cameras were unable to accommodate film with these smaller perforations, nor did its camera blimps (acoustical housing surrounding the camera to reduce camera noise) permit mounting of the CinemaScope lens attachment.[15] At the same time, Technicolor's dye-transfer process employed a system of belts, which held the matrices for printing; these belts had been built to convey film possessing the larger sprocket holes and were unable to accept these

smaller perforations.[16] Technicolor's tardiness in converting to the new perforations cost it a considerable amount of business until mid-1953, when plant retooling enabled it to process Eastman stock (including that with the new CinemaScope perforations).[17] As a result of these problems, the first few Fox CinemaScope films were shot with Eastman film, which was subsequently processed by Technicolor, with whom Fox had an outstanding contract.[18]

The increase in the area of film around the perforations on the Cinema-Scope release prints, coupled with the decrease in the size of the perforations, also increased the strength of the film stock, making it less subject to wear and tear. Fox thus saved money on replacement footage sent to theaters to replace torn or damaged prints. Durability tests of these new perforations conducted by Eastman Kodak indicated that "the life of CinemaScope film is three to four times as great as can be expected from former standard practice" because of the larger film area and because of changes brought about in the pitch of the intermittent sprockets on projectors that had been converted to CinemaScope.[19]

CHRÉTIEN'S ANAMORPHIC LENSES

The most crucial element in the creation of a widescreen system compatible with the 35mm standard was, of course, Chrétien's Hypergonar lens, which anamorphically squeezed a horizontally wide angle of view onto standard 35mm film. In projection a comparable lens unsqueezed the image, spreading it out across a screen roughly two and a half times as wide as it was high.[20] Chrétien's Hypergonar was a cylindrical lens that, when attached to a standard camera lens, compressed the horizontal field of view by a factor of two (that is, had a compression factor of x2) while leaving the vertical field of view unaltered. Unfortunately, engineers at Fox encountered a number of problems with Chrétien's original anamorphic attachment and were forced to redesign the optics of the lens—a process which began before Fox started production on *The Robe* but which continued for over a year thereafter. The first problem was that Chrétien's Hypergonar was an attachment; thus it and the prime lens had to be focused separately, making sharp focus difficult for the cameraman. During filming of *The Robe* Zanuck complained that in viewing the rushes he noticed "several spots where we appear to be definitely soft or out of focus," citing scenes with "the Queen

[*sic*] in the hallway corridor outside the throne room" and "the scene where Diana crosses over and goes out of the door from the throne room."[21]

The compression factor of these early lenses also tended to vary from lens to lens and even within a single lens: a x2 lens might be found to have a x2.5 compression factor at distances greater than thirty feet and a x1.8 compression factor at distances under eight feet.[22] This variation resulted in quite visible distortion on forward or backward tracking shots.[23] Sponable wrote to Chrétien on March 27, 1953, complaining that "on the 'follow'

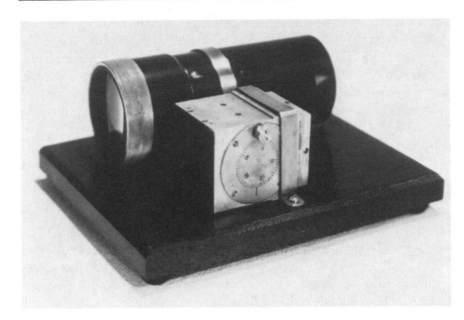

CHRÉTIEN'S
ANAMORPHIC LENS
(AUTHOR'S
COLLECTION).

shots which are very common in production work, the subject matter on the screen shows a noticeable distortion with people tending to become fat as the camera moves in."[24] This case of what was known as the "anamorphic mumps" prompted one Fox starlet to threaten to sue the studio unless her close-ups were reshot.[25]

Chrétien's lenses also possessed compression factors which varied across the surface of the lens, making objects at the edges of the screen seem thinner than those at the center.[26] After screening rushes of *Beneath the Twelve-Mile Reef*, Zanuck sent a memo to Sponable complaining that when actor Robert Wagner "goes to the left side of the screen, he seems to shrink up and there is an illusion of thinness. His arms look like toothpicks."[27] Both of these forms of distortion can be seen in release prints of *The Robe*, though they do not appear in films shot with the first batch of Bausch & Lomb Chrétien-formula lenses.

Because Chrétien's cylindrical lens was "made in a substantially square form" and "held in a square mounting,"[28] when it was combined with the standard camera lens, which was round, it produced what is known as vignetting. The smaller diameter of Chrétien's attachment "cut in" on the

larger diameter of the regular camera lens, resulting in a falling off of light at the corners of the image and creating something of an "iris" effect.

In April 1953 Fox contracted with Bausch & Lomb to make anamorphic camera and projection attachments based on Chrétien's design, placing "the largest commercial optical order in the history of the industry—for $2½ million—and accompan[ying] it by $625,000 in cash to enable the company to tool up."[29] Bausch & Lomb worked closely with Fox's engineers to solve some of the problems associated with Chrétien's original attachment. The first copies of the lens, which became available in late April and early May, relied on computer-derived formulas, "modern types of optical glass and the establishment of manufacturing tolerances and inspection standards,"[30] and resulted in some improvement in the quality of the taking lens. By July, vignetting had been eliminated by changing Chrétien's original lens profiles from square to circular in shape, which also "produced a gain of more than 20% in light transmitting area over the maximum size of the usual square form of converging element." By the same time, variation in the compression factor had been slightly reduced.[31]

BAUSCH & LOMB LENSES

It was not until January 1954 that lenses were produced that marked a significant improvement over the old, Chrétien-formula lenses (which were shortly thereafter retired).[32] These lenses combined the objective lens and the anamorphic attachment in a single housing, enabling them to be focused together by means of a single control. At the same time, they dramatically reduced distortion resulting from variation in compression factor. Indeed, Bausch & Lomb reported that "the distortion has been reduced by 600 percent."[33] The lenses also possessed "improved resolving power, better depth of field, and better flatness of field—that is, better relative definition at the edges of the field."[34] These lenses were first used to photograph *The Egyptian* (1954).

Chrétien's most recent Hypergonars dated back to 1937, when he had constructed several pairs to use in the Palace of Light Exhibition. These lenses were used to film the first three Fox CinemaScope features—*The Robe, How to Marry a Millionaire,* and *Beneath the Twelve-Mile Reef* (though the original French lenses were supplemented by several Chrétien-formula Bausch & Lomb lenses before production on these three films was com-

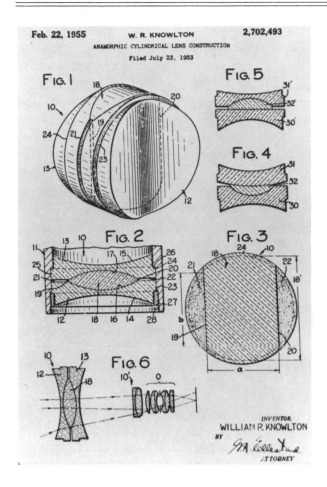

Feb. 22, 1955 W. R. KNOWLTON 2,702,493

ANAMORPHIC CYLINDRICAL LENS CONSTRUCTION

Filed July 23, 1953

INVENTOR.
WILLIAM R. KNOWLTON
BY
ATTORNEY

BAUSCH & LOMB'S PATENT FOR THE IMPROVED CINEMASCOPE LENS (AUTHOR'S COLLECTION).

pleted).[35] Since only three of Chrétien's original Hypergonars were deemed acceptable for purposes of production, and because all three features were in production simultaneously, each production was limited to the use of just one lens; other CinemaScope productions at Fox, as well as those at M-G-M, had to await the first delivery of Chrétien-formula Bausch & Lomb lenses at the end of April 1953.[36] Confronted with these delays, M-G-M decided to shoot its next big-budget picture, *Kiss Me Kate* (1953), in 3-D instead of CinemaScope; its first CinemaScope picture was *Knights of the Round Table* (1953).

By increasing camera and projector aperture sizes, Fox also effectively

increased its system's transmission of light both from the scene being photographed to the negative and from the projector to the screen. This was crucial for two reasons. First, the optics of Chrétien's original Hypergonar lens were considered slow, initially estimated by Earl Sponable at "about f2.5."[37] Thus they demanded a great deal of light and a wide aperture setting. As a result, considerable light was lost in both photography and projection. Second, the slowness of the lens resulted in increased production costs for additional lighting units; cameramen also tended to overlight then stop down the aperture in order to improve definition and depth of field.[38]

MIRACLE MIRROR SCREENS

Widescreen projection in the theater tended to demand more light because a light source of fixed value—that is, the arc lamp of the standard projector—was required to light more screen area. All 3-D and widescreen systems of the period encountered similar problems in screen illumination, either because of light loss due to intervening polaroid filters and glasses, or because of decreased aperture size due to masking coupled with an increased screen area in need of illumination. The solution to light loss lay in the development of more highly reflective screen material, something that Fox had already been working on for several years in connection with its Eidophor project, a system for theater television.[39]

Like Chrétien's anamorphic lens, Fox's directional screen had its origins in the transition-to-sound period. From 1928 to 1930 the German firm of Siemens Halske experimented with an embossed screen using aluminum foil cemented to a backing. Basing its research on this technology, Fox developed a curved screen consisting of a special cotton fabric embossed with thousands of "tiny concave mirror-like elements" which directed the reflected light only into the actual seating area of the theater.[40] In fact the Research Department generated two embossment patterns—"one for head-on projection and a tilted design for high-angled projection."[41] The directional quality of these screens, which Fox called "Miracle Mirror" screens, served to reduce scatter and to improve overall screen brightness. "By concentrating all of the incident light only to the regions of the audience, a screen is obtained which is at least twice as bright as the usual screen for the same value of projector illumination."[42]

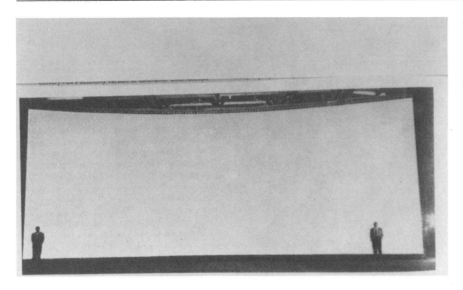

To ensure the best possible screen illumination for its CinemaScope features, Fox's initial contract with exhibitors required that theaters install these screens or others of equal reflectivity, such as the Magniglow Astrolite screens.[43] These new screens, however, were not without problems. They were expensive and difficult to install. Reports on theater installations noted that they sometimes suffered from moire (shaped patterns put on them during manufacture which were often visible from certain angles in the theater); seam visibility when sections were badly sewn together; lack of tautness when the laces connecting the individual sections loosened; and paneling (the effect of vertical bars produced by the joining together of darker and lighter strips of screen material).[44]

In terms of the overall cost of conversion to CinemaScope, the lenses themselves proved something of a bargain. Fox estimated installation costs at $25,000 for a large first-run house seating over 2,000 (such as Radio City Music Hall), $15,000–17,000 for a medium-sized house (seating 1,500–2,000), and $10,000–12,000 for a small theater.[45] The studio initially marketed a pair of projection lenses for $2,800, then lowered that price to $1,900; by April 1954, lenses sold for as little as $1,000 a pair.[46] Miracle Mirror screens required a greater investment; they cost two to two and a

BEFORE AND
AFTER: THE
CONVERSION OF A
SMALL THEATER
TO CINEMASCOPE
(AUTHOR'S
COLLECTION).

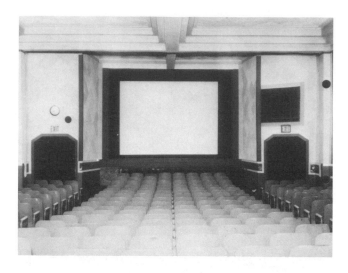

half times as much as a conventional screen per square foot and, because of the added width, demanded about twice as much total screen material.[47] Depending upon theater size, the screens could cost $800–3,200 for screen material alone. At the same time, since only a few theaters possessed proscenia wide enough to accommodate the CinemaScope image, most were forced to install new ones.[48]

STEREOPHONIC SOUND

CinemaScope's curved Miracle Mirror screens presented a dramatically visible departure from the 35mm norm, and although theaters objected to the cost (and negotiated with Fox for cheaper substitutes),[49] they realized that they could not cut corners on screen width without seriously compromising the novelty of the very attraction that drew spectators back to their theaters. But Fox's inclusion of stereophonic sound in the CinemaScope package posed a more challenging set of problems in terms of cost and compatibility with existing exhibition standards, especially for small, independently owned theaters, which could not afford the extra $3,000 price tag for stereo sound (even with Fox's much-publicized offer of assistance in financing).[50]

The association between widescreen formats and improved sound quality dated back at least as far as Fox's experiments with the 70mm Grandeur system in the transition-to-sound era. Sponable viewed the advent of wide film as an opportunity to increase by 250 percent the space devoted to the monaural, optical soundtrack on the film stock, thus increasing sound information and improving sound quality in reproduction.[51] Sponable and others subsequently reasoned that wide formats such as CinemaScope demanded a "wider" sound display, in which spatially displaced speakers behind the screen would accentuate this broader visual field. The postwar diffusion of magnetic sound recording as a production standard made high-fidelity monaural sound reproduction in the theater a possibility as early as 1950, but theaters had resisted it as an exhibition standard. As a result, theatrical release prints continued to be issued with optical soundtracks, largely to accommodate theatrical standards, which remained the same as they had been in the early 1930s, when optical means of sound reproduction became the norm. Fox engineers insisted that the use of magnetic sound tracks in theaters for certain 3-D presentations, Cinerama, and CinemaScope marked a dramatic improvement over earlier optical sound systems, providing a sound "with low distortion and a high signal to noise ratio"[52] and hoped to use stereo magnetic sound as a weapon to force theaters to upgrade what the engineers considered to be an antiquated exhibition technology.

Fox based its sound process on the optical stereo sound system pioneered by Harvey Fletcher of the Bell Telephone Laboratories in the mid-1930s

and by Disney for its optical stereo release of *Fantasia* just before the war, and on the magnetic stereo sound system developed by Hazard Reeves for Cinerama.[53] Previous experiments with stereo sound for motion pictures had relied on double-system presentation, with the multiple soundtracks contained on one strip of film and the images on another (or, in the case of Cinerama, others). After initial demonstrations in March and April 1953 using a double system, by May Fox had modified the system in order to get all the picture and sound information onto a single strip of film.[54] In doing this, Fox was forced to reduce the original CinemaScope aspect ratio from 2.66:1 to 2.55:1.

Fox's campaign to convert the nation's exhibitors to stereo magnetic sound proved only partially successful. Though all of the 3,234 theaters that had installed CinemaScope by April 1954 bought stereo sound as part of the entire package, exhibitor resistance to Fox's stereo-only policy throughout 1953 and the spring of 1954 forced the studio to begin to release Cinema-Scope films in three different versions—with monaural optical, with one-track magnetic, and with four-track stereo magnetic soundtracks. In June 1956, in order to reduce the costs involved in striking separate magnetic and optical release prints, Fox announced that it would release all future productions, starting with *Bus Stop*, in a combined magnetic and optical format which was subsequently referred to as "magoptical" and which provided both kinds of tracks on a single print.[55] At the same time Fox also abandoned its "fox-hole" perforations, returning to the larger sprocket holes favored by the majority of producers and exhibitors. However, in order to add an optical soundtrack to its revamped CinemaScope film frame, Fox was forced to reduce the picture area by 10 percent. This step reduced the overall aspect ratio from 2.55:1 to 2.35:1, which remains the current aspect ratio for anamorphic release prints in use today.

CINEMASCOPE 55

The advent of VistaVision's wide-negative-area production format in 1954, together with the threat posed by Todd-AO's 65/70mm wide-film system from 1953 through 1955, forced Fox to continue to search for ways to improve CinemaScope. Though double-frame VistaVision could be exhibited in only two theaters—Radio City Music Hall in New York and the Warner Beverly in Beverly Hills—Paramount's high-quality 35mm reduc-

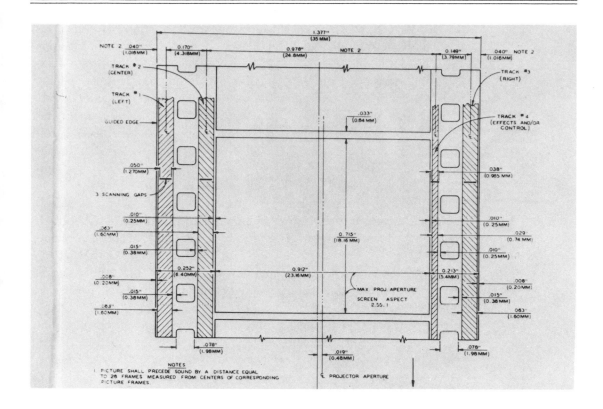

tion prints provided a convincing argument for filming with large-area negatives and printing down for theatrical release.[56] VistaVision provided one production model for Fox. But it was the sensational box-office success of *Oklahoma* (1955) in Todd-AO that impelled Fox management to accelerate its development of a wide-film format suitable for roadshow exploitation.

Fox engineers, realizing that many of CinemaScope's early problems with distortion and lack of sharpness were due, in large part, to the use of 35mm as a recording format, had repeatedly suggested using wide film as a production medium. Now that management had given them the go-ahead to innovate a wide-film process that could compete with Todd-AO, the Research Department began work on CinemaScope 55, a wide-film format that could be roadshown in select first-run houses and could easily be reduced for 35mm distribution and exhibition, thus dramatically improving

FOX'S DESIGN OF THE CINEMASCOPE FORMAT PLACED THE IMAGE AND FOUR STEREO MAGNETIC SOUNDTRACKS ON A SINGLE STRIP OF FILM (AUTHOR'S COLLECTION).

the visual quality of 35mm CinemaScope release prints. Working with Eastman Kodak and Bausch & Lomb, Fox conducted tests to see "what the optimum size of the negative image might be" from the point of view of film grain and information storage capabilities, if that image were to be reduced to a 35mm format for projection.[57] It was thus the studio's intention to take into account in its design process the needs of the current multitiered exhibition marketplace, hoping to avoid many of the problems it had originally encountered with CinemaScope in trying to adapt it to the requirements of both large and small theaters.

As a result of these tests, Fox discovered that a 55.625mm wide-film production format was ideal; beyond it there appeared to be little gain (if the image was to be reduced to 35mm for exhibition); but up to it, there were marked improvements in grain and definition.[58] Using the smaller CinemaScope perforations and an eight-sprocket two-frame-high image, the 55.625mm format provided four times the picture area of the standard 35mm frame. When reduced to 35mm, it resulted in an image which Zanuck and others declared to be "without grain."[59]

Like CinemaScope, CinemaScope 55 employed an anamorphic lens, designed by Bausch & Lomb, with a 2:1 squeeze that would yield, in wide-film projection, a 2.55:1 aspect ratio. Bausch & Lomb also came up with a lens that could be used in reduction printing.[60] Six-track stereo magnetic sound, which gave "a clarity and separation of musical instrumentation, and a depth and realism which [was] unobtainable by any other recording means," was chosen to augment the image in roadshow presentation; sound and image were run double system in several first-run theaters.[61] The process involved the printing of release prints on 55.625mm positive stock by means of optical reduction, printing down the eight-perforation frame of the original camera negative to a six-perforation frame for projection. Fifty-five-millimeter projectors were designed and built by Laurence Davee, as were 55mm conversion kits for 35mm projectors.[62]

CinemaScope 55 was first used to film *Carousel* and *The King and I* (1956), which were tradeshown in CinemaScope 55 but released in 35mm CinemaScope only.[63] The dismal box-office returns on *Carousel* prompted Fox to abandon the process.[64] Even though *The King and I* made money,[65] the CinemaScope 55 process never caught on with the public, in large part because (as Zanuck explained it) "most people did not know the difference between regular CinemaScope and CinemaScope 55."[66] Since Fox never

presented CinemaScope 55 in a wide-film format, it lacked (except for its sharper image) any differentiation as a product from 35mm CinemaScope films. Zanuck balked at any further experimentation with CinemaScope 55. In 1958, after the death of Mike Todd, Zanuck began to campaign for Fox to adopt Todd-AO. He was assisted in this effort by several partners in the Todd-AO process who had close ties to Fox: George Skouras, Spyros' brother and head of Magna Theatre Corporation; and Joe Schenck, a former executive at Fox who had originally been Zanuck's partner in Twentieth Century Films, had accompanied him to Fox in 1935, and had left the company in early 1953 to join Todd in the launching of Todd-AO.[67]

Zanuck explained that Fox's 55mm process "may be almost as good as Todd-AO, but I doubt it greatly, particularly from the standpoint of the public."[68] For Zanuck, Todd-AO was "associated in the public's mind with two enormously successful films," *Oklahoma!* and *Around the World in 80 Days*, "making the system a box-office star in the public's mind."[69] In 1958 Fox bought 51 percent of Todd-AO and began producing roadshow films, such as *South Pacific*, in that format, demoting CinemaScope in status from a premiere production and exhibition format to one associated with conventional releases.

PANAVISION

Although Fox continued to make films in CinemaScope until 1967, when it released its last CinemaScope film, *In like Flint*, CinemaScope's preeminence as an anamorphic process was eclipsed in the early 1960s by Panavision's 35mm anamorphic technology. In 1954 Robert Gottschalk developed an anamorphic projection "lens" which was compatible with all widescreen formats, whether anamorphic or flat. It consisted of a pair of prisms which could be moved in relation to each other to alter the horizontal expansion factor; thus projectionists could use the lens at one setting for flat films and at a series of intermediate settings for anamorphic films which possessed squeeze ratios ranging from x1.1 to x2 (CinemaScope).[70] Gottschalk subsequently designed a high-quality anamorphic camera lens, which he began to market aggressively, through comparison tests with Bausch & Lomb's CinemaScope lens, in 1958. This lens dramatically reduced the distortion inherent in CinemaScope lenses when filming extreme close-ups and won Panavision a "Class II" Technical Award from the

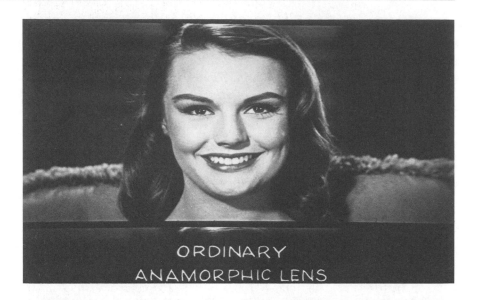

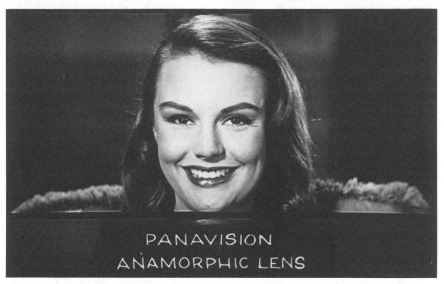

PANAVISION'S COMPARISON TEST REVEALS THE ABILITY OF ITS NEW LENS TO CORRECT FOR LATERAL DISTORTION (AUTHOR'S COLLECTION).

Academy of Motion Picture Arts and Sciences in 1958.[71] In 1959 several major studios began using Gottchalk's camera lens for 35mm production, and Fox itself finally adopted the Panavision lens in 1968.

The development of CinemaScope provides a dramatic example of the ways in which motion picture technology adapted itself to suit the demands of the marketplace. Though Fox satisfied most of those needs by innovating a process that was compatible with existing 35mm equipment in the theater, it was unable to change the exhibition standard from monaural optical to multiple-track stereo magnetic sound. Yet even as CinemaScope was being dismantled in the marketplace in April and May of 1954, the research department which designed it was receiving a "Class I" Technical Award from the Academy of Motion Picture Arts and Sciences for "creating, developing and engineering the equipment, processes and techniques known as CinemaScope."[72] Though Fox had successfully innovated and diffused a Cinerama-like widescreen process, by 1955 another Cinerama clone had taken its place as the most exciting, new, widescreen experience in an ever-changing exhibition market—Todd-AO.

8 TODD-AO: THE HALLMARK OF QUALITY

In 1989 the motion picture industry commemorated the hundredth anniversary of 35mm motion picture film. Though 35mm film continues to be the dominant format for commerical film production and exhibition and was virtually the sole film gauge used by the industry for over sixty years, it is no longer the only production and exhibition standard. Over the past thirty-five years a second standard—that of 70mm—has entered the motion picture marketplace. In 1955 there were only four theaters equipped to show films in 70mm; today there are more than nine hundred, and, since the release of *Star Wars* (1977), almost every potential blockbuster has been released in 70mm and shown at a rapidly growing number of top-tier first-run theaters.[1]

The words *70mm* on a theater marquee or in a newspaper advertisement have become identified in the public's mind with the highest quality in motion picture presentation.[2] Like the trade name Dolby Stereo, with which 70mm is almost invariably associated, a 70mm presentation promises, regardless of the quality of the film's dramatic content, spectacular entertainment values. But unlike Dolby Stereo, 70mm is not a trademark. It has established its special status in the film industry without the marketing muscle of a specific corporation. It has become a generic term for wide-film, big-screen entertainment. This "generic" 70mm revolution began more than thirty-five years ago with a "brand name" known as Todd-AO, the combined product of the entrepreneurial energy of Mike Todd and the engineering efforts of American Optical, whose initials became part of the name of the process.[3]

Dozens of wide-film systems, ranging from Magnafilm (56mm, 1929) to Natural Vision (63.5mm, ca. 1930) and Grandeur (70mm, 1929), had been developed during the transition to sound in an attempt both to compensate for the reduction in image size brought about by the addition of an optical soundtrack alongside the image and to facilitate large-screen projection in the nation's movie palaces, but none of these systems was adopted by the

film industry at the time. It was not until the the 1950s, with the introduction of Cinerama, CinemaScope, VistaVision, and other widescreen formats that wide film emerged as a commercially viable solution to technical problems introduced by the new popular demand for large-screen motion picture entertainment.

FILLING THE LARGE SCREEN

Before the widescreen revolution the average screen size was 20 × 16 feet, and "a 24 × 18-foot picture was considered to be just about the limit for good illumination and resolution."[4] Cinerama and CinemaScope involved the projection of 35mm images on much larger screens, ranging in width from 40 to 65 (or more) feet.[5] Though Cinerama's use of three adjacent 35mm images (and a faster, 26-frames-per-second film speed) actually increased image resolution in projection, even on a 65 × 23 foot screen other widescreen systems, especially those employing wide-angle projection lenses, magnified the 35mm image to such an extent that image quality deteriorated quite visibly. After the advent of Cinerama the 35mm image was regularly masked in projection and blown up to fill a larger screen area than ever before, thus forcing less film to cover more area. The redesign of the 35mm frame for CinemaScope brought some improvement in overall image information and quality, as did 35mm VistaVision, which enhanced image sharpness by generating conventional release prints from large-area original negatives. Additional gains were achieved by improvements in projector arc lamps, reliance upon aluminum screen surfaces, and use of high-speed, short-focal-length projection lenses.[6] Nonetheless, even the best of these new widescreen systems—CinemaScope and VistaVision—involved greater magnification than had been the case with the old Academy format, which enlarged the 35mm image 125,000 times in projection to fill a 24 × 18 foot screen. In blowing images up to fill a 64 × 24 foot screen, CinemaScope magnified its original 35mm film image 330,000 times; the 35mm VistaVision frame was enlarged 216,000 times for projection on a somewhat narrower, 55 × 27 foot screen.[7] The only way to preserve the sharpness and resolution of the projected image was to use larger negative areas in production and reduce them to 35mm for exhibition, as the VistaVision and CinemaScope 55 processes did, or to shoot and project films on wide film stock. CinemaScope 55, though never shown commer-

cially using wide-film projection, was designed to solve many of these magnification problems; the projected image was intended to fill a 60 × 24 foot screen yet, in doing so, to magnify the image only 86,000 times.[8]

Todd-AO, introduced with the premiere of *Oklahoma!* at the Rivoli Theatre on October 10, 1955, provided a similar solution to the magnification problem experienced by earlier widescreen formats. Todd-AO relied on a 65mm negative for filming, which possessed three and a half times the negative area of 35mm film, and a 70mm print for projection (the extra 5mm being used to carry six magnetic soundtracks for stereo sound).[9] Todd-AO achieved the sharpness and resolution of the average pre-widescreen film but did so on a larger screen, magnifying, in projection, its five-perforation, 65mm frame 127,000 times (that is, only 2,000 times more than the 1.33/7:1 35mm projected image) to fill a deeply curved 52 × 26 foot screen. The sharpness of the image was also enhanced by a 30-frames-per-second film speed in both camera and projector, which "smoothed out" the action on the screen by eliminating flicker and improved image resolution.[10] The commercial success of *Oklahoma!* ensured that wide film and a new production and exhibition standard of 65/70mm would gain acceptance in the industry, though the adoption of this new format remained limited to a select number of producers and exhibitors.

A CLASS ACT

Todd-AO's reliance on a 65/70mm format not only solved technical problems, ensuring a sharp image when blown up onto a large screen; it also endowed the process with a certain prestige, which its promoters exploited in marketing Todd-AO films. Because it cost producers about two and a half times more to shoot films in Todd-AO than in 35mm, properties were chosen with greater care; economics dictated that only high-quality, pre-sold productions could guarantee a return on the large investment necessary to generate a negative. Though CinemaScope and VistaVision got their products into the nation's theaters first, Todd-AO gained a foothold despite their increasing domination of the market by providing something that they did not—the superior quality of 70mm and the most highly sought-after theatrical property of the past decade, Richard Rodgers and Oscar Hammerstein's 1943 Broadway musical, *Oklahoma!*[11]

Like CinemaScope, Todd-AO sought "to duplicate the results of

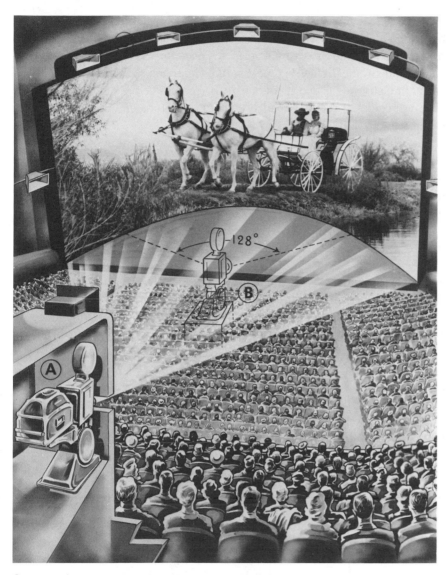

OKLAHOMA! PROJECTED BY A SINGLE PROJECTOR ONTO A DEEPLY CURVED SCREEN.
SEVEN SPEAKERS PROVIDED STEREO SOUND (COURTESY OF ACADEMY OF MOTION
PICTURE ARTS AND SCIENCES).

Cinerama" by using a single film and projector instead of Cinerama's three film strips and three projectors.[12] But whereas CinemaScope was engineered by a major studio to satisfy mass-market needs for large-screen, widescreen entertainment, the Todd-AO process, like Cinerama, was developed outside of the industry itself, and it was designed to answer the demand for a new kind of special-attraction, roadshow motion picture entertainment, which Cinerama had stimulated.

Though Fox attempted to redefine the nature of the motion picture experience with CinemaScope, it did so within the constraints of an industry whose conflicting needs it was forced to satisfy. As a result, CinemaScope, initially hailed as a "poor man's Cinerama," ultimately devolved into a poor man's CinemaScope, playing on small screens in small theaters, stripped of its stereo sound. As industry outsiders, the developers of Todd-AO (like those of Cinerama) ignored the mass market for the "class" market, pitching their wares to a select number of top-tier first-run theaters and to an elite audience of traditional theatergoers, who were willing to pay top prices to see Broadway-style entertainment in exclusive, roadshow situations.[13] As Todd explained it, with a roadshow you "make believe you got round actors and sell hard [reserved seat] tickets." If the product is high quality, "the carriage trade will swim a river of crocodiles to see it. To show they got class and appreciate the arts, they'd be insulted if you didn't charge premium prices and make it a little hard to see. This way they don't have to rub elbows with the gum chewers. Besides, if you get the reviews and have a hot ticket, the gum chewers will figure out how to get in as well. Once you're a hit in New York, you'll have to fight the out-of-town exhibitors off with a stick."[14]

By associating itself with prestigious theaters and exceptional motion picture productions, Todd-AO established itself, at the height of the wide-screen revolution in the mid- and late 1950s, as the premiere widescreen process. Unlike CinemaScope, which sought to saturate the exhibition market and which was installed in tens of thousands of theaters worldwide, Todd-AO never played in more than several hundred theaters around the world.[15] Unlike CinemaScope, which was used to photograph over six hundred films, only fifteen feature films were made in Todd-AO; yet those fifteen films won eighteen Academy Awards (not including one which Todd-AO and Westrex received in 1957 for developing the Todd-AO sys-

tem).[16] Todd-AO was no poor man's Cinerama; if anything, Todd-AO reduced Cinerama to a poor man's Todd-AO.

TODD THE SHOWMAN

The inspiration for Todd-AO, like that for CinemaScope and several other widescreen processes, had its origins in Cinerama, whose strong sense of audience participation it attempted to reproduce. Michael Todd, whom one critic described as possessing "the soul of a carnival pitchman and the ambition of a Napoleon,"[17] was tremendously impressed by Waller's demonstration of Cinerama, which he saw on an enclosed tennis court on Long Island in December 1950. Todd viewed Cinerama's ability to engulf the audience as the basis for a kind of supercolossal sideshow attraction that would have unprecedented audience appeal. After this initial screening, Todd kept telling Lowell Thomas, his future partner in the Cinerama venture, "It'll hit them and squeeze them . . . hit them and squeeze them," stressing the potential of the process as an audience-grabber.[18]

Throughout his career Todd kept his fingers on the pulse of the audience, designing entertainment which he could sell to the public. For the 1933 Century of Progress Exposition in Chicago, Todd produced the Flame Dance, in which a female dancer, representing a moth, "had her clothes gradually singed off by a real flame."[19] After his success with *The Hot Mikako,* a jazz version of the Gilbert and Sullivan operetta, at the 1939 world's fair, Todd opened a nightclub in Chicago which seated 5,000 and which catered to the middle-class family, featuring floor shows which started at 6:15 (so parents could get home and put the kids to bed at a reasonable hour) and serving champagne cocktails for 25 cents and dinner for 75 cents.[20] Todd's astute manipulation of leisure-time entertainment culminated in his 1952–53 production of A *Night in Venice,* featuring gondoliers and a water ballet, at Jones Beach's Marine Stadium. "With a company of 300, including Metropolitan Opera singers, Todd presented the show, set to Johann Strauss music, across a 90-foot stretch of Zachs Bay from a 104-foot island stage with a revolving center."[21] Reviewers described the production as "a strange parlay between culture and carnival excitement . . . between Strauss and a hot dog."[22]

TODD AND CINERAMA

Todd's initial enthusiasm for Cinerama as a crowd-pleaser was soon dampened by his increasing awareness of its various technical flaws. During the production of the European sequences of *This Is Cinerama*, Todd discovered that much of the footage he had shot was unusable because of optical distortion in the side panels, which skewed horizontal lines, and because of the visibility of the blend lines, which had not been adequately camouflaged by the cameraman in framing the overall composition.[23] Todd complained to Cinerama's board of directors. But they were assured, in turn, by Waller that these problems would eventually be solved and that they would not be immediately noticeable. As a result, the board refused to take any immediate action.[24]

Cameramen eventually learned that the camera had to be carefully positioned and the action ingeniously staged to avoid calling attention to

the process' inherent distortion. This tactic resulted in a certain impoverishment of cinematic technique. The *New York Times* reported that the Cinerama camera was "too immobile; there is little use of the customary drama-heightening tricks used in conventional moviemaking, e.g., panning, cutting, tilting."[25] Though certain spectacular sequences, such as the rollercoaster ride, so overwhelmed audiences that they did not perceive the distortion in the image, the blend lines, the different color temperature of each panel, and the frequent loss of register as the horizontal frame lines shifted from panel to panel, more seasoned viewers spotted these defects, and, after the release of the film, critics repeatedly called the general public's attention to these problems.[26] Todd's concern about Cinerama's faults prompted his initial disenchantment with the process. Other disagreements between Todd and the Cinerama board led to his replacement; Merian C. Cooper and Robert L. Bendick produced the remainder of the film. Shortly after the release of *This Is Cinerama*, Todd sold his interests in Cinerama and decided that "if the Cinerama people were not going to try to perfect the process, he would get out and do it on his own."[27]

PACKAGING TODD-AO

While Fox was busy developing its own solutions to the problems inherent in Cinerama, Todd, the inveterate showman, began to "produce" his own single-strip, wide-angle, widescreen system by signing up "talent" and by amassing money for financing. The first and most crucial member of Todd's all-star cast was Brian O'Brien, whom Todd referred to as "the Einstein of the optical racket."[28] O'Brien, a former professor of optics at the University of Rochester and current director of the Institute of Optics, had no connection with the motion picture industry; but as a member of the National Defense Research Committee from 1940 to 1946 he had built for the government an ultra-high-speed motion picture camera, which ran at 10 million frames per second and which was used to film test explosions of the atomic bomb.[29]

In October 1952 Todd contacted O'Brien, described the virtues and limitations of Cinerama, and asked him to design a Cinerama-like motion picture system "where everything comes out of one hole."[30] Having just taken a leave of absence from the university in order to assume the position of vice-president in charge of research at American Optical, O'Brien rec

ognized the commercial potential of a single-strip Cinerama system and agreed to take on Todd's project. By December 1952 one of O'Brien's associates, Robert Hopkins, had worked out the basic optical system on paper, including its centerpiece—a 128-degree bug-eye lens.[31] Todd then based his sales campaign to potential investors on this design and on O'Brien's prestige in the field of optics. Todd first secured the backing of his old friend and gambling crony Joe Schenck, who was executive head of production at Fox and a major stockholder in the United Artists Theater Circuit.[32] Schenck, in turn, brought George Skouras, president of UA Theaters, into the financing group, which also included producers Arthur Hornblow, Jr., and Edward Small. Schenck, who had been with Fox since 1935 and with Zanuck since 1933, abruptly resigned his position from Fox in February 1953, claiming (in what was subsequently revealed to be a cover story for his real reason for leaving) that his control of the United Artists Theatre circuit violated the terms of the Paramount consent decree and prevented him from remaining involved in production.[33]

On March 25, 1953, Schenck, Skouras, Todd, and the others announced the formation of the Magna Theatre Corporation, which would produce, distribute, and exhibit a new, 65mm widescreen process. Hornblow, who had worked with Richard Rodgers (and Lorenz Hart) on *Mississipi* (1935), contacted his old friend Rodgers and Rodgers' song-writing partner Oscar Hammerstein II, sold them on the box-office potential of Todd's new widescreen process, and convinced them to join Magna's board of directors.[34] Rodgers and Hammerstein agreed to write an original story for Magna's first film and to produce "a limited number of musical pictures," two or more of which would be distributed through Magna.[35] What Magna really wanted was *Oklahoma!*, but Rodgers and Hammerstein remained noncommittal about this particular property until the Todd-AO process was ready to be demonstrated to them six months later.

When initial financing had been completed, O'Brien put 100 research specialists and engineers at American Optical to work on perfecting the process, which included not only a series of camera and projection lenses and special optical printers but also a new kind of lenticular screen, which was designed by O'Brien and based on his own optical formula.[36] American Optical was also commissioned to develop a projection system that could be installed in existing projection booths and that would eliminate the distortion involved in projecting images from extreme projection angles onto

deeply curved screens.[37] American Optical farmed the actual construction
of projectors out to Philips of Eindhoven, Holland, which collaborated
closely with AO on the design of an all-purpose projector head and projec-
tion booth equipment.[38] Westrex was enlisted to develop recorders for
six-track magnetic stereo sound;[39] and Ampex designed a special "equal-
izer-relay-switching rack" to make Todd-AO's six-track magnetic sound
compatible with all existing theater sound systems.[40] The Todd-AO camera
was made by the Mitchell Camera Company, had a three-blade dissolving
shutter with an opening of 170 degrees, and ran at a speed of 140.25 feet
per minute, or 30 frames per second rather than the 24 frames per second
of standard 35mm film.[41] Since sound was recorded at the standard speed

of 90 feet per minute, sound recording equipment interlocks were redesigned to "marry" the faster film speed to the slower sound speed.[42]

DESIGNING A BETTER CINERAMA

The Todd-AO system attempted to match and surpass Cinerama in a variety of ways. One of these was angle of view. Todd-AO's 128-degree bug-eye camera lens achieved an angle of view which closely approximated that of Cinerama, which was 146 degrees.[43] The bug-eye lens was permanently mounted on one Todd-AO camera.[44] However, American Optical also designed three other wide-angle lenses, which were also classified by their angles of coverage and which could be used interchangeably on a second Todd-AO camera.[45] (Subsequent streamlining by American Optical enabled all four lenses to be used interchangeably on a single camera.)[46] These lenses took in angles of view of 64, 48, and 37 degrees.

Critics of Cinerama complained that because of its extremely wide coverage, it lacked the "sense of intimacy" that was crucial in conventional motion picture storytelling.[47] In other words, it could not provide acceptable close-ups. Cameramen could use Todd-AO's bug-eye lens for spectacular effects in exterior long shots, then switch to lenses with narrower angles of view for medium shots and close-ups.[48] Introducing a greater optical variety into the system than was available in Cinerama, Todd-AO's battery of lenses permitted the cameraman to exploit the full range of expression traditionally found in 35mm production, which relied on a variety of lenses of different focal length.[49] *Oklahoma!*'s director, Fred Zinnemann, commented that "so far as I'm concerned, there is nothing you cannot do with this medium. This includes the use of close-ups and complete mobility of the camera as regards pan shots, dolly shots, etc. The tremendous importance of this is that a story can be told by this process in motion picture terms, and this to my mind is the difference between Todd-AO and Cinerama in which the camera is static."[50]

Another area of concern was film speed. Cinerama had improved the sharpness and resolution of the projected image by increasing the number of frames per second (fps) for camera and projector from 24 to 26. Todd-AO's 65mm negative and five-sprocket-holes-high frame approached the information capacity of Cinerama. Its film speed of 30 frames per second surpassed Cinerama's 26, providing a more detailed and steadier image in

projection. However, since this speed deviated from that used in standard 35mm projection, Todd-AO was forced to shoot *Oklahoma!* in a 35mm 24-fps CinemaScope version as well as in Todd-AO. *Around the World in 80 Days,* the second production, was filmed in 65mm at two different speeds—30 and 24 frames per second; the latter speed facilitated the reduction of the original wide-film negative to a 35mm anamorphic format. This provided Magna with prints that could be run in theaters not equipped with Todd-AO.[51] O'Brien had designed an optical printer to generate 35mm prints from 30-fps Todd-AO originals, but he was unable to build a printer that could accomplish continuous reduction without mutilating the film.[52]

Another feature addressed was stereo magnetic sound. Todd-AO's six-track stereo magnetic sound, with a frequency range of 40- 12,000 cycles, was patterned after Cinerama's seven-track stereo system but was designed as a single-system format. However, in its first theatrical presentations of *Oklahoma!* Todd-AO relied on a Cinerama-like double system, placing six 100-mil magnetic tracks on a separate strip of 35mm film that was run in synchronization with the image.[53] Five channels fed speakers located behind the screen, a sixth track provided surround sound, and a seventh track contained information controlling the other six.[54] Seventy-millimeter composite prints featured two "outboard" sound tracks outside the perforations and one track between the perforations and the image area, resulting in an aspect ratio of 2:1.[55]

Todd-AO also sought to increase negative area. Its use of 65mm film and of a five-perforation frame resulted in an image quality that approximated the three-strip, six-perforation frame of Cinerama. Robert Surtees, director of photography on *Oklahoma!*, insisted that Todd-AO's use of a 65mm negative made it, "from the standpoint of optics alone, a superior picture process" to all other 35mm widescreen processes.[56]

CURVED-SCREEN EXHIBITION

Cinerama introduced the deeply curved screen to motion picture exhibition. Although curved screens automatically amplified the sense of audience participation by surrounding spectators with the image, they also presented several problems. Light reflected from one edge of the screen struck the opposite edge, washing out the image. Cinerama's louvered screen, consisting of 1,100 vertical strips, prevented the reflection of light back onto the

other side of the screen. Todd-AO's specially designed lenticular screen, which was "a plastic-coated fabric with an aluminum surface embossed in a formation of lenticles, or tiny lenses," performed a similar function, preventing "the surface from reflecting light back on itself at the extremities."[57] Like CinemaScope's Miracle Mirror screen, Todd-AO's screens also concentrated the reflected light into the area occupied by the audience rather than dispersing it throughout the auditorium.

However, deeply curved screens also introduced distortion into the image. Whenever a flat image is projected upon a curved screen, the horizontal lines of the image are necessarily distorted. The Cinerama system thus resulted in severe distortion, given the extreme curvature of its screen. CinemaScope minimized distortion by opting for a slightly curved screen—a screen which curved at the approximate rate of one inch per foot, resulting, in the case of a 62-foot-wide screen, in a 5-foot curve. The CinemaScope curve compensated for the horizontal expansion of the image, keeping the screen at a more or less constant distance from the center of the projection lens and thus ensuring a focus that was as sharp at the edges as at the center. A 60-foot-wide Cinerama screen curved to a depth of 16 feet.[58] The Todd-AO screen curved to a depth of 13 feet for a 52 × 26 foot screen.[59] This extreme curvature resulted in visible distortion, which O'Brien corrected in his design of the system's optics.

The use of wide-angle lenses in photography, upon which the Cinerama and the Todd-AO optical systems almost exclusively relied, compensated somewhat for the distortion introduced by the curved screen, as did Cinerama's use of three separate projection booths, which facilitated the angling of the side booths and thus diminished some linear deformation. Cinerama's would-be solution to the distortion problem—head-on projection from three separate booths—was only partially successful and involved considerable cost. This projection system demanded significant changes in theater architecture. In most cases, three new booths had to be constructed at floor level in the orchestra section of the auditorium in order to avoid distortion problems introduced by off-angle, balcony projection and to facilitate the three-film projection process. The installation of three booths on the ground floor cut into the theater's seating area, "reducing the capacity for cash customers by about 30%."[60]

Todd-AO's ingenious answer to the problem of distortion was to compensate for it in the printing process, by introducing optical distortions into the

projection prints. Thus American Optical developed an "optical correcting printing process which eliminate[d] distortions in wide films when projected from high angles onto a sharply curved screen."[61] This corrective-printing process also corrected prints for distortion "caused by the use of extreme wide-angle lenses in photography."[62] (The degree of curve in the screen also eliminated some of the distortion introduced by the use of extreme wide-angle camera lenses, but Mike Todd, Jr., insisted that O'Brien's lenses resulted in some optical distortion in the final print of *Oklahoma!* even when "corrected" prints were projected on the Todd-AO screen.)[63]

Todd-AO's film laboratory in Fort Lee, New Jersey, actually produced two "classes" of projection prints for theaters—one for projection at angles from 10 to 15 degrees and another for angles of 15 degrees or more.[64] Demonstrations of this "corrective printing process" were given in September 1955 at George Skouras' Rivoli Theatre in New York, which had installed a new projection booth on the ground floor to permit comparison tests. One optically corrected 70mm print of *Oklahoma!* was projected from the theater's original booth, which had an extreme projection angle of 22 degrees, and another, noncorrected print was projected from this new booth, which featured virtually head-on projection at an angle of 2.8 degrees.[65] Later that year, similar tests were conducted at the Rivoli for participants at the seventy-ninth SMPTE conference in New York, but this time a single booth was used. To demonstrate the virtues of the corrective printing process, an uncorrected print of *Oklahoma!* was projected at an angle of 22 degrees, followed by a corrected print, which eliminated the distortions seen previously.[66] Todd-AO claimed that this system could accommodate projection angles as great as 25 degrees.[67] Though Todd-AO prints could be tailor-made for individual theaters, the deeply curved Todd-AO theater screen remained incompatible with prints filmed in other widescreen processes, such as CinemaScope, which employed no corrective printing process. These films were therefore terribly distorted when shown on a Todd-AO screen from extreme projection angles.

Todd-AO's corrective printing process enabled theaters to minimize conversion costs by using existing booths. As a result, Todd-AO installations cost about $40,000.[68] Although this was more expensive than Cinema-Scope's conversion cost of $25,000 for theaters of a similar size, it proved much more economical for theaters than conversion to Cinerama. At the same time, Todd-AO provided exhibitors with an "all-purpose" system

THE PICTURE HEAD OF THE PHILIPS PROJECTOR (COURTESY OF ACADEMY OF MOTION PICTURE ARTS AND SCIENCES).

which was compatible with all existing film formats (except three-strip Cinerama).[69] Todd-AO's Philips projector was designed to handle standard 35mm film, 3-D, CinemaScope, and 70mm film at projection speeds of 24 or 30 frames per second.[70] Its two sound heads, a magnetic head built into the upper corner of the projector housing and an optical head in the standard position beneath the picture head, could play back six-track and four-track magnetic stereo as well as one-track magnetic and optical sound and tracks recorded in Perspecta sound. A special sound relay rack, designed and built by Ampex, featured individual equalization and level balancing controls for twenty magnetic tracks. This accommodated two six-track 70mm Todd-AO sound heads as well as two four-track 35mm CinemaScope penthouses; it also allowed operators to switch easily from one sound format to another.[71] Unfortunately, by the time this all-purpose projection equipment was made available in late 1955 and early 1956, most of the key, first-run theaters had already converted to CinemaScope. Todd-AO installations therefore effectively cost theaters more than $40,000, since they had already undergone a $25,000 CinemaScope conversion, most of which equipment (except for some speakers and speaker wiring) would have to be replaced with Todd-AO projectors, screens, and amplifiers. As a result, the majority of Todd-AO installations occurred in theaters which were four-walled and then converted to Todd-AO at Magna's expense or in theaters owned by Skouras' United Artists circuit.[72]

SECURING OKLAHOMA!

While American Optical was working with Mitchell, Philips, and other equipment manufacturers to construct 65mm cameras, 70mm projectors, and other specially designed machinery, Magna bought a vintage-1930 65mm camera from Paramount, outfitted it with several of O'Brien's wide-angle lenses, and began shooting footage for a demonstration of what the Todd-AO system could do.[73] By mid-June 1953 test footage had been assembled for a private demonstration of the process in August at the Regent Theatre in Buffalo, New York.[74] This top-secret demo, to which no outsiders were invited, was designed to sell the system to two of Magna's own backers, Rodgers and Hammerstein, who had so far refused to sell Magna the film rights to *Oklahoma!*[75] Skouras, Todd, and other Magna officials wanted *Oklahoma!* to be the first Todd-AO production and cam-

paigned to secure that property by involving a former associate of Rodgers, Arthur Hornblow, in the first Todd-AO production. Hornblow, whom Rodgers described as one of the few people in Hollywood whom he trusted, was put in charge of producing a demonstration film, which featured audience-participation effects reminiscent of Cinerama (including a roller-coaster ride, water skiing, scenes of Venice canals, and a bull ring in Spain) as well as production tests of a picnic scene from *Oklahoma!* filmed by Fred Zinnemann.[76]

The demo worked—especially the picnic sequence, which showed that the process could be effective in filming "intimate" sequences. Rodgers said, "I found myself wanting to reach for a doughnut and then for both the girls. That picnic sold us."[77] The package of Todd-AO, Hornblow, and Zinnemann, whose status as a "class" director had been confirmed by the critical and box-office success of his last two films, *High Noon* and *From Here to Eternity,* proved irresistible.[78] The next day, Rodgers and Hammerstein sold *Oklahoma!* to Magna for $1,020,000 and 40 percent of the box-office gross and gave Magna a five-year option on all their other Broadway properties (except *The King and I,* which Fox already owned).[79] Rodgers and Hammerstein retained complete artistic control over the filming of *Oklahoma!*, which was produced by Hornblow through their family-owned company, Rodgers and Hammerstein Pictures, Inc.[80] With *Oklahoma!* slated as the first Todd-AO release, the sale of the system to select theaters around the country was assured.[81]

SUPERCIRCUIT PRESENTATION

Todd-AO emerged, in comparison with the industry's reigning widescreen system, CinemaScope, as a process associated with a highly exclusive product: Todd-AO, like Cinerama, was used to make only one, lavishly produced film a year instead of a studio's entire annual output, as was the case with CinemaScope at Fox. In fact Todd-AO was used in the production of only fifteen films over a period of sixteen years.[82] Like Cinerama, Todd-AO was conceived of as a specialized form of entertainment that would be restricted to a finite number of theaters. Skouras and Todd initially planned to distribute *Oklahoma!* "at premium prices" on a roadshow basis "in one selected theatre in each of thirty major cities in the country for extended periods of time."[83] Magna proposed to lease these first thirty theaters,

thereby reducing its distribution and sales costs while increasing its share of box-office revenues.[84]

Magna estimated that it would be able to convert 2,000 first-run theaters (of a total of 16,000 theaters nationwide) during its first two years of operation, essentially saturating the first-run market; but by 1957 there were only 60 Todd-AO installations, largely because only two films had been made in the process and because many of the targeted theaters had already converted to CinemaScope and were understandably hesitant to change to yet another widescreen system until they could gauge popular response to the new wide-film process. Others, aware of Fox's efforts with CinemaScope 55 and of Paramount's with double-frame lazy-8 projection in VistaVision, quite sensibly refused to commit themselves to one wide-film projection system until wide-film formats had been standardized.[85] Theaters also realized that Todd-AO films would eventually be released in 35mm CinemaScope versions. Yet even the number of Todd-AO conversions more than doubled the number of Cinerama installations at this time, despite Cinerama's three-year head start.

Like Cinerama, Todd-AO sought to create a supercircuit in theatrical exhibition: a small number of large first-run urban theaters who could afford the $40,000 conversion cost would be rewarded with an exclusive product that would be guaranteed, because of the 70mm multitrack stereo technology, not to play in non-Todd-AO houses until the first-run market had been virtually exhausted. In this way Todd-AO reinstituted, in a legal way, the system of runs and clearances that had been outlawed as a result of the 1948 consent decree. Indeed, *Oklahoma!* ran for over a year in Todd-AO in several cities, rivaling the two-year run of *This Is Cinerama*, before it was released in its 35mm CinemaScope format.

Todd's partnership with the United Artists Theatre Circuit assured the success of the process by providing him with a built-in market (of over 100 theaters located in fifty major cities) for Todd-AO productions. And, since more than half of a film's total income during this period came from first-run exhibition in only a handful of theaters (that is, from approximately 700 first-run theaters in ninety-two cities), Todd-AO producers realized fantastic profits, as did the stockholders of Todd-AO and of Magna Theatre Corporation, who received a combined royalty of 5 percent of the admission price for each person who saw the film in Todd-AO but who received no royalty for the 35mm CinemaScope release.[86]

ROADSHOWING

Again like Cinerama, Todd-AO exhibition relied on a "theatrical," roadshow pattern, scheduling only two or three screenings a day and making tickets available on an advance-sale, reserved-seat basis. Todd's partners Richard Rogers and Oscar Hammerstein insisted that the integrity of the original stage musical be respected and forbade the inclusion of any sensational "audience participation type of screen action" such as the roller-coaster ride used in Cinerama (and in the Todd-AO demo).[87] This restriction did not, however, prevent Zinnemann from indulging in a modified "Cinerama effect" when the camera dollied forward through an enveloping field of corn "as high as an elephant's eye" during the opening "Oh, What a Beautiful Morning" song sequence or from introducing a roller-coaster-like thrill with a scene filmed on a runaway carriage.

Todd, who was not involved in the production of *Oklahoma!*, did produce a short, *The Thrill of Todd-AO* (1955), to accompany it and used the short to display the audience-participation aspects of the system, incorporating in it footage, such as the roller-coaster ride, which had been used in the initial demo. Though Todd tried to sell the public on Todd-AO's sensational qualities, he promoted the theatrical nature of Todd-AO films, which he called "shows." He carefully differentiated Todd-AO productions from standard Hollywood fare. "I'm not interested in making movies," Todd claimed. "Movies are something you can see in your neighborhood theater and eat popcorn while you're watching them." To reinforce this distinction between "movies" and "shows," Todd insisted that no popcorn be sold in Todd-AO theaters and put this condition into his contract with exhibitors.[88]

Todd-AO drew on the theater in other ways as well. Todd, a Broadway producer, launched the process with the help of another pair of Broadway producers—Rodgers and Hammerstein, whose theatrical properties provided much of the basic dramatic material *(Oklahoma!, South Pacific, The Sound of Music)* filmed in the system.[89] Even though the second Todd-AO feature, *Around the World in 80 Days,* superficially resembled a Cinerama travelogue, it, too, had theatrical origins, deriving from Todd's collaboration with Orson Welles on a short-lived Broadway musical version of the Jules Verne novel in the late 1940s.[90] Todd-AO producers continued to ransack Broadway for material, adapting George Gershwin's *Porgy and Bess* and Cole Porter's *Can-Can* for the screen and spearheading a trend in which

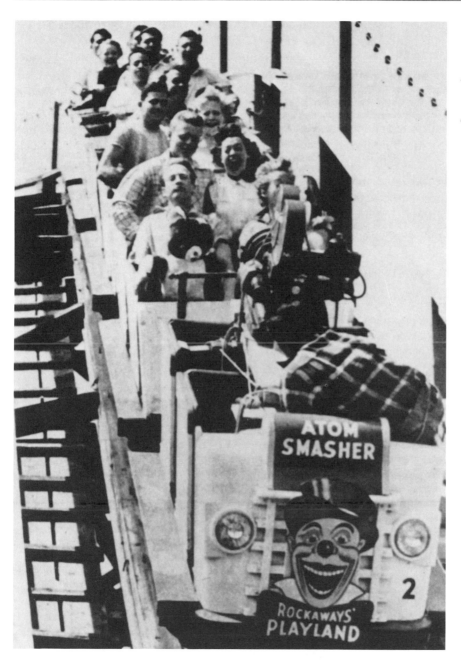

FILMING THE
ROLLER-COASTER
EFFECT FOR A
TODD-AO SHORT
(AUTHOR'S
COLLECTION).

producers drew more and more regularly upon Broadway for material for their big-budget widescreen spectacles.

The ultimate success of the Todd-AO process can be measured, in part, by the failure of rival systems, such as Fox's CinemaScope 55 and Grandeur (which was revived for a re-release of the CinemaScope 55 production of *The King and I*), and Fox's own capitulation to Todd-AO through its acknowledgment that by 1958, when *Around the World in 80 Days* was experiencing record profits at the box office, "CinemaScope had lost much of its novelty and . . . customers were no longer drawn to theatres solely because the picture was in the CinemaScope process."[91] In 1958 Fox invested $600,000 in Todd-AO, securing the right to make pictures in that process, and, after Mike Todd's death in an airplane crash later that year, obtained control of the Todd-AO Corporation.

WIDE-FILM BLOCKBUSTERS

Todd-AO's success can also be gauged through the subsequent innovation of other wide-film systems. In 1957 with its production of *Raintree County* M-G-M introduced a wide-film anamorphic process, M-G-M Camera 65, which, like Todd-AO, employed a six-track stereo magnetic sound system.[92] The studio used the same system to film *Ben-Hur* (1959). M-G-M's 65mm cameras, built by Mitchell and outfitted with lenses developed by Panavision, then became the basis of Super Panavision 70, which relied upon spherical rather than anamorphic lenses and which was used to film *The Big Fisherman* (1959).[93] A modification of the 1.33 anamorphic compression ratio used in the M-G-M Camera 65 system resulted in Ultra Panavision 70, which employed a 1.25 squeeze and was used to film *Mutiny on the Bounty* (1962).[94] In 1963, for the filming of *It's a Mad, Mad, Mad, Mad World*, Cinerama finally abandoned its three-strip process for Ultra Panavision 70, a 70mm system that employed anamorphic optics and, when unsqueezed in projection, produced a Cinerama-like image with an aspect ratio of 2.76:1.[95] Thus Cinerama tacitly acknowledged the technological superiority and economic viability of 70mm as a format and followed (albeit belatedly) Mike Todd's example in his switch from three-strip Cinerama to 65/70mm Todd-AO.

During the 1960s several hundred first-tier theaters around the country screened films in 70mm, though only a few of these were in Todd-AO. Super

and Ultra Panavision 70 cornered much of the blockbuster market with films such as *Exodus* (1960), *West Side Story* (1961), and *Lawrence of Arabia* (1962)—as did Super Technirama 70 with *Spartacus* (1960), *El Cid* (1961), *King of Kings* (1961), and *The Music Man* (1962).[96] However, the motion picture marketplace had taken its toll on 70mm production. Todd-AO never recovered from its association with Fox's box-office disasters *Doctor Doolittle* (1967) and *Star!* (1968), and although *Airport* (Universal, 1970) fared well, the Todd-AO trademark had little to do with its success.

70MM BLOWUPS

By the mid-1960s the expense of filming in 65/70mm had begun to limit original production in 70mm. Because of the 70mm product shortage, theaters which had converted to 70mm were forced to play more and more 35mm films on screens designed for 70mm projection and blew the 35mm image up to fill the screen, producing a less-than-satisfactory image on the screen.[97] In 1963 Panavision's Robert Gottschalk introduced an optical system which enabled producers to blow 35mm film up to 70mm for purposes of theatrical roadshow exhibition, using a liquid-gate optical printing technique which retained much of the quality of the original 35mm negative.[98] The 70mm blowup required less magnification than a 35mm print, thus filling the same size screen with a sharper image than could be obtained with 35mm film.[99] The larger projector aperture employed in 70mm projection also enabled theaters to put more light on the screen, which improved the projectionist's ability to achieve sharp focus.[100] Roadshowing in 70mm also enabled many theaters, especially those abroad, to charge higher admission prices, making 70mm prints more desirable.[101]

However, though print-ups from 35mm to 70mm may have aided the exhibitor (and even increased the number of 70mm installations), they effectively pulled the rug out from under wide-film production. Fewer films were designed and budgeted with 70mm roadshow exhibition in mind; the decision on how to release films was no longer made before or even during production but later, during the post-production phase. The success of *The Cardinal, Becket,* and *The Carpetbaggers* demonstrated the viability of this new, economical means of generating 70mm roadshow prints.[102] Now any 35mm film could be blown up to 70mm for roadshow presentation in the then 1,100 existing 70mm theaters around the world without the expense

involved in wide-film production, which cost between 2.5 and 2.75 times as much as in 35mm.[103] Blowup technology enabled distributors to wait until a film had been completed before deciding whether or not it warranted roadshowing in 70mm.[104]

Since the advent of this print-up process, fewer than 30 films have been shot on wide film, and more than 230 have been shot in 35mm and blown up to 70mm for first-run exhibition.[105] The kinds of films that have been blown up range from 35mm anamorphic productions *(The Cardinal, Dr. Zhivago, Close Encounters of the Third Kind, Star Wars, Apocalypse Now,* and *The Untouchables)* to 35mm flat 1.85:1 productions *(Days of Heaven, Altered States, E. T.: The Extra-Terrestrial, War Games, Gremlins, Back to the Future, The Color of Money,* and *The Last Temptation of Christ),* resulting in blowups which crop the edges of the the former and necessitate the addition of black masking along the sides of the latter.[106]

At the same time, changes in the exhibition sector during the 1960s tended to eliminate many of the technical demands which wide film originally satisfied. The advent of multiplexing, which began in 1963, played a crucial role in the demise of 70mm production.[107] Multiplexing reduced overhead costs for exhibitors by housing several screens within a single structure. Quite often these screens were smaller, having been created by "twinning" one larger theater or constructing a multiple-theater complex consisting of smaller houses. Projection onto smaller theater screens decreased the amount of magnification necessary in projecting 35mm films, enabling an increasing number of newer theaters to rely solely on 35mm prints without any noticeable loss in image quality. Though many of the multiplexes built since *Star Wars* have included at least one 70mm screen in order to be able to run blowups, there is no longer any demand from exhibitors for original production in 65/70mm. Audiences who patronize 70mm theaters remain content with ersatz 70mm blowups. Ironically, the rise of 70mm as an exhibition medium remains coupled with its demise as a production medium.

Although deeply curved screens are no longer found in first-run theaters and although extreme wide-angle bug-eye lenses find infrequent use in contemporary filmmaking, the 65/70mm six-track magnetic stereo sound format which the Todd-AO process introduced in 1955 remains with us today, as does the notion of an exclusive supercircuit of motion picture theaters which can provide audiences with a motion picture experience that

THE NEW ARRIFLEX 65MM STUDIO CAMERA, THE ARRI 765 (COURTESY OF ARRIFLEX

CORPORATION).

cannot be duplicated by contemporary 35mm exhibition. Over the past few years there has even been some movement back to 70mm as a production standard with the introduction by Arriflex of its extremely quiet (25 decibels) state-of-the-art 65mm studio camera, the Arriflex 765.[108] Meanwhile Todd-AO continues to rent out 65mm cameras, which are used regularly in process work.[109] At the same time, Panavision has announced its own, updated 65mm camera. Yet no 65/70mm system has found wide acceptance in the film industry except for use in special-effects cinematography.

Though the Todd-AO trademark appeared on only a handful of films and the Todd-AO Corporation currently exists only as a sound-mixing lab and camera rental company, the original Todd-AO process, which prompted the development of Technirama (1957), M-G-M's Camera 65 (1958), Super Panavision 70 (1959), Ultra Panavision 70 (single-strip Cinerama, 1963), and Dimension 150 (1963, which Todd-AO acquired that year),[110] was clearly the forerunner of the 70mm multitrack stereo magnetic sound processes found in the film industry today.

The growth of 70mm exhibition in recent years, which increased from 300 screens in 1982 to over 900 in 1988, is a complex phenomenon, determined by a variety of factors. Its current popularity as a special-event attraction undoubtedly looks back, however, to its association, through Todd-AO and similar wide-film processes, with the roadshow extravaganzas in the late 1950s and early 1960s. The slow diffusion of 70mm exhibition during that era and its more rapid diffusion in the 1980s serve as indices of its transformation from what Mike Todd would call a "show" into merely a "movie," albeit a movie made semi-special through the prestige of its presentation. Viewing a film in a 70mm blowup continues to be a special event, especially in comparison with the dominant mode today, which involves small screens in multiplexes or even smaller television screens in a video format. The "authentic" 70mm experience died when Todd-AO, Super Panavision 70, Ultra Panavision 70, Super Technirama 70, and other genuine name-brand wide-film processes gave way to the generic substitute, to mere "70mm."

Cinerama, CinemaScope, Todd-AO, and other large-screen and widescreen processes redefined traditional notions of spectatorship. The changes that occurred call for a rethinking of the ways in which cinema studies has tended to theorize the spectator's relationship to the screen.

Contemporary theory has appropriated the motion picture screen as a metaphor, which it has used, in turn, to describe the spectator's experience of the cinema. The notion of screen-as-metaphor, which took hold—appropriately enough—in the English-speaking world at *Screen* magazine in the 1970s, was, however, not unique to film theory but emerged, rather as a deliberate rewriting of both André Bazin's realist notion of the screen-as-window and Jean Mitry's formalist rendering of the screen-as-frame.[1] Following the psychoanalytically informed work of Jean-Louis Baudry, which had earlier appeared in *Cinétheque* and *Communications*, *Screen* embraced Baudry's transformation of Bazin's window and Mitry's frame into a Lacanian mirror, in which the child, immobile and lacking motor coordination, (mis)recognized its own image as an Imaginary, ideal, unified, and more perfect reflection of itself.[2]

For Baudry in "The Apparatus," the transcendental subject which the spectator found reflected in the cinema's screen/mirror resembled the deluded spectator in Plato's Cave, who mistook the shadowy images projected on the cave wall for reality. Thus Plato's "apparatus," which consisted of chained, immobilized spectators imprisoned in "a cavernous underground chamber with an entrance open to the light" who could not see the outside world but only the shadows on the cave wall, served as an analogy for the film viewer's experience of the screen in a darkened movie theater.[3] As an ideological apparatus, the screen, in effect, constituted the spectator as subject in a programmatic, regressive way, rendering the spectator into an ideological construction—into a "subject,"[4] who/which invested the images on the screen with a certain "impression of reality," activating a mechanism that provided an "answer to a desire inherent in our psychical structure"

for such an illusion.[5] The screen-as-mirror reflected back images "cut to the measure of" our own desire, thus functionary as a machine which reproduced the ideology that had initially produced it.[6]

FIXING DESIRE

In "On Screen, in Frame: Film and Ideology," Stephen Heath recast the metaphor of screen-as-mirror slightly, exploring its status as an ideological apparatus which, much like Althusser's state apparatuses, transformed spectators into subjects of a statelike institution—the cinema. For Heath, the screen did not so much "reflect" as "fix" desire, regulating the operations of desire and assigning prescribed positions to those who look to the screen for an answer to their desires. Heath insisted that the cinema was born not when the basic apparatus of silent cinema—consisting of camera, film, projector, and screen—was perfected, but when the spectator's relationship to that apparatus was fixed, that is, when "the spectators [were] no longer set on either side of a translucent screen but [had] been assigned their position in front of the image which unroll[ed] before them."[7] In other words, for Heath, the cinema was more than a mechanical apparatus; it was an ideological apparatus. As such, the cinema came into being only when the circuit implicit in the mechanical apparatus was completed by the addition to it of a spectator whom the screen fixed in place.

Heath then extended his argument from consideration of the screen, which positioned spectators in the theater, to that of the frame, which organized the spectator's vision, centering it in various ways on the contents of the frame. For Heath screen and frame functioned, along with certain spatial codes (such as perspectival space, which furthered the work of the screen and the frame in organizing vision) and narrative, to determine the conditions of spectatorship.

Heath insisted that these conditions of spectatorship have remained more or less constant from 1896 to the present. The film frame, unlike the frame in painting, for example, remained limited to a standard 1.33/7:1 aspect ratio or "to a number of such ratios."[8] In "Narrative Space," Heath made the same point again with a further qualification, noting that the frame was limited "to a very small number of ratios."[9] The implication of Heath's argument, especially his comparison of the standard film frame with the variety of frames found in painting, was that the relative fixity of the film

frame (which was determined by the cinema's technological base in 35mm motion picture film) defined, in large part, the conditions of film spectatorship. Heath's theory of the frame rested upon an assumption of its uniformity. But that uniformity did not in fact exist, at least not in post-1952 cinema.

Historicizing Spectatorship

The advent of widescreen motion picture production and exhibition in the early 1950s transformed the previous relationship between spectators and the screen, a relationship that had been established with the advent of projection in 1896 and with the rise of the small-screen nickelodeons in 1905, that was consolidated in the 1910s and 1920s with the introduction of the large-screen motion picture palace, and that continued to flourish in the 1930s and 1940s, during the heyday of classical Hollywood cinema. During the years 1952–1955 the screen aspect ratio changed from the traditional 1.33/7:1 to various widescreen formats, which ranged from 1.66:1 (VistaVision) to 2.77:1 (Cinerama), and the size of the screen dramatically expanded from an average of 20 × 16 feet to an optimum (in large downtown theaters) of 64 × 24.[10] Widescreen cinema, especially Cinema-Scope and Cinerama, which relied on peripheral vision for much of their effect, addressed spectators in a markedly different way than did standard, narrow-screen 1.33/7:1 films. The wide screen may still have been a symbolic instrument of Lacanian and Althusserian subject formation, but it clearly reconstituted that subject in dramatically new ways and had redefined the traditional conditions of spectatorship established by the narrow-screen cinema, which had served as the basis for Baudry's and Heath's theorization of the cinema as an "apparatus."

Heath treated spectatorship and subject positioning as unchanging, as an ahistorical phenomenon. Spectatorship, however, needs to be viewed in terms of the changes in the cinema's basic exhibition practices from one historical period to another. Yet both Baudry and Heath, who discuss spectatorship in terms of the cinema's "basic" technological apparatus and the codes of Renaissance perspective that determine cinematic space, maintained that, once the screen-spectator relationship had been established, it remained unchanged. For them, as long as the basic apparatus remained essentially the same and as long as screen space remained more

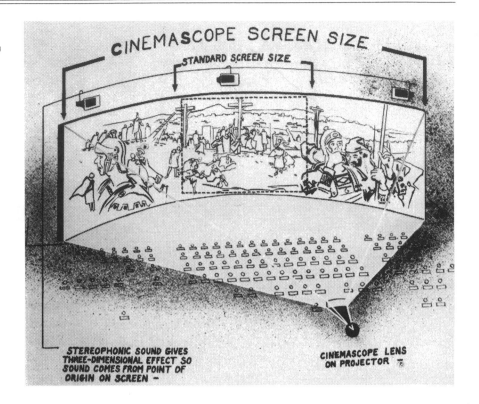

or less perspectival, spectators would continue to be positioned in relation to the image in roughly the same way regardless of changes in the smaller signifying practices of the cinema (those practices which vary from film to film) and of changes in the social formation. The only variable in the system was the content of films, which was seen to address spectators in different ways. Discussions by Heath and others of spectatorship and subject positioning frequently explored the differences among kinds of address and kinds of larger signifying practices—the differing modes of address of the Western and the woman's film, the different signifying practices of classical cinema, of art cinema, of modernist films by Jean-Marie Straub and Danièle Huillet or Nagisa Oshima, but these practices and modes of address were rarely historicized.[11]

Heath, it would seem, minimized the historical changes in film aspect ratios for a variety of reasons. Heath, more than Bazin or Mitry, consciously

used the notions of screen and frame metaphorically—as visible symbols of the way in which classical cinema "hold[s] the subject—on screen, in frame."[12] Since Heath's screen and frame were metaphorical, their actual size or shape was of less concern to him than their symbolic function as abstractions for describing the spectator-screen relationship.[13] At the same time, variability in the shape of the screen was far less significant for Heath than were certain constants, such as the codes of Renaissance perspective which informed the way in which space was represented on screen, the operations of narrative which transformed space into place, and, in particular, the operations of suture, which effaced certain absences or differences that might, if perceived, threaten the illusory subject-unity which narrative cinema aimed to create. The screen, the frame, linear perspective, narrative, and suture worked together to overdetermine, as it were, how we look at what we see.

REDEFINING SPECTATORSHIP

Yet the changes in viewing situations that took place during the early 1950s marked a crucial break with the past; a new form of spectatorship was introduced, and a new set of expectations governed moviegoing. Passive viewing became associated, in industry marketing discourse at least, with traditional narrow-screen motion pictures; widescreen cinema became identified with the notion of "audience participation," the experience of heightened physiological stimulation provided by wraparound widescreen image and multitrack stereo sound. Although in both situations the spectator still remained immobile in a theater seat, the perceptible difference in audience-screen relationships between traditional cinema and the new widescreen formats was exaggerated in an attempt to foreground the spectator's new relationship with the screen, which was now, if nothing else, no longer invisible. The wide screen came to represent difference; it marked a new kind of spectatorship. Something basic had changed in the motion picture experience that redefined the spectator's relationship with the screen, which now entered further into the spectator's space, and with the soundtrack, which reinforced this extension of the image and exceeded even the image's border through strategically placed speakers on the sides, ceiling, and rear wall of the theater, surrounding the spectator with sound.

During this period it was also clear that one form of spectatorship had

not merely been replaced by another monolithic universal model of spectatorship. Rather, spectators were confronted with a variety of viewing situations from which they could choose, each of which engaged them in a different way, depending upon theater size and design, projection aspect ratio, and the dramatic content of the film. The cinema became a host of different cinemas; its traditional mass audience became, in turn, an assortment of highly diverse viewing groups.[14] For the spectator, watching a narrative film in black and white in the traditional 1.33/7:1 format at the neighborhood theater remained strikingly distinct from experiencing the colorful travelogues mounted in Cinerama on huge, deeply curved screens in large downtown theaters; viewing "flat" widescreen films in VistaVision differed from being visually assaulted by 3-D films which exploited the technology's ability to create the illusion of emergence;[15] by the same token, CinemaScope's epics and biblical spectacles and Todd-AO's superproductions of theatrical extravaganzas gave viewers experiences that were different not only from flat, 3-D, regular widescreen, and Cinerama films but from one another as well. The spectator was not only beckoned by ads to "participate" in a new form of motion picture experience but also invited to choose from among a variety of different kinds of participation.

Motion pictures attempted to maximize their participatory potential by adopting two dramatically different models of recreational participation—the amusement park and the legitimate theater—around which they then constructed new definitions of spectatorship. The coexistence of these different models marked a break with the monolithic notions of spectatorship which had preceded this era.

Though this assortment of viewing situations resembled, in part, the montage of attractions available at the circus, carnival, or amusement park, only Cinerama and 3-D provided spectators with the visceral thrills associated with this kind of participatory activity. Cinerama was carefully marketed by a sophisticated public relations firm as a radical new motion picture experience for audiences, promoting what it did to spectators and ignoring the technical details which produced its illusory sense of participation.[16] Ads for Cinerama depicted spectators sitting in their theater seats perched precariously in the bows of speedboats, "skiing" side by side with on-screen water skiers, or hovering above the wings of airplanes, "flying" along with an on-screen aerial view of the countryside. The text for ads for *This Is Cinerama* promised, "You won't be gazing at a movie screen—you'll

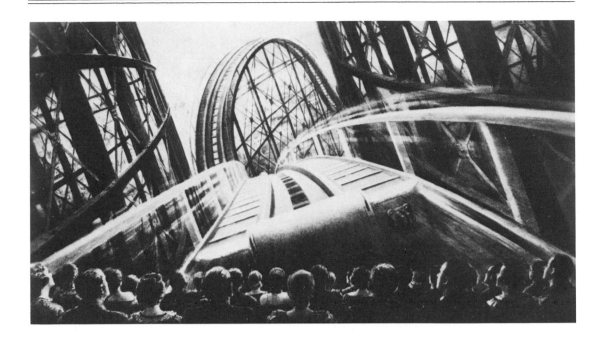

find yourself swept right into the picture, surrounded by sight and sound."[17] The film's program booklet proclaimed: "you gasp and thrill with the excitement of a vividly realistic ride on the roller coaster . . . You feel the giddy sensations of a plane flight as you bank and turn over Niagara and skim through the rocky grandeur of the Grand Canyon. Everything that happens on the curved Cinerama screen is happening to you. And without moving from your seat, you share, personally, in the most remarkable new kind of emotional experience ever brought to the theater."[18] The second Cinerama film, *Cinerama Holiday,* was described as a picture about people and places—"where they go . . . what they do . . . and you are with them . . . Cinerama . . . brings you into the drama of people's lives."[19] Subsequent Cinerama releases continued to sell the way in which the format put the viewer into the picture. Thus *Battle of the Bulge* "turns the screen into the mightiest battleground ever as it hurls you into the most extraordinary days of World War II."[20]

The participation effect was reversed in the marketing of 3-D; instead of audiences' entering into the world depicted on the screen, the space on

PUBLICITY FOR CINERAMA PUTS THE AUDIENCE (FOREGROUND) INTO THE FRONT SEAT OF A ROLLER COASTER (AUTHOR'S COLLECTION).

screen was represented in ads as invading that of the audience, resulting in "a lion in your lap" and "a lover in your arms."[21] But the copresence of image and audience remained a strong selling point in the marketing of 3-D.

THEATER AND CINEMA

With CinemaScope, the appeal was less visceral. Though early ads, which announced that CinemaScope "puts YOU in the picture," resembled those for Cinerama, CinemaScope extended a much more subtle invitation to

audiences to enter into the screen space. CinemaScope and other wide-screen processes sought a middle ground between the notion of passive consumption associated with at-home television viewing and that of active participation involved in outdoor recreational activities. The model chosen by these systems for purposes of redefining their product, however, was less that of the amusement park, which retained certain vulgar associations as a cheap form of mass entertainment, than that of the legitimate theater.[22] Thus the credits for *The Robe* play against a dark red theater curtain, which then opens to reveal the panoramic spectacle of ancient Rome. During the credits of the second CinemaScope feature, *How to Marry a Millionaire*, greenish-gold theater curtains part to reveal the Twentieth Century–Fox studio orchestra playing theatrical-style overture music to introduce the comic spectacle which follows.

The theater emerged as the one traditional form of entertainment that possessed the participatory effect of outdoor recreational activities and a strong sense of presence, and, at the same time, retained a strong identification with the narrative tradition in which Hollywood remained steadfastly rooted. In aligning itself with the experiential quality of the theater, widescreen cinema sought to erase the long-standing distinction between spectatorship in the theater and cinema, which viewed the former as active and the latter as passive.

In comparing the theater and the cinema, Bazin argued that the theater, featuring a live performance which is presented in a space shared by both performers and audience, elicited the participation of the audience in a much more direct and intense way than did the cinema, which separated the space of the performance (that is, the space depicted on-screen) from that of the audience (that is, the space of the movie theater). In Bazin's view, "theater is based on the reciprocal awareness of audience and actor . . . The theater acts on us by virtue of our participation in a theatrical action across the footlights and as it were under the protection of their censorship. The opposite is true in the cinema. Alone, hidden in a dark room, we watch through half-open blinds a spectacle that is unaware of our existence . . ."[23]

The cinema, as Jean Cocteau observed, was an event seen through a keyhole.[24] Widescreen cinema expanded the keyhole to a point where, though it did not quite disappear, it provided spectators with a spectacle that possessed an increased sense of presence, especially in theaters with

curved screens, in which the image engulfed the audience. Participation was no longer a matter of absolute distinctions between active and passive spectatorship. Widescreen cinema had created an entirely new category of participation.[25] What widescreen cinema created was a greater illusion of participation, at least in comparison with the narrow, 1.33/7:1 aspect ratio of pre-widescreen cinema, in which that illusion, if it existed at all, was weaker.

James Spellerberg has examined both advertising and trade magazines in terms of their identification of CinemaScope with theatrical forms.[26] As Spellerberg points out, "In its new position in the late 1950s, Hollywood was more like Broadway. Hollywood was less a mass medium and more a specialized form of entertainment."[27] In other words, motion picture spectators were addressed in (what was for the cinema, at least) nontraditional ways, which emphasized the motion picture as a participatory experience comparable to recreational activities. This discourse clearly distinguished it, as a form of entertainment, from traditional or even nontraditional forms such as radio or television.

Advertisements for CinemaScope films told audiences that they would be drawn into the space of the picture much as if they were attending a play in the theater.[28] Advertisements for CinemaScope and Todd-AO (as well as Cinerama and 3-D) repeatedly depicted audiences together with the on-screen spectacle as if they shared the same space, as if there were an actual copresence between screen and spectator. These ads promoted not so much individual films, as in the past, as a new form of spectator/screen relationship that promised a radical new experience of motion pictures in the theater. In a number of these ads, the action on screen extended beyond the borders of the frame into the space of the audience, breaking down in an illusory way the traditional "segregation of spaces." In 3-D ads the screen action reached out into the audience, while in ads for widescreen films it extended beyond the top and side frame lines into the theater space but remained more or less within the horizontal and vertical planes established by the screen.

Publicists compared the panoramic CinemaScope image to the oblong *skene* (stage) of the ancient Greek theater[29] and insisted that "due to the immensity of the screen, few entire scenes can be taken in at a glance, enabling the spectator to view them . . . as one would watch a play where actors are working from opposite ends of the stage," the widescreen format

CINEMASCOPE PUBLICITY SUGGESTS THE COPRESENCE OF SPECTATOR AND SPECTACLE,
AS IN THIS SKETCH OF AN AUDIENCE WATCHING THE ROBE PROJECTED ON THE
SIXTY-FIVE FOOT SCREEN AT GRAUMAN'S CHINESE THEATRE IN LOS ANGELES
(AUTHOR'S COLLECTION).

enhancing the sensation of the actors' presence and giving spectators the illusion that they could reach out and touch the performers.[30] Darryl Zanuck boasted that CinemaScope gave audiences "a feeling of being part of the action."[31] He insisted that with CinemaScope "members of the audience seem to be surrounded by the curved and greatly enlarged screen" and that "the increased scope of the production cannot fail to draw the audience into the action on the screen."[32] With widescreen it was "possible for the spectator to feel that things are going on 'all around.'"[33] In other words, the

"participation effect" quite literally meant the creation of a strong sense of physical participation.

Even though CinemaScope remained associated with classical narrative films, it introduced a level of visual spectacle that often threatened to overwhelm the narrative. This threat could be contained only by a shift in terms of the kinds of films that were made—a shift to historical spectacle— which functioned to naturalize pictorial spectacle. Yet this shift also involved a change in traditional modes of address which, even in the genre of the historical spectacle, carefully regulated tendencies toward spectacular excess. With CinemaScope (and other large-screen processes), the sit-

uation was initially reversed. Spectacular excess carefully regulated the sorts of narratives selected. As Zanuck realized, the main value of Cinema-Scope lay "in the production of large scale spectacles and big outdoor films . . . In time, we may find a way to use it effectively for intimate dramas and comedies but at the present time small, intimate stories or a personal drama . . . would mean nothing on this system."[34]

Todd-AO combined the theatrical aspects of Cinerama presentation and marketing with the theatrical presence and dramatic narratives of Cinema-Scope. Todd-AO produced "a sense of participation which brings the spectator into the action on the screen for any type of scene whether a close-up, a wide shot, or distant scenic shots." This sense of participation resulted in "a quality of intimacy between the spectator in the theatre and the image projected on the screen . . . [so] that the patron . . . feels as though he is sitting in a living room participating in the action with the characters on screen."[35] Advertisements for *Oklahoma!* boasted that "You're in the show with Todd-AO" and emphasized the sense of presence produced by the system: "Suddenly you're there . . . in the land that is grand, in the surrey, on the prairie! You live it, you're a part of it . . . you're in Oklahoma!"[36]

The appeal made by the promoters of widescreen processes in the 1950s to theatrical notions of participation drew attention to the relationship between spectator and screen in ways that were reminiscent of earlier historical moments when spectatorship was dramatically redefined—the transition from peep show to projection in 1896 and the transition to sound in the late 1920s. Both of these earlier redefinitions were invoked by the industry in its marketing campaigns. Against the background of flat, narrow-screen cinema, widescreen cinema distinguished itself in terms of its greater sense of "presence," a comparison which similarly underlay these two earlier technological transformations. Seen in this historical context, "presence" emerges as a relative rather than an absolute term which is constantly subject to renegotiation by audiences and the industry.

Widescreen systems such as Cinerama, CinemaScope, and Todd-AO created a spectator-screen relationship that both exceeded and undermined that of traditional cinema. On a purely physical level, these systems literally overwhelmed the spectator. All three relied on curved screens (Cinerama and Todd-AO on deeply curved screens) ranging in depth from five to fifteen or sixteen feet depending on the width of the screen. The ideal viewing

position lay at the center of the theater auditorium, at a distance from the screen of two and a half times the height of the image. Cinerama, in particular, depended for its increased sense of audience participation on enveloping the spectator in wraparound image and sound.

The participation effect, however, was itself a radical departure from previous modes of spectatorial address, which involved no use of peripheral vision. Cinerama and CinemaScope, in particular, effectively transformed the notion of frame, expanding the horizontal angle of view to such an extent that there was, for all intents and purposes, no sense of any borders at the edges of the frame.[37] In contrast to the "distraction" which Siegfried Kracauer suggested characterized the spectator's experience in the 1920s movie palace, in which the architecture of the theater encouraged the spectator's eyes to wander from the screen to the surrounding decor, Cinerama, CinemaScope, and Todd-AO relied upon curved screens and wraparound images and sounds to draw the spectator into the world depicted on-screen; distraction gave way to attention-grabbing participation. Changes in theater design in the postwar era mirrored this development. The ornate prosceniums of the movie palace were either torn down or hidden behind panoramic screens. These extended into the space of the audience and transformed the front of the theater from an atmospheric frame within which a motion picture attraction was presented into an eye-filling, wall-to-wall display of image and sound, in which screens blended into the side walls of the theater auditorium and the film was experienced directly, as it were, unmediated by theater architecture. This transformation of the front wall of the theater into a borderless screen survives today in modern theater architecture. However, contemporary screens tend to be significantly smaller than those of the 1950s, reduced in size by the "twinning" of older theaters and by the creation of smaller multiplexed mall theaters.

SUTURE

In the history of painting, the canvas painting bordered by a wooden frame replaced the fresco or wall painting during the Renaissance; 1950s cinema reversed this change as the frame gave way to the wall. Though the notion of frame did not (and could not) disappear, it was dramatically redefined— and, with it, the notion of suture. The Absent Field filled in by suture became, with widescreen, less prominent, given the increased Present Field of the Cinerama, CinemaScope, or Todd-AO image. The anxiety produced

in 1.33/7:1 films by the spectator's gradual awareness of the limits of the field depicted on-screen is, though not entirely allayed, delayed in widescreen cinema because it takes the spectator longer to digest the contents of the frame. As a result, the spectator's awareness of an Absent Field extending beyond the borders of the frame at the extreme right and extreme left is retarded, if not repressed altogether, covered over by an apparent excess of information filling the viewer's perceptual field.[38] Like Circlevision, which extended the frame 360 degrees, these semicircular processes created the illusion of limitless horizontal vision (though the vertical field remained the same as it was in traditional cinema). Of course, even Circlevision is subject to the process of suture—there is always an unseen field—but the system of the suture (in Circlevision, Cinerama, Todd-AO, and CinemaScope, at least) remains less pronounced than that in traditional films: takes tend to be longer, the viewer's ability to exhaust the details contained within them tends to be reduced, and shot/reverse shot editing patterns tend to give way to "theatrical," single-perspective (that is, unedited) modes of dramatic presentation.

In positioning the spectator at the center of a semicircular arc that filled the field of vision, widescreen processes both centered and decentered the spectator. The spectator was physically centered in the theater, but his or her attention was dispersed across a wider area; the horizontal field of view of Cinerama (at 146 degrees) was so extensive that the spectator did not know where to concentrate attention. Human vision perceives events through a series of saccadic eye movements, which scan events through a process that encompasses angles of view from 5 to 35 degrees. This more or less approximates the angle of view of traditional lenses used in 1.33/7:1 cinematography, whose angles of view, at normal focal lengths of 40mm and 50mm, range from roughly 25 to 30 degrees. Cinerama's angle of view was almost five times, and Todd-AO's and CinemaScope's were roughly twice, that of traditional lenses. These extreme widescreen processes encouraged the spectator constantly to redirect his or her interest across a panoramic field of view.

WIDESCREEN COMPOSITION

Early CinemaScope films relied on a number of compositional strategies, often using several within a single sequence, which encouraged the spectator to shift his or her center of attention from one area of the widescreen

frame to another within shots or from shot to shot and to engage with the image in a new way. These techniques contrasted markedly with compositional paradigms employed in traditional narrow-screen 1.33/7:1 filmmaking. One dominant strategy involved the placing of figures in various positions across the full width of the frame. Darryl Zanuck, head of production at Fox, repeatedly stressed that in order to take advantage of the new widescreen format directors should stage action to emphasize its width. Responding to rushes from *How to Marry a Millionaire*, Zanuck wrote: "I only repeat, wherever you can, keep the people spread out or get that wonderful composition you got in the demonstration reel where the three girls were on the three couches. Try wherever possible to fill the screen. This is something that you can get in no other medium."[39] Thus in *The Robe* characters interact across the width of the frame, as in the final "trial" sequence when Marcellus (Richard Burton), Diana (Jean Simmons), and Caligula (Jay Robinson) articulate different political stances and personal loyalties, breaking the widescreen frame down into a series of disparate yet interconnected positions.

The linear perspective employed in pre-widescreen films encouraged the spectator's eyes, via depth cues, to explore the depth of the frame. These films conformed, more or less, to the perspectival system of the Renaissance; though, as David Bordwell has argued, classical Hollywood space was not literally centered, as in certain shots in the films of Yasujiro Ozu, but centered itself around a T-shaped design in which "the upper one-third and the central vertical third of the screen constitute the 'center' of the shot."[40] Nonetheless, the composition of these films led spectators into depth and positioned them at a central station point where the lines of the composition projected and converged. Because the CinemaScope lens possessed a limited depth of field, filmmakers' continued use of traditional cinematic staging techniques, coupled with the horizontal compositional strategy of widescreen, encouraged spectators both to scan across the width of the frame and to look into depth, positioning them on a bidirectional axis quite different from the one-directional axis of "deep focus" cinema that emerged in the mid-to-late 1940s.

Filmmakers such as Otto Preminger used horizontal compositions and lateral character and camera movements to explore the horizontal dimensions of the frame. In *River of No Return* (1954), for example, the attention

of the spectator is directed across the frame by the lines of the composition, the directions of the characters' gazes, or both. When Matt (Robert Mitchum) demonstrates his marksmanship with a rifle, the composition leads the gaze of the spectator along the line of the rifle barrel in the left foreground across the frame to the branch of the tree in the right background that his bullets hit and sever. Later, when Matt pulls Weston's raft ashore, using a rope attached to his horse, the horizontal line of the rope provides a graphic cue which guides the spectator's eyes across the frame from Matt in the right foreground to the raft in the left background. This "lateral/axial" compositional strategy draws the eye across the frame as well as into its depth, pulling the spectator's attention in two directions.[41]

The simultaneous graphic pull across and into the frame introduces a dramatic tension into the activity of the traditional viewing process, which was inclined to be more axial than lateral. As a result, widescreen compositional strategies tended to demand greater participation by the spectator in digesting the space and action depicted on-screen. While the operations of narrative continued to contain or center the spectator, the frame expanded that containment in a new direction. The spectator occupied a succession of different station points that stretched across the frame and that at each lateral position extended into the depth of the frame.[42]

Inasmuch as the compositional strategy of filling the width of the frame decentered the frame, it increased the work of the spectator in digesting the narrative. Given the extreme width of the frame, especially in early 2.55:1 CinemaScope films, filmmakers increasingly recognized the importance of trying to direct the spectator's attention to information within the shot—that is, of combatting the apparent spatial diffuseness of the widescreen image and weighting or privileging one part of the frame over another. Howard Hawks, according to Charles Barr, complained that, with CinemaScope, "it's very hard for an audience to focus—they have too much to look at—they can't see the whole thing." Barr concluded that the CinemaScope image must be carefully organized to lead the spectator from one thing to another in the frame.[43] This organization often involved a strategy which narrowed the lateral field—sometimes literally. In *Lola Montès* (1955), for example, Max Ophuls repeatedly directs the spectator's attention within the frame by masking the CinemaScope frame down to 1.66 or 1.33:1 proportions. However, this practice, by calling attention to itself,

CINEMASCOPE COMPOSITION ENCOURAGES THE SPECTATOR TO SCAN THE FRAME
HORIZONTALLY AS IN THIS SCENE FROM RIVER OF NO RETURN (COURTESY OF
TWENTIETH CENTURY–FOX).

violates the codes of stylistic invisibility which govern classical cinema and
rarely appears in conventional filmmaking, except for comic effect. Thus
Frank Tashlin's credit sequence for *The Girl Can't Help It* (1956) begins in
1.33/7, and when Tom Ewell, who introduces the picture, suddenly realizes
that the image is not being presented "in the grandeur of CinemaScope,"
he "extends" the frame on either side to produce a full 2.55:1 aspect ratio.

Most typically, the frame was composed with the primary figure of interest
in the center, with the secondary figure (or figures) placed to the right or
left. (Though exact symmetry tended to be avoided because it "deadened"
the composition, rough symmetry did occasionally appear, but usually in
sequences in which quasi-symmetrical compositions were intercut with
asymmetrical compositions.) The effect of this strategy was to redirect the
spectator's attention around figures grouped to either side of the literal
center of the screen, that is, to "recenter" them around an "eccentric" focal
point. This process even involved abrupt shifts from side to side, smoothed
over by balanced compositions.[44] Yet another strategy, used less often than
the other two, involved the placing of figures at the center of the right or
left half of the image, with the remaining three-quarters of the image left

empty of narratively significant information. This sort of composition can be seen in *The Robe* when Marcellus, shown at the first-quarter position of one frame, first encounters Diana, at the three-quarter position in another frame, in the marketplace before the slave auction.

WIDESCREEN, STEREO SOUND, AND GREATER REALISM

The participation effect, however, does not entirely describe the full range of spectators' responses to widescreen cinema in the 1950s. Widescreen was both marketed and received as a new advance in cinematic realism. For Charles Barr, for example, the history of the cinema was "a nicely arranged series of advances," and widescreen marked the furthest development to date in the realization of the myth of total cinema, that is, the creation of "a total illusion, with sound, color and depth."[45] "The cinema," Barr insisted, "evolves by a form of Natural Selection: technicians and financiers provide the 'mutations,' and their survival depends upon whether they can be usefully assimilated at the time."[46] Widescreen was associated with greater realism because it had greater "impact" than the earlier format—the narrow, 1.33-to-1 image—and thus provided a stronger sense of actuality.[47] For Barr, widescreen formats "enable complex scenes to be covered even more naturally; detail can be integrated, and therefore perceived, in a still more realistic way . . . it gives a greater range for gradation of emphasis."[48] Barr's thesis, however, fails to take into account certain contradictions which underlie widescreen cinema's association with greater realism, contradictions which become apparent on a review of the popular reception of one of widescreen cinema's most realistic features—stereo magnetic sound.

Technological innovation in the cinema has traditionally been associated with the production of "greater realism." The invention of the motion picture camera enabled filmmakers to create images which they described as "life-size" or "life-like;"[49] the Lumières presented their Cinématographe shows as *"la vie sur le vif,"* or "life on the run."[50] With the advent of sound, film could "provide the most marvellous reproduction of life as it unfolds before our eyes."[51] Cinerama declared that it was a medium "that creates

all the illusion of reality . . . you see things the way you do in real life—not only in front of you as in conventional motion pictures, but also out of the corners of your eyes . . . you hear with the same startling realism."[52] Stereophonic sound was praised for its realistic sense of directionality; "sound seem[ed] to come from the exact point of origin—[made] it appear as if the words spoken by each actress came from her lips, giving the whole scene a life-like quality."[53]

But "greater realism" was not always the product nor the goal of technological development. As Ed Buscombe has pointed out, early color films were associated not with realism but with its opposite—with "unrealistic" genres—with animated Disney cartoons, fashion shows and musical sequences inserted in black-and-white films, with fantasy films, and with musicals.[54] Indeed, realism continued to be signified in the cinema not by color but by black and white, which remained the dominant mode of realistic motion picture representation until the widespread diffusion of color television in the late 1960s. For Buscombe, the demand for greater realism which informed certain models for technological development set forth by Bazin, Comolli, and others may have been a dominant determinant of technical change, but it was not necessarily the only demand satisfied by innovation. Color, for example, provided spectators with "luxury or spectacle"; and in certain cases it simply celebrated technology.[55]

Significantly, the advent of sound, color, and widescreen was identified not only with realism but with spectacle. The attention of the audience was drawn to the novelty of the apparatus itself. The "greater realism" produced by the new technology was understood, it would seem, as a kind of excess, which was in turn packaged as spectacle. Nonetheless, the artifice which underlay the heightened illusion of reality was celebrated, if not always displayed. Thus ads for *Broadway Melody* declared it, as an "all talking, all singing, all dancing dramatic sensation," to be "the New Wonder of the Screen!"[56]

In a similar way, stereo magnetic sound was praised for both its realism and its artifice. Scientists celebrated its "greater realism" in relation to monaural optical sound. Thus Fox engineers proudly noted that stereo magnetic sound provided "direction, presence, proper phase relationships of the sound waves, and all the other aspects of the actual sound from the original source."[57] Showmen boasted of its greater artifice. Skouras informed

reporters that "in *The Robe* you'll hear angels' voices. And they'll come from the only place where you'd expect to see angels—right above you. And when you see the film and hear the voices, you'll look up for the angels."[58]

TRAVELING SOUND

Despite the gradual decline of the use of the fourth track during the mid-1950s, Hollywood continued to use surround sound on occasion for special sonic effects. Concerned about his own studio's failure to utilize the fourth track fully, Darryl Zanuck sent a memo to Fox staff praising the work of a rival studio. "In some of the battle sequences [of Warner's *Battle Cry*] it is a tremendous and realistic thrill when you hear the roar of the cannon coming from behind you and then it seems to pass over your head and land on the screen in the distance. They use this about six or seven times . . . and each time . . . it gave a terrific impact." The "realism" of these effects is clearly bound up with spectacular display, as Zanuck himself seemed to realize when he mentioned that his wife, who was "usually never conscious of anything of a technical nature and concentrates only on the story or the actors," noted these effects and "discussed [them] after she had seen the picture . . . I know we have used things similar to this, but this is the first time she has ever noticed them and it came without any coaching from me."[59]

Cinerama pioneered the practice of "traveling" sound which so impressed Zanuck and his wife and exploited it as a form of audience participation. In an attempt to heighten the participation effect, Cinerama sound recordists regularly mounted five microphones in fixed positions on a support that was itself attached to the Cinerama camera, effectively binding visual and auditory perspective together and putting the spectator in the very midst of the on-screen action.[60] During the Long Island Choral Society's rendition of Handel's *Messiah*, "as you sit in the theater, the music of the thrilling 'Hallelujah' chorus comes to you from every direction . . . first, behind you . . . then, on both sides of you, as the singers approach the stage pictured on screen . . . and finally, from the great stage itself."[61] Though traveling sound contributed an apparent realism to the scenes, providing exact correspondence between sound and image, it also functioned as a display

of what multitrack stereo magnetic sound could do. While undeniably realistic, the practice nonetheless drew attention to itself, violating the time-worn conventions of stylistic invisibility which governed Hollywood filmmaking practice and ensured that the audience's access to the events unfolding before them would be unmediated (that is, realistic). This self-consciousness remained consistent with Cinerama's overall marketing campaign, which foregrounded the experience of the process and, as the word *Cinerama* in the titles of the first two features *(This Is Cinerama* and *Cinerama Holiday)* suggests, the spectacular effects of the process itself.

Directionality

Fox and other producers of narrative features in stereo relied upon a somewhat more sophisticated system of microphone placement, which did not establish the exact identity between visual and auditory perspective employed by Cinerama and therefore drew attention to the camera itself. Rather, they adapted standard Hollywood sound recording practice to the new medium of stereo and placed microphones in positions that matched "visible or desired implied [on-screen] action" instead of the position of the camera itself.[62] Thus the microphones, like the camera itself, occupied quasi-objective, unmarked positions and functioned as omniscient onlookers rather than as a subjective presence identified with the position of the camera.

 Sound recordists set up microphones in an attempt to capture the original "directionality" of the sound information. Sound effects, such as the footsteps of a character walking across the screen, would "travel" from speaker to speaker with the on-screen action. In *The Robe*, when Demetrius scoured Jerusalem in search of Christ in an attempt to warn him that he was about to be arrested, Demetrius hid behind a range of pillars from troops of Roman legions whose marching footsteps moved with them (from speaker to speaker) from screen right to screen left. During the crucifixion scene, first thunder signaling an impending storm and then sounds of wind and rain engulfed the theater, moving from one speaker to another. On occasion even music would have a directional quality. At the end of *Demetrius and the Gladiators* (1954), the romantic sacrifice of Messalina (Susan Hayward), who has repressed her desire for Demetrius (Victor Mature) in order to

assume her place as the wife of Caesar, is underlined with a melodramatic violin solo coming from a single speaker located at the same position in the frame which she occupies, underscoring her individual emotion within a larger context of an impersonal public ceremony.

For a time, stereo recording actually dictated on-screen composition; actors would be positioned across the frame so that their voices would be picked up by different microphones, ensuring their separation upon playback in the theater. Zanuck insisted that "stereophonic sound is not effective when two people are face to face, unless of course they are in big closeups or a big 2-shot. The full value of stereophonic sound comes from the distance between the two people who are talking. If one person is planted at one end of the set and the other person is on the other side of the set then the sound has an opportunity to add to the illusion of depth."[63] As a result, even stationary performers spoke from screen right, left, or center, and the sound shifted from one theater speaker to another during conversations.

For the first time in film history, off-screen dialogue was literally off-screen, emanating from surround speakers on either side of the auditorium. In *The Robe*, when Marcellus bids farewell to Diana before his departure to Judea, fog-enshrouded shots of the couple are accompanied by off-screen calls warning him of his ship's imminent departure. From *Battle Cry* to *Spartacus*, stereo sound extended off-screen space farther to the right and to the left than it had ever done before and provided a specificity of location which monaural films could only vaguely suggest. The effect was decidedly theatrical, duplicating the off-stage voice which the theater had exploited for centuries, but which monaural cinema could only loosely approximate. Off-screen voices literally drew the audience's attention to off-screen space, spectacularizing the concept of voice off.[64]

Resistance to Traveling Dialogue

Although a number of studios eventually adopted CinemaScope's four-track stereo magnetic sound process, only Fox and Todd-AO (which employed a somewhat different, six-track stereo system) persisted in maintaining both directional and traveling dialogue. By the mid-1950s M-G-M, Warners, Columbia, and Universal, for example, recorded and played back music in

stereo but recorded original dialogue and sound effects in monaural sound; they played dialogue back in mono through all the behind-the-screen speakers and played sound effects back in stereo.[65]

At Paramount, sound engineer Loren Ryder complained that "the movement of dialogue to follow picture action can be very annoying," though stereo playback could be quite effective for sound effects and music.[66] *New York Times* critic Bosley Crowther found traveling dialogue distracting and complained that "the business of switching from one to another outlet . . . as the character moves becomes an obvious mechanical contrivance that confuses the image on the screen." Though Crowther concurred with Ryder and others that stereo was ideal for "background music and disassociated sound effects," he concluded that voices and on-screen sound effects were "more uniform and plausible" when played back through a single behind-the-screen horn.[67]

Crowther's reaction and that of the major studios, who refused to adopt completely Fox's uses of directional dialogue and sound effects and of "traveling" dialogue, seem to have been prompted in part by a sense that certain practices identified with stereo violated the accepted conventions of monaural sound playback. In other words, Crowther, Ryder, and others perceived stereo sound not as realistic but as artificial. This perception can be attributed to essential differences between stereo sound, with which audiences had little familiarity, and monaural sound, which audiences had already experienced for a number of years. Stereo records and tapes were not mass marketed until 1957, and FM broadcasts in stereo were not licensed by the Federal Communications Commission until 1961; thus audiences could not draw upon these other media for an understanding of stereo's codes and conventions.[68] Mono, on the other hand, was a familiar fixture in mass entertainment, made accessible to audiences through both radio broadcasts and the "talkies." As a commonplace in these media, mono had come to be associated with realistic representation.

SOUND CODES AND CONVENTIONS

In the first days of the transition-to-sound period—in 1926 and early 1927—theater loudspeakers were placed beside or below the screen. Early Vitaphone films even drew upon silent film conventions, playing back

orchestral scores through speakers placed in the area of the former orchestra pit.[69] Earl Sponable's development in 1927 of a porous screen material facilitated the placing of loudspeakers behind the screen. This encouraged the illusion of the homogeneity of sound and image, which was achieved quite literally through their physical superimposition. Over the years, this location became a rigid convention—sound came from the center of the image. For over twenty-five years, dialogue had been played back to audiences from central speakers located behind the screen. CinemaScope changed that, shifting actors' voices from speaker to speaker. Though the directionality of stereo sound does have a source in the world of theatrical performance, upon which CinemaScope, Todd-AO, and several other wide-screen formats consciously drew, theatrical codes did not translate smoothly into the cinema, particularly when those codes violated preexisting cinematic codes. On the other hand, the playback of film music in stereo succeeded for somewhat similar reasons, relying upon codes established earlier to ensure its reception as verisimilitudinous. The live orchestra which accompanied the first-run exhibition of silent films had established a precedent for the "stereo playback" of music; it is this tradition to which *Fantasia* appealed in 1940 with its depiction of Leopold Stokowski conducting the Philadelphia Orchestra and which *How to Marry a Millionaire* revived in 1953 with its filmed overture, "Street Scene," featuring Alfred Newman and the Twentieth Century–Fox Orchestra. Cognizant of this tradition, critics, industry personnel, and audiences accepted stereo musical scoring, while rejecting directionality for dialogue.[70]

The perception of stereo as an artifice can be attributed to technological factors as well. All multitrack stereo systems channeled the original sound into a finite number of theater speakers. Ideally, as stereo expert Harvey Fletcher pointed out, every square inch of the screen should have a separate speaker and track to reflect the nearly limitless number of potential sources for sounds, while an infinite number of speakers and tracks would be needed to duplicate sounds emanating from off-screen space.[71] Stereo systems that established three, four, five, six, or even seven sound sources, rather than creating a more perfect illusion of depth on the screen, necessarily called attention to the arbitrariness of their choice of sources. The number of sound channels, however, did play a major role in the reception of stereo sound. While CinemaScope was criticized for its noticeable channeling of sound,

other multitrack systems with more channels fared better in their overall reception. For example, Todd-AO's six-track sound enabled it to use five, rather than three, speakers behind the screen; this lessened somewhat the abruptness of shifts in traveling dialogue as it moved from speaker to speaker and proved less objectionable to critics.[72] Contemporary 70mm stereo magnetic formats similarly avoid the excessive channeling of Cinema-Scope by relying upon six tracks instead of four.

The identification of stereo magnetic sound with spectacle was the product not only of diachronic but also of synchronic differentiation. Stereo marked a dramatic departure from earlier, mono sound styles. Audiences, at least in certain CinemaScope and Todd-AO films, were repeatedly "distracted" by the dialogue, which traveled from one position to another behind the screen, and were overwhelmed by sound effects on the fourth track (when it was used).[73] But stereo also attempted to define itself against the background of monaural film sound, with which it competed. Stereo entered an industry dominated by monaural sound and sought to distinguish itself as a marketable commodity from its predecessor. The myth inspiring its evolution may have been the quest for "greater realism," but that demand was already being satisfied, it would seem, by existing sound technologies—in particular, by monaural optical sound. Instead, it satisfied other demands—the need for spectacle and the desire for and fascination with technological display.

The film industry satisfied these differing needs in different ways. Inexpensive neighborhood theaters offered general audiences the traditional "realism" of monaural sound on a regular, day-to-day basis, while the more expensive, first-run theaters provided them with the occasional opportunity to experience the spectacle of stereo sound as a special entertainment event.

Stereo's association with genres of spectacle and with special presentation in first-run theaters confirmed its status in relation to mono: it was not only different but deviant. Mono remained the dominant form of sound reproduction in theaters around the country, functioning as a norm or "background set" against which stereo emerged as a violation of that norm. The conventions associated with mono had established not only its dominance but also its identification with realism as a representational form. For over twenty-five years, mono had served as the realistic form of sound reproduction par excellence. By contrast, stereo sound emerged in the early 1950s as "unrealistic." This distinction was only confirmed by the widespread

perception of certain nonstereo (black-and-white) 1950s films, such as *On the Waterfront, High Noon,* and *Marty,* as more realistic than their widescreen stereo (and color) counterparts, such as *The Robe, Brigadoon,* and *A Star Is Born.* Unable to displace mono as the dominant, stereo could only retain its status as a variant. And, as a variant, it could only continue to attempt to exploit its spectacular characteristics. If this study of the widescreen revolution teaches us anything about the nature of technological change and its relation to realism, it demonstrates that, as Buscombe observed years ago, greater realism is not the only determinant governing the development of new technologies. But realism nonetheless does play a crucial role in the ultimate form those new technologies take. Though it was introduced as a single technological phenomenon, widescreen cinema subsequently evolved in two radically different directions—toward greater realism and toward greater artifice. These different forms of widescreen cinema satisfied the demands of a new motion picture marketplace, which catered to different groups of spectators, ranging from the mass audiences serviced by CinemaScope and other 35mm widescreen systems to the "class" audiences courted by Todd-AO and other wide-film formats.

Ironically, the "greater realism" which inspired the evolution of widescreen led to a dismantling of the original technology (widescreen and stereo sound) and the substitution of a supposedly "less realistic" form—monaural sound—for a supposedly "more realistic" form—stereo sound. The first stage of the widescreen cinema's evolution toward "greater realism" lay in its adoption of monaural sound. The "failure" of stereo suggests that the combination of widescreen images and multitrack stereo sound proved to be too much of a revolution in the mid-1950s. Widescreen cinema and stereophonic sound, as idealistic phenomena, conceived by the film industry to provide a perfect illusion of reality, proved to offer an excess of spectacle that could survive only in the most artificially theatrical of venues—in high-priced, reserved-seat, first-run theaters that, like the legitimate theater they sought to emulate, adopted theatrical schedules, featuring matinees in the afternoon, one show in the evening, and three shows on weekends and holidays.

The redefinition of the nature of the motion picture experience and of motion picture spectatorship that took place in the 1950s succeeded in the short term but failed over the long haul. Dwindling audiences did return to theaters, but the appeal to participation and presence did little to halt the

slow erosion of the traditional, pre-widescreen motion picture audience. As the habitual moviegoer disappeared, the industry attempted to shore up its losses by instituting a new kind of entertainment product and a new pattern of moviegoing, both of which resembled, to a certain extent, the content and form of the legitimate theater. This pattern of infrequent spectatorship could sustain the industry only in an era of blockbusters—that is, through the commodification of participation whereby each film became a special event which drew the sometime spectator away from other leisure-time activities back into the movie theater. Though we are still living within the terms of this last redefinition, over the years the commodification and reification of participation have emptied out their impact as novelties and undermined their original challenge to traditional notions of spectatorship. By the mid-1960s widescreen had become the norm, having lost its revolutionary status with the disappearance of the narrow-screen cinema against which it had initially defined itself.

Though certain elements of the contemporary cinema continue to revive the discourse of participation, describing films as "events" as is the case with the amusement-park cinema of Steven Spielberg and George Lucas, the concepts of participation and presence have atrophied into an almost programmatic stimulus and response. Participation has gradually become more and more passive—the infrequent consumption of motion pictures more and more automatic and habitual, especially in today's chopped-up former movie palaces and small-screen multiplexes. Even large-screen 70mm Dolby presentations today cannot quite recapture the defamiliarizing impact of the widescreen revolution in the 1950s. Participation and presence were always illusory phenomena; they are now only illusions of earlier, pseudo-authentic illusions, copies of copies.

Spectatorship was dramatically redefined during the 1950s by the advent of large-screen/widescreen exhibition of lavishly produced motion pictures with multitrack stereophonic sound. But this redefinition took place against a larger background of more conventional exhibition practices which ultimately came to dominate the industry. The supercircuit of first-run theaters which provided an enhanced sense of spectacle and of participation remained the exception in an exhibition marketplace ruled by small-screen/widescreen presentation in monaural sound. During the 1960s and 1970s this two-tiered system of theatrical exhibition gave way to a multitiered system ranging from exclusive, 70mm, six-track stereo movie palaces and less-exclusive drive-ins, mall cinemas, and neighborhood theaters to mundane home viewing on television. Video exhibition, in turn, introduced a new succession of "runs," which in the 1960s included prime-time network broadcast snd local syndication and, during the 1970s and 1980s, expanded, beginning with home video sales/rentals followed by cable distribution; next films went to the networks and, after that, into syndication.[1] As widescreen films moved "down" through each successive tier of exhibition, the participatory experience of the original theatrical presentation of these works diminished. They played on smaller and smaller screens; they were cropped to fit the much narrower TV screen; and they were edited to meet community standards regarding violence, nudity, and language or to fit a designated time slot.[2] These new markets redefined, yet again, the widescreen experience for an increasing number of spectators who no longer saw films on big screens but saw them instead on screening-room-sized screens in mall cinemas or on 12-to-25-inch television sets.[3]

THE RETURN OF THE NICKELODEON

The success of the widescreen revolution was mixed. In 1953 André Bazin had written about the rush to new formats such as Cinerama, CinemaScope,

and 3-D in an article titled "Will CinemaScope Save the Cinema?"[4] The answer to Bazin's question was neither yes nor no but an indecisive perhaps. CinemaScope did save Twentieth Century–Fox—but only for a few years. The fortunes of Fox improved dramatically just after the introduction of CinemaScope; annual profits jumped from $4.8 million in 1953 to $8 million in 1954 then tapered off to from $6–6.5 million over the next three years.[5] But these figures in no way rivaled the astounding profits which the studio had reaped earlier, in the postwar period. Studio income had climbed from a respectable $12.7 million in 1945 to an alltime high of $22.6 million in 1946.[6] Other studios similarly improved their finances during the first few years of the widescreen era until the recession of 1958–59 put an end to the new prosperity associated with "glorious Technicolor, breathtaking CinemaScope, and stereophonic sound."[7] Yet the short-term success of the widescreen revolution merely delayed for a few years a long-term decline in motion picture attendance that began in 1950 and continued, more or less without interruption, until the 1980s, when it leveled off. Although box-office revenues have steadily risen—as a result of increasing ticket prices—over this period, average weekly attendance figures have just as steadily dropped from a high of 90 million in 1948 to around 21 million in the mid-to-late 1980s.[8] Attendance fell precipitously from 87.5 million per week in 1949 to 46 million in 1953; it rebounded for a year to 49 million in 1954 and then sank to 40 million by the end of the decade.[9] In the late 1960s and early 1970s moviegoing declined even further, consistently averaging below 20 million per week and reaching an alltime low of 15.8 million in 1971; by the end of the 1970s it had slowly climbed back to the 20 million mark.[10]

Although the widescreen revolution failed to reverse the declining fortunes of the motion picture industry, it did permanently alter the shape of the movie screen. But the size of the screen gradually grew smaller as attendance fell and exhibitors adapted themselves to this new marketplace by multiplexing, reducing the size of new theaters, or both. Hundreds of new theaters were built in conjunction with the proliferation of shopping centers and malls in the suburbs during the 1960s, but they tended to be small, resembling the storefront nickelodeons of the pre–movie palace era.[11] In this new era of the multiplex, several small theaters, each seating around 150–200 spectators, were clustered with a larger theater, seating around 500 spectators, to form a movie arcade.[12] The multiplex, pioneered by

exhibitor Stanley H. Durwood in the mid-1960s, provided a new lease on life for exhibitors, who could suddenly expand the number of films they rented and thus increase their chances of booking a blockbuster while holding down extra overhead costs.[13] Multiplexes required few additional staff—a single projectionist could supervise three or more automated booths under one roof, a single cashier could sell tickets to all the theaters, and, with a few more personnel, the concession stand could handle as many patrons as the theaters could hold.[14] Overflow crowds from the more popular films were lured into adjoining theaters to bolster sagging attendance for pictures with less box-office drawing power, more popcorn and candy was sold, and greater profits were realized while expenses were minimized. Thus multiplexing gave rise to one of the greatest ironies of postwar exhibition: as attendance declined, the number of movie screens actually increased. Smaller audiences, divided by more screens in smaller theaters and multiplied by higher ticket prices and concession sales, yielded greater profits for exhibitors as they streamlined their operations in response to the new motion picture marketplace of the 1970s-1990s.

Multiplexes may have solved certain economic problems faced by exhibitors, but in the process they transformed—and diminished—the nature of the motion picture experience, which the widescreen revolution had dramatically redefined in the 1950s. The rise of the large-screen movie palace, which provided audiences with engulfing 24-by-64-foot curved widescreen images, gave way in the 1960s to the demise of the movie palace, symbolized by the demolition of the 6,200-seat Roxy Theatre in 1960, and the return of the large-screen nickelodeon in the form of the shopping-center multiplex. Extravagant atmospheric decor yielded to economical functionalism in design; movie theaters began to look less and less like theaters and more and more like screening rooms (though they lacked the high standards of projection associated with the latter). As Douglas Gomery observed, "the new movie chains seemed to push the slogan of the international style to a new low of literalness: only function should dictate building form."[15]

The seating in old movie palaces averaged from 2,000 to 5,000; multiplexes could hold, on average, only 150–200 spectators in each theater.[16] As more and more movie palaces were broken down into four-, five-, or six-plex houses and as neighborhood theaters were "twinned," the average number of seats per theater fell from 750 (1950) to fewer than 500 (1978).[17]

Whereas the superscreens of the 1950s averaged 18–20 feet in height by 40–50 feet in width, today's multiplexes feature living-room-sized screens that average 12–15 by 26–35 feet (though some larger theaters do have 20-by-40-foot screens).[18] Smaller theaters resulted not only in smaller screens but also in cropped images. Theaters tacitly adopted the 1.85:1 aspect ratio as a standard and, in an attempt to fill both the height and width of their screens, cropped the sides of 2.35:1 anamorphic films.[19]

At the same time, with the increase in the number of multiplexes, showmanship began to disappear from exhibition. Not only were the theaters, designed to conform architecturally with the rest of the mall, blandly impersonal, but the solitary projectionist was too overworked to be able to maintain traditional projection standards, such as sharp focus, precise framing, and good sound, in all the theaters at once. The movie palace served, to a great extent, as a world apart from the surrounding urban landscape; theaters in malls become part of the larger array of products around them; indeed, multiplexes are themselves minimalls, each theater functioning as a separate shop or boutique which features different merchandise for shoppers who select, often on impulse, which movie they wish to see among those on display. Theaters are filled not so much with spectators in search of participatory entertainment as with shoppers looking for a bargain matinee. The spectator's figurative status as consumer and that of the screen as shop window, an analogy suggested by Charles Eckert and others in reference to classic Hollywood cinema of the 1920s-1940s, became, with the development of mall cinemas in the 1960s-1990s, more and more literal. The spectator's evolution from moviegoer into shopper has only been confirmed by the increasing reliance upon product placement/plugging and merchandising tie-ins which inform the address of more and more contemporary films to their spectators.[20]

THE RETURN OF THE PEEPSHOW

Even before exhibitors had taken measures to adapt to a diminished postwar demand for motion pictures, the major studios had already begun to cut back, producing fewer (but more expensive) films and reducing overhead costs by dropping contract personnel. In an attempt to increase revenues, studios auctioned off their back lots, props, and costume collections; sold or leased their film libraries to television; and produced specially made

series programs for television.[21] In motion picture production and distribu-
tion, the late 1950s and the 1960s became the era of the blockbuster—
mammoth, expensively produced spectacles filmed and exhibited on wide-
film formats and in multitrack stereophonic sound.[22] As negative costs
soared, the number of domestic releases fell, from 391 in 1951 to 131 in
1961; although they rebounded to the 300 level in the 1970s, the majority
of these titles were less-expensively-made independent productions; re-
leases by the majors/MPAA members account for less than half of this
total.[23] In the 1960s Fox and M-G-M sold studio property in an attempt to
refinance and pay off loans incurred in their acquisition by new owners.[24]
Meanwhile, financially troubled Paramount, United Artists, and Warners
were absorbed by larger conglomerates.[25] In terms of the history of wide-
screen cinema, however, the most significant step taken by the majors was
their decision to market to television both their backlog of older titles and
their more recent releases.

For a number of years, the only feature films avaliable for televison were
those of independent producers of "A" films, such as Alexander Korda and
David O. Selznick, or of studios involved with "B" films, such as Monogram,
Republic, and Eagle-Lion.[26] The networks' refusal to pay studios what the
latter considered to be adequate compensation for the rights to show their
products provided one reason for the majors' decision to withhold films from
television; pressure from exhibitors, who were in direct competition with
broadcasters for product, furnished another.[27] But the intervention of syn-
dicators, who could meet the studio's price by selling packages of films to
hundreds of independent TV stations (or by bartering for advertising time
which was then sold by syndicators to advertisers), resulted in a rash of
sales of studio libraries to television.[28] In December 1955 General Tele-
radio, which had just purchased the assets of RKO, sold that studio's lib-
rary of 740 features and 1,100 shorts to the C & C Television Corporation,
which in turn leased them to TV stations around the country. Though
syndication produced revenues that could tempt the major studios to sell
or lease their libraries to television, studio contracts with creative personnel
limited these dealings. Aware of the potential market for theatrical features
on television, in 1951 the Screen Actors Guild began negotiations for
royalties and residuals from the TV broadcast of films in which they
appeared. As part of these negotiations they ceded all rights to films made
before August 1948 and received, in return, an agreement that the studios

would contract with them for royalties accruing from the sale to television of features made after 1948; later in 1951 the studios agreed to the same conditions with the Screen Directors Guild and the Writers Guild of America.[29] This left the studios free to sell their pre-1948 films to television, which they began to do after RKO had sold off its library in 1955.[30] In January 1956 Columbia's television subsidiary, Screen Gems, began to release pre-1948 features to TV; in March Warners sold its library of features and shorts, and in May Fox released its backlog of older films through National Telefilm Associates; in June M-G-M created a subsidiary to market its titles to TV; and finally, in February 1958, Paramount followed suit, selling its pre-1948 features to MCA.[31]

FEATURE FILMS IN PRIME TIME

Meanwhile, rights and royalty negotiations between producers and the major craft guilds over post-1948 features continued; in 1960 the studios and the guilds reached an agreement which paved the way for the release of more recent motion pictures to television.[32] On September 21, 1961, the first of this new package of post-1948 features, Twentieth Century–Fox's *How to Marry a Millionaire* (1953), was aired on "NBC's Saturday Night at the Movies."[33] *Millionaire* ushered in not only the era of the prime-time network feature film but also that of the panned-and-scanned film. Filmed at the same time as *The Robe, Millionaire* was Fox's second CinemaScope feature. Films in CinemaScope, which had an aspect ratio of either 2.55 or 2.35:1, posed problems for television broadcast because the TV screen possessed only a 1.33:1 aspect ratio. If the full width of the widescreen image were to be shown on the TV screen, the top and bottom of the screen would be left with blank areas above and below the image. If the top and bottom of the screen were to be filled, then the sides of the image would have to be cropped by 50 percent or more. The major networks quickly "resolved" the essential incompatibility between the widescreen and television formats by deciding to pan and scan (that is, to crop) films rather than to present them in what was subsequently referred to as the "letterbox" format.[34]

To facilitate the release of its CinemaScope films to television, in 1961 Fox developed an optical printer that could produce a special flat 1.33:1 television print by "extracting" sections of the original widescreen image. Fox's process employed a 1.33:1 "finder frame" which an operator could

THE
RECOMPOSITION
INVOLVED IN THE
PAN-AND-SCAN
PROCESS
(AUTHOR'S SKETCH).

shift horizontally from one position to another "to follow the important action."[35] Information regarding the location of these positions was then fed into a computer, which programmed the optical printer's movements during the actual transfer process. The finder frame could be programmed to pan (at two different speeds) to the right or to the left or to cut from one position to another during the printing operation, permitting the technician in charge of the transfer to reframe during a shot or to edit from one side of the CinemaScope frame to the other.[36] This process, known as panning and scanning, recomposed widescreen films for television, extending their marketability beyond the specifically theatrical exhibition for which they had been designed. As in the case of theatrical exhibition, in which the con-

flicting demands of different exhibition tiers forced the studios to "unpack" the original package of widescreen image and stereo magnetic sound, the new market for widescreen cinema on television introduced a new set of conflicting demands which filmmakers found virtually impossible to satisfy. Films which exploited widescreen technology in an attempt to provide an experience attainable only in a theater were now suddenly asked to adapt themselves to the demands not just of a different but of an opposed technology—narrow-screen television. Though it may have extended the commercial life of widescreen films, television emerged as yet another stage in the dismantling of the widescreen revolution and the demise of wide-screen cinema. It not only returned the cinema, for a great number of viewers, to the era of the small-screen peepshow but in doing so also materially altered original theatrical releases.

PAN-AND-SCAN SCANDALS

Initial attempts to adapt widescreen films to the narrow-screen television format proved to be disastrous. Televison broadcasted either more or less image than could be seen in the theater (until recently, it never even tried to present audiences with the same aspect ratios used in theaters). With the exception of wide-film and anamorphic processes, such as CinemaScope and Panavision, the majority of widescreen processes produced widescreen images in the theater by cropping or masking off the top and bottom of the standard 35mm frame to a 1.66 or 1.85:1 aspect ratio. For the most part, these films were originally shot full-frame and thus provided few problems for television broadcasters, who merely ran them full-frame, providing viewers with more image at the top and the bottom than had been intended. Unfortunately, more is not always better. Television broadcast of full-frame widescreen films like *Hatari!* (1962), which were composed for projection in 1.85:1, occasionally reveals microphones above the heads of actors; in the theater, projection aperture plates would have concealed the microphones. In the famous shower sequence in *Psycho!* (1960), the television screen reveals to viewers more than Hitchcock had originally planned for them to see; here and at several other points in the film, black masking appears at the bottom of the image, masking that would not have been seen in the theater. The full-frame version of *Bonnie and Clyde* (1967) displays more of Faye Dunaway's nudity in the opening sequence than director Arthur Penn, who expected this nudity to be masked in projection, ever

intended. In the case of VistaVision and the few features filmed with a hard matte, the images on the original 35mm prints are not full-frame; for television broadcast, these films are blown up to full-frame and cropped on the sides, resulting in a loss of approximately 30 percent of the original image. In both cases, the composition of the original is destroyed and replaced by another, which is dictated by the shape of the TV screen.

Panning and scanning, which provides less rather than more image, presents an even greater threat to the composition of the original. Though pan-and-scan technology has improved over the years and contemporary filmmakers have learned how to protect their original compositions for television broadcast, it continues to play havoc with widescreen aesthetics. Primitive pan-and-scan techniques involved simply rephotographing the center portion of the original image, lopping off both sides. Single fixed-position scanning often resulted in unintentional avant-garde minimalism in films that exploited the extreme edges of the frame. In a crucial sequence of *A Star Is Born* (1954), Judy Garland and Jack Carson stand talking in her dressing room at either edge of the CinemaScope frame; on television, we continue to hear them talk, but both actors are missing; all that can be seen is the space between them, occupied by Garland's dressing table and mirror.

By the early 1960s, major improvements permitted from seven to twelve different positions from which the original CinemaScope image could be viewed by a scanning telecine device. M. Peter Keane, who developed a seven-position pan-and-scan system for Screen Gems in 1961, explains that "you could now cut from position to position during a dialogue sequence in order to keep whoever is speaking in frame and occasionally get a reaction shot of whoever is listening."[37] Earlier that same year, Alex Alden had devised a similar system for Fox which used twelve positions, which his tests concluded to be the minimum number necessary to cover the action adequately.[38] Today there are virtually an infinite number of possible positions, as well as new technologies which make optically introduced panning movements virtually indistinguishable from actual camera pans.

Rules of Thumb

Even though panning-and-scanning technology is better, panned and scanned films have not necessarily improved in quality. Ralph Martin, a former editor who supervises panning and scanning for Warner Brothers, complains

that many films today are panned and scanned "on the fly" by a camera operator in a laboratory who may pan and scan a two-hour film in as little as two and a half hours of real time. "It's better if it's done shot by shot by an experienced cameraman or film editor like we do here at Warners," says Martin, but that practice appears to be the exception rather than the rule.[39] In 1969 Pete Comandini of YCM labs worked on the first film-to-video transfer, which prepared the Vistarama production of *The Big Country* (1958) for network airing. Comandini reported that he and his colleagues spent almost six months working on this single transfer, though today from six to twelve hours might be spent on the average in panning and scanning a feature film.[40] Keane, presently director of tape quality at Home Box Office, insists on shot-by-shot panning and scanning and cut-by-cut color correction, which he does in-house at a cost of $6,000–8,000 per feature film, which is about half the cost charged if the work is sent out to a professional Hollywood lab.

A handful of directors, such as Woody Allen, have secured contractual agreements which permit them to supervise the transfer of their films to video, but the majority of creative personnel who worked on the theatrical release of a film have no control over subsequent video or broadcast versions of their work. Martin says that the goal of the best panning and scanning is "to try to preserve what the director did with the original film and to try to make it look its best."[41] But good intentions cannot replace the significant proportion of image that has been lost in the transfer process. And the original intentions of the director are, more often than not, reduced to the lowest common denominator of the pan-and-scan industry, whose codes and conventions tend to be fairly basic; scanners are primarily concerned with keeping whoever is speaking in frame and with trying to be as unobtrusive as possible.

Scanners can pan across a CinemaScope image or cut from side to side; both procedures, however, impose a foreign aesthetic pattern onto the original film, shifting the spectator's attention in ways that the filmmaker never intended. In effect, panned-and-scanned versions of widescreen films constitute secondary rereadings of them, often by a sensibility that is completely different from that of the original filmmaker. And these rereadings are unacknowledged; no warning informs viewers that the film has been recomposed and reedited for television. In Otto Preminger's *Advise and Consent* (1962), panning and scanning dramatically transforms the mise-en-

scène of the original film. Preminger's Panavision frame holds a variety of disparate politicians, each with his own goal and strategy for attaining it, within the unified space of the chamber of the Senate. The narrative of the film, which culminates in a deadlocked vote for a new secretary of state, demonstrates, on one level, the democratic notion of a necessary balance of power. Preminger's original blocking of characters within the widescreen frame graphically illustrated the basic system of checks and balances which underlies American government. Panning and scanning, however, introduces cuts into these long takes, destroying the intricately worked-out equilibrium of opposing forces in the original.

In some instances, optical panning can have a comical effect. Unlike most CinemaScope films, the title sequence for Joshua Logan's *Picnic* (1956) is panned and scanned rather than shown squeezed or masked. (Contractual agreements with the craft guilds stipulated that credit sequences be shown in their entirety; thus they are frequently presented with their original anamorphic compression intact, ensuring that every name will be seen.) In the panned-and-scanned credits of *Picnic*, star William Holden's name appears first as "William Ho," then, after panning to the right, as "m Holden." Rosalind Russell gets similar "star" treatment, though in slightly smaller letters; she evolves from "Rosalind Rus" to "ind Russell." Cameraman James Wong Howe suffers similar indignities, as do the names in the technical credits, which are detached by a robotic-looking pan from the jobs they performed. The literal nature of the motivation for the pans here calls attention to the arbitrariness of the pan-and-scan process as a whole. The panning in the rest of the film is just as arbitrary, though a bit harder to see because the spectator is not forced to acknowledge its absurdity in quite as obvious a way.

The rule of thumb for panners and scanners is to follow the action, which simply translates into holding on whoever is speaking or following the movements of the central character. In a film like *Rebel without a Cause* (1955), dialogue sequences between two characters, originally shown in two-shot, routinely drop whoever is listening when reframed for television. The essential alienation of the teenage stars, such as James Dean, Sal Mineo, and Natalie Wood, becomes all that more poignant because panning and scanning regularly deprives them of an audience to whom they can tell their problems. The quality of Dean's performance in *Rebel* and *East of Eden* (1955) is seriously compromised by the pan and scan process. Dean's

acting consists, in part, of establishing an intense physical relationship between his body and the surrounding setting. The mise-en-scène of a Dean film relies on the careful positioning of his body in relationship to the other characters around him; he often turns his body slightly away from them so as to isolate himself in a somewhat private space of his own. But this eccentric spatial choreography is lost when panning and scanning focuses, in dramatically tighter shots, on Dean alone. One curious moment in the television version of *East of Eden* is symptomatic of certain problems that panning and scanning introduces. While Raymond Massey, who plays Dean's father, talks on screen left with a group of characters, Dean wanders about in the background on the extreme right. Instead of observing pan-and-scan convention and focusing on Massey, the scanner perversely watches the silent figure of Dean in the background. This may be a subtle attempt to drive home the impact of the father's words upon his son, but it is just as likely to be an instance of star idolatry. The scanner's privileged selection of Dean here and in countless dialogue sequences which favor the actor elsewhere is, in part, a response to the subsequent importance that Dean and the cult that grew up around him after his death had in the rereading of his widescreen work for television audiences.

Though panning and scanning plays havoc with the work of directors, performers, and cameramen, it rarely results in plot confusion. The chief goal of scanners is to follow important action and to preserve the essentials of the story. And even if a scanner becomes obsessed with an actor or actress to the point of losing the thread of the central action, most Hollywood narratives are conveyed on so many different levels that a viewer could easily piece the plot together in some other way, such as by simply listening to the sound track. A little cropping here and there won't render the plot indecipherable. But it can result in a certain Beckett-like absurdism, such as the scene in *The High and the Mighty* (1954) when John Wayne's nose talks to Robert Stack's ear over the empty space of the airplane cockpit between them. Though the plot of David Lynch's *Blue Velvet* (1986) may be said to begin with the discovery of a severed ear, the scanner's attempt to reframe Lynch's widescreen compositions results in further dismemberment, particularly in the diner sequences between the police detective's daughter (Laura Dern) and the hero (Kyle MacLachlan), in which her nose listens attentively to his unraveling of the bizarre mystery that lies at the heart of the film.

Sergio Leone's *The Good, the Bad, and the Ugly* (1967) builds to a climactic gunfight in a gladiatorial-style arena which is implausibly located in the middle of an enormous Civil War graveyard. Here the film's eponymous heroes meet and, taking up positions at the extreme edges of the frame, face off against one another in a remarkable three-way shootout. But on TV, the long shot that situates them in relation to one another in a single space has been cropped, eliminating one of the combatants and momentarily destroying the novelty of the situation. The Good, the Bad, and the Ugly suddenly become the Good, the Bad, and the Missing. By the same token, the sole appearance of the Three Stooges in *It's a Mad, Mad, Mad, Mad World* (1963), which was filmed in Ultra Panavision 70, is reframed on TV in such a way that two of the Stooges are left on the panning-and-scanning room floor.

In the opening sequence of M-G-M's *It's Always Fair Weather* (1955), three war buddies who have just been discharged from the army bid farewell to one another at a New York bar, vowing to meet again at the same place ten years from that day. To remind his pals of the date they are to meet, the character played by Gene Kelly tears a dollar bill into three equal sections, writes the date of their proposed reunion on the pieces, and gives one to each of his friends. Ten years later, during their reunion, the three former friends dance side by side, but in different locales. In a split-screen effect that playfully parodies the three-screen process of Cinerama, Kelly, Dan Dailey, and Michael Kidd synchronize their movements to the music of "Once Upon a Time," each dancer serving, as it were, as an integral third of a widescreen composition that is torn like the dollar bill each man carries in his wallet.

Filmed in CinemaScope, *It's Always Fair Weather* dramatically calls attention, through the uncanny resemblance between the devices of the split screen and the tripartite dollar bill, to a remarkable fact. By a strange coincidence, American currency is almost exactly the same shape as CinemaScope; both have an approximate ratio of width to height of 2.35 to 1. For Hollywood, the shape of CinemaScope was, indeed, the shape of money; it was a symbol of the profits which Fox and other studios sought to realize by engineering a widescreen revolution. Though the shape of money remains constant, the shape of movies is constantly in flux; a film's aspect ratio depends as much upon the source of the next dollar to be earned as it does on the format in which the film was shot. Thus, when *It's*

Always Fair Weather is shown on television, the original widescreen spectacle is chopped into pieces that, unlike the heroes' dollar bill, can never be reassembled. We see Gene Kelly dancing with the dismembered limbs of Dan Dailey and Michael Kidd, whose faces and torsos are now cropped from the original image so that the dance number can be squeezed into the narrower aspect ratio of the television frame. Here and in countless other panned-and-scanned versions of widescreen films, the shape of money has become the shape of the television screen. And this new shape has permanently transformed the shape of widescreen filmmaking in the counterrevolutionary decades following the era of the original widescreen revolution.

TWO FILMS IN ONE

Since the first sale of widescreen films to television in 1961, filmmakers have been making two films instead of one. One film is made for the theater and the other for television. In certain instances, two somewhat different versions of the same film are produced; sequences containing nudity, objectionable language, or excessive violence are filmed twice—once with this material intact (for the more "adult" audience that will view the film in a movie theater or on cable) and then once again without it (for the home viewer, whose sensibilities are protected by the FCC's concern that the

standards of the community in which the film is shown are observed by the standards and practices of broadcasters).

More often than not, however, the theatrical film and the video version are combined into one, especially in the case of widescreen works. In 1962 the Research and Education Committee of the American Society of Cinematographers devised a method of "producing motion pictures for theatrical wide screen presentation so they may also be shown on television without impairment of the picture image." To accomplish this seemingly impossible task, the committee established what it called a "safe action area": "that portion of the picture area inside the camera aperture borders within which all significant action should take place for 'safe' or full reproduction on the majority of black-and-white and color home receivers."[42] Camera manufacturers began to produce viewfinders which indicated this area with a dotted line, and directors of cinematography began to "protect" their compositions for television by keeping essential narrative and aesthetic elements within this frame-within-a-frame. Though many cinematographers deny that they compose for subsequent television release of their work, awareness of TV's "safe action area" undoubtedly influences their approach to widescreen composition. In the 1950s, Zanuck instructed his directors and cameramen to spread the action out across the full width of the frame in an attempt to maximize the CinemaScope format. Today, with one or two notable exceptions, directors and cameramen, who realize that the majority of their audience will see their work on television rather than in the theater, take pains to insure their films against the potential damage that panning and scanning can inflict.

Director of photography Nestor Almendros acknowleges, "I try to take the TV image into consideration. I don't allow myself to make extreme compositions, and I try to keep what is important in the center of the frame."[43] In an attempt to protect their work, Almendros and directors such as Martin Scorsese and Joe Dante avoid filming in aspect ratios greater than 1.85:1. "I've been obsessed with 'Scope for years and would love to shoot everything in 'Scope," Scorsese admitted, "but I realize that when it's shown on TV the power of the picture will be completely lost."[44] With *Cape Fear* (1991), however, which was filmed in Panavision, Scorsese has finally made a 'Scope film, encouraged, no doubt, by the success of some of his colleagues in releasing their widescreen films on video in the letterbox format.

LETTERBOXING

Letterboxing preserves the aspect ratio of the original theatrical release by diminishing the height of the video image.[45] In 1985 Woody Allen, having secured a contractual agreement with United Artists which gave him control over the video versions of his work, introduced the letterboxing of new films to the video marketplace with the release of *Manhattan* (1979), which had originally been filmed in Panavision. Subsequently, Steven Spielberg issued *The Color Purple, Innerspace, Empire of the Sun*, and *E. T.: The Extraterrestrial* in 1.85:1 widescreen versions. In December 1986, shortly after Allen's experiment with *Manhattan*, Criterion began to issue a number of new and old widescreen titles on laser disc, which were marketed to serious collectors and high-end videophiles. Criterion began with 'Scope features such as *Blade Runner, The Graduate, 2001: A Space Odyssey*, and *Lola Montès*. Today their catalogue includes letterboxed versions of both 'Scope and non-'Scope widescreen films, such as *Annie Hall, L' Avventura, Blowup, Close Encounters of the Third Kind, Forbidden Planet, The Great Escape, Hidden Fortress, Invasion of the Body Snatchers, Lawrence of Arabia, North by Northwest, The Princess Bride, Shoot the Piano Player, Taxi Driver, West Side Story*, and *Yojimbo*. At the same time, in an attempt to address this new "connoisseur" market, several major distributors began to distribute widescreen films on laser, with titles ranging from *The Apartment, Ben-Hur, Cleopatra, Gigi, Oklahoma!, Patton, The Robe*, and *Silk Stockings* to *Alien, Batman, Die Hard, The Empire Strikes Back, The Last Emperor, The Return of the Jedi, Star Wars*, and *Victor/Victoria*. Although more and more widescreen films are being issued in letterbox editions on laser, these releases constitute only a small fraction of the total video marketplace, which is dominated by the mass marketing of widescreen films in panned-and-scanned versions on videotape.

At the same time, letterboxed widescreen films, though preferable to panned-and-scanned copies, lack the impact of widescreen films in the theater. The engulfing experience of viewing *2001* in Cinerama, *Oklahoma!* in Todd-AO, or *The Robe* in CinemaScope on wraparound theater screens bears little or no relation to the experience of seeing them on a television screen, even in their proper aspect ratio. High-definition television, which employs a widescreen aspect ratio, promises to increase image size and to improve image quality, but HDTV remains, at best, merely very good

television; it cannot duplicate the experience of seeing films on a large screen in a movie theater. Besides, HDTV is a product of compromise. Proposed HDTV formats are restricted by FCC demands that they remain compatible with existing broadcast technology so that their signals can be played on traditional, non-HDTV home receivers, thus limiting the number of scan lines that can be used. The proposed aspect ratio for HDTV is 16:9 (1.77:1), which conforms to no theatrical widescreen format and appears to be a compromise of sorts between the European widescreen standard of 1.66:1 and the American (nonanamorphic) widescreen standard of 1.85:1.[46] Even in the supposedly utopian age of widescreen high-definition television, widescreen films won't fit on the TV screen unless they are cropped.

Video continues to be the lowest common denominator in the story of the decline and fall of widescreen cinema. Though consciously shooting for the theater, filmmakers unconsciously shoot for video, knowing that their films are financed, in part, by presale to cable and that a greater and greater proportion of their overall income will derive from video sales and rentals. As traditional distribution patterns change and as a greater percentage of a film's income derives from sale to cable TV or from the sale of prerecorded videocassettes, both the kinds of films that will get made and the way in which they are made will become increasingly determined by the video market. A study conducted by Wilkofsky Gruen Associates for Merrill Lynch predicted that by 1995 the sales of prerecorded videocassettes (PRCs) will reach 700 million per year, amounting to over $14 billion in sales. They forecast that total 1995 PRC sales and rentals will add up to $20 billion. At the same time, on the basis of statistics for theater admissions, they predict that motion picture box offices will take in revenues of only $8 billion. In other words, the video revenues of motion pictures will more than double box-office gross.[47] Subsequent statistics tend to bear these predictions out. PRC sales for 1990 stood at about 220 million for $4 billion in revenues, while box-office receipts were over $5 billion, giving theatrical exhibition revenues only a slight edge over video sales and rentals.[48]

With the advent and proliferation of home VCRs, which number 65.4 million and which have penetrated over 70 percent of all TV-owning households, motion pictures have returned to the era of the Kinetoscope and the Mutoscope. As in the 1890s, in the 1990s viewers can determine when the film will start, can themselves set it in motion, and can run it both forward and backward as well as "freeze-frame" it. But as audiences

gain more and more control over moving images, those images tend to lose some of their power to move spectators. Though it is still possible to recreate the original experience of widescreen cinema at the Ziegfeld, the Chinese, the Cinerama Dome, or a handful of other large-screen theaters, for most audiences that which was truly revolutionary about the widescreen revolution has long since disappeared. The widescreen revolution of the 1950s may well represent the last chapter in the cinema's attempt, as a medium, to recapture its original ability to excite spectators. The future, it seems, belongs not to the cinema but to video.

Notes
Index

Notes

Introduction

1. Quoted in *This Is Cinerama,* (yellow) program booklet, n.d. (ca. 1952).
2. Quoted in *This Is Cinerama,* (black) program booklet, n.d. (ca. 1952).
3. André Bazin, "The Myth of Total Cinema," in *What Is Cinema?* vol. 1, trans. Hugh Gray (Berkeley: University of California Press, 1967), p. 20.
4. See Charles Barr, "CinemaScope: Before and After," *Film Quarterly* 16, no. 4 (Summer 1963), 4–25.
5. The refusal to theorize historical activity has come under sharp attack by revisionist historians influenced by Thomas Kuhn's conventionalist history of science. Kuhn focuses on the problem of the directness of the historian's access to history itself, arguing that history can be known only through conventionalized representations of it. For Kuhn, historians are not so much historians as model-builders, constructing new paradigms or implementing preexistent ones to use in the explanation of phenomena. From a conventionalist perspective, history is inaccessible to us, having been "replaced" by forms of knowledge and by the writing of history itself, which determine, according to the methodology employed by the historian, history's shape and meaning. To put it another way, conventionalism teaches us that there was no history—there was only "history." In other words, history was rendered suspect by questioning its status as fact and revealing its sources in the ideological assumptions of the historian, a revelation which forced it into the questionable confines of quotation marks. See Thomas Kuhn, *The Structure of Scientific Revolutions,* 2d ed. (New York: New American Library), pp. 3–4. For a discussion of conventionalism and its critique of empiricism, see Terry Lovell, *Pictures of Reality* (London: British Film Institute, 1980).
6. Louis Althusser, "Reply to John Lewis," in *Essays in Ideology* (London: Verso, 1984), p. 91. Also cited in Fredric Jameson, *The Political Unconscious: Narrative as a Socially Symbolic Act* (Ithaca: Cornell University Press, 1981), p. 29.
7. The notion of history as narrative has been seriously challenged by a number of contemporary historians, among them the French *Annales* group, who regarded previous, narrativized histories as polemical and nonscientific, shaped by ideology rather than by objective fact. See Hayden White's discussion of the *Annalistes* in

The Content of the Form (Baltimore: Johns Hopkins University Press, 1987), p. 31. Yet, as White suggests (pp. 31–32), even the *Annalistes* refused to question the *representability* of history. They merely rejected one form of its representation—the short-term, novelistic account—for another—the long-term, impersonal, "scientific" account. And the question remains whether even this account is entirely free of narrativization.

8. André Bazin, "An Aesthetic of Reality," in *What Is Cinema?* vol. 2, trans. Hugh Gray (Berkeley: University of California Press, 1971).

9. André Bazin, "The Evolution of the Language of Cinema," in *What Is Cinema?* vol. 1.

10. This particular essay is relentlessly dialectical, opposing (under the category of the shot or "photo-fragment of nature") realistic and fantastic staging. The latter leads to the concept of typage; montage looks back to the circus and the harlequin's particolored costume, etc. Sergei Eisenstein, "Through Theater to Cinema," in *Film Form,* ed. and trans. Jay Leyda (New York: Harcourt, Brace & World, 1949).

11. Sergei Eisenstein,"Dickens, Griffith, and the Film Today," in Leyda, *Film Form.*

12. Ibid., p. 232.

13. See Kenneth Macgowan, *Behind the Screen: The History and Techniques of the Motion Picture* (New York: Dell, 1965); and Barry Salt, *Film Style & Technology: History & Analysis* (London: Starword, 1983).

14. See Jean-Louis Comolli, "Technique et idéologie," in *Cahiers du cinéma,* nos. 229 (May–June 1971), 230 ((July 1971), 231 (August–September 1971), 233 (November 1971), 234/235 (December 1971–January 1972), and 241 (September–October 1972); translated as "Technique and Ideology: Camera, Perspective, Depth of Field" in Bill Nichols, ed., *Movies and Methods,* vol. 2 (Berkeley: University of California Press, 1985); and in Philip Rosen, ed., *Narrative, Apparatus, Ideology: A Film Theory Reader* (New York: Columbia University Press, 1986).

15. Comolli, "Technique and Ideology," in Nichols, *Movies and Methods,* p. 55.

16. John Hess, "Film and Ideology: Introduction," *Jump Cut,* no. 17 (April 1978), 14.

17. Comolli, "Technique and Ideology," p. 55.

18. See ibid.

19. The term *materialism* is used here in opposition to Bazinian idealism and should not be confused with Marx's notion of historical materialism, which differs from Engels' and Eisenstein's theories of the essence of nature itself.

 Comolli's attempt to develop a materialist historiography has, in many respects, influenced the way we think about the relation of technique and technology to ideology and about the writing of film history. More importantly, it has influenced a number of revisionist, theoretically oriented studies of technology and history, such as James Spellerberg's work on CinemaScope, Ed Buscombe's essays on film history, Ed Branigan's history of color, Stephen Neale's *Cinema and Technology,*

and, to a somewhat lesser extent, Robert Allen and Douglas Gomery's *Film History: Theory and Practice* (New York: Knopf, 1985). See Spellerberg, "Technology and Ideology in the Cinema," *Quarterly Review of Film Studies* 2, no. 3 (August 1979), 288–301; idem, "CinemaScope and Ideology," *Velvet Light Trap*, no. 21 (Summer 1985), 26–34; Buscombe, "A New Approach to Film History," *1977 Film Studies Annual: Part Two* (Pleasantville, N.Y.: Redgrave, 1978), 1–8; idem, "Sound and Color," *Jump Cut*, no. 17 (April 1978); Branigan, "Color and Cinema: Problems in the Writing of History," *Film Reader* 4 (1979), 16–33; Neale, *Cinema and Technology: Image, Sound, Colour* (Bloomington: Indiana University Press, 1985).

Though not all of these works could be said to answer Comolli's call for a materialist historiography, they do implicitly repudiate the traditional writing of motion picture history, which Comolli faults as both empiricist in method and idealist in concept. In other words, they avoid the notion that the cinema and its history can be known merely through empirical observation and that the scenario of its development can be constructed through an idealist projection into the past of an evolutionary chain which leads linearly, and in a cause-and-effect manner, directly to the present.

20. These rejections can be understood, in large part, as a rejection of Bazin, whose writings Comolli singles out and whose essay "The Myth of Total Cinema," in particular, emerges as a compendium of what is wrong with idealist approaches to history. A similar outline of the concerns of materialist historiography can be found in Kristin Thompson and David Bordwell, "Linearity, Materialism, and the Study of Early Cinema," *Wide Angle* 5, no. 2 (1983), 5–6.

21. Paul Ricoeur, *Time and Narrative*, vol. 3, trans. Kathleen McLaughlin and David Pellauer (Chicago: University of Chicago Press, 1985).

22. The relationship between history, historical evidence, and historiography is similar to, though not identical with, that between ideology, the literary text, and criticism outlined by Pierre Machery in his *Theory of Literary Production* (Paris: Maspero, 1966). Of course, ideology, which belongs to the Imaginary, quite clearly is not the same thing as history, which belongs to the Real—*pace* Stephen Heath, who insists that the imaginary relationship that ideology provides us to the Real "is itself real, which means not simply that the individuals live it as such . . . but that it is effectively, practically, the reality of their concrete existence, the term of their subject positions, the basis of their activity, in a given social order"; *Questions of Cinema* (Bloomington: Indiana University Press, 1981), p. 5.

23. Jameson, *The Political Unconscious*, p. 37.

24. The French word *histoire*, which means "story" as well as "history," conveys something of the problems involved in the writing of history. History is a "fiction," and the writing of history is, like other writings, always a narrative account of past events.

Histoire differs somewhat from the original Greek term, *historia*, which literally means "inquiry" and which is etymologically linked to the verbs *eido* and *oida*, which mean "to know." The word *istoria* thus conveys a distinction between history-as-totality and history-as-structure; for the Greeks, history was the knowledge acquired through an investigation of the past. Knowledge was seen as a function of subjectivity rather than of objectivity and, as a result, never confused with the object which it was knowledge of.

1. The Shape of Things to Come

1. Bosley Crowther, "The Three-Dimensional Riddle: Will the New 'Depth' and 'Width' Films Revolutionize the Movies as Sound Did, or Are They a Passing Wonder?" *New York Times,* March 29, 1953.

2. "The Fine Arts: The Kinetoscope," *The Critic* 24, no. 638 (May 12, 1894), 330; reprinted in George C. Pratt, ed., *Spellbound in Darkness,* vol. 1 (Rochester: University School of Liberal and Applied Studies, University of Rochester, 1966), p. 8.

3. For Edison's perception of the Kinetoscope as chiefly a toy or novelty, see Benjamin Hampton, *History of the American Film Industry* (New York: Dover, 1970), pp. 6–7.

4. André Bazin, "The Myth of Total Cinema," in *What Is Cinema?* vol. 1, trans. Hugh Gray (Berkeley: University of California Press, 1967), p. 22.

5. See, for example, Noel Burch, "Film's Institutional Mode and the Soviet Response," *October* 11 (Winter 1979); and David Bordwell, Janet Staiger, and Kristin Thompson, *The Classical Hollywood Cinema: Mode of Production to 1960* (New York: Columbia University Press, 1985).

6. Not all large-screen formats are greater than the 1.66:1 aspect ratio. For example, the Imax and Omnimax systems, which expose 65mm film horizontally and use 70mm film in projection, produce an aspect ratio of 1.43:1.

7. In "CinemaScope: Before and After," *Film Quarterly* 16, no. 4 (Summer 1963), 6, Charles Barr described this other form of cinema—pre-widescreen cinema—as "narrow." However, it is not literally narrow, that is, higher than it is wide. It has an aspect ratio that possesses greater width than height. It is narrow only in relation to wider aspect ratios.

8. The term *aspect ratio* refers to the ratio of width to height of the film image when it is projected onto a screen.

9. W. K. L. Dickson, "A Brief History of the Kinetograph, the Kinetoscope, and the Kineto-phonograph," in *A Technological History of Motion Pictures and Television,* ed. Raymond Fielding (Berkeley: University of California Press, 1967), p. 14. In *The Edison Motion Picture Myth* (Berkeley: University of California, 1961), Gordon Hendricks questions Dickson's dating of this development, arguing that only

¾-inch images were being used as late as 1891 (p. 165). Hendricks suggests that Edison and Dickson dated certain developments two years earlier than they actually occurred in order to establish Edison's priority in the invention of the motion picture and thus to ensure the validity of Edison's patents, which were being contested in the courts.

10. The Kinetograph was, according to Edison's "official" chronology, perfected in 1889; the Kinetoscope was demonstrated publicly in 1893. Technically, the 4:3 Kinetoscope image should not be referred to as an aspect ratio, since the image was not projected onto a screen. The operative term in this statement is *established*. No claims are made here for Dickson as an inventor of the motion picture camera or motion picture film. Earlier cameras, such as Etienne Jules Marey's photographic gun, which exposed images successively on a revolving glass plate (rather than on sensitized paper or film), predate Dickson's work. Nor did Dickson "invent" motion picture film, which had been the subject of experimentation carried out before 1889 by Hannibal Goodwin, John Carbutt, Henry M. Reichenbach (Eastman), and others. However, the success of the Kinetograph and Kinetoscope did "establish" the 35mm gauge and the 4:3 aspect ratio as early standards.

11. Major variations from the 35mm standard include the subsequent development of nonprofessional film gauges, such as 16mm, 8mm, and super-8mm, as well as the introduction, through the advent of Todd-AO in the mid-1950s, of a new professional production and exhibition standard of 65mm/70mm. Although many films continue to be exhibited in 70mm today, the great majority of them have, since the mid-1960s, been blown up from 35mm, which remains the chief production standard in current use. A variety of other gauges, ranging from 9.5mm to 75mm, have been introduced over the years but have failed to gain industrywide use.

12. With the exception of anamorphic films, which continue to use the full height and most of the width of the 35mm negative image area, the actual image area of films made from the early 1930s to the present is slightly less than the $1 \times \frac{3}{4}$ inch dimension cited by Dickson, though the aspect ratio of the image area remains 1.33/7:1. When soundtracks were placed alongside the image in the early sound-on-film processes, a portion of the width of the original silent film frame was lost. In order to retain the 1.33:1 aspect ratio, the height of the image was also subsequently changed by the use of aperture plates which masked off the top and bottom of the image. For a discussion of these changes see John Belton, "The Development of CinemaScope by Twentieth Century–Fox," *SMPTE Journal* 97, no. 9 (September 1988), 712. After the transition to sound, when the Academy of Motion Picture Arts and Sciences reestablished the silent film aspect ratio, the former 1.33:1 standard was altered slightly, becoming 1.37:1. References to the Academy format in the text are to 1.33/7:1.

13. Dickson, of course, did not invent the projector, but a peephole viewing mechanism (the Kinetoscope), which was subsequently supplanted by the projector. I use the term *viewing mechanism/projector* here to describe a device essential to the reproduction of motion pictures and to suggest that the Kinetoscope performs a function within the basic system similar to that of a projector.

14. The operation of the camera and viewing mechanism/projector would remain the same even if different formats had been used; it would merely be necessary to alter them slightly to accommodate the desired formats.

15. See W. K. L. Dickson and Antonia Dickson, *History of the Kinetograph, Kinetoscope and Kinetophonograph* (1895; reprint, New York: Arno, 1970). See also their *Edison's Invention of the Kineto-Phonograph,* introduced by Charles G. Clarke (Los Angeles: Pueblo Press, 1939); and W. K. L. Dickson's "A Brief History," in Fielding, *A Technological History.* In a letter to F. H. Richardson, Thomas Edison points out that early ½-inch wide pictures "were too small for satisfactory reproduction especially if enlarged for projection on a screen," a factor which apparently motivated the movement to the somewhat larger, 1 × ¾ inch image. F. H. Richardson, "What Happened in the Beginning," in Fielding, *A Technological History,* p. 24. Edison's stated interest in projection here conflicts with evidence supplied by Dickson indicating that Edison saw no future in projection, but opted instead to exploit the peepshow market with his Kinetoscope; Dickson, "A Brief History," p. 9.

16. Terry Ramsaye, *A Million and One Nights: A History of the Motion Picture through 1926* (New York: Simon and Schuster, 1926), pp. 62–63; Paul Rotha, *The Film till Now* (London: Hamlyn House, 1967), p. 68; Gerald Mast, *A Short History of the Movies,* 3d ed. (Indianapolis: Bobbs-Merrill, 1981), p. 13.

17. Richardson, "What Happened in the Beginning," p. 29.

18. Brian Coe, *The History of Movie Photography* (London: Ash & Grant, 1981), pp. 52–53.

19. Rick Mitchell, "History of Wide Screen Formats," *American Cinematographer* 68, no. 5 (May 1987), 36–37.

20. See Olive Cook, *Movement in Two Dimensions* (London: Hutchinson, 1963), pp. 81–99, as well as the illustrations in Coe, *Movie Photography,* pp. 11, 14–15, 18–21.

21. Coe, *Movie Photography,* p. 21.

22. Tom Gunning, conversation with author, January 1989.

23. See William Welling, *Photography in America: The Formative Years, 1839–1900* (New York: Crowell, 1978). Variable aspect ratios are also found in Muybridge's series photographs documenting human and animal motion. Marey used Eastman's 90mm film in his film camera (ca. 1890), which was outfitted with a variable masking. This enabled Marey to vary image size and shape to suit the proportions of the subject he was photographing. See Coe, *Movie Photography,* p. 53.

24. Hendricks, *Edison Myth*, pp. 86, 88, 92; and Coe, *Movie Photography*, pp. 49–50.

25. Carl Louis Gregory, "The Early History of Wide Films," *Journal of the Society of Motion Picture Engineers* (hereafter cited as *JSMPE*) 14, no. 1 (January 1930), 27, voiced a popular assumption underlying the "naturalness" with which the 35mm format was regarded when he wrote that the standardization of 35mm film was the result of a "coincidence," pointing out that the Lumières in France had arrived independently at the same standards as those set forth by Dickson and Edison in the United States. However, the Lumières had, of course, seen Edison's Kinetoscope in Paris in 1894 prior to their invention of the Cinématographe (see Ramsaye, *A Million and One Nights*, p. 163), and Antoine Lumière had even purchased an Edison Kinetoscope, along with eight 35mm film strips; see Georges Sadoul, *Louis Lumière* (Paris: Editions Seghers, 1964), p. 8.

26. Cecil M. Hepworth, *Animated Photography: The A B C of the Cinematograph* (1900; reprint, New York: Arno, 1970), p. 6.

27. For a discussion (and illustration) of various determinations employed in the writing of film history see Stephen Heath, "The Cinematic Apparatus: Technology as Historical and Cultural Form," in *Questions of Cinema* (Bloomington: Indiana University Press, 1981), p. 227; Jean-Louis Comolli, "Technique and Ideology: Camera, Perspective, Depth of Field," in *Movies and Methods*, vol. 2, ed. Bill Nichols (Berkeley: University of California Press, 1985), p. 35; and Jean-Louis Baudry, "Ideological Effects of the Basic Cinematographic Apparatus," in *Narrative, Apparatus, Ideology: A Film Theory Reader*, ed. Philip Rosen (New York: Columbia University Press, 1986), pp. 295–296.

28. Phil Condax, George Eastman House, and Dave Gibson, Eastman Kodak Patent Museum, telephone conversation with author, January 26, 1989. See also Gordon Hendricks, *The Kinetoscope* (New York: Beginnings of the American Film, 1966), p. 73, n. 17; and Coe, *Movie Photography*, p. 63. In a similar fashion, Germany's Max Skladanowsky innovated a wide-film system by slitting 90mm film, developed for the Kodak No. 2 camera, in half. See Coe, *Movie Photography*, pp. 75–76.

29. Again, see Edison's letter to F. H. Richardson in "What Happened in the Beginning," p. 24.

30. For a discussion of the problems Dickson encountered when he enlarged non-Eastman emulsions smaller than one inch wide, see Dickson and Dickson, *Edison's Invention of the Kineto-Phonograph*, p. 11.

31. Comolli, "Technique and Ideology," p. 55.

32. Eastman's plant provided customers who ordered large quantities of film with whatever gauge they desired by slitting a 200 × 3½ foot "table" of celluloid to order. See Brian Coe, *George Eastman and the Early Photographers* (London: Priory Press, 1973), p. 71. Dickson's initial orders, however, were for small quantities of film; thus his use of preexisting 70mm rolls involved no extra expenditure

on the part of the notoriously frugal Edison. See Hepworth, *Animated Photography,* pp. 7–8, on the prohibitive expense of wide-gauge filmmaking.

33. Mitchell dismisses the traditional argument raised by technicians in the 1920s based on the formats used by painters in the plastic arts, replacing it with an unsubstantiated (and contradictory) argument based on aesthetics. Mitchell writes that "humans have a preference for a squared-off frame," then qualifies that by arguing that the idea "was not to make this image perfectly square, but to give it a bit more width than height"; "Wide Screen Formats," p. 36.

34. Welling, *Photography in America,* p. 321.

35. Coe, *George Eastman,* p. 71.

36. Phil Condax, telephone conversation with author, January 26, 1989.

37. See photographic reproductions opposite page 70 in Ramsaye, *A Million and One Nights.*

38. This did not prevent other pioneers from relying upon circular images, however. See illustrations of the work of Wordsworth Donisthorpe (1890), William Friese-Greene (1890), and C. Francis Jenkins (1894) in Coe, *Movie Photography,* pp. 59, 60, 66.

39. Dickson, "A Brief History," pp. 10–11.

40. Dickson and Dickson, *Edison's Invention of the Kineto-Phonograph,* p. 11.

41. David B. Thomas, *Origins of the Motion Picture* (London: Her Majesty's Stationery Office, 1964), pp. 21, 26. But Coe observes that Marey used a variable aperture in his subsequent experiments, in 1889, with Eastman film; *Movie Photography,* p. 53.

42. The term *static* is applied to rectangles, "the area of which can be divided into an equal number of squares." See Vladimir Nilsen, *The Cinema as a Graphic Art,* trans. Stephen Garry (New York: Hill and Wang, 1936), p. 28. A square is automatically such a rectangle.

43. In mathematics, the Golden Section involves the division of a single line into two smaller segments in such a way that the ratio of the original line to the larger segment is the same as the ratio of the larger segment to the smaller segment. For its fascination for engineers, see (symptomatically) Loyd A. Jones, "Rectangle Proportions in Pictorial Composition," *JSMPE* 15, no. 1 (January 1930), 34–36. Rudolf Arnheim cites Heinrich Wolfflin's observation that in the baroque style "when the square yields to the rectangle, the favorite proportion of the rectangle is rarely that of the golden section, which was popular during the Renaissance because of its harmonious and more stable character"; *Art and Visual Perception: A Psychology of the Creative Eye* (Berkeley: University of California Press, 1954), p. 409.

Dickson's status as a scientist was complemented by a background in aesthetics. His father was "a distinguished English painter and lithographer," and Dickson

himself sketched and was an amateur photographer, exhibiting his work at the Orange Camera Club (of which he was a member). See Hendricks, *The Edison Motion Picture Myth*, pp. 143, 148, 156.

44. Nilsen, *Cinema as a Graphic Art*, p. 28.

45. Hendricks, *The Edison Motion Picture Myth*, pp. 118, 140.

46. Ibid., p. 156. See also Dickson's *The Life and Inventions of Thomas Alva Edison* (New York: Crowell, 1894), which is illustrated throughout with Dickson's own photographs of Glenmont (Edison's West Orange home), Edison's laboratory, and the surrounding countryside.

47. The terms *invention, innovation,* and *diffusion* were introduced to film studies by Douglas Gomery to describe the tripartite economic process which informs technological change. During the invention stage, a limited financial commitment is made to fund the initial development of a new product. "Innovation" describes the phase in which an invention is adapted to satisfy the needs of the marketplace (or in which the marketplace is adapted to receive the invention). This phase demands an even greater outlay of capital as well as considerable risk on the part of the innovator. The diffusion or exploitation of the invention involves its adoption by the industry as a whole. In terms of economic commitment, the entire film industry (not just a single innovator) invests in the exploitation of the invention. See Douglas Gomery, "The Coming of the Talkies: Invention, Innovation, and Diffusion," in *The American Film Industry,* ed. Tino Balio (Madison: University of Wisconsin Press, 1976), pp. 193–194.

48. John Izod, *Hollywood and the Box Office, 1895–1986* (New York: Columbia University Press, 1988), pp. 1–2, 17. Edison filed a patent (no. 589,168) for the motion picture camera on August 31, 1897 (reissued as Patent no. 12,037), and for 35mm motion picture film (reissue Patent no. 12,038) on August 24, 1891. Thomas Armat, "My Part in the Development of the Motion Picture Projector," in Fielding, *A Technological History,* p. 21. Eastman, the major manufacturer of motion picture film, initially respected Edison's 35mm film patents, becoming Edison's licensee. Eastman subsequently refused to sell negative film stock solely to Edison and Edison licensees, including Biograph among his clients. By 1912 Eastman was selling film stock to many of the nonlicensed independent production companies.

49. Izod, *Hollywood and the Box Office,* p. 2.

50. According to the anonymous author of "A Pot-pourri of Film Widths and Sprocket Holes," *American Cinematographer* 50, no. 1 (January 1969), the standardization of 35mm as format took place in 1907: "A voluntary agreement was reached in 1907, which became known as the Motion Picture Patents Agreement of 1907. The agreement defined the 35mm width and certain other specifications as a standard motion picture film" (pp. 99, 101). Although Edison appears to have

been negotiating with future members of the Motion Picture Patents Company in 1907, histories of the MPPC mention no Motion Picture Patents Agreement of 1907. The trust was not officially formed until 1908. See Robert Anderson, "The Motion Picture Patents Company: A Reevaluation," in *The American Film Industry*, rev. ed., ed. Tino Balio (Madison: University of Wisconsin Press, 1985), p. 135.

51. Edison's successful litigation in defense of his patents forced his most successful rivals to join him, resulting in the creation of the Motion Picture Patents Company in 1908. Independents like Carl Laemmle began to challenge the Patents Company in 1909. See Izod, *Hollywood and the Box Office*, pp. 16–27.

52. Coe, *Movie Photography*, p. 88.

53. Narrower gauges were also developed as part of this strategy, but, as we shall see, wide film satisfied another demand as well—the need for a larger image area for purposes of projection.

54. Considering that 70mm film was readily available from Eastman, it is surprising that, during the movement from peepshow to projection, this widest gauge was not adopted by the industry as a standard. Edison's belief that his patents granted him control over 35mm cameras, projectors, and film stock (and not over 70mm equipment and film stock) may have informed his refusal to upgrade his system from 35mm to 70mm for projection on large theater screens.

55. Grant Lobban, "Wide-Screen & 3-D Film Formats," British Kinematograph, Sound and Television Society (BKSTS) poster, n.d. It is not clear that the Eidoloscope was the "first" wide-film system, though it is likely that it was the earliest quasi-successful commercial venture in this area. According to Gregory ("Early History of Wide Films"), in May 1889 William Friese-Greene filmed scenes in Brighton on a "paper film negative with frames 2½ inches wide and 1½ inches high. Later in the same year he used celluloid film displacing the paper used earlier" (p. 29). Series still photographs (using transparencies) had been projected on screens even earlier—in 1879–80 by Eadweard Muybridge and by Ottomar Anschütz in 1887. On November 1, 1895, the Skladanowsky brothers exhibited their Bioscope process, apparently using 90mm film made for the Kodak No. 2 still camera slit in half. See C. W. Ceram, *Archeology of the Cinema*, trans. Richard Winston (New York: Harcourt, Brace & World, n.d.), p. 147. Anschütz had also given a public demonstration of his disc projector in Berlin on November 25, 1894. See Coe, *Movie Photography*, p. 50.

56. Grant Lobban, "Film Gauges and Soundtracks," BKSTS poster, n.d. (ca. 1988). The Biograph camera circumvented Edison's patents by using unperforated film (which was perforated in the camera at the moment of exposure) and by producing irregularly rather than equally spaced images. See Ramsaye, *A Million and One Nights*, p. 214.

57. Lobban BKSTS posters.

58. See Ramsaye, *A Million and One Nights*, pp. 110–111.

59. Ibid., p. 129.

60. Ibid., pp. 66–69. Although some experiments with the Kinetoscope involved projection on a small screen in the Edison workshop, Edison repeatedly resisted the idea of projection, which he felt would ruin the commercial market for peepshow machines. After the Kinetoscope had given way to the Vitascope Edison insisted that he considered projection in designing his equipment (and in selecting 35mm film as a gauge), but Ramsaye (pp. 67–69) suggests otherwise.

61. Hepworth, *Animated Photography*, p. 6.

62. Ibid., p. 7.

63. Ramsaye, *A Million and One Nights*, pp. 122–123. The larger the negative area, the greater the information on the film; the larger the aperture in the camera and projector, the greater amount of light that strikes the camera negative and reaches the screen. The Lathams used Eastman film, ordering an entire batch (or "table"), which was then slit into 51mm strips. See also Hepworth, *Animated Photography*, p. 110, for the dimensions of the lantern slide. Although lantern-slide projection involved the use of a larger image area, it is not clear that the 3¼-inch size was a universally accepted standard.

64. On the technical limitations, see Kenneth Macgowan, *Behind the Screen: The History and Techniques of the Motion Picture* (New York: Delta, 1965), p. 77. For economic and artistic problems, see Ramsaye, *A Million and One Nights*, pp. 180, 185–186. For an account of the rise and fall of the Eidoloscope, see George C. Pratt, "Firsting the Firsts," in *"Image" on the Art and Evolution of the Film*, ed. Marshall Deutelbaum (New York: Dover, 1979), pp. 20–22. Pratt notes that the Eidoloscope disappeared from the regular exhibition circuit in 1897; it appears to have been purchased by the Vitagraph Company in that year; Richardson, "What Happened in the Beginning," p. 30.

65. Ceram, *Archeology of the Cinema*, p. 146.

66. Coe, *Movie Photography*, pp. 75–76.

67. See Armat, "My Part in the Development," pp. 17–20.

68. The Lumières modeled the Cinématographe on the Kinetoscope, which was demonstrated in Paris in 1894, adopting Edison's 35mm format. See Louis Lumière, "The Lumière Cinématographe," in Fielding, *A Technological History*, p. 49. Gregory, "Early History of Wide Films," reports that the Lumière 35mm film stock initially differed by 0.01 inch from Edison's but was subsequently altered, along with the round, two-hole Lumière perforations, "in order to sell films to users of Edison machines" (pp. 27–28).

69. Izod, *Hollywood and the Box Office*, p. 4. See also Gregory Waller, "Introducing the 'Marvelous Invention' to the Provinces: Film Exhibition in Lexington, Kentucky, 1896–1897," *Film History* 3, no. 3 (1989).

70. George C. Pratt, "'No Magic, No Mystery, No Sleight of Hand': The First Ten Years of Motion Pictures in Rochester," in Deutelbaum, *"Image,"* pp. 39–43. See also Waller ("Introducing the 'Marvelous Invention'"), who reviews the introduction of the Cinématographe, Phantoscope, Vitascope, and Armet Magniscope (but not the Eidoloscope) in Lexington, Kentucky.

71. Izod, *Hollywood and the Box Office,* pp. 3, 9.

72. For an analysis of the various reasons for a need for standardization during this period, see Janet Staiger, "Standardization and Independence: The Founding Objectives of the SMPTE," *SMPTE Journal* 96, no. 6 (June 1987), 534.

73. Laurence J. Roberts, "Cameras and Systems: A History of Contributions from the Bell & Howell Co. (Part I)," *SMPTE Journal* 91, no. 10 (October 1982), 934–936.

74. Izod, *Hollywood and the Box Office,* p. 27.

75. See "Motion Picture Standards Adopted in Committee of the Whole Society," *Transactions of the Society of Motion Picture Engineers,* July 16–17, 1917.

76. For a discussion of this shift in relation to the development of a mass audience, see Judith Mayne, "Immigrants and Spectators," *Wide Angle* 5, no. 2 (1982), 34. Press accounts describe the size of the image projected by the Eidoloscope (then called the Panoptikon) in its public debut (on April 21, 1895) as "about the size of a standard window sash" (Ramsaye, *A Million and One Nights,* illustration opposite p. 137). The term *life-size* was used by Edison to describe the image he planned to obtain with his projecting Kinetoscope (Ramsaye, p. 130). In 1896 (at Marlborough Hall in London), the Lumières' Cinématographe projected images upon a "small screen, five or six feet square, or rather oblong, with a dark border." See Coe, *Movie Photography,* p. 70. In comparison with peepshow images, a 5-to-6-foot projected image would clearly be perceived as "life-size," rendering human figures on a scale closer to their actual size.

77. "The Fine Arts: The Kinetoscope," in Pratt, *Spellbound in Darkness,* p. 8.

78. Stephen Heath, "On Screen, in Frame: Film and Ideology," in *Questions of Cinema,* p. 8.

79. "Edison's Vitascope," *New York Dramatic Mirror* 35, no. 905 (May 2, 1896), 19; reprinted in Pratt, *Spellbound in Darkness,* p. 14.

80. Heath, "On Screen, in Frame," p. 1. Heath's emphasis upon the spectator-screen relationship in his account of the creation of the cinema tends to ignore the fact that the cinema "begins" by introducing an old technology—that of large-screen projection, developed much earlier for lantern-slide projection, dioramas, and panoramas. In other words, the spectator-screen relationship which Heath uses to describe the cinema as an ideological apparatus derives from an earlier technology, rendering problematic the notion that "the cinema *begins*" with the fixing in place of a screen.

81. Or, as Heath explains: "The hypothesis, in short, is that an important—determining—part of ideological systems in a capitalist mode of production is the achieve-

ment of a number of machines (institutions) which move, which *movie*, the individual as subject—shifting and placing desire, the energy of contradiction—in a perpetual retotalization of the imaginary"; ibid., p. 8.

82. Clearly, the space depicted on the screen is necessarily separate from the physical space of the theater auditorium; thus the spectator cannot enter into it. What is "coextensive" here is the *spectatorial* space in the auditorium. For a discussion of the segregation of spaces, see Christian Metz, *Film Language: A Semiotics of the Cinema* (New York: Oxford, 1974), pp. 10–11. In this respect, the historical transition of the cinema from peepshow to projection calls into question Jean-Louis Baudry's, Metz's, and Heath's theories of how the cinema constructs the spectator as subject. Indeed, their notions of the spectator's relationship with the moving image are more applicable to the era of the Kinetoscope than to the era of projection. The Kinetoscope, for example, literally demands a fixed station for the spectator to occupy when watching the film; requires the physical centering of the spectator, who, as all-perceiving, transcendent subject, literally "releases" the film with a nickel; and creates a closed space which, like Plato's cave, cuts the spectator off from the outside world (from anything outside of the image-seen-through-the-peephole). I am referring here to Baudry's (and Heath's) discussion of the station point posited by the use of artificial perspective in Renaissance painting (and film), to Metz's description of the way in which the cinema constructs a transcendent subject, and to Baudry's use of Plato's cave analogy in his account of the ideological effects of the basic cinematographic apparatus. See Baudry, "Ideological Effects of the Basic Cinematographic Apparatus," *Film Quarterly* 28 (Winter 1974–75), 41–42 and 44–45; Heath, "Narrative Space," in *Questions of Cinema*, pp. 27–31; and Christian Metz, *The Imaginary Signifier* (Bloomington: Indiana University Press, 1982), pp. 45–51.

83. I do not mean to diminish the importance of other images reflected in the mirror, such as that of the child's parent; these "familiar" images play a crucial role in the Lacanian mirror phase. But the film spectator is constructed in the presence not only of family and friends but of anonymous strangers as well.

84. Metz, *Imaginary Signifier*, pp. 46–51.

85. Siegfried Kracauer, "Cult of Distraction: On Berlin's Picture Palaces," trans. Tom Levin, *New German Critique*, no. 40 (Winter 1987), 94.

86. Kracauer refers to this multiple stimulation as "the uncontrolled anarchy of our world"; ibid., p. 95.

2. From Novelty to Norm

1. A parallel instance can be found in the marketing of television sets whenever the term *widescreen* is used to describe large-screen 36-inch sets, which have a traditional aspect ratio of 4:3.

2. Joseph Medill Patterson, "The Nickelodeon: The Poor Man's Elementary Course in the Drama," *Saturday Evening Post* (November 23, 1907), 10–11, 38; reprinted in George C. Pratt, ed., *Spellbound in Darkness*, vol. 1 (Rochester: University School of Liberal and Applied Studies, University of Rochester, 1966), p. 43.

3. Patterson describes the "spectatorium" as being 25 × 70 feet. In his survey of Manhattan nickelodeons, Robert C. Allen concludes from a survey of Manhattan insurance maps that "the size of most nickelodeons on the Lower East Side did not exceed twenty-five by one hundred feet"; "Motion Picture Exhibition in Manhattan, 1906–1912: Beyond the Nickelodeon," *Cinema Journal* 18, no. 2 (Spring 1979), 4.

4. See "Conversations Heard in the Office of a Dealer in Motion Picture Machines," *Moving Picture World* (May 4, 1907), 138; F. H. Richardson, "Lessons for Operators," ibid. (April 18, 1908), 340; David S. Hulfish, "Increasing Size of Pictures," in *The Motion Picture: Its Making and Its Theater* (Chicago: Electricity Magazine Corp., 1909), p. 88; and Lewis M. Townsend and William W. Hennessey, "Some Novel Projected Motion Picture Presentations," *Transactions of the Society of Motion Picture Engineers* 12, no. 34 (April 1928), 348. The latter gives the size as 9 × 12 feet.

5. "Model Theater for Schenectady, N.Y.," *Moving Picture World* (March 14, 1908), 207.

6. Gregory Waller, "Situating Motion Pictures in the Prenickelodeon Period: Lexington, Kentucky, 1897–1906," *Velvet Light Trap*, no. 25 (Spring 1990), 17.

7. In *The Best Remaining Seats: The Story of the Golden Age of the Movie Palace* (New York: Clarkson Potter, 1961), Ben M. Hall reports that around 1927 the standard screen size was 16 × 12 feet, while screens in large theaters were roughly 20 × 15 feet (p. 202).

8. The rise of the movie palace began in 1913 with the opening of the Regent, followed by that of the Strand in 1914; Dennis Sharp, *The Picture Palace* (New York: Praeger, 1969), p. 73. The Rialto (April 21, 1916), the Rivoli (December 28, 1917), the Capitol (October 24, 1919), Grauman's Egyptian (October 28, 1922), the Roxy (March 11, 1927), and Grauman's Chinese (May 18, 1927) led in this development toward larger theaters. The limit on screen size was suggested by Francis M. Falge, "Motion Picture Screens—Their Selection and Use for Best Picture Presentation," *JSMPE* 17, no. 3 (September 1931), 355. Townsend and Hennessey give the standard screen size in 1928 as 17 × 21 feet; "Some Novel Presentations," p. 345.

9. Kenneth Macgowan, *Behind the Screen: The History and Techniques of the Motion Picture* (New York: Delta, 1965), p. 456.

10. *Old Ironsides* was not the first film to be projected in Magnascope. The lens had been used as early as February 15, 1925, to project a stampede in *North of 36;* Townsend and Hennessey, "Some Novel Presentations," p. 345.

11. For a description of these Magnascope scenes see Tom Flinn, "*Old Ironsides:* The Influence of Seapower upon Hollywood," *Velvet Light Trap,* no. 8 (1973), 4–5.

12. "Edison's Vitascope," *New York Dramatic Mirror* (May 2, 1896), 19.

13. For a discussion of Magnascope projection practice, see H. Rubin, "The Magnascope," *Transactions of the Society of Motion Picture Engineers* 12, no. 34 (April 1928), 403–405.

14. Townsend and Hennessey, "Some Novel Presentations," p. 345.

15. For an anecdotal, eyewitness account of Magnascope exhibition, see Glendon Allvine, *The Greatest Fox of Them All* (New York: Lyle Stuart, 1969), pp. 27–34. Allvine claims that Fox's theaters in Brooklyn, Atlanta, Detroit, St. Louis, and San Francisco were built with large screens as a result of *Old Ironsides'* projection in Magnascope. See also James L. Limbacher, *Four Aspects of the Film* (New York: Brussel and Brussel, 1968), pp. 86–87; and Robert E. Carr and R. M. Hayes, *Wide Screen Movies: A History and Filmography of Wide Gauge Filmmaking* (Jefferson, N.C.: McFarland, 1988), p. 5.

16. The Polyvision camera was built by André Debrie in the first months of 1926 and was used for filming in August of that year; Kevin Brownlow, *Napoleon: Abel Gance's Classic Film* (New York: Knopf, 1983), pp. 132, 135. Brownlow suggests that it inspired Paramount's Magnascope; however, Lorenzo del Riccio's invention of the lens predates the development of Polyvision, and it was used in 1925 to project sequences in two Paramount pictures, *North of 36* and *The Thundering Herd,* as well as *The Iron Horse* (Fox, 1925) and *The Black Pirate* (UA, 1926) at the Eastman Theater in Rochester, N.Y. See Townsend and Hennessey, "Some Novel Presentations," pp. 345–346.

17. Brownlow, *Napoleon,* pp. 131–132.

18. Ibid., pp. 286–287.

19. Ibid., pp. 161–169, 175.

20. See *brevet d'invention* no. 644,254 granted to his brother, Georges Chrétien, on June 4, 1928, who requested the patent on April 29, 1927. For this information and other original French material, I am indebted to Paul Rayton, who obtained copies of Chrétien's *brevets* from Georges Bonnerot, a former associate of Chrétien.

21. Chrétien's announcement seems to locate the origins of CinemaScope in the Christian iconography of the cross. The vertical dimension is described as suitable for filming the interiors of churches, and one figure, illustrating the vertical screen, depicts the facade of the cathedral of Notre Dame. The fact that one of the first films made in this process, Marc de Gastyne's *La merveilleuse vie de Jeanne D'Arc,* and the initial CinemaScope production, *The Robe,* are both religious subjects should not go unnoticed.

22. Autant-Lara shot the film as a silent and had trouble, in this transition-to-sound period, finding a theater willing to screen a silent film, a factor which resulted in the delay of its release until December 5, 1930. See Jean-Claude Maillet,

"G. Bonnerot nous raconte: La grande aventure de l'Hypergonar," *Cinéma pra-filme*, no. 137 (June 1975).

23. See Maillet, "Bonnerot nous raconte," pp. 76–77. See also Karel Reisz and Gavin Millar, *The Technique of Film Editing*, enl. ed. (New York: Focal Press, 1969), p. 280.

24. Reisz and Millar, *Film Editing*, p. 280.

25. Maillet, "Bonnerot nous raconte."

26. According to Bonnerot (who appears to have seen the film), in *Construire un feu* Autant-Lara used the various formats to express the feelings and thoughts of the actor, thus motivating the shifts from one shape and size to another and identifying them as subjective shots. See ibid., p. 76.

27. Brownlow, *Napoleon*, p. 159.

28. Maillet, "Bonnerot nous raconte."

29. Ibid.

30. Actually, the multiple-lens system significantly minimized parallax but did not eliminate it. When used for stereoscopy, the lens relied on parallax to achieve the necessary separation of the right-eye and left-eye images.

31. Maillet, "Bonnerot nous raconte." Also *brevet d'invention* no. 638,542, applied for by Georges Chrétien on December 9, 1926, and granted February 21, 1928.

32. Chrétien's patent application (no. 644,254) even refers to the earlier patent application "for a multiple-lens anamorphoser" for filming in color and relief, noting that the present invention differs in that it involves a single rather than a multiple-lens anamorphoser and that its purpose is to provide panoramic horizontal and vertical images; *brevet d'invention* no. 644,254, applied for on April 29, 1927.

33. Maillet, "Bonnerot nous raconte," p. 75.

34. Ibid., p. 77.

35. Chrétien also delivered a paper on the potential use of anamorphic optics in film to the Academy of Sciences on May 30, 1927, and to the Optical Society of America in November 1928. Chrétien's demonstration of his lens at the Palace of Light in the Paris Exposition of 1937 was described in a paper written by Chrétien and his associates, published in *JSMPE* 37, no. 5 (May 1939). Internal correspondence at Fox shows that it was through this article that Chrétien's work came to the attention of Earl Sponable and Herbert Bragg of Fox's Research Department. One other film was made with the Hypergonar, Deschamps' *Lancement d'un petrolier aux chantiers de la Ciotat* (1948). See Maillet, "Bonnerot nous raconte," p. 78.

36. Loyd A. Jones, "Rectangle Proportions in Pictorial Compositions," *JSMPE* 14, no. 1 (January 1930), 32. The actual aspect ratio varied from studio to studio—ground glass markings in cameras at the various studios showed Paramount using 1.3:1, Fox 1.28:1, M-G-M 1.15:1, Columbia 1.3:1, UA 1.3:1, and Universal 1.34:1 and

1.15:1. Image height would be reduced further in projection. See Lester Cowan, "Camera and Projector Apertures in Relation to Sound-on-Film Pictures," *JSMPE* 14, no. 1 (January 1930), 116.

37. Jones, "Rectangle Proportions," pp. 33–34, 38.

38. L. M. Dieterich, "The Larger Screen," *Cinematographic Annual*, ed. Hal Hall, vol. 2 (Los Angeles: American Society of Cinematographers, 1931), pp. 210–214.

39. Sergei Eisenstein, "The Dynamic Square," in *Film Essays and a Lecture*, ed. and trans. Jay Leyda (Princeton: Princeton University Press, 1982), pp. 48–65.

40. See Daniel B. Clark, "Composition in Motion Pictures" (pp. 87–89), and Paul Allen, "Wide Film Development" (pp. 188–190), both in *Cinematographic Annual*, ed. Hal Hall, vol. 1 (Los Angeles: American Society of Cinematographers, 1930).

41. Cowan, "Camera and Projector Apertures," p. 108.

42. Ibid.

43. The 1.37:1 aspect ratio continues to be referred to as 1.33:1 by cameramen and projectionists, who regard the Academy ratio as a perpetuation of the the silent aspect ratio. See, for example, *American Cinematographer Manual*, 2d ed., ed. Joseph V. Mascelli (Los Angeles: American Society of Cinematographers, 1966), p. 152.

44. Camera apertures were changed to 0.868 × 0.631 inch and projection apertures were standardized at 0.825 × 0.600 inch; Barry Salt, *Film Style & Technology: History & Analysis* (London: Starword, 1983), p. 273.

45. Maillet, "Bonnerot nous raconte," p. 77.

46. "Report of the Standards and Nomenclature Committee," *JSMPE* 14, no. 1 (January 1930), 130.

47. "Report of the Standards and Nomenclature Committee," ibid., 15, no. 6 (December 1930), 822.

48. Allen, "Wide Film Development," p. 190.

49. "Methods of Securing a Large Screen Picture," *JSMPE* 16, no. 2 (February 1931), 181–182.

50. "Methods of Securing a Large Screen Picture," *JSMPE* 16, no. 1 (January 1931), 82.

51. "Securing a Large Screen Picture," *JSMPE* (February 1931), 174.

52. See ibid., p. 176, which cites notes taken at a meeting of the Academy of Motion Picture Arts and Sciences. In considering aspect ratios from 5:3 to 2:1, members of the Academy preferred those ranging from 1.6:1 to 1.8:1.

53. One 65mm process, developed by Capt. Ralph G. Fear, is described by Allen, "Wide Film Development," pp. 190–194. Fear also developed a 35mm horizontal-exposure camera, which produced an image ten perforations wide (somewhat similar to the VistaVision system used in 1954 by Paramount), and called the

process "Fear's Super Pictures"; Rick Mitchell, "History of Wide Screen Formats," *American Cinematographer* 68, no. 5 (May 1987), 38–39. Fear's Super Pictures also had a 2:1 ratio.

54. Mitchell, "Wide Screen Formats," p. 39.

55. For a description of the Grandeur camera, see Allen, "Wide Film Development," pp. 186–187. Fox also purchased 70mm cameras, primarily it seems for newsreel use, from the J. M. Wall Camera Company in Syracuse. See the "Grandeur Equipment" inventory, Grandeur 1928–1930 folder, box 10, Sponable Collection, Columbia University Libraries.

56. M-G-M's parent company, Loew's, was briefly owned by William Fox in 1929–30, which may account for M-G-M's decision to use a wide-film format compatible with Fox's Grandeur system. For technical data here and in the following studio-by-studio survey, see "Wide Film Activities," memo from H. Keith Weeks to W. R. Sheehan, Grandeur 1930–31 folder, box 10, Sponable Collection.

57. Carr and Hayes, *Wide Screen Movies*, p. 7, mistakenly conclude that UA's *The Bat Whispers* was shot in 70mm because a Mitchell camera was used. UCLA film archivist Robert Gitt, who was involved in the restoration of the film, worked with the original 65mm material, transferring it to 70mm for preservation purposes.

58. "Securing a Wide Screen Picture," *JSMPE* (January 1931), 83; also see Macgowan, *Behind the Screen*, p. 476.

59. *Variety* (November 26, 1930), 78.

60. Allen, "Wide Film Development," p. 183.

61. *The 1930 Film Daily Yearbook of Motion Pictures*, ed. Jack Alicoate (New York: Film Daily, 1930), p. 1.

62. "Securing a Wide Screen Picture," *JSMPE* (January 1931), 85.

63. "Report of the Standards and Nomenclature Committee," *JSMPE* 17, no. 3 (September 1931), 431–433.

64. Grandeur file, box 10, Sponable Collection. *The 1930 Film Daily Year Book* gives the dimensions of the Gaiety's screen as 35 × 17 feet (p. 860).

65. The Fox Grandeur Corporation was established by William Fox to develop camera and projection equipment for the system. In Upton Sinclair's *Upton Sinclair Presents William Fox* (Los Angeles: Sinclair, 1933), Fox describes it as his own experiment, undertaken without the financial participation of Fox Film Corporation because of the financial risks involved (p. 65).

66. Director Raoul Walsh complained that "William Fox went bust and none of his houses had the Grandeur screen. Nor would other theaters spend the fifty thousand for the equipment. Aside from the Roxy and Grauman's Chinese, *The Big Trail* was only shown in the 35mm version"; quoted in Maurice Zolotow, *Shooting Star: A Biography of John Wayne* (New York: Simon and Schuster, 1974), p. 90.

67. See Sinclair, *Fox* (passim), as well as Anthony Slide, *The American Film Industry*

(Westport, Conn.: Greenwood Press, 1986), p. 137. Temporarily bolstered by a new administration, Fox Film Corporation did not go into receivership until 1933. By mid-May 1930, several reels of *The Big Trail* had already been filmed in Grandeur, according to *Variety* (May 21, 1930), 23.

68. Mitchell, "Wide Screen Formats," p. 40.
69. Ibid., p. 41. For a discussion of Realife technology, see "Wide Film Activities," Grandeur 1930–31 folder, box 10, Sponable Collection.
70. See "Wide Film Activities" memo.
71. Carr and Hayes, *Wide Screen Movies*, p. 7.
72. Ibid., p. 9.
73. *Fox Movietone Follies of 1929* program, Grandeur 1930–31 folder, box 10, Sponable Collection.
74. Grandeur 1930–31 folder, box 10, Sponable Collection.
75. Ibid.
76. *Variety* (February 19, 1930).
77. Unsigned memo, Grandeur folder, box 10, Sponable Collection.
78. Grandeur 1930–31 folder, box 10, Sponable Collection.
79. Mordaunt Hall, "Grandeur Films Thrill Audiences," *New York Times* (September 18, 1929).
80. Ad for the Chicago premiere reproduced in *Variety* (November 26, 1930), 16.
81. *Variety* (March 19, 1930), 16.
82. See, for example, *Variety*, December 17, 1930, which announces "Wide Film Is Ruled Out" after the failure of *The Big Trail* at the box office.

3. Wide Film and the General Audience

1. I am speaking here of the origins of widescreen, large-screen, and wide-film *motion picture exhibition*. Other forms of large-screen projection, from the diorama to the lantern slide, figure importantly in the archeology of this development and are discussed in Chapter 5.
2. The failure of wide film to emerge as an alternative standard during the first few years of motion picture projection (1896–1900) does not provide a useful scenario for the analysis of either the failure of wide film in the late 1920s or the success of widescreen in the 1950s. Unlike those in later eras, experiments with wide film in this period did not constitute an attempt to introduce a *new* standard, since the 35mm standard was not yet in place. This period was dominated by the invention, innovation, and diffusion of 35mm film; in this process wide film played only a marginal role.
3. This "reinvention" proved to be fairly complex; it did not consist merely in repackaging older technology in a new form. For a discussion of the differences

between the "invention" and "reinvention" stages, see John Belton, "CinemaScope and Historical Methodology," *Cinema Journal* 28, no. 2 (Fall 1988), 28–30.

4. See H. F. Jermain's reports to Fox on the trouble-free Grandeur screenings at the Gaiety Theater, September 17–28, 1930, Grandeur 1928–1930 folder, box 10, Sponable Collection, Columbia University Libraries. For critical response to Realife, see the enthusiastic reviews of *Billy the Kid* by Ed Jacobs in the *Cleveland News* (November 2, 1930) and by W. Ward Marsh, who noted in the *Cleveland Plain Dealer* (November 2, 1930) that "reality is intensified" in the Realife process. For a review of Grandeur, see *Variety* (October 29, 1930), 12, and James Limbacher, *Four Aspects of the Film* (New York: Brussel and Brussel, 1968), pp. 120–121.

5. Kenneth Macgowan, *Behind the Screen: The History and Techniques of the Motion Picture* (New York: Delta, 1965), pp. 478–479. Richard Patterson, "Highlights from the History of Motion Picture Formats," *American Cinematographer* 54, no. 1 (January 1973), 42.

6. Production of *The Big Trail* began in July 1930, according to press releases on file at Lincoln Center in a *Big Trail* scrapbook. For release dates see Kenneth W. Munden, ed., *The American Film Institute Catalogue of Motion Pictures Produced in the United States: Feature Films, 1921–1930* (New York: Bowker, 1971), pp. 60–61, 408, 41, 418.

7. M-G-M's *The Great Meadow*, the last of this batch of wide films, was released on March 15, 1931; Robert E. Carr and R. M. Hayes, *Wide Screen Movies: A History and Filmography of Wide Gauge Filmmaking* (Jefferson, N.C.: McFarland, 1988), p. 341. Andrew Bergman dates the arrival of the Great Depression in Hollywood as January 1931; *We're in the Money* (New York: Harper & Row, 1972), pp. xx–xxi.

8. Cobbett Steinberg, *Reel Facts: The Movie Book of Records* (New York: Vintage, 1978), p. 371. Attendance figures vary according to the source used; Alicoate, for example, puts the attendance for 1929 at 80 million per week. See Jack Alicoate, ed., *The 1951 Film Daily Year Book of Motion Pictures* (New York: Film Daily, 1951), p. 90.

9. Alicoate, *1951 Film Daily Year Book*, pp. 931–943.

10. *Variety* (December 17, 1930), 40, did connect a 4 percent drop in recent box-office revenues to decisions to curtail wide-film productions.

11. Howard T. Lewis, *The Motion Picture Industry* (New York: Van Nostrand, 1933), pp. 139–140.

12. Douglas Gomery, "The Coming of Sound: Technological Change in the American Film Industry," in *The American Film Industry*, rev. ed., ed. Tino Balio (Madison: University of Wisconsin Press, 1985), p. 239.

13. Rick Mitchell, "History of Wide Screen Formats," *American Cinematographer* 68, no. 5 (May 1987), 39–41.

14. By "first batch," I refer to the quasi-simultaneous release of wide films by several studios. Fox had, of course, released earlier films in Grandeur, including *Fox Movietone Follies of 1929* (September 1929) and *Happy Days* (February 1930). For Hays Office agreement details, see *Variety* (May 7, 1930), 5, and (December 17, 1930), 5.

15. *Variety* (February 26, 1930), 11.

16. Gomery, "The Coming of Sound," p. 243.

17. *Variety* (April 9, 1930).

18. Compare go-ahead plans announced in *Variety* (February 12, 1930), 10, with the announcement of delays in *Variety* (March 12, 1930), 7.

19. *Variety* (May 7, 1930), 5.

20. *Variety* (April 30, 1930), 61.

21. Aubrey Solomon, *Twentieth Century–Fox: A Corporate and Financial History* (Metuchen, N.J.: Scarecrow, 1988), p. 13.

22. *Variety* (May 7, 1930), 5.

23. Letter to W. C. Michel, July 19, 1930, Grandeur 1930–31 folder, box 10, Sponable Collection.

24. Gilbert Warrenton, "Why Wide Film?" *American Cinematographer* 11, no. 6 (October 1930), 9.

25. In this way, the reluctance of the industry to change its marketing status quo can be seen to reflect another feature of the national economy during this period—increased government intervention. As Vatter points out, the laissez-faire policies of the 1920s gave way, during the Depression, to increasing restrictions on the private sector. The economy, in effect, was neither private nor public but mixed; government controls in the film industry appear initially in the National Recovery Administration regulations, and later in the investigation of monopolistic practices in the industry. The investigation began in the mid-1930s and peaked in 1948 with the *Paramount* case. Settlement of the consent decree took longer, continuing for most studios into the mid-to-late 1950s.

26. Warrenton, "Why Wide Film?" p. 9. Conversion to sound cost theaters $15,000–25,000, depending upon the theater's size, construction, and acoustics. See Alexander Walker, *The Shattered Silents: How the Talkies Came to Stay* (New York: William Morrow, 1979), p. 21. Walker also notes that the cost depended upon the theater's location and "its reputation for good business." Conversion to wide film, which entailed the purchase of a pair of new projectors as well as a new screen, involved an additional cost of $15,000–25,000.

27. *Variety* (October 22, 1930), 42; Grandeur 1928–1930 folder, box 10, Sponable Collection. "Wide Film Activities" reports, however, that the Fearless Camera Company was converting 35mm Simplex projectors to 65mm projectors for as little as $750 apiece.

28. Warrenton, "Why Wide Film?" p. 9.

29. *Variety* (October 29, 1930), 24.

30. *Variety* (February 26, 1930), 11.

31. Upton Sinclair, *Upton Sinclair Presents William Fox* (Los Angeles: Sinclair, 1933), p. 65.

32. James Cameron, "Wide Film," in *Sound Pictures* (Coral Gables, Fla.: Cameron Publishing, 1930), p. 671; Carr and Hayes, *Wide Screen Movies*, p. 7.

33. *Variety* (October 22, 1930), 42.

34. Carr and Hayes, *Wide Screen Movies*, p. 8. Macgowan notes that wide films were shown as wide films (rather than in 35mm versions) "only in New York and Los Angeles"; *Behind the Screen*, p. 477. But reviews indicate that Realife, which played in ten theaters nationwide (see *Exhibitor's Daily Review*, October 15, 1930), could be seen at the Stillman in Cleveland (see the *Cleveland News* and *Cleveland Plain Dealer* reviews of *Billy the Kid* on November 2, 1930) and at the Paramount in Detroit (*Billy the Kid* clippings file, Lincoln Center).

35. *Variety* (October 29, 1930), 24.

36. By the time of *Soldier's Plaything* Harry Langdon's career was on the decline, having peaked in the mid-1920s. John Wayne *(The Big Trail)* was not yet a star, nor was John Mack Brown, who played, opposite star Wallace Beery, the title role in *Billy the Kid*. Broadway stage star Otis Skinner *(Kismet)* was not a film star. Fox's *Happy Days* (1930) did feature the studio's stars (Will Rogers, Janet Gaynor and Charles Farrell, Victor McLaglen and Edmond Lowe) in short skits, although their talents as "dramatic" (nonsinging, nondancing) performerrs did not necessarily lend themselves to the revue format (with the exception of Rogers). Although stars were present here, they were not functioning in the sorts of narratives that made them stars.

37. *Variety* (October 22, 1930), 23; *New York Times* (October 18, 1930).

38. *Variety* (November 26, 1930), 78.

39. *New York Times* (January 1, 1931).

40. *Variety* (October 29, 1930), 12.

41. Ibid., p. 27.

42. Sid Silverman in *Variety* (December 31, 1930), 7.

43. Miles Kreuger, ed., *The Movie Musical: From Vitaphone to 42nd Street (as Reported in a Great Fan Magazine)* (New York: Dover, 1975), p. 16.

44. John B. Rae, *The American Automobile* (Chicago: University of Chicago Press, 1965), p. 105. Cited in Garth Jowett, *Film: The Democratic Art* (Boston: Little, Brown, 1976), p. 192.

45. Harold G. Vatter, *The U.S. Economy in the 1950s* (New York: W. W. Norton, 1963), pp. 28–29, 52.

46. As Thomas C. Cochran notes in *American Business in the Twentieth Century* (Cambridge, Mass.: Harvard University Press, 1972), p. 123, "with the collapse of demand in the depression there was little incentive for investment in new equipment."

47. John Izod, *Hollywood and the Box Office, 1895–1986* (New York: Columbia University Press, 1988), pp. 95–96; Tino Balio, ed., *The American Film Industry*, rev. ed. (Madison: University of Wisconsin Press, 1985), pp. 255–256. See also Sinclair, *Fox*, passim.

48. Balio, *American Film Industry*, p. 256.

49. Memo from E. I. Sponable to Otto Koegel, May 28, 1956, recounting the developments leading to the start of CinemaScope; History file, box 97, Sponable Collection.

50. David Bordwell, Janet Staiger, and Kristin Thompson, *The Classical Hollywood Cinema: Mode of Production to 1960* (New York: Columbia University Press, 1985), pp. 251–253.

51. Internal Fox memos suggest that Darryl Zanuck, in particular, was uninterested in technological change before the advent of CinemaScope. See memo from E. I. Sponable to Otto E. Koegel, May 28, 1956, noting Zanuck's deliberate absence from an important research and development demonstration on the West Coast in the mid-1940s; History folder, box 97, Sponable Collection. Zanuck's lack of interest in technology was confirmed by former Fox R & D engineer Alex Alden in an interview with the author April 15, 1987.

52. Alicoate, *1951 Film Daily Year Book*, p. 90.

53. Jowett, *Film*, p. 475. Steinberg, *Reel Facts*, p. 371.

54. George A. Lundberg, Mirra Komarovsky, and Mary Alice McInery, *Leisure: A Suburban Study* (New York: Columbia University Press, 1934), chart I, p. 5.

55. Ibid., p. 6.

56. Kathy Peiss, *Cheap Amusements: Working Women and Leisure in Turn-of-the-Century New York* (Philadelphia: Temple University Press, 1986), pp. 15–17, 88, 115–124.

57. Lundberg quotes one person he interviewed as saying: "Yes, I think it is very important to do something with leisure time, so I go to the movies every day"; Lundberg, Komarovsky, and McInery, *Leisure*, p. 290.

58. Belton, "CinemaScope and Historical Methodology," pp. 26–27.

59. Statistics based on figures for color films in Limbacher, *Four Aspects*, appendix, and on total domestic releases in Steinberg, *Reel Facts*, pp. 366–367. Additional figures come from David A. Cook, *A History of Narrative Film* (New York: W. W. Norton, 1981), p. 413.

60. Cook, *Narrative Film*, p. 414.

61. The sudden increase in color filmmaking can also be tied to increased competition in the color market, stimulated by Eastman Kodak's entry into a field previously monopolized by Technicolor.

62. Distribution costs remain unchanged by either of these technologies, which is why they have not been considered here.

63. Bordwell, Staiger, and Thompson, *Classical Hollywood Cinema*, pp. 353–354.

64. According to the U.S. Bureau of the Census, weekly attendance per household averaged roughly 2.5, a figure which approximates the average size of the family. See Jowett, *Film*, p. 475.

65. For audience preferences see Leo A. Handel, *Hollywood Looks at Its Audience* (Urbana: University of Illinois Press, 1950), pp. 118–154.

66. Jowett, *Film*, pp. 191–192; Sinclair, *Fox*, p. 62.

67. Frederick Lewis Allen, *Only Yesterday: An Informal History of the 1920s* (New York: Harper & Row, 1931), pp. 136–138; idem, *Since Yesterday* (New York: Harper and Brothers, 1940), pp. 215–217; and Leo Bogart, *The Age of Television* (New York: Ungar, 1956), pp. 6–7. Jowett, *Film*, p. 265; Lundberg, Komarovsky, and McInery, *Leisure*, pp. 289–293.

68. Jowett, *Film*, p. 261. Radio, of course, involved only the initial expense required for the purchase of the apparatus and the negligible cost of the electricity necessary to operate it. Thus it would not figure significantly in recreation expenditures.

69. On the "positive correlation between radio listening [and] motion picture attendance," see Handel, *Hollywood Looks at Its Audience*, pp. 155–159. See also Jowett, *Film*, p. 280. For the Lux Radio Theatre, see Michele Hilmes, *Hollywood and Broadcasting* (Urbana: University of Illinois Press, 1990), pp. 67–70.

70. Hilmes, *Hollywood and Broadcasting*, pp. 70–71.

71. Douglas Gomery, *The Hollywood Studio System* (New York: St. Martin's Press, 1986), pp. 30–31, 126–127, 104. See also Lewis, *Motion Picture Industry*, p. 78; Hilmes, *Hollywood and Broadcasting*, pp. 63–71. For a discussion of Paramount's purchase of CBS, see Jonathan Buchsbaum, "Zukor Buys Protection: The Paramount Stock Purchase of 1929," *Cine-tracts* 2, nos. 3–4 (Summer–Fall 1979).

72. Cited in *Fortune*'s "$30 Billion for Fun," in *The Changing American Market* (New York: Fortune, 1955), chap. 10.

4. The Leisured Masses

1. This title originally appeared on an article published in *Business Week* (September 12, 1953).

2. Eric F. Goldman, *The Crucial Decade and After: America, 1945–1960* (New York: Vintage, 1960), p. 20.

3. Leo A. Handel cites a survey, conducted by the Motion Picture Research Bureau

in New York City in August 1942—eight months after U.S. entry into the war—that indicates that 22 percent of the population attended movies more frequently, 19 percent less frequently, and 59 percent with the same frequency as before the war; *Hollywood Looks at Its Audience* (Urbana: University of Illinois Press, 1950), pp. 116–117. These statistics suggest only a 3 percent increase in attendance (though *degree* of frequency is not tabulated). These figures do not include those unable to attend or to respond to the survey, such as people already in the armed services either in the United States or overseas; his figures fail to account for the increase of 5 million spectators per week within a decreased moviegoing population.

4. Marion Clawson and Jack L. Knetsch, *Economics of Outdoor Recreation* (Baltimore: Johns Hopkins Press, 1966), pp. 318, 320. There was not only less time for these activities; there were also fewer people to engage in them, if it is possible to assume that many of the men who traditionally constitute the majority of the "sporting" population were now in the service.

5. Cobbett Steinberg, *Reel Facts: The Movie Book of Records* (New York: Vintage, 1978), p. 371.

6. Ibid.

7. Ibid.

8. See, for example, David Robinson, *The History of World Cinema* (New York: Stein and Day), p. 248; and Gerald Mast, *A Short History of the Movies* (Indianapolis: Bobbs-Merrill, 1981), pp. 260–261.

9. See, for example, Tino Balio, ed., *The American Film Industry*, rev. ed. (Madison: University of Wisconsin Press, 1985), pp. 401–402; and Garth Jowett, *Film: The Democratic Art* (Boston: Little, Brown, 1976), p. 344.

10. Michael Conant, "The Paramount Decrees Reconsidered," in Balio, *American Film Industry*, pp. 540–541.

11. Borneman in ibid., p. 459. See also Michael Conant, *Antitrust in the Motion Picture Industry* (Berkeley: University of California Press, 1960).

12. Conant, "The Paramount Decrees Reconsidered," p. 558.

13. Ibid., p. 557.

14. These average weekly wages are based on a forty-hour work week. See Walter Yust, ed., *1948 Britannica Book of the Year* (Chicago: Encyclopaedia Britannica, 1948), p. 787; and J. Ronald Oakley, *God's Country: America in the Fifties* (New York: Dember, 1986), p. 8.

15. Clawson and Knetsch, *Outdoor Recreation*, p. 318.

16. Goldman, *Crucial Decade*, p. 26. Walter Yust, ed., *1947 Britannica Book of the Year* (Chicago: Encyclopaedia Britannica, 1947), p. 817. Disposable personal income rose from $93 billion in 1941 to $117.5 billion (1942), $133.5 billion (1943), $148.6 billion (1944), $150.4 billion (1945), $160.6 billion (1946). $170.1

billion (1947), and to $189.3 billion in 1948 while expenditures fell during the war years. See Clawson and Knetsch, *Outdoor Recreation*, p. 318.

17. Douglas T. Miller and Marion Nowak, *The Fifties: The Way We Really Were* (New York: Doubleday, 1977), p. 115; and Oakley, *God's Country*, p. 229.

18. Oakley, *God's Country*, p. 9.

19. Francis Bello, "The City and the Car," in Editors of *Fortune, Exploding Metropolis* (Garden City, N.Y.: Doubleday, 1958), p. 33.

20. Oakley, *God's Country*, p. 9.

21. Total travel per capita rose from 480 miles in 1900 to 5,000 miles in 1956 (Clawson and Knetsch, *Outdoor Recreation*, p. 5).

22. Overseas tourism in 1950 involved 676,000 Americans who spent $1 billion abroad; by 1960, over 1.6 million tourists spent $2.7 billion abroad. See Oakley, *God's Country*, pp. 260, 301.

23. Ibid., p. 259.

24. Ibid., p. 239.

25. Ibid., p. 112.

26. Ibid., p. 9.

27. Editors of *Fortune, Exploding Metropolis*, p. ix.

28. Oakley, *God's Country*, p. 10.

29. Ibid., p. 113.

30. William H. Whyte, Jr., "Downtown Is for People,"in Editors of *Fortune, Exploding Metropolis*, p. 115.

31. Oakley, *God's Country*, p. 236.

32. Ibid., p. 114.

33. The famous "kitchen debate" between Richard Nixon and Nikita Khrushchev in the late 1950s took place in a model kitchen on display at an international trade fair. American superiority as a society was measured in terms of its labor-saving consumer items.

34. Oakley, *God's Country*, p. 10.

35. Ibid., p. 236.

36. Jowett, *Film*, p. 348.

37. Balio, *American Film Industry*, p. 401.

38. Zanuck, "Entertainment vs. Recreation," *Hollywood Reporter* (October 26, 1953).

39. "30 Billion for Fun," in *The Changing American Market* (New York: Fortune, 1955).

40. Ibid.

41. Oakley, *God's Country*, pp. 236–237.

42. See surveys by the Motion Picture Reseach Bureau in Handel, *Hollywood Looks at Its Audience*, p. 103; and by the Opinion Research Corporation in Jowett, *Film*, p. 476.

43. Oakley, *God's Country*, p. 121.

44. Ibid., pp. 98, 105; "$30 Billion for Fun."

45. Mae Heuttig notes that "2.5 million seats out of the total of approximately 11 million were in thirteen cities with population over 500,000 each" and "60 percent of the total film rentals of the major producing companies was derived from the exchange areas containing the thirteen cities with population over 500,000"; "Economic Control of the Motion Picture Industry," in Balio, *American Film Industry*, pp. 298–299.

46. Conant, "The Paramount Decrees Reconsidered," p. 573.

47. Ibid., p. 561.

48. Steinberg, *Reel Facts*, p. 371.

49. Gary R. Edgerton, *American Film Exhibition and an Analysis of the Motion Picture Industry's Market Structure, 1963–1980* (New York: Garland, 1983), p. 33.

50. Ibid., p. 32.

51. Robert L. Lippert, "4,000 Drive-Ins (5,400,000 Seats) Hurt Least by Video's Inroads," *Variety* (January 14, 1953), 17. Reported by Dennis L. Myers in "Under the Stars: An Account of the Drive-In Theater" (M.F.A. thesis, Columbia University, 1985), p. 25.

52. Myers, "Under the Stars," pp. 25, 53.

53. Obviously, not all Americans abandoned the movies; average weekly attendance ranged between 60 and 40 million throughout the 1950s; Steinberg, *Reel Facts*, p. 371.

54. "$30 Billion for Fun."

55. Ibid.

56. Zanuck, "Entertainment vs. Recreation."

57. Ibid.

58. Ibid.

59. Clawson and Knetsch, *Outdoor Recreation*, p. 25.

60. Myers, "Under the Stars," pp. 28–29.

61. Several drive-ins offered a laundry service, which could not only launder but also iron clothing before the show was over; ibid., p. 30.

62. Ibid., p. 31.

63. Ibid., pp. 37–39.

64. Ibid., p. 39.

65. Ibid., pp. 40–41.

66. Bob Thomas, *Walt Disney: An American Original* (New York: Simon and Schuster, 1976), pp. 218, 245–253, 268–273.

67. Ibid., p. 265.

68. Ibid., pp. 255, 249.

69. Ibid., p. 256–258.

70. John Izod, *Hollywood and the Box Office, 1895–1986* (New York: Columbia University Press, 1988), p. 164. As Izod points out, Columbia's entry into television production with Screen Gems in 1949 and with "The Ford Theatre" in 1952 predates Disney's own, but it was Disney's success at self-promotion that led the way into television production for the other studios.

71. Clawson and Knetsch, *Outdoor Recreation,* p. 17.

72. Ibid.

73. Ibid., p. 320.

74. Ibid.

75. In 1934 Lundberg et al. observed that movie theaters did their best business on Saturday afternoons and evenings; George A. Lundberg, Mirra Komarovsky, and Mary Alice McInery, *Leisure: A Suburban Study* (New York: Columbia University Press, 1934), p. 291.

76. Steinberg, *Reel Facts,* p. 371.

77. Thomas Doherty, *Teenagers & Teenpics: The Juvenilization of American Movies in the 1950s* (Boston: Unwin Hyman, 1988), pp. 2–3.

78. Lundberg, Komarovsky, and McInery, *Leisure,* p. 291.

79. Handel, *Hollywood Looks at Its Audience,* p. 99. Robert Sklar dates this transformation from a mythical general audience to an "educated audience in the higher-income groups" to the decade 1935–1945, when movies began to appeal to a more sophisticated audience and attendance figures rose accordingly; *Movie-Made America: A Cultural History of American Movies* (New York: Random House, 1975), p. 271.

80. Motion Picture Association of America, *The Public Appraises Movies* (Princeton: Opinion Research Corporation, 1957), p. 4.

81. Jowett, *Film,* p. 477.

82. Oakley, *God's Country,* p. 234.

83. C. Wright Mills, *White Collar: The American Middle Classes* (New York: Oxford University Press, 1951), pp. 63–76.

84. The obsession with golf in the postwar period was not limited to the United States *(Pat and Mike, The Caddy)* but was shared by the Japanese as well—or so it would seem from the subplot of Yasujiro Ozu's *An Autumn Afternoon* (1962), in which the hero's eldest son displays his desires as a consumer through his acquisition of golf clubs.

85. Oakley, *God's Country,* p. 152.

86. Miller and Nowak, *The Fifties,* p. 8.

87. Oakley, *God's Country,* pp. 8, 126.

88. Miller and Nowak, *The Fifties,* p. 115.

89. Doherty, *Teenagers & Teenpics,* p. 54. Miller and Nowak break this $10 billion down into "cars, dogs, pimple cream, TV sets, lipsticks (alone worth $20 million in 1958), records, and phonographs"; *The Fifties,* p. 266.

90. Doherty, *Teenagers & Teenpics*, p. 58.

91. Clawson and Knetsch, *Outdoor Recreation*, p. 318.

5. Cinerama

1. Gordon Hendricks, *The Kinetoscope* (New York: Beginnings of the American Film, 1966), pp. 40–45. There is considerable dispute over whether a Kinetoscope was actually put on display at this event in 1893, though it does seem certain that a machine had been installed at the exposition before it closed in 1894.

2. Kenneth Macgowan, *Behind the Screen: The History and Techniques of the Motion Picture* (New York: Delta, 1965), pp. 72, 79, 465–467.

3. Emmanuelle Toulet, "Le cinéma à l'Exposition universelle de 1900," *Revue d'histoire moderne et contemporaine* 33 (April–June 1986), 195.

4. Ibid., p. 196.

5. Ibid., pp. 185–188.

6. Ralph Walker, "The Birth of an Idea," in *New Screen Techniques*, ed. Martin Quigley (New York: Quigley Publishing, 1953), p. 116.

7. Michael Todd, Jr., and Susan McCarthy Todd, *A Valuable Property: The Life Story of Michael Todd* (New York: Arbor House, 1983), pp. 49–52.

8. David Katz, "A Widescreen Chronology," *Velvet Light Trap*, no. 21 (Summer 1985), 64. "Cinerama to Unveil Spacearium at New York World's Fair," *Box Office* (December 4, 1963). See also *Imax at Expo '90*, publicity brochure prepared by the Imax Systems Corporation.

9. Ibid.

10. Letter to author, July 24, 1990, from Huang Ke, Corporate Communications, Imax Systems Corporation.

11. See Kevin Brownlow, *Napoleon: Abel Gance's Classic Film* (New York: Knopf, 1983), p. 159.

12. *This Is Cinerama*, (yellow) program book, n.d. (ca. 1952).

13. *Chicago Sunday Tribune* (December 21, 1952), 11.

14. *This Is Cinerama*, (yellow) program book.

15. *New York Times* (July 6, 1955).

16. *Cinerama Holiday* program book, n.d. (ca. 1955).

17. Ibid.

18. *Los Angeles Times* (August 9, 1953).

19. *Beverly Hills Daily News Life* (August 12, 1955).

20. *Life* (January 31, 1955), 47.

21. *Time* (June 8, 1953) reported that "the Russians formally announced that they had invented the thing first" (p. 66). By the mid-1960s the United States and the Soviet Union had ceased hostilities on the large-screen front. Cinerama negotiated with the Russians for footage used in six early Kinopanorama films, adding English

voiceover narration and releasing the compilation as *Cinerama's Russian Adventure.* In return, the Russians were, according to Carr and Hayes, given *The Best of Cinerama;* Robert E. Carr and R. M. Hayes, *Wide Screen Movies: A History and Filmography of Wide Gauge Filmmaking* (Jefferson, N.C.: McFarland, 1983), p. 307.

22. *Imax/Omnimax Films in Distribution,* publicity brochure provided by Imax Systems Corporation, September 1989, pp. 3, 6. Imax is a Canadian corporation, a factor which qualifies, to some degree, the "American" perspective I mention. In fact it has been more extensively used to document Canadian than U.S. life and landscapes.

23. *Cinerama Holiday* program book.

24. Ibid.

25. The former was filmed by cameramen who worked on the James Bond series.

26. The films are *This Is Cinerama, Cinerama Holiday, Seven Wonders of the World, Search for Paradise,* and *Cinerama South Seas Adventure.*

27. *Variety* (April 10, 1963).

28. *New York Times* (October 5, 1952); *American Mercury* 76 (March–April 1953), 16.

29. *Daily Variety* (October 2, 1952).

30. *Fortnight* (October 13, 1952).

31. *Magazine Digest* (September 1953), 40.

32. Olive Cook, *Movement in Two Dimensions* (London: Hutchinson, 1963), p. 32.

33. Ibid., pp. 36, 38.

34. Ibid., pp. 31–32.

35. *Rama* literally means "a sight" or "spectacle" and derives from the Greek *horama,* which is related to the verb *horao,* meaning "I see."

36. Cook, *Movement in Two Dimensions,* p. 32.

37. Ibid., pp. 33–34.

38. Toulet, "Le cinéma à l'Exposition universelle," p. 189.

39. Ibid., pp. 189–191.

40. *New York Times* (October 5, 1952).

41. Ibid. As late as May 1960 *American Cinematographer* noted that "closeups of people shot with Cinerama cameras show typical wide-angle closeup distortion. Noses appear very long and foreheads slant back. Ears are very small in proportion and chins recede"(p. 304).

Early CinemaScope, which employed an anamorphic lens that was unable to focus clearly at distances under four feet from the camera, faced a somewhat different problem involving not distortion but sharpness of focus. However, though extreme close-ups remained difficult to achieve in CinemaScope, standard close-ups were easily accomplished.

Three-strip Cinerama was ultimately used to film narratives, such as *The Wonderful World of the Brothers Grimm* and *How the West Was Won,* but narrative

information was conveyed in these films without the use of close-ups, relying on narrative techniques borrowed from the theater (which CinemaScope had also drawn upon).

42. William Daniels, "Cinerama Goes Dramatic," *American Cinematographer* 43, no. 1 (January 1962), pp. 50–51.

43. *Time* (October 13, 1952).

44. *This Is Cinerama*, (yellow) program book.

45. Publicity handout quoted by Judith Crist, *New York Herald-Tribune* (September 22, 1957).

46. *Los Angeles Times* (August 9, 1953).

47. *New York Herald-Tribune* (September 27, 1953).

48. Ibid.

49. Ibid.

50. Clifford M. Sage in the *Dallas Times Herald* (November 4, 1952).

51. Private collectors, of course, could obtain copies of motion pictures, although such collections were considered illegal by the film industry.

52. *Motion Picture Herald* (October 4, 1952).

53. Lynn Farnol, "Finding Customers for a Product," in Quigley, *New Screen Techniques*, p. 143.

54. *Film Daily* (January 21, 1963).

55. Waller devised a special black mask with two small holes in it so positioned as to be precisely over the center of each eye. He discovered that individuals wearing this mask, though possessing binocular vision, had great difficulty navigating space, while people with only monocular vision (or whose center vision in both eyes was obscured) could easily move through space without bumping into things, relying entirely on what they could see out of the corners of the eye. See Mary Jean Kempner, "Cinerama," *Vogue* (January 1953), 171.

56. Ibid.

57. Ralph G. Martin, "Mr. Cinerama," *True* (August 1953), 87.

58. Ibid., p. 89.

59. Kempner, "Cinerama," p. 171; Martin, "Mr. Cinerama," p. 86.

60. Martin, "Mr. Cinerama," p. 88.

61. Harland Manchester, "Fred Waller's Amazing Cinerama," *Reader's Digest* 62 (March 1953), 46–47: Walker, "The Birth of an Idea," p. 113.

62. Walker, "The Birth of an Idea," p. 113.

63. Ibid., pp. 114–116.

64. Ibid., pp. 116–117. Waller's initial system required the use of eleven 16mm cameras and projectors, which, he reasoned, could be reduced to five if the system was upgraded to 35mm. See Waller, "Cinerama Goes to War" in Quigley, *New Screen Techniques*, pp. 120–121.

65. Memo, David O. Selznick to Katherine Brown, December 20, 1937, box 7219,

Selznick Archive, Harry Ransom Humanities Research Center, University of Texas at Austin.

66. Letter, Selznick to Kenneth Macgowan, October 14, 1955, box 7219, Selznick Archive.

67. Waller, "Cinerama Goes to War," pp. 123–125.

68. Initial Cinerama installations used the 1,100-strip screen but larger theaters subsequently employed screens with as many as 2,000 strips. See Keith H. Swadkins, "Whatever Happened to Cinerama?" *Cinema Technology* 3, no. 4 (July 1990), 59.

69. Kempner, "Cinerama," p. 173.

70. "Cinerama—The Broad Picture," *Fortune* (January 1953), 148.

71. Todd and Todd, *A Valuable Property*, pp. 215–216.

72. Ibid., pp. 217–218.

73. Lowell Thomas, "This Cinerama Show," in Quigley, *New Screen Techniques*, pp. 137–138; Todd and Todd, *A Valuable Property*, pp. 232–235.

74. *Daily Variety* (August 6, 1952).

75. *Daily Variety* (October 2, 1952); *Commonweal* 57 (November 21, 1952), 165.

76. Philip Hartung's review of Cinerama in *Commonweal* 57 (November 21, 1952) compares it with other current releases (p. 165); Kempner, "Cinerama," p. 129.

77. *Daily Variety* (October 19, 1952); *Variety* (October 29, 1952); *Daily Variety* (February 11, 1953) noted that Mayer also brought with him the rights to *Joseph and His Brethren* and *Blossom Time*.

78. Robert Stanley, *The Celluloid Empire* (New York: Hastings House, 1978), p. 161.

79. *Daily Variety* (October 10, 1952).

80. *Variety* (May 27, 1953). Mayer fought with Cooper, demanding complete control over the production of films in Cinerama (*Daily Variety*, May 4, 1953, p. 1). The corporate structure of the Cinerama organization was fairly complex, consisting of the Vitarama Corporation, which held Waller's patents; Cinerama, Inc., which sublicensed production rights and supplied all equipment; and Cinerama Productions Corporation, which produced pictures in Cinerama (*Fortune*, January 1953, p. 93). De Rochemont was not signed to make the second Cinerama film until November 1953 (*Daily Variety*, November 11, 1953).

81. According to the *Hollywood Reporter* (July 7, 1953), Stanley Warner agreed to help finance one feature a year for the next five years and to provide $1.6 million to equip theaters to show Cinerama.

82. *Daily Variety* (June 26, 1953), 3.

83. *Daily Variety* (March 3, 1954), 6.

84. *Daily Variety* (November 20, 1952).

85. Todd and Todd, *A Valuable Property*, p. 244, put the figure at 17 and note that alhough *This Is Cinerama* played in only 17 theaters, it was, by the completion of its run, the third-largest-grossing picture of all time. The figure of 22 comes from

Film Daily's special tenth-anniversary edition, devoted to Cinerama (January 21, 1963), 26. According to Willem Bouwmeester of the International Cinerama Society (in conversation with the author, May 12, 1991), Cinerama theaters increased from 58 in 1962 to 85 in 1963, before a large-scale expansion to 230 in 1967.

86. Letter, Sol Halprin to Herbert Bragg, February 5, 1963, box 117, Sponable Collection, Columbia University Libraries.

87. This was due not only to the use of three strips of film but also to the increased camera speed and the increased height of each 35mm image, which was six rather than four sprocket holes high.

88. *Daily Variety* (April 29, 1953), 3.

89. Willem Bouwmeester and John Harvey of the International Cinerama Society, conversation with the author, May 12, 1991.

90. *Daily Variety* (February 2, 1953), 10.

91. *Daily Variety* (March 3, 1954), 6.

92. For a discussion of issues related to Cinerama projection, see Carr and Hayes, *Wide Screen Movies*, pp. 11–25. According to Bouwmeester and Harvey, Cinerama features after *This Is Cinerama* employed eight-track stereo sound, using the eighth track to direct elements on the seventh track to speakers in the rear of the auditorium.

93. *Time* (June 8, 1953), 66.

94. See *Daily Variety* (October 15, 1952), 4.

95. The labor dispute was announced in *Daily Variety* on January 13, 1953, in a story reporting that Cinerama had decided to bypass Chicago because of union demands. The dispute was settled near the end of April, when the union yielded on its demand for additional staff in return for an hourly wage increase; *Daily Variety* (April 22, 1953), 9. See also *Film Daily* (February 11, 1953).

96. *Variety* (November 7, 1962). Alexander Korda secured the British rights to Cinerama before its New York opening but experienced problems getting equipment and encountered government opposition regarding Cinerma's contractual obligation that its licensees pay royalties (*Variety*, September 3, 1952).

97. Lorin Grignon noted considerable optical distortion in his report to Fox on the process on October 14, 1952: "The distortions of Cinerama are such that the ordinary interior does not look natural but there are circumstances where the distortion of scenes is of little apparent consequence, for example, the church interior. However, in this particular sequence the change in the shape of the steps is apparent as the camera dollies in." He also noted horizontal distortion; it was "as though the floor is bowl-shaped . . . people or moving objects appear to go up the sides of the bowl. This is particularly noticeable in the opera scene." Cinerama folder, box 117, Sponable Collection.

98. Todd and Todd, *A Valuable Property*, pp. 219, 230. These flaws remained in the

system as long as it relied on the three-screen format. In his review of *The Wonderful World of the Brothers Grimm*, Bosley Crowther noted that the format still suffered from "the saucer or arch shape of the horizon . . . the inconsistency of the color quality in the different panels . . . and the marginal lines at which the separate images blend"; *New York Times* (August 8, 1962).

99. Todd and Todd, *A Valuable Property*, p. 225.
100. Memo, Grignon to Sponable, October 14, 1952.
101. Letter to the editor from former Cinerama projectionist Laurence J. Roberts, *American Cinematographer* 64, no. 12 (December 1983).
102. Memo, Grignon to Sponable, October 14, 1952 (p. 2), box 117, Sponable Collection; letter to the editor from Roberts, *American Cinematographer*.
103. Memo, Grignon to Sponable, p. 2.
104. *Daily Variety* (January 13, 1960); Carr and Hayes, *Wide Screen Movies*, pp. 40–45.
105. It also enabled producers to "extract" three 35mm strips from the original 65mm negative for use in Cinerama's original three-projector exhibition.
106. Swadkins, "Whatever Happened to Cinerama?" pp. 60–61.
107. *Variety* (April 3, 1968).
108. Swadkins, "Whatever Happened to Cinerama?" pp. 62–63.
109. CRC also announced that it would release films produced by ABC Productions; *New York Times* (August 16, 1967), 36.
110. *Variety* (September 13, 1978), 8; Swadkins, "Whatever Happened to Cinerama?" p. 63.
111. *Motion Picture Exhibitor* (April 5, 1961); *Film Daily* (January 21, 1963).
112. John H. Richardson, "The Best Writer in Hollywood?" *Premiere* 3, no. 12 (August 1990), 30.
113. Dale Pollock, *Skywalking: The Life and Films of George Lucas* (New York: Harmony, 1983), p. 21.
114. Christopher Byron, "MCA Faces the Future," *Premiere* 3, no. 12 (August 1990), 80–87.

6. CinemaScope

1. Kenneth Macgowan, *Behind the Screen: The History and Techniques of the Motion Picture* (New York: Delta, 1965), p. 461.
2. "Goldgets against Gadgets," *Variety* (March 11, 1952), 3; "Yates Raps 3-D Pix as Impractical," *Daily Variety* (March 3, 1953); "UA—The Flat Films' Fortress," ibid. (April 8, 1953). Republic was one of the few studios that never made a film in CinemaScope; Richard Hincha, "Selling CinemaScope: 1953–1956," *Velvet Light Trap*, no. 21 (Summer 1985), 46. With one or two notable exceptions, such as *The Quiet Man* (1952), Republic produced low-budget films and thus could not afford to make films in CinemaScope. (Fox charged a $25,000 fee to producers for

use of the CinemaScope process and demanded script approval on the first CinemaScope films made by others, in an attempt to ensure that these productions would have significant production value; Fox also insisted that producers film in color.) By the time Fox launched a series of cheaper, black-and-white CinemaScope productions in 1956, Republic had ceased theatrical production; Richard M. Hurst, *Republic Studios: Between Poverty Row and the Majors* (Metuchen, N.J.: Scarecrow, 1979), p. 25.

3. "Fox Films Embark on 3-Dimension Era," *New York Times* (February 2, 1953); "Fox Converts to 3-D," *Motion Picture Herald* (February 7, 1953).

4. Thomas M. Pryor noted that "the process does not achieve a true three-dimensional effect, such as the depth of vision obtainable via stereoscopic photographs"; *New York Times* (March 19, 1953); Bosley Crowther wrote that CinemaScope "is not stereoscopic but gives a moderate illusion of depth"; *New York Times* (April 25, 1953); see also John Belton, "CinemaScope and Historical Methodology," *Cinema Journal* 28, no. 1 (Fall 1988), 35–37.

5. Three-page ad for *The Robe* in *Daily Variety* (July 27, 1953), 5–7.

6. Thomas, of course, did have experience as a commercial filmmaker, producing one or two documentary films (notably *With Lawrence in Arabia: With Allenby in Palestine and Romantic India*) and a series of newsreels for Fox's Movietone News.

7. "Strictly for the Marbles," *Time* (June 8, 1953), 67.

8. In August 1953 the *Hollywood Reporter* declared that 3-D was dead; James Spellerberg, "Technology and the Film Industry: The Adoption of CinemaScope" (Ph.D. diss., University of Iowa, 1980), p. 157; "3-D Looks Dead in United States," *Variety* (May 24, 1954), 1. By September 4, 1953, Natural Vison had cut its prices for projection equipment for 3-D by 40 percent (*Daily Variety*, p. 1), and by mid-October exhibitors began requesting flat versions of 3-D pictures (*Daily Variety*, October 13–14, 1953).

9. "Cinerama—The Broad Picture," *Fortune* (January 1953), 146.

10. *Business Week* (March 14, 1953), 126 and (July 25, 1953), 62.

11. *Daily Variety* (April 14, 1953).

12. Robert Stanley, *The Celluloid Empire* (New York: Hastings House, 1978), p. 152.

13. Republic's resistance to various forms of 3-D did not prevent it from adopting a flat (under 1.85:1) widescreen format. For the ratios, see the letter from the Motion Picture Research Council, May 11, 1953, Warner Bros. Archive, University of Southern California. See also "Strictly for the Marbles," *Time*, p. 70; *Daily Variety* (May 19 and August 3, 1953); and Leonard Spinrad, "Mapping the Growing Wide-Screen, 3-D Maze," *New York Times* (April 12, 1953).

14. *Daily Variety* (April 6, 1953). Two months later they attempted to extend the life of their 1952 hit, *The Greatest Show on Earth*, by rereleasing it in 1.66:1 (*Daily Variety*, June 11, 1953).

15. *Daily Variety* (20 May 1953), 1.

16. Al Lichtman, quoted in *Daily Variety* (June 17, 1953), 2.

17. "Strictly for the Marbles," *Time*, p. 70.

18. "Cinerama," *Fortune*, 93.

19. Letter, L. D. Grignon to E. I. Sponable, May 31, 1956, History folder, box 97, Sponable Collection, Columbia University Libraries.

20. Memo, Sponable to Charles Moskowitz, October 31, 1950, cited in memo, Sponable to Otto Koegel, May 28, 1956 (p. 2), History folder, box 97, Sponable Collection.

21. Memo, Sponable to Koegel, May 28, 1956, p. 3; Herbert E. Bragg, "The Development of CinemaScope," ed. John Belton, *Film History* 2, no. 4 (November–December 1988), p. 360.

22. Memo, Sponable to Koegel, May 28, 1956, p. 4.

23. Ibid.; letter, Grignon to Sponable, May 31, 1956. Sponable's memo noted that at the 50mm demonstrations held in Los Angeles in October 1946 "Mr. Zanuck did not choose to attend"; that, considering the health of the motion picture business at the present, Joe Schenck did not see the need for a new process at that time; and that "Skouras said if executives on the Coast did not support the program it should be tabled."

24. Alex Alden, former member of the Fox research staff, noted that Zanuck was not interested at all in technological development (conversation with the author, April 15, 1987). Skouras, however, gave his support to the Eidophor and lenticular color projects and proved to be the driving force in Fox management behind CinemaScope.

25. Bragg, "Development of CinemaScope," p. 366; Robert Prall, "Studio Gambles 10 Millions in Bid to Woo TV Addicts," *New York World Register* (September 14, 1953), 21.

26. After Fox management compromised on its stereo-only policy, Sponable expressed his disappointment in a confidential letter (July 7, 1954) to Grignon, complaining that "in effect, the sales department seems to have knowingly undermined our efforts to make CinemaScope releases the best motion picture presentation available today [and] are tacitly saying that we have been wrong all along and that sound associated with CinemaScope is of practically no importance, contrary to the the publicity of the past several months"; Grignon folder, box 96, Sponable Collection.

27. *Daily Variety* (December 17, 1952), 3.

28. "Battle of the 20th Century," *Time* (April 13, 1953).

29. *Daily Variety* (February 25, 1953), 1.

30. *Daily Variety* (April 3, 1953), 7; "Battle," *Time*.

31. "Battle," *Time*.

32. Green objected to Zanuck's twenty-year contract at $260,000 per year as well as

to his $750,000 after-death benefits and to Skouras' similar deal for $250,000 per year; *Daily Variety* (April 3, 1953), 7; "Battle," *Time.*

33. *Motion Picture Herald* (February 7, 1953), 1, 12.

34. *Daily Variety* (April 28, 1953), 8.

35. *Daily Variety* (February 2, 1953), 1, 10.

36. *Daily Variety* reported "heavy purchases of 20th-Fox stock by Charles Green" in mid-December 1952 (December 17, 1952, p. 3). The campaign for proxy votes took place in April (*Daily Variety,* April 4, 6, 15–17, 21, 28, 1953).

37. Skouras insisted that these were Green's objectives (*Daily Variety,* April 17 and 28, 1953).

38. Michael Todd reportedly began work on Todd-AO the day after the Broadway opening of *This Is Cinerama;* Michael Todd, Jr., and Susan McCarthy Todd, *A Valuable Property: The Life Story of Michael Todd* (New York: Arbor House, 1983), p. 245. Nathan Levinson of Warners sent an analysis of Cinerama (October 10, 1952) to Jack Warner (Warner Bros. Archive), and Warners began work on a Cinerama-like system shortly thereafter, as did Paramount ("Major Studios in 3-D Race," *Daily Variety,* January 26, 1953). After seeing a special preview of CinemaScope, Nicholas Schenck, president of Loew's (M-G-M), said that M-G-M "had been working on a system similar to CinemaScope," which it had decided to abandon for the Fox process (*Motion Picture Herald,* February 7, 1953, p. 12). Schenck may have been referring here to renewed experiments with the studio's 1930 wide-film process, Realife.

39. The first anamorphic lenses were developed by Ernest Abbé and Carl Zeiss for still photography in 1898. However, the principle of anamorphosis dates at least as far back as the fifteenth century and can be seen illustrated in Leonardo da Vinci's sketch of a child's head and an eye which appeared in his Codex Atlanticus circa 1485. *Anamorphosis* is a Greek word meaning "change or transformation of shape." The president of Twentieth Century–Fox, Greek-born Spyros Skouras, upon hearing Chrétien's Hypogonar lens described as "anamorphic," is said to have become fascinated with the process, in part because of the Greek origin of the word (Bragg, "Development of CinemaScope," p. 361). His initial announcement of the studio's acquisition of the lens, which referred to it as a process known as "Anamorphoscope," represented an attempt to retain its Greek origins, but this somewhat cumbersome name was quickly changed to "CinemaScope" in order to link the process more clearly to the film medium. *Daily Variety* (January 14, 1953, p. 1) announced the "Anamorphoscope." The tradename CinemaScope was chosen at a West Coast meeting attended by Skouras, Michel, Lichtman, Zanuck, Sponable, Klune, Rogell, and Halprin on January 29, 1953 (memo, Sponable to Koegel, May 28, 1956, p. 6). The name Cinemascope proved to have been already copyrighted by KLAC-TV general manager Don Fedderson in 1949 in conjunction with

a process designed by Louis H. Loew for the kinescoping of television shows (*Daily Variety*, February 3, 1953, p. 1). Fedderson later sold his rights in the trademark to Fox for $50,000.

The "discovery" of the principle of anamorphosis is the result of da Vinci's exploration of art historian and architect Leonbattista Alberti's work on linear perspective. Linear perspective draws upon the Euclidian notion that conceives of the field of vision "as a pyramid whose apex lies in the eye of the observer. Alberti used this formulation as the basis for his famous definition of a painting as a cross section of the visual pyramid." The concept of centered station points led da Vinci to investigate off-center positions for observers in a series of sketches which employed anamorphic perspectival encoding. Perhaps the most famous example of a work with multiple station points is Hans Holbein's *The Ambassadors* (1533), which employs both linear perspective and anamorphosis, encoding a death's-head into a portrait that otherwise celebrates the wealth and prosperity of its subjects. Other anamorphic art ranged from works that encoded religious subjects to those that camouflaged erotic or obscene themes. F. Leeman, H. Schuyt, and J. Elffers, eds., *Anamorphoses: Games of Perception and Illusion in Art* (New York: Abrams, 1976). The first workable anamorphic lens developed for motion picture photography was patented by Chrétien in April 1927.

40. Chrétien's Hypergonar was a cylindrical (rather than spherical) lens. In cylindrical lenses, "a concave cylinder shape is hollowed out of [the lens's] front surface"; the concave shape bends incoming light differently depending upon its angle (i.e., horizontal or vertical) of entry; Stephen E. Huntley, "Historical and Technical Analysis of Early CinemaScope Lenses: 1952–1954" (B.Sc. thesis, Massachusetts Institute of Technology, June 1986), p. 12.

41. Bragg, "Development of CinemaScope," 361. Chrétien, born in Paris in 1879, was an expert in optics, had designed a spectroheliograph, an astrolabe, an aplanetic telescope, various collimators (ranging from a gunsight used by French combat planes in World War I to catadioptric devices used in optical signaling and night advertising), and the Hypergonar, which was employed in color and 3-D processes, as well as in panoramic photography, and which was subsequently adapted for use as a periscope viewfinder in tanks and other combat vehicles (Albert Arnulf obituary tribute to Chrétien [1956], Chrétien folder, box 91, Sponable Collection). Bragg knew of Chrétien's anamorphic motion picture lens through H. Dain's description of it in the *Journal of the Society of Motion Picture Engineers* in December 1932; Chrétien had written about it himself in the same journal in May 1939; and in late 1929 and early 1930 an American student of Chrétien's, H. Sidney Newcomer, had filed several patents for an anamorphic lens in this country. See *JSMPE* 37, no. 5 (May 1939); and H. Sidney Newcomer, "The Anamorphoser Story," in *New Screen Techniques*, ed. Martin Quigley (New York: Quigley Publishing, 1953), p. 197.

42. It is not clear on exactly which date Warners first learned of Chrétien's lens or dispatched representatives to locate him. Presumably they began their search shortly after Fox did.

43. Letter of agreement from Chrétien to Skouras, December 18, 1953, Chrétien folder, box 91, Sponable Collection.

44. *Business Week* (March 14, 1953), 124.

45. Twentieth Century–Fox publicity release, French (Hummel) folder, Warner Bros. Archive. Chrétien's contract with Fox guaranteed him a payment of $150,000 over the next ten years, exclusive rights for the production of CinemaScope lenses in France, and a one-dollar royalty for each lens produced and sold elsewhere. In return, Chrétien was to supply Fox with 500 projection and camera lenses; Agreements and Contracts folder, box 86, Sponable Collection.

46. Letter, Darryl Zanuck to Jack Warner, March 5, 1953, in which Zanuck claims that Warner himself confessed to the "one day late" story (Twentieth Century–Fox folder, Warner Bros. Archive). Warner Brothers records indicate that J. S. Hummel met with Chrétien on January 16, 1953, almost a month after Fox made its deal with him; a cable from Hummel to Warner, January 19, 1953, reports that he saw a demonstration of Chrétien's lens in France on that date and was "convinced Professor's process has tremendous possibilities"; Warners, like Fox, also attempted to locate Newcomer and another former student of Chrétien, André Levy of Optique Boyer, but was unable to make a deal with either of them; French (Hummel) folder, Warner Bros. Archive.

47. John Belton, "CinemaScope: The Economics of Technology," *Velvet Light Trap*, no. 21 (Summer 1985), 36–37.

48. When Skouras made Chrétien an offer, the latter reportedly replied, "But I have no patent. You can have it for nothing"; Publicity folder, box 108, Sponable Collection. See also *Business Week* (March 14, 1953), 126.

49. Huntley, "Early CinemaScope Lenses," p. 44.

50. *Business Week* (July 25, 1953), 64. See also *Daily Variety* (February 2, 1953), 1; *Motion Picture Herald* (February 7, 1953), 12.

51. *Motion Picture Herald* (February 7, 1953), 1, 12.

52. Freeman Lincoln, "The Comeback of the Movies," *Fortune* (February 1955), 129.

53. *New York Times* (February 8, 1953).

54. *Motion Picture Herald* (February 7, 1953), 12.

55. *Daily Variety* (February 2, 1953), 1.

56. M-G-M's contract guaranteed it the delivery of twenty camera lenses and six projection lenses by certain dates (beginning with an initial delivery on June 15, 1953), sold the studio the lenses outright (rather than leasing them, as Fox did with other studios), and agreed to let M-G-M use the tradename CinemaScope or its own tradename, MetroScope. The $75,000-per-year deal also contained an escape clause, permitting M-G-M to terminate the agreement if CinemaScope

proved to be unsuccessful commercially, if it was not adopted by the industry, or if it was adopted but later abandoned. After the first ten years, M-G-M could continue to use CinemaScope without paying a yearly licensing fee; contract with Loew's, dated April, 15, 1953, but beginning on March 18, Contracts folder, box 91, Sponable Collection.

57. Spellerberg, "Technology and the Film Industry," pp. 144, 176.

58. *Variety* (July 29, 1953).

59. James Limbacher, *Four Aspects of the Film* (New York: Brussel and Brussel, 1968), p. 108.

60. *Daily Variety* (March 23, 1953), 3, 7.

61. *Daily Variety* (August 19, 1953), 1, 11.

62. *Daily Variety* (September 21, 1953), 3.

63. See *Variety* (July 29, 1953).

64. Letter, Skouras to Y. Frank Freeman, October 21, 1953, Skouras folder, box 112, Sponable Collection.

65. *Hollywood Reporter* (October 28, 1953), 1.

66. *Daily Variety* (March 3, 1954), 14.

67. Limbacher, *Four Aspects*, p. 127.

68. Leonard Spinrad, *Motion Picture Newsletter* (May 3, 1954); see also Paramount's VistaVision demonstration booklet (n.d.), VistaVision folder, box 120, Sponable Collection.

69. VistaVision publicity booklet, VistaVision folder, box 120, Sponable Collection.

70. Thomas Pryor, "Hollywood Expands," *New York Times* (March 7, 1954).

71. Fox memo, E. H. McFarland to W. C. Michel, June 3, 1954, Paramount folder, box 119, Sponable Collection.

72. "Brief History of CinemaScope" chronology, History folder, box 97, Sponable Collection.

73. *Daily Variety* (July 13, 1953).

74. Spellerberg, "Technology and the Film Industry," p. 161.

75. *Daily Variety* reported that Columbia "rack[ed] up the greatest one-week's billing in its 33-year history" with *Eternity, Stranger Wore a Gun,* and *Cruisin' down the River* (September 24, 1953). Columbia earned $1.25 million that week and $1.35 million the next (*Daily Variety,* October 1, 1953, p. 2).

76. According to Fox sources, Columbia persisted in confining the important action to the center of the CinemaScope frame so that the film could be released in a 1.85:1 format. Zanuck, who saw Columbia's practice as a potential threat to the value of CinemaScope, complained to Skouras about it; letter, Zanuck to Skouras, April 16, 1954, Zanuck folder, box 116, Sponable Collection.

77. Zanuck thus describes Skouras' efforts in relation to CinemaScope in Mel Gussow, *Don't Say Yes until I Finish Talking* (New York: Simon and Schuster, 1972), p. 163, quoted in Hincha, "Selling CinemaScope," 44.

78. Limbacher, *Four Aspects,* p. 113.

79. *Daily Variety* (April 14, 1953); *Variety* (October 21, 1953), 11, 22.

80. *Daily Variety* (April 14, 1953).

81. *Daily Variety* (June 16, 1953), 1.

82. Letter, Joe Westreich to Jack Warner, March 7, 1953, referred to in a subsequent, undated letter to "Joe" and in "Specifications," March 20, 1953 (Zeiss folder, Warner Bros. Archive).

83. Letter, Sponable to Fox vice-president J. Moskowitz, March 30, 1953, Sponable Collection, quoted in Huntley, "Early CinemaScope Lenses," p. 37.

84. See the introduction to Bragg, "Development of CinemaScope," p. 359. Zeiss worked with both Warners and Fox on making anamorphic lenses, never disclosing to one that it was also working for the other. In July, when Sponable mentioned his discussions with Zeiss to the technical people at Warners, Warners and Fox realized that they had been tricked into thinking that Zeiss was working for them alone and began to exchange information about their dealings with the optical film. See Huntley, "Early CinemaScope Lenses," pp. 44–46; and Jack Warner's undated letter to "Joe," Zeiss folder, Warner Bros. Archive.

85. See undated "Dear Joe" letter, which documents Warners' dealing with Zeiss from March 7 through June 26, 1953, Zeiss folder, Warner Bros. Archive.

86. *Daily Variety* (December 22, 1952).

87. Spellerberg, "Technology and the Film Industry," p. 162.

88. Letter, Zanuck to Jack Warner, May 7, 1953, Twentieth Century–Fox folder, Warner Bros. Archive.

89. Draft of letter, Jack Warner to Zanuck, May 1953, Twentieth Century–Fox folder, Warner Bros. Archive.

90. *Daily Variety* (May 28 and 29, 1953).

91. *Daily Variety* (July 21, 1953), 8.

92. Warner had extended its order to Zeiss for lenses producing a 2:1 aspect ratio to include additional lenses that, like Fox's, produced a 2.66:1 image; cable, Warner to Hummel, July 19, 1953, French (Hummel) folder, Warner Bros. Archive; *Daily Variety* (July, 24, 1953), 1.

93. Warners resumed production, including that on *Rear Guard* (which was retitled *The Command*), on July 10 (*Daily Variety,* July 10, 1953). Warners' contract with Dudley was dated July 17, 1953 (memo, R. J. Obringer to Steve Trilling, July 28, 1953, Sound folder, Warner Bros. Archive). See also *Daily Variety* (August 18, 1953), 5. A memo from David Weisbart to Steve Trilling indicates that the film was shot in both 3-D and Vistarama (*The Command* folder, Warner Bros. Archive). The film was not released in 3-D; one of the two 3-D negatives was used to strike flat prints.

94. Because Warners was now licensed to film in CinemaScope and wished to take advantage of the CinemaScope trademark on *The Command,* Zanuck instructed

the Fox staff "to say nothing whatever about the situation" to the press and reported that he himself "successfully evaded the question" as to what process the picture was actually filmed in when interviewed by a *New York Times* reporter; letter, Zanuck to Jack Warner, December 14, 1953, Twentieth Century–Fox folder, Warner Bros. Archive.

95. Memo summarizing conference in Hollywood with Zeiss representative, Hans Sauer, October 22, 1953, Zeiss folder, Warner Bros. Archive.

96. Warners technician Al Tondreau cabled Zeiss engineer Hans Sauer, praising the Fox lens: "Results razor sharp all over. No color aberrations. Excellent definition and contrast over entire screen. Projected same test film with Zeiss anamorphic lens. Results deinitely inferior. Lost definition and contrast. Color aberration prominent. Also image flare on vertical lines in center extending two inches to right on thirty-six-foot picture. Impossible to secure sharp focus over entire screen with soft focus most prominent on right side . . ."; cable, September 9, 1953, Zeiss folder, Warner Bros. Archive.

97. "WB Gets 300 C'Scope Lenses to Rent as Part of Giving up Own System," *Variety* (October 28, 1953), 15.

98. Ibid., p. 5.

99. *Variety* (October 21, 1953), 22.

100. *Daily Variety* (February 4, 1953). The next day, *Daily Variety* reported that Fox would use the Polaroid 3-D process, not Natural Vision.

101. Kazan may also have been reluctant to film this particular project in CinemaScope; *Daily Variety* (February 2, 1953, p. 10, and April 16–17, 1953); Elia Kazan, *A Life* (New York: Knopf, 1988), p. 508; see also Aubrey Solomon, *Twenthieth Century–Fox: A Corporate and Financial History* (Metuchen, N.J.: Scarecrow, 1988), p. 136.

102. *Daily Variety* (June 15, 1953), 1, 4.

103. Ibid. (June 19, 1953), 5.

104. In *Daily Variety* on January 14, 1953, Fox announced that it would shoot *The Robe* in two versions and that it had acquired "a French large-screen process known as Anamorphoscope."

105. In a letter to Jack Warner on March 5, 1953, Zanuck acknowledged that "I am looking each night at flat rushes, 3-D polaroid rushes and finally the CinemaScope rushes on *The Robe*"; Twentieth Century–Fox folder, Warner Bros. Archive.

106. *Gentlemen Prefer Blondes* had already been made and released flat. Zanuck reshot this musical number in CinemaScope, using it to sell producers on the advantages the process might have for production. The original number, he noted, took four days to shoot, but it was filmed in CinemaScope in only three and a half hours; *Daily Variety* (March 19, 1953), 3.

107. Ibid.

108. Ibid., pp. 1, 3.
109. *Motion Picture Herald* (March 28, 1953), 12.
110. *Daily Variety* (March 23, 1953), 6.
111. Ibid. (March 27, 1953).
112. Ibid. (March 25, 1953), 1.
113. Ibid. (March 24, 1953), 2.
114. Ibid.
115. Ibid. (April 1, 1953). Spellerberg ("Technology and the Film Industry," pp. 169, 187–189) concludes that only first-run houses could afford to install the Cinema-Scope package and that the advent of CinemaScope helped eliminate the less capitalized, weaker, independent exhibitors. Hincha ("Selling CinemaScope," pp. 46–50) reviews Fox's relations with organizations representing the smaller theaters.
116. Memos, January 16 and 19, 1954, Theater Installations: Drive-ins folder, box 114, Sponable Collection.
117. R. J. O'Donnell, "The Threshold of Great Things," *Daily Film Renter* 5 (June 30, 1953).
118. Jack Prendergast, letter to *To-day's Cinema* 6 (July 10, 1953).
119. *Daily Variety* (May 20, 1953).
120. Ibid. (December 2, 1953), 3.
121. Ibid. (January 15, 1954), 6.
122. Letter, Grignon to Sponable, June 5, 1954, Grignon folder, box 96, Sponable Collection.
123. *Daily Variety* (January 21, 1954), 1; *Film Daily* (January 29, 1954).
124. *Daily Variety* (February 1, 1954). The same issue printed a letter from a theater owner who had resigned from TOA because of Reade's action, complaining that it had "jeopardize[d] our investment [and] endanger[ed] the only invention and the first real technical advance since the advent of sound."
125. See Spellerberg, "Technology and the Film Industry," pp. 170–172; Hincha, "Selling CinemaScope," pp. 48–51; Belton, "CinemaScope," p. 39.
126. *Daily Variety* (December 11, 1953), 7.
127. Ibid. (December 9, 1953), 1, 11.
128. Ibid. (March 24, 1954), 3.
129. Report on Perspecta, May 5, 1954, Widescreen: Perspecta folder, box 119, Sponable Collection.
130. Cable, Skouras to Zanuck, May 13, 1954, Skouras folder, box 112, Sponable Collection; *Daily Variety* (May 7, 1954), 1.
131. *Film Bulletin* (May 3, 1954), 11.
132. *Business Week* (May 8, 1954), 42, 43.
133. *Daily Variety* (May 7, 1954), 1.

134. *Twentieth Century–Fox: Annual Report* (1953), 6, and (1954), 3.
135. *Business Week* (May 8, 1954), 42.
136. *Twentieth Century–Fox: Annual Report* (1953).

7. The Development of CinemaScope

1. "Progress Committee Report," Charles R. Daily, chairman, *JSMPTE* 62 (May 1954), 333–363.
2. The Todd-AO system was previewed as early as January 19, 1954, in Buffalo, when Earl Sponable reported on it to Darryl Zanuck, but no mention of a public demo was made by the press until June.
3. *Daily Variety* (January 14 and 27, 1953).
4. *Variety* (March 25, 1953), 4.
5. *Harrison's Reports* 35, no. 12 (March 21, 1953).
6. See press survey in *Daily Variety* (April 27, 1953), 2; Also New *York Times* (April 25, 1953).
7. *Film Bulletin* (March 9, 1953), 6.
8. James Spellerberg, "Technology and the Film Industry: The Adoption of Cinema-Scope" (Ph.D. diss., University of Iowa, 1980), p. 169.
9. CinemaScope Publicity—General, 1957 folder, box 106, Sponable Collection, Columbia University Libraries.
10. Fox ultimately bought the Hurley Screen Company, which had been involved in the installation of Cinerama screens, and contracted with Hazard Reeves, Cinerama's sound engineer, for magnetic stripping machinery, indicating that they had studied the Cinerama process rather carefully with an eye to what they might make use of in it.
11. E. I. Sponable, H. E. Bragg, and L. D. Grignon, "Design Considerations of CinemaScope Film," *JSMPTE* 63 (July 1954), 1.
12. When Fox shifted to Magoptical sound tracks in 1956, the aperture used in projection retained the same height (0.715 inch) but was somewhat narrower (0.839 inch) in order to accommodate the optical track. This change reduced the projected aspect ratio from 2.55:1 to 2.35:1.
13. R. T. Ryan, *A History of Motion Picture Color Technology* (New York: Focal Press, 1977), pp. 148–149. *Technicolor: Annual Report for 1954* (February 21, 1955), p. 19.
14. Alex Alden, interview with the author, April 15, 1987, SMPTE Headquarters, White Plains, N.Y.
15. Letter, Sid Rogell to Edward O. Blackburn, September 18, 1954, p. 1; Rogell 1953–1957 folder, box 110, Sponable Collection.

16. Alex Alden, interview with the author, April 15, 1987.

17. Technicolor's three-strip camera could not accommodate the CinemaScope lens. At the same time, Fox found Eastman Kodak negatives superior, providing release prints with "better color and definition" (according to Sponable). A 1957 letter explains Fox's switch to Eastman Color as follows: "CinemaScope imposed requirements of resolution and definition on the motion picture image which Technicolor at that time seemed unable to meet" (letter, Skouras to Kay Harrison of French Technicolor, April 19, 1957). Fox was forced, however, to rely on Technicolor for the processing of some domestic and almost all foreign release prints because of the large demand for prints of *The Robe* and other early CinemaScope features, a demand which their own lab, Deluxe, was not yet equipped to meet. In a memo to Skouras and others on March 4, 1954, Zanuck himself faulted Technicolor's dye-transfer release prints for their low definition and softness; Prints and Printing 1953–1955 folder, box 104, Sponable Collection.

18. *Daily Variety* (September 18, 1953), 6. A memo from Zanuck to Sid Rogell, February 6, 1953, asks whether Technicolor will agree to trade off its existing contract in exchange for processing Fox dailies and release prints; Zanuck folder, box 116, Sponable Collection.

19. Sponable, Bragg, and Grignon, "Design Considerations," p. 4.

20. The exact aspect ratio shifted from 2.66:1 (in early 1953, when Fox demonstrated the process using a dual system) to 2.55:1 (in late 1953, when the image and the four magnetic tracks were placed on a single piece of 35mm film) and, finally, to 2.35:1 (in 1956, when the Magoptical system was introduced).

21. Memo, Zanuck to Sponable, March 25, 1953, Sponable Collection, quoted in Stephen E. Huntley, "Historical and Technical Analysis of Early CinemaScope Lenses: 1952–1954" (B.Sc. thesis, Massachusetts Institute of Technology, June 1986), pp. 30–31.

22. Huntley, "Early CinemaScope Lenses," p. 27.

23. John Belton, "CinemaScope: The Economics of Technology," *Velvet Light Trap,* no. 21 (Summer 1985), 40.

24. Letter, Sponable to Chrétien, March 27, 1953, Zanuck folder, box 116, Sponable Collection.

25. Huntley, "Early CinemaScope Lenses," p. 29; Alex Alden, conversation with the author, April 15, 1987.

26. Huntley, "Early CinemaScope Lenses," pp. 27–28.

27. Memo, Zanuck to Sponable, March 26, 1953, Zanuck folder, box 116, Sponable Collection.

28. W. R. Knowlton's patent for "Anamorphic Cylindrical Lens Construction," no. 2,702,493 (filed with the U.S. Patent Office July 23, 1953).

29. *Film Daily* (September 16, 1954), 18.

30. James R. Benford, "The CinemaScope Optical System," *JSMPTE* 62 (January 1954), 64.

31. Knowlton's patent for "Anamorphic Cylindrical Lens Construction"; Huntley, "Early CinemaScope Lenses," pp. 47–48.

32. Huntley, "Early CinemaScope Lenses," p. 50.

33. Letter, Coleman to Bragg, March 11, 1954, Bausch & Lomb folder, boxes 87–89, Sponable Collection.

34. Fox press release, March 30, 1954.

35. Alex Alden, conversation with the author, April 15, 1987.

36. In a memo to Spyros Skouras on March 5, 1953, Darryl Zanuck informed him that Fox had only three anamorphic lenses, all of which were in use for the filming of *The Robe, How to Marry a Millionaire,* and *Beneath the Twelve-Mile Reef;* Zanuck folder, box 116, Sponable Collection.

37. Chrétien folder, box 91, Sponable Collection.

38. Letter, Rogell to Blackburn, September 18, 1954, Rogell folder, box 110, Sponable Collection.

39. A prototype of the "Miracle Mirror" screen was installed in Fox's television laboratory on 54th Street. Later, a similar screen was installed in the Fox Theatre for a theater television broadcast of the Louis-Walcott prizefight in June 1948.

40. Benford, "The CinemaScope Optical System," 67.

41. *CinemaScope: Information for the Theatre,* 3d rev. ed. (October 1954), p. 41.

42. Ibid.

43. Fox subsequently relaxed its screen requirement for small theaters, where the throw was not as great. But by that time most of the larger downtown houses had installed approved screens.

44. Letter, Alex Alden to Herbert Bragg, July 23, 1954, Theatre Installation folder, box 114, Sponable Collection.

45. "East Looks at CinemaScope," *Motion Picture Herald* (May 2, 1953), 21, quoted in Richard Hincha, "Selling CinemaScope: 1953–1956," *Velvet Light Trap,* no. 21 (Summer 1985), 46.

46. Spellerberg, "Technology and the Film Industry," p. 165.

47. Ibid., p. 168.

48. A survey by the SMPTE suggested that fewer than 5.6 percent of all theaters could show films with an aspect ratio of 2.2:1 or more; only 42.5 percent could project at 1.9:1, and 51.9 percent were restricted to 1.7:1 or less; *Daily Variety* (October 9, 1953), 3.

49. Fox relented on its Miracle Mirror/Astrolite-only screen policy in December 1953, permitting small theaters with a short throw or a narrow house to use substitutes; large houses were still required to use only Fox-approved screens; *Daily Variety* (December 11, 1953), 1, 3.

50. Hincha, "Selling CinemaScope," p. 47; Perspecta memo, May 5, 1954, Widescreen: Perspecta folder, box 119, Sponable Collection.

51. Memo, E. I. Sponable to Otto Koegel, May 28, 1956, History folder, box 97, Sponable Collection.

52. Press conference handout, March 30, 1954, CinemaScope Publicity folder, box 106, Sponable Collection.

53. Speech by Herbert Bragg on stereophonic sound, March 30, 1954, Publicity folder, box 108, Sponable Collection.

54. *Daily Variety* (May 12, 1953), 1.

55. According to Aubrey Solomon, Fox saved $3 million annually by using magoptical prints; *Twentieth Century–Fox: A Corporate and Financial History* (Metuchen, N.J.: Scarecrow, 1988), p. 89.

56. *Daily Variety* (February 24, 1955).

57. Earl Sponable, "Why Wide Film?" *JSMPTE* 65 (February 1956), 82.

58. Ibid., pp. 81–82.

59. Memo, Zanuck to Skouras, August 5, 1955, Zanuck folder, box 116, Sponable Collection.

60. Sponable, "Why Wide Film?" p. 81.

61. Sponable to SMPTE, in SMPTE, *Widescreen Motion-Picture Systems* (White Plains, N.Y., 1965).

62. SMPTE, *Widescreen Motion Picture Systems*, letter, Herbert Bragg to Alex Alden, January 8, 1984.

63. SMPTE, *Widescreen Motion-Picture Systems*.

64. Carr and Hayes mistakenly claim that *Carousel* was "a huge financial success"; Robert E. Carr and R. M. Hughes, *Wide Screen Movies: A History and Filmography of Wide Gauge Filmmaking* (Jefferson, N.C.: McFarland, 1988), p. 67. The negative cost (which does not include advertising and prints) of *Carousel* was $3.38 million; it brought back rentals of $3.75 million, thus actually losing money for the studio; Solomon, *Twentieth Century–Fox*, pp. 250, 226).

65. *The King and I* cost $4.55 million and earned rentals of $8.5 million; Solomon, *Twentieth Century–Fox*, pp. 250, 226.

66. Letter, Zanuck to W. C. Michel, November 13, 1958, Zanuck folder, box 116, Sponable Collection.

67. John Mosely, unpublished letter to the editor of *JSMPTE*, September 30, 1988.

68. Letter, Zanuck to Michel, October 23, 1958, Zanuck folder, box 116, Sponable Collection.

69. Letter, Zanuck to Michel, November 13, 1958, Zanuck folder, box 116, Sponable Collection.

70. Intermediate settings were used for anamorphic film formats with compression factors different from that of CinemaScope, such as anamorphic VistaVision, which

Carr and Hayes report employed a x1.5 factor; *Wide Screen Movies,* p. 69. For a discussion of Gottschalk's prismatic device, see Huntley, "Early CinemaScope Lenses," pp. 58–60.

71. Huntley, "Early CinemaScope Lenses," pp. 63–65; Richard Shale, *Academy Awards: An Ungar Reference Index* (New York: Ungar, 1978), p. 442.

72. Shale, *Academy Awards,* p. 414.

8. Todd-AO

1. Statistics courtesy of Dolby Laboratories, Inc., as of March 24, 1988. *Variety* (April 25, 1984) credits *Star Wars* with launching the current trend for 70mm theatrical presentation.

2. *Variety* noted (April 25, 1984) that "both distributors and theater owners report that the '70mm Six-Track Stereo' designation on a marquee is a demonstrable audience draw."

3. The phrase "The Hallmark of Quality" was used by Todd-AO in its advertising, along with the tag-line "Dedicated to Better Motion Pictures." See *1966 International Motion Picture Almanac,* ed. Charles S. Aaronson (New York: Quigley Publications, 1967), p. 75A.

4. Gio Gagliardi, *Motion Picture Herald* (August 6, 1955), 14.

5. Certain drive-ins playing CinemaScope pushed the format to and beyond its limits, projecting 35mm film (with a 6-inch lens) from a distance of over 400 feet to achieve an image 125 feet wide; Theatre Installations: Drive-ins folder, box 114, Sponable Collection, Columbia University Libraries.

6. Gagliardi, *Motion Picture Herald* (August 6, 1966), 14.

7. Ibid., p. 15.

8. Ibid., p. 14.

9. There was also a seventh track, which controlled the other six.

10. "Todd A.O. [*sic*] System" memo from Sponable to Zanuck, January 19, 1954 (p. 1), Widescreen: Todd-AO folder, box 120, Sponable Collection.

11. Joel Sayre, "Mike Todd and His Big Bug-Eye," *Life* (March 7, 1955), 144.

12. Thus Earl Sponable described Todd-AO to Zanuck in a memo dated January 19, 1954; Widescreen: Todd-AO General: 1953 folder, box 120, Sponable Collection.

13. In *A Valuable Property* the authors credit Todd with the postwar innovation of the roadshow format through advice Todd gave to Gradwell Sears, general sales manager at United Artists, regarding the distribution of Olivier's *Henry V* (1945). See Michael Todd, Jr., and Susan McCarthy Todd, *A Valuable Property: The Life Story of Michael Todd* (New York: Arbor House, 1983), pp. 268–269. The practice of roadshowing motion pictures precedes Todd, dating back to 1896 and the first exhibition of films projected on a theater screen.

14. Todd and Todd, *A Valuable Property*, pp. 268–269. Though Todd is speaking here of the marketing of Olivier's *Henry V*, the tactic worked equally well with *Oklahoma!* and other Todd-AO productions.

15. As of September 1957 there were 46,544 CinemaScope installations around the world. Though Todd-AO initially estimated that it would be playing in 2,000 theaters by the end of 1956, there were only 60 Todd-AO installations by the end of 1957. By the end of 1961 there were only 606 Todd-AO installations around the world; "Magna Theatre Corporation," report for Twentieth Century–Fox by Harris, Upham & Co., December 2, 1953, and list of first 60 Todd-AO installations, Widescreen: Todd-AO folder, box 120, Sponable Collection.

16. By author's count.

17. John Chapman in *Collier's* (May 12, 1945), cited in "Mike Todd," *Current Biography* (1955), 608.

18. Sayre, "Big Bug-Eye," p. 141.

19. "Mike Todd," *Current Biography*, p. 608.

20. Todd and Todd, *A Valuable Property*, pp. 71–72; Sayre, "Big Bug-Eye," p. 151.

21. "Mike Todd," *Current Biography*, p. 609.

22. Ibid.

23. Todd and Todd, *A Valuable Property*, p. 219.

24. Ibid., p. 232.

25. *New York Times* (October 13, 1952), 104.

26. See, for example, Aaron Nadell's itemization of Cinerama's eight basic faults in "Cinerama," *International Photographer* (December 1952), 9–10.

27. Todd and Todd, *A Valuable Property*, p. 242.

28. Sayre, "Big Bug-Eye," p. 142.

29. Bill Doll, "Out of O'Brien's Lab," *New York Times* (August 29, 1954); Sayre, "Big Bug-Eye," p. 142; O'Brien, telephone interview with the author, November 1988.

30. Todd and Todd, *A Valuable Property*, p. 245.

31. Doll, "Out of O'Brien's Lab." Cameramen dubbed the lens a "bug-eye" because of its curvature and because of the extreme angle of coverage it possessed; Sayre, "Big Bug-Eye," p. 144.

32. Todd and Todd, *A Valuable Property*, p. 104; *Daily Variety* (February 27, 1953), 1 and (March 25, 1953), 1.

33. *Daily Variety* (February 27, 1953), 1.

34. Richard Rodgers, *Musical Stages: An Autobiography* (New York: Random House, 1975), p. 283.

35. *Daily Variety* (March 25, 1953), 1, 6; *New York Times* (March 25, 1953).

36. Sayre, "Big Bug-Eye," p. 142; *Film Daily* (September 2, 1955), 14.

37. "Magna Theatre Corporation," p. 1; *Film Daily* (September 2, 1955), 1.

38. Arthur Rowan, "Todd-AO—Newest Wide-Screen System," *American Cinematog-*

rapher 35, no. 10 (October 1954), 526; *Motion Picture Daily* (October 7, 1955), 14–16.

39. *Motion Picture Daily* (October 7, 1955), 18, and "Progress Committee Report," *JSMPTE* 64, no. 5 (May 1955), 233, indicate that Altec designed the sound rack. Al Lewis, a former Todd-AO sound engineer, explained (in conversation with the author on October 20, 1990) that although Altec had a contract with Todd-AO for the electronics, Westrex equipment was actually used. He also reports that Ampex equipment was used in the Todd-AO installations in the Rivoli and the Egyptian.

40. *Motion Picture Daily* (October 7, 1955), 16, 18.

41. Ibid., p. 12.

42. Rowan, "Todd-AO," p. 526.

43. In the fall of 1953 Fox also sought to develop a special anamorphic lens with a broad, 122-degree angle of view in an attempt to match that of Todd-AO (letter to Bausch & Lomb, March 11, 1954, Bausch & Lomb folder, box 87, Sponable Collection). After Fox's attempt to contract with Todd-AO fell through in early 1954, the company went to work on designing its own 70mm system using bug-eye lenses with angles of view of 125 and 145 degrees (Skouras memo, May 13, 1954, Skouras folder, box 112, Sponable Collection).

44. "Progress Committee Report," *JSMPTE* 64, no. 5 (May 1955), 228.

45. Ibid.

46. *Can-Can* licensing agreement, August 1959, Todd-AO–TCFF [Twentieth Century–Fox Films] Corp., 1959–60 folder, box 120, Sponable Collection.

47. "Magna Theatre Corporation," p. 1.

48. Thomas M. Pryor, "Hollywood Revelation," *New York Times* (June 27, 1954).

49. Though Todd-AO lenses were generally classified in terms of angle of view rather than focal length, their focal lengths were given as follows: 128 degrees (22mm), 64 degrees (44 mm), 48 degrees (58mm), and 37 degrees (76mm). See also "Magna Theatre Corporation," pp. 1–2.

50. Quoted in "Magna Theatre Corporation," p. 1.

51. A 35mm Technicolor four-track magnetic stereo CinemaScope version of *Oklahoma!* is on deposit at the UCLA Film Archives. The CinemaScope version was released to non–Todd-AO houses after the wide-film version had completed its initial run. See also Hugh Fordin, *Getting to Know Him: A Biography of Oscar Hammerstein II* (New York: Random House, 1977), p. 320.

52. Letter, Bragg to Alden, January 8, 1984 (author's collection).

53. *Motion Picture Daily* (October 7, 1955), 12; "Progress Committee Report," *JSMPTE* 65, no. 5 (May 1956), 248–249.

54. *Motion Picture Daily* (October 7, 1955), 18.

55. Ibid., p. 12.

56. Rowan, "Todd-AO," p. 495.

57. *Motion Picture Daily* (October 7, 1955), 16.

58. John Harvey, International Cinerama Society, conversation with the author, May 12, 1991.

59. The actual width of the Rivoli screen was 63 feet when measured along the curve, but it was 52 feet along the chord, which was the term used to describe the distance, in a straight line, from one edge of the screen to the other.

60. "Magna Theatre Corporation," p. 1.

61. *Film Daily* (2 May 1956).

62. "Progress Committee Report," *JSMPTE* 65, no. 5 (May 1956), 248.

63. Pryor, "Hollywood Revelation." Todd and Todd, *A Valuable Property*, pp. 294–295.

64. *Film Daily* (September 2, 1955), 10.

65. Ibid., p. 14.

66. Ibid. (May 2, 1956).

67. Ibid. (October 26, 1956).

68. *Daily Variety* (October 26, 1956). The full Todd-AO package included two projectors, a screen, a sound relay rack (with amplifiers and pre-amplifiers), five behind-the-screen speakers, nineteen auditorium speakers, two lenses, two lens adaptors, focal magnifiers and minifiers, rewinds, a film splicer, a film cabinet, and reels.

69. Ibid. *Variety* noted that Todd-AO conversion costs were cut to $20,000 by October 1956.

70. The projector could handle (1) 70mm film with any number of magnetic tracks, (2) 70mm with a separate magnetic sound track, (3) CinemaScope with four-track magnetic sound, (4) CinemaScope with optical or Perspecta Sound, (5) standard 35mm film, (6) single-strip 3-D, and (7) double-strip 3-D.

71. *Film Daily* (October 10, 1955), 10. Ampex had introduced a sound switching panel in 1954, which handled all types of existing soundtracks (single-track optical, single-track magnetic, stereo magnetic, and Perspecta) but not six-track magnetic, which was still in development at that time; "Progress Committee Report," *JSMPTE* 64, no. 5 (May 1955), 228.

72. "Four-walling" involves the outright leasing of a theater by a film's producer or distributor, who then merely pays the theater's operating costs and retains the remainder of the box-office gross.

73. Sponable memo to Zanuck on the "Todd A.O. System," January 19, 1954, Widescreen: Todd-AO, box 120, Sponable Collection (p. 2).

74. Sponable to Zanuck on "Todd A.O."; Sayre, "Big Bug-Eye," p. 144; *Daily Variety* (June 24, 1953), 2.

75. Richard Rodgers reports that Paramount had once offered them 100 percent of the profits for the rights to *Oklahoma!* (Paramount hoped to make its money by charging a distribution fee), but that they had refused because the musical was

still returning tremendous profits from its initial theatrical runs (*Musical Stages*, p. 283. *Oklahoma!* grossed over $100 million on the stage (*Film Daily*, October 10, 1955, p. 5).

76. Sponable to Zanuck on "Todd A.O." Mike Todd apparently filmed the roller-coaster ride and other participation-effect footage; although his son claims that Todd also filmed the picnic sequences (Todd and Todd, *A Valuable Property*, p. 257), other sources indicate that this was done by Zinnemann (Sponable to Zanuck on "Todd A.O.").

77. Sayre, "Big Bug-Eye," p. 144.

78. Todd, who had assumed that he would produce the first Todd-AO film, found himself cut out of the deal (Todd and Todd, *A Valuable Property*, p. 258). Rodgers' fondness for Hornblow and scorn for Todd, who had behaved temperamentally at one of their meetings, may have been responsible for this decision (Rodgers, *Musical Stages*, p. 284).

79. Sayre, "Big Bug-Eye," p. 144; *Daily Variety* (July 1, 1953).

80. Fordin, *Getting to Know Him*, p. 315.

81. "The initial agreement with Rodgers and Hammerstein provides, however, that no picture using the Todd-AO process will be shown in any city prior to the initial showing of *Oklahoma!*"; "Magna Theatre Corporation," p. 2.

82. Robert E. Carr and R. M. Hayes, *Wide Screen Movies: A History and Filmography of Wide Gauge Filmmaking* (Jefferson, N.C.: McFarland, 1988), pp. 187–188. Carr and Hayes list nineteen Todd-AO films, which include one short, two Soviet films (which may or may not have used Todd-AO equipment), and two Cinerama films (shot in Super Panavision 70).

83. "Magna Theatre Corporation," p. 3.

84. Ibid., p. 7.

85. See ibid.; also *Motion Picture Daily* (December 20, 1957).

86. See Todd-AO–Twentieth Century–Fox Film Corp., 1959–60, Contracts, box 120, Sponable Collection.

87. *Film Daily* (May 2, 1956).

88. Todd and Todd, *A Valuable Property*, p. 269.

89. Other Rodgers and Hammerstein properties, such as *Carousel* and *The King and I*, had already been contracted to Fox and were filmed there in the rival wide-film process of CinemaScope 55.

90. Barbara Leaming, *Orson Welles* (New York: Viking Penguin, 1985), pp. 395–401; Todd and Todd, *A Valuable Property*, pp. 134–136.

91. Internal Fox memo by Donald A. Henderson on "The Todd-AO Matter," September 16, 1963, box 120, Sponable Collection.

92. M-G-M Camera 65 also used a frame that was five perforations high. The anamorphic camera lens employed a compression factor of 1.33. Release prints were made

in 65mm (with a separate film containing the six-track magnetic sound) and in 70mm (with the six-track sound on the same strip of film). An optical reduction printer generated a 35mm anamorphic release print compatible with CinemaScope projection equipment. See SMPTE, *Widescreen Motion-Picture Systems* (White Plains, N.Y., 1965).

93. *Widescreen Motion-Picture Systems;* "Progress Committee Report," *JSMPTE* 68, no. 5 (May 1959), 278.

94. SMPTE, *Widescreen Motion-Picture Systems;* and Carr and Hayes, *Wide Screen Movies*, p. 174.

95. Carr and Hayes, *Wide Screen Movies*, p. 177.

96. Though all of these films were blockbusters, not all of them made money. *Spartacus,* for example, cost over $15 million and earned only $13.5 million; Herb Lightman, "Filming *Spartacus* in Super-Technirama," *American Cinematographer* 42, no. 1 (January 1961), 43; Cobbett Steinberg, *Reel Facts: The Movie Book of Records* (New York: Vintage, 1978), p. 349.

97. Walter Beyer, "35mm to 70mm Print-Up," *American Cinematographer* 49, no. 1 (January 1968), 40.

98. Douglas Trumbull, conversation with the author, October 14, 1988.

99. Beyer, "35mm to 70mm Print-Up," pp. 40–41.

100. Greater amounts of light on the screen also enabled 70mm-equipped drive-ins to start their shows "earlier in the evening without worrying about whether [the] audience will be able to see the picture," facilitating one extra show each night; Charles Loring, "Breakthrough in 35mm-to-70mm Print-Up Process," *American Cinematographer* 45, no. 4 (April 1964), 225.

101. Ibid., p. 224.

102. Ibid.

103. Ibid.; *Variety* (July 28, 1982), 32.

104. Loring, "Breakthrough," p. 225.

105. Carr and Hayes, *Wide Screen Movies*, pp. 187–189, 200–206.

106. The anamorphic image, which has an aspect ratio of 2.35:1, does not quite fit on a 70mm frame, which is roughly 2.21:1, thus requiring cropping. A 1.85:1 image does not quite fill the 70mm frame, which must then be masked. For an excellent discussion of blowups, see ibid., pp. 196–206.

107. Edgerton notes that exhibitor Stanley Durwood began experimentation with multiplexing in Kansas City in 1963, where he had a twin theater; by 1979, Durwood ran 108 theaters with 522 screens; Gary Edgerton, *American Film Exhibition* (New York: Garland, 1983), p. 38.

108. Kurt H. Ropin, "Designing a 65mm Motion-Picture Camera: The Arriflex 765," *SMPTE Journal* 99, no. 6 (June 1990).

109. John Mosely, letter to the author, July 6, 1990.

110. *Variety* (December 11, 1963), 1, 17.

9. Spectator and Screen

1. Charles F. Altman, "Psychoanalysis and Cinema: The Imaginary Discourse," *Quarterly Review of Film Studies* 2, no. 3 (August 1977), 260–261.

2. For Baudry, see "Ideological Effects of the Basic Cinematographic Apparatus," *Cinéthique*, nos. 7–8 (1970), and "The Apparatus: Metapsychological Approaches to the Impression of Reality in the Cinema," *Communications*, no. 23 (1975). Baudry's "Ideological Effects," translated by Alan Williams, appears in *Film Quarterly* 28, no. 2 (Winter 1974–75), 39–47. This translation and that of "The Apparatus," by Jean Andres and Bertrand Augst, are anthologized in Philip Rosen, ed., *Narrative, Apparatus, Ideology: A Film Theory Reader* (New York: Columbia University Press, 1986). Page references are to the Rosen anthology. Although *Screen* did not publish either of the Baudry essays, the metaphor figures most centrally in *Screen's* publication, in an English translation, of Christian Metz's "The Imaginary Signifier," 16, no. 2 (Summer 1975), as well as in Laura Mulvey's "Visual Pleasure and the Narrative Cinema," 16, no. 3 (Autumn 1975), reprinted in Rosen. Page references for Mulvey are to the Rosen anthology.

3. Baudry, "Ideological Effects" and "The Apparatus," in Rosen, *Narrative, Apparatus, Ideology*, pp. 294, 302–307.

4. John Caughie, *Theories of Authorship* (Boston: Routledge & Kegan Paul, 1981), p. 292, distinguishes a subject from an "individual with a personality," describing the former as "a 'place' which that individual may be called upon to occupy within a formation (social, political, textual)." The spectator before the screen is both an individual with a personality and a social-political-textual (as well as a psychical) subject, yet the spectator-as-physical-presence-before-the-screen remains distinct from the spectator-as-subject. Though the actual spectator in the theater remains somewhat distinct from the abstract subject of theory, the physical relationship of the spectator to the screen plays a role in the theorization of subject positioning, if only as the primary point of departure for the conceptualization of a theory of subjectivity, as the individual instance upon which the theoretization of spectatorship in general depends.

5. Baudry, "The Apparatus," p. 307.

6. Laura Mulvey ("Visual Pleasure," p. 208) specifies the nature of this ideology as patriarchal by defining the desire as "male"; Baudry (in "The Apparatus") and Metz (in "The Imaginary Signifier") do not identify it with a specific gender.

7. Stephen Heath, *Questions of Cinema* (Bloomington: Indiana University Press, 1981), p. 1.

8. Stephen Heath "On Screen," in *Questions of Cinema*, p. 10.

9. Stephen Heath, "Narrative Space," in *Questions of Cinema,* p. 35.

10. Gio Gagliardi, *Motion Picture Herald* (August 6, 1955), 14.

11. On the various modes of address employed by different genres see Stephen Neale, *Genre* (London: British Film Institute, 1980), pp. 25–30. Though Heath does not explore the issue of modes of address as such, his discussions of classical cinema in "Narrative Space" and of Oshima in "The Question Oshima" sketch out basic differences in the way these cinemas position subjects. For a discussion of the different narrative strategies employed by classical cinema and art cinema, see David Bordwell, *Narration in the Fiction Film* (Madison: University of Wisconsin, 1985), pp. 147–233. Bordwell's cognitive approach to the viewing process provides a radically different model of spectatorship within which there is no place for a "subject"; yet his discussion of various modes of narration suggests ways in which the psychoanalytic notion of mode of address might be articulated differently in different kinds of cinema.

12. Heath, "On Screen," p. 15.

13. Heath's discussion of subject positioning moves, as Noël Carroll has pointed out, through a series of metaphors, which suggest the ways in which the cinematic apparatus and the cinema's signifying system construct subjects. See Carroll, "Address to the Heathen," *October* 23 (Winter 1982), 117. The "screen" provides the initial metaphor for the fixing of subject position; the "frame" is then presented as a metaphor for the creation of a boundary that centers the spectator's attention, a centering that is completed by the compositional codes of Quattrocento perspective, which in turn functions as a metaphor for the way in which the cinema establishes a fixed station point for its spectators to occupy. Renaissance perspective is necessarily a metaphor for two reasons: because film images, unlike paintings, contain movement (of characters, objects, the camera itself), which redirects the spectator's eye; and because films, unlike paintings, combine a variety of different perspectival systems; that is, each shot presents a different compositional organization (not to mention possible shifts from lens to lens or within a lens—the zoom—that slightly alter the way in which space is represented). Thus perspective images bind the spectator in place, while suture contains the necessary shifts in perspective from shot to shot or changes that occur within a single shot.

14. Thomas Doherty discusses the transformation of the motion pictures from a mass entertainment medium to a tiered medium in *Teenagers & Teenpics: The Juvenilization of American Movies in the 1950s* (Boston: Unwin Hyman, 1988), pp. 1–3. For an account of how certain widescreen (and 3-D) formats were marketed to specific class groups, see John Belton, "CinemaScope and Historical Methodology," *Cinema Journal* 28, no. 1 (Fall 1988), 34–38.

15. The term *flat* was regularly used in the industry to distinguish films shot and

projected with normal lenses from those filmed in 3-D and CinemaScope (or some other anamorphic process). For a discussion of 3-D's emergence effect, see William Paul, "The Aesthetics of Emergence" (Paper delivered at the Society for Cinema Studies conference in Bozeman, Montana, June 1988).

16. Lynn Farnol, "Finding Customers for a Product: Notes on the Introduction of Cinerama," in *New Screen Techniques*, ed. Martin Quigley, Jr. (New York: Quigley Publishing, 1953), pp. 141–142.

17. Ibid., p. 143.

18. *This Is Cinerama*, (yellow) program booklet, n.d. (ca. 1952).

19. *Cinerama Holiday* program booklet, n.d. (ca. 1955).

20. Promotional advertisement for *The Battle of the Bulge*.

21. William Paul in "The Aesthetics of Emergence" contrasts these screen/spectator relationships in terms of movement into and out of the frame and notes that both 3-D and widescreen processes have "the common aim of breaking down our sense of the frame."

22. Comparison of the participation effect produced by widescreen cinema to the theatrical experience constitutes a major thread of the industry discourse surrounding CinemaScope, as James Spellberg points out in "CinemaScope and Ideology," *Velvet Light Trap,* no. 21 (Summer 1985), 30–31.

23. André Bazin, "Theater and Cinema—Part Two," in *What Is Cinema?* vol. 1, trans. Hugh Gray (Berkeley: University of California Press, 1967), p. 102.

24. Quoted in ibid., p. 92.

25. Christian Metz argues that the cinema's impression of reality produces a sense of participation, which informs every film, giving us "the feeling that we are witnessing an almost real spectacle." See *Film Language: A Semiotics of the Cinema* (New York: Oxford, 1974), p. 4. Some sense of participation undoubtedly exists in all cinema, even in pre-widescreen films, but widescreen increased and expanded this sense to a point that it predominated.

26. Spellberg, "CinemaScope and Ideology," pp. 30–31.

27. Ibid., p. 31.

28. Ironically, although the cinema of the 1950s modeled itself after the experience of the theater, the theater itself had evolved, over the past two centuries, closer and closer toward the cinema. Eighteenth-century theaters, for example, lit the auditorium as well as the stage, establishing a spatial continuum between the two. Nineteenth-century theater began to separate these two spaces by lighting one (the stage) but not the other (the audience). At the same time, late nineteenth-century dramaturgy, which began to create a more realistic world onstage through the use of three-dimensional set design and lighting, transformed theater audiences from knowing participants with the actors in the construction of a dramatic illusion into voyeurs who looked in on a seemingly autonomous world.

29. Charles Einfeld, "CinemaScope and the Public," in Quigley, *New Screen Techniques*, p. 182.

30. Spellerberg, "CinemaScope and Ideology," p. 30. See also Thomas Pryor, "Fox Films Embark on 3-Dimension Era," *New York Times* (February 2, 1953). Spellerberg has examined the industry's discourse on CinemaScope in both advertising and trade magazines in terms of the identification of it with theatrical forms. As he points out, "In its new position in the late 1950s, Hollywood was more like Broadway. Hollywood was less a mass medium and more a specialized form of entertainment" (p. 31).

31. *Life* (March 9, 1953), 35.

32. Darryl Zanuck, "CinemaScope in Production," in Quigley, *New Screen Techniques*, p. 156.

33. *Newsweek* (September 28, 1953), 96.

34. Memo, Zanuck to Spyros Skouras, 27 January 1953. Zanuck folder, box 116, Sponable Collection, Columbia University Libraries.

35. Todd-AO folder, box 120, Sponable Collection.

36. *Film Daily* (October 10, 1955), 7.

37. After initial demonstrations of CinemaScope in Los Angeles in mid-March 1953, one exhibitor remarked that with the expansiveness of the CinemaScope frame, there was "so much to see that the viewer was not conscious of the limitations of the framework"; *Hollywood Reporter* (April 24, 1953), 6, quoted by James Spellerberg, "Technology and the Film Industry: The Adoption of CinemaScope" (Ph.D. diss., University of Iowa, 1980), p. 210.

38. A similar effect is produced by certain dense forms of mise-en-scène in 1.33/7 films in which the contents of the frame exceed the viewer's ability to consume them within the duration of the shot. The long takes of F. W. Murnau, Orson Welles, and Max Ophuls, for example, are determined in part by the density of the mise-en-scène; yet even in the work of these directors the increased duration of the take does not necessarily permit the spectator to read the contents of the shot in its entirety.

39. See Zanuck's memo to Nunnally Johnson and others on *How to Marry a Millionaire*, March 25, 1953, Zanuck folder, box 116, Sponable Collection.

40. David Bordwell, Janet Staiger, and Kristin Thompson, *The Classical Hollywood Cinema: Film Style and Mode of Production to 1960* (New York: Columbia University Press, 1985), p. 51.

41. The terms *lateral* and *axial* are employed by cameramen to describe different camera movements. I have adapted these terms to describe compositional strategies which lead the eye in different directions within the space of the frame. "Axial" refers to movement, usually along a diagonal line, into depth.

42. The question remains whether a wider frame in perspectival painting would result

in multiple station points. Are there any Renaissance perspective paintings that have aspect ratios as great as CinemaScope, that is, from 2.35:1 to 2.55:1?

Sergei Eisenstein cites a study by Loyd A. Jones of rectangular proportions employed in artistic compositions which concludes that most have a 1.5:1 aspect ratio. Eisenstein disputes the accuracy of Jones's statistics (suggesting that they were based on only a limited sample) but provides no statistical evidence of his own; see Eisenstein, "The Dynamic Square," in *Film Essays and a Lecture*, ed. Jay Leyda (Princeton: Princeton University Press, 1968), pp. 54–55.

Certain Renaissance frescoes have proportions that come close (Masaccio's *Tribute Money*, ca. 1427, is 2.2:1; Andre Del Castagno's *Last Supper*, ca. 1445–1450, is 2.3:1), but da Vinci's *Last Supper* is more typical at 2:1, and the Golden Sector or Mean was described as 1.618:1.

43. Charles Barr, "CinemaScope: Before and After," *Film Quarterly* 16, no. 4 (Summer 1963), 18.

44. David Bordwell demonstrates the process by reproducing the sequence of shots from *Carmen Jones* (1954) in "Widescreen Aesthetics and Mise en Scene Criticism," *Velvet Light Trap*, no. 21 (Summer 1985), 22.

45. Barr, "CinemaScope: Before and After," pp. 8–9.

46. Ibid, p. 9.

47. Ibid., p. 7.

48. Ibid., p. 18.

49. See "Edison's Vitascope," *New York Dramatic Mirror* (April 25, 1896), 20; and "The Cinematographe at Keith's," ibid. (July 4, 1896), 17; both cited in George C. Pratt, ed., *Spellbound in Darkness*, vol. 1 (Rochester: University of Rochester, 1966), pp. 13–14.

50. The familiar phrase is actually an abridgment of a description of the Cinématographe which appeared in *La poste* on December 30, 1895: "C'est la vie même, c'est le mouvement pris sur le vif." See Georges Sadoul, *Louis Lumière* (Paris: Editions Seghers, 1964), p. 119.

51. *Filma*, no. 260 (September 11, 1929), cited in Neale, *Genre*, p. 96.

52. *This Is Cinerama*, (yellow) program booklet, n.d. (ca. 1952).

53. "The CinemaScope Demonstration," *Harrison's Reports* 35, no. 12 (March 21, 1953).

54. Ed Buscombe, "Sound and Color," in *Movies and Methods*, ed. Bill Nichols, vol. 2 (Berkeley: University of California Press, 1985), p. 90.

55. Ibid., pp. 87, 90–91.

56. Miles Kreuger, *The Movie Musical: From Vitaphone to 42nd Street* (New York: Dover, 1975), p. 23.

57. Herbert Bragg, speech on stereophonic sound, Twentieth Century–Fox press conference, Plaza Hotel, New York City, March 30, 1954; Publicity file, box 106, Sponable Collection.

58. Robert Prall, "Studio Gambles 10 Millions in Bid to Woo TV Addicts," *New York World Telegram and Sun* (September 14, 1953), 21. Approximately thirty surround speakers were installed in the Roxy for the premiere of *The Robe* (though no mention is made of ceiling speakers). See letter, Earl Sponable to Harry Enequist, November 20, 1953, "AGA" file, box 86, Sponable Collection.

59. Memo from Zanuck to Sid Rogell, Carl Faulkner, Sol Halprin, Alfred Newman, all producers, all producers-directors, January 8, 1955, box 10, Philip Dunne Collection, Archives of Performing Arts, University of Southern California.

60. Willem Bouwmeester and John Harvey of the International Cinerama Society, in conversation with the author, May 12, 1991.

61. *This Is Cinerama,* (yellow) program booklet, n.d. (ca. 1952).

62. See Lorin D. Grignon, "Experiments in Stereophonic Sound," *JSMPTE* 61, no. 3 (September 1953), 376.

63. Zanuck memo on *How to Marry a Millionaire* to Nunnally Johnson and others, March 25, 1953, Zanuck file, box 116, Sponable Collection.

64. Zanuck reported that in *Battle Cry* "a character on the screen would be talking to someone off the screen and the off-stage reply would definitely be off stage. This gave a real sense of audience participation and . . . the effect is excellent." See Zanuck memo to Sid Rogell and others, January 8, 1955, Philip Dunne Collection.

65. "Progress Committee Report," *Journal of the SMPTE* 64, no. 5 (May 1955), 233.

66. Memo, Loren Ryder to Earl Sponable, June 16, 1953, box 119, Paramount folder, Sponable Collection.

67. Bosley Crowther, "Sound and (or) Fury: Stereophonic System Is Debated in Hollywood," *New York Times* (January 31, 1954).

68. Peter Fornatale and Joshua E. Mills, *Radio in the Television Age* (Woodstock: Overlook Press, 1980), p. 124.

69. Bob Gitt, UCLA film archivist, in conversation with the author, January 8, 1989.

70. Limited experiments with FM/AM radio broadcasts of music in stereo and with high-end home stereo tape players also tended to identify the stereo format with music for pre-1953 audiences.

71. Harvey Fletcher, "Stereophonic Recording and Reproducing System," *JSMPTE* 61, no. 3 (September 1953), 356.

72. Al Lewis, interview with the author, October 20, 1990.

73. Certain studios, such as Columbia, never even used the fourth track, according to the SMPTE Progress Report Committee; *JSMPTE* 64, no. 5 (May 1955): 233.

10. The Shape of Money

1. Tino Balio, "Introduction to Part II," in *Hollywood in the Age of Television* (Boston: Unwin Hyman, 1990), p. 263.

2. For a survey of these latter practices, see Michael Kerbel's series of three articles, titled "Edited for Television," in *Film Comment* 13, nos. 3–5 (May–October 1977).

3. Screen sizes of television sets have a much broader range than specified here, extending from 2-to-3-inch Watchman screens to 40-inch (or a bit more) screens. Average TV viewers, however, watch on 12-to-25-inch screens.

4. André Bazin, "Will CinemaScope Save the Cinema?" *Esprit*, nos. 207–208 (October–November 1953), 627–683; subsequently translated by Catherine Jones and Richard Neupert and reprinted in *Velvet Light Trap*, no. 21 (Summer 1985), 9–14.

5. Cobbett Steinberg, *Reel Facts: The Movie Book of Records* (New York: Vintage, 1978), p. 394.

6. Ibid.

7. Lyrics from Cole Porter's "Stereophonic Sound" number in *Silk Stockings* (M-G-M, 1954).

8. Steinberg, *Reel Facts*, p. 371. Motion Picture Association of America (MPAA), press release, "1990 U.S. Economic Review," p. 2.

9. Steinberg, *Reel Facts*, p. 371.

10. Ibid.

11. Douglas Gomery, "If You've Seen One, You've Seen the Mall," in *Seeing through Movies*, ed. Mark Crispin Miller (New York: Pantheon, 1990), p. 70.

12. Ibid.

13. Ibid.

14. Tino Balio, "Introduction to Part 1," in *Hollywood in the Age of Television* (Boston: Unwin Hyman, 1990), p. 29. Multiplexing also maximized the labor potential of projectionists, cashiers, and concessionaires by staggering the starting times and thus reducing "slow periods" between reel changeovers, between shows, or when audiences were inside the theater "consuming" the film instead of snacks.

15. Gomery, "The Mall," p. 68.

16. Ibid., p. 70.

17. Steinberg, *Reel Facts*, p. 363.

18. Screen manufacturers rightly contend that there is no such thing as an "average screen size," since screen size continues to be determined by theater architecture. These figures reflect averages compiled by the author in discussion with several screen suppliers. Ino Schafert of Hurley Screen Corporation, and a representative of Technikote Corporation, in conversation with the author, July 31, 1990.

19. See John Belton, "Pan and Scan Scandals," *Perfect Vision* 1, no. 3 (Indian Summer 1987), 48.

20. Charles Eckert, "The Carole Lombard in Macy's Window," *Quarterly Review of Film Studies* 3, no. 1 (1978). For a bibliography on consumerism and the cinema, see Lynn Spigel and Denise Mann, "Women and Consumer Culture: A Selective Bibliography," *Quarterly Review of Film Studies* 11, no. 1 (May 1989), 85–105.

See also Mark Crispin Miller, "Advertising: End of Story," in *Seeing through Movies,* pp. 186–246.

21. Balio, "Introduction to Part I," pp. 3, 10, 20–21, 30–37.
22. David A. Cook, *A History of Narrative Film* (New York: W. W. Norton, 1981), pp. 424–425.
23. Steinberg, *Reel Facts,* p. 367.
24. John Izod, *Hollywood and the Box Office, 1895–1986* (New York, Columbia University Press, 1988), p. 125.
25. Tino Balio, "Retrenchmeant and Reorganization," in *The American Film Industry,* rev. ed. (Madison: University of Wisconsin Press, 1985), p. 439.
26. Michele Hilmes, *Hollywood and Broadcasting* (Urbana: University of Illinois Press, 1990), pp. 158–159.
27. Ibid., p. 157.
28. Ibid., pp. 160–162.
29. Ibid., pp. 158–159.
30. Since RKO had gone out of business and was thus impervious to strike threats from craft guilds, it felt free to violate the 1951 agreement and included post-1948 films in its sale to television. A provision in the sale stipulated that C & C clear its sale of post-1948 films with various guilds, which it did. See William Lafferty, "Feature Films on Prime-Time Television," in Balio, *Hollywood in the Age of Television,* p. 241.
31. Hilmes, *Hollywood and Broadcasting,* pp. 161–162.
32. Lafferty, "Feature Films on Prime-Time Television," pp. 244–245.
33. Ibid., p. 245.
34. Walter Beyer, "TV Safe Action Limits for Wide Screen Films," *American Cinematographer* 43, no. 6 (June 1962), 381.
35. Ibid., p. 382.
36. Ibid.
37. M. Peter Keane, interview with the author, May 1987.
38. Alex Alden, interview with the author, April 15, 1987.
39. Ralph Martin, interview with the author, May 1987.
40. Pete Comandini, interview with the author, May 1987.
41. Ralph Martin, interview with the author, May 1987.
42. Beyer, "TV Safe Action Limits," pp. 366, 367.
43. Nestor Almendros, interview with the author, May 1987.
44. Martin Scorsese, interview with the author, May 1987.
45. Not all letterbox versions of widescreen films reproduce the full width of the original image. The top and bottom of the screen are masked, and the width of the image runs from edge to edge. But since manufacturers continue to "overscan" (that is, to provide a signal that would fill the screen even if the strength of the

signal weakened during a brownout), the extreme edges of the frame remain unseen. Thus 2.35:1 films often have letterbox aspect ratios that are only 2:1 or less. For an empirical study of this form of cropping, see Harry Pearson, "The Letterbox Scandal," *Perfect Vision* 1, no. 4 (Spring/Summer 1988), 4–9.

46. The only SMPTE standard written for HDTV was published in 1988. It is a production rather than a broadcast standard and calls for 1125 lines of resolution and 60 fields per second. It has not yet been adopted by ANSI as an American National Standard. The FCC, which is currently investigating HDTV systems, will not recommend a standard until 1992. SMPTE staff engineer Mark Hyman, in conversation with the author, August 15, 1991.

47. Bob Brewin, "VCRs: Bigger than Box-Office," *Village Voice* (March 11, 1986), 45.

48. MPAA, "1990 U.S. Economic Review." MPAA statistics delineate a decline in theater admissions from 1983 (1,196.9 million) to 1990 (1,057.9 million) which coincides rather remarkably with the dramatic increase in VCR households, which rose from 8.3 million in 1983 to 65.4 million in 1990. Though film industry analysts insist that video has encouraged moviegoing, many Americans are clearly being lured away from the theater by the home entertainment industry.

INDEX